PLAYA DUST

COLLECTED STORIES FROM BURNING MAN

EDITED BY
SAMANTHA KRUKOWSKI

black dog
publishing
london uk

ACKNOWLEDGEMENTS

I cannot thank enough the authors, artists and photographers who gifted their time, energy, persistence and generosity to this project. All are extraordinary human beings with deep hearts, open spirits and massive talents, and this book would not exist without them.

Administration, faculty and staff in the Department of Architecture, College of Design and the Office of Risk Management at Iowa State University supported the design studio that inspired this book—thank you to Luis Rico-Gutierrez, Cal Lewis, Gregory Palermo, Cameron Campbell, Mark Chidister, Deborah Sunstrom, Teddi Barron, Virgene Monthei, Jean Holt and Deb Hearn.

During the development of this book I have been fortunate to be encouraged and motivated by colleagues who are iconoclasts and adventure-seekers: Dan Naegele, Pete Goché, Mitchell Squire, Tom Leslie, Mikesch Muecke, Pete Evans, Karen Bermann, Ingrid Lilligren.

Marcos Novak is my champion, he celebrates my efforts and being on so many levels—thanks is insufficient. Richard Shiff continues to be a most important mentor.

Deep appreciation goes to Paul Mellion, who ran the camp that welcomed the Burning Man Studio, and to my friends Scott Myers, Dan Levine Mellion, Amy McGrotty, Idit Oz, Duke Shibukawa, Barbara Bourne, Larry Laba, Kc Welch and Brook Turner. I admire all of the students who participated in the Burning Man Studio for who they are, the chances they took, and for the projects they made in the desert. And thanks to Jessica Bruder, who accepted my cold-call invitation to visit us in Iowa.

Many people at the Burning Man Organization assisted with the production of this book, especially Marian Goodell, Megan Miller, Lee Anna Mariglia, Miss Nik and Bettie June. John Law made the last roads smoother than they might have been.

Michael Hickey provided excellent legal counsel.

Nancy Eklund Later, agent, editor and eloquent adviser, helped shape this book and find it a home. Black Dog Publishing brought it into the world—thank you to Duncan McCorquodale, Lauren Whelan, Thomas Howells, João Mota, and Nick Warner.

My husband, Jeffrey Miller, first got me to Burning Man and maintained the supply of jolly ranchers and brushpicks that made our adventures on the playa most memorable. He keeps me from wandering too deep in the desert and still looks better as Candi.

My daughter Zoë is my forever inspiration.

And my parents, Lucian and Marilyn Krukowski, gave me a rich childhood that supported my imagination and taught me tenacity. I could have never conceived or produced this book without them. I wish my mother were here to enjoy and celebrate it—she missed it by only a year.

for Zoë

Recording an oncoming dust storm, 2006
Photo: NK Guy

INTRODUCTION
SAMANTHA KRUKOWSKI

Many books about Burning Man begin with a caveat. Their authors write that Burning Man cannot be described, that its whole is incomprehensible to anyone, even to those who have attended the event. They say Burning Man cannot really be written about, and that what they are offering is dangerously incomplete. And yet, these authors do go on to write and produce books, and clearly some do want to offer a comprehensive overview. There is richness in the tension between the desire to communicate what Burning Man is and the sense that it is impossible to do so. This tension is perhaps what inspires so many people, an increasing number of people, to try to capture it—it is so hard to describe and yet so worthy of description. There must be something extraordinary about it, after all, since almost 70,000 people decided to spend a week at Burning Man in 2013.

This book swerves away from these preoccupations to celebrate an aspect of the event that generates so much of its energy: stories. The culture of Burning Man inspires freedom of expression of many kinds: physical, emotional, performative, artistic, interactive. This freedom is magnified by the seemingly infinite expanse of the Black Rock Desert, and it encourages an unusual openness of self, friends and strangers. You can have the deepest conversations with people whose names you never learn. It's rare to be asked what you 'do' in the Default World (what people who go to Burning Man call the world outside the event.) You never know who you will meet, what you will engage, what you will see or climb, where you will rest, what you will eat. Maybe someone will hand you a hot dog. Or grab your hand and pull you onto a giant teeter-totter. Or put a candy necklace around your neck. Or give you a ride on a dragon. Predictability is not a part of Burning Man.

The stories that follow were gathered early on in a haphazard way. I had a series of themes in mind that I hoped would provide a framework for a book of this kind: art/architecture; music; theatre; ritual; spiritualism; idolatry; creativity; utopias; economy; landscape; Black Rock City; the history and evolution of Burning Man; the Burning Man Organization; law; beyond Burning Man. But I didn't know where to find the authors who could write about these things. I didn't know anyone at Burning Man, so I appealed to colleagues and friends and friends of friends and used social media to make some initial contacts. I was able to get in touch with artists, authors, photographers and filmmakers who had engaged Burning Man, and some generously joined in. They also introduced me to people they thought might be interested. I contacted the Burning Man Organization, and a small group of staff members spread word about the project via internal networks. I went to San Francisco to visit the Burning Man offices. I got a tour. Had lunch. Spoke briefly to a few people. Saw the back of Larry Harvey's hat. I met people who knew people who knew people. The book slowly gained momentum, albeit of a diffuse nature.

The articles here speak to some, but not all, of the categories I first identified. Everyone who contributed gifted their work, and so some who might have addressed the categories that are missing could not participate for reasons of time or money. The most egregious omissions are those that would have addressed Black Rock City as an urban space and utopian city plan; the business model and workings of the Burning Man Organization; the future of Burning Man from within and without. Hopefully stories about these will appear elsewhere. I have been asked if a second volume is in the works. Who can say? There are so many more stories to share.

But why take on this project in the first place?

The book was inspired by experiences I had when I taught a design studio at Iowa State University, The Burning Man Studio. In this studio, I asked students to

conceive, design and build works for Burning Man; transport them to the playa and install them; participate fully in the event; figure out what to do with their work afterwards; find their way home. It was a great challenge to prepare them for the event—some had never been outside Iowa and so their first travel experience was to spend a week at Burning Man. We were joining a camp—I brought in the camp director to talk to them. I called Jessica Bruder, author of *Burning Book: A Visual History of Burning Man*. I had never met her, yet she graciously accepted my invitation to come to Iowa to share her experiences on the playa with my students. But even after these and a few other visitors had gone, I realized what could have helped my students see into Burning Man was a book full of stories written from different points of view. A book that would reveal, rather than describe, the many faces of the event. There were bits and pieces spread around, but there was nothing curated. Nothing that in the reading felt like you were walking around the playa having conversations about whatever with whomever whenever.

Hopefully this book fills the void I perceived, hopefully it works in the way I imagined it could.

But before the stories ahead, I will offer some of my own.

Many rolls of neon pink duct tape were in our cars—it was cheap at one of the big box stores in Reno. By the time we got to the playa, my clothes and one boot were covered in pink tape shapes and strips.

I jumped on the Disco Fish. It went far out to the perimeter fence, to an odd structure with theatrical pretensions and a burlesque feel. The Disco Fish stayed. And stayed. I was done. Started walking back. Not enough water, not enough sunscreen. Dumb, dumb, dumb. First contact was a western saloon under construction. I asked one of the builders if he had any water. He looked at me. "Do you think we have any water?" I looked at him. "Here's a beer." I got schooled, but ended up with a cold frosty in my hand.

My husband and I got re-married on the Metro-Pole by Father Dan. I did not pole dance (a missed opportunity) while I waited for his sobbing friends to walk him to the fuzzy red platform altar. I wore fur, he wore polyester, Father Dan wore shiny gold short-shorts, my students wore animal masks.

The Spank Bank was our afternoon entertainment. Pink oil barrels with sheepskin draped across them, a rack with restraints and all manner of toys, and then there was Big Mike. He wore a black skirt and black and white striped stockings and high leather boots and he was probably 6'8" before he put them on. He'd give people what they asked for—serious straps or sweet feathers. People asked me if I had gotten spanked. Nuh, uh. I saw where those things had been.

A favorite retreat, the tent covered in sun-shading material with a floor of damp grass. Not in line with the Burning Man rule of bring-in-no-foreign-species, but we were all foreign species anyway, and it was lovely in there, so very strangely cool and out-of-place in such a brutally hot world.

I am not going to give away where the best porta-potties are. I was momentarily tempted.

There's a bike ride at Burning Man called Critical Tits. Imagine, thousands of topless women riding bikes in an endless stream across the desert! The first time I rode there was a group of men on the sidelines yelling "We love you! You are all our mothers! You make the universe!" I started crying. It was so beautiful. Women! Look what our breasts can do! The third time I rode was two months after my double mastectomy. It wasn't an easy trip—my mutilated chest amongst all of the beautiful ones. Before the ride my friends kissed my scars. At the end of the ride, a snow cone in my hand, a man did the same, saying he knew those scars because his sister had them. This book is being released almost exactly two years after I was diagnosed with breast cancer, seven surgeries later.

SAMANTHA KRUKOWSKI

BAKER BEACH 1989
STEWART HARVEY

STEWART HARVEY

BAKER BEACH 1989

STEWART HARVEY

BAKER BEACH 1989

STEWART HARVEY

BAKER BEACH 1989

STEWART HARVEY

BAKER BEACH 1989

STEWART HARVEY

IN THE BEGINNING
JERRY JAMES

1986, BURNING MAN #1

21 June. It was the summer solstice and the day Burning Man was born. Larry Harvey and I were close friends. He called and asked if I was interested in building a figure, a man, to burn on the beach to mark the longest day of the year. We decided to meet that afternoon at a garage in San Francisco's Noe Valley. A friend of Larry's owned the garage and while he had an old table saw and some scrap lumber there weren't any other carpentry tools around—a dull handsaw, a motley collection of finish nails—not much natural light either. Cutting and assembling was going to be a challenge if we built the figure there. But I was a carpenter by trade and Larry was doing some landscaping so I figured we'd work it out.

Larry and I became friends around 1985. I'd come to San Francisco from Boise, Idaho in 1980 and Larry had come from Portland, Oregon a few years before. Larry was six years older than me—I was in my early thirties. We both had young sons. Larry had a good rap, and was deep into all kinds of stuff like Freud, Kohut and Conrad. I'd been reading Celine, Bukowski and playing Bob Marley and Captain Beefheart. He and I read *Nostromo* with friends, and hung out with Dan Richman, who introduced us and often had people over to play music, get high, get laid. When Larry and I went to the Noe Valley garage, he was reading *The Golden Bough*, an anthropological work that referenced the history of burning effigies. He had already attended a few solstice events on Ocean Beach that involved burning a variety of objects.

So there we were, in that dim garage, talking about how to build a wooden figure with seriously limited resources. We planned to build it right then and get it to Baker Beach by sunset. Rather than aiming for a two-dimensional stick figure I went for volume. I shaped a rib cage out of the leftover wood and made an inverted pyramid for the head. I made triangular legs and stick arms and fastened them to improvised hips. I stapled burlap inside to approximate skin and to hold kindling. The effigy ended up being about eight feet tall, primitive, but it clearly represented a human form. We loaded it onto my small pickup on its back, feet off the tailgate, its shoulders angled up on the cab. We headed for Baker Beach.

It was about 18:00 when we got there, sunny, but the wind was coming up. We got the figure off of my truck and I took some photos of it leaning against a hippie school bus. Then we carried it to the north end of the beach towards the Golden Gate Bridge. Halfway there we unexpectedly ran into Dan Richman, heading for the parking lot. We paused to say hi and kept on going. Dan was also a builder. He looked like Brando and played flamenco guitar. He had finished his day at the beach and wasn't interested in joining us for the burn.

Within ten minutes we were positioned facing the rock face rising at the end of Baker Beach. We planted the effigy with its back to the Pacific. I had formed the base of the legs into sharp points so we could force it into the sand and keep it standing. It looked at us; the lighthouse at Point Bonita flashed a rhythm. A few friends showed up, we drank beer, ate, laughed and felt the wind increase.

The sun gave up and the sky became dark like the ocean. I reached as high as I could and doused the figure with a gallon of gasoline. I lit the burlap and the thing went up—we had an eight-foot fire. Some strangers came over, one with a tambourine, another with a guitar. There was chanting—"burn fire burn." The chanting seemed kind of weird to me, but it also brought a somber tone to the event. Somebody held the effigy's arm while another person took a photo. I took shots of the fire. I wish I could say I felt we had started something larger than ourselves, but

I didn't. I had no thoughts about repeating the build or burn of the effigy. But Larry and I talked about it, the day after, a month later, and did decide to do it again the next year.

Who knew that two years later Rob Morse, a columnist for the San Francisco Examiner, would write about three guys preparing to burn a three-story tall sculpture on Baker Beach?

1987, BURNING MAN #2

My girlfriend Maria and I were getting past some major turmoil and were living together in a worn-out mansion on Capp Street with three roommates. It was a groovy place with a couple of fireplaces and a lot of forgotten stories. There was a deck out back that was sometimes sunny and that was framed by the adjacent buildings. The second man was built there. As the solstice approached, Larry and I *began* working out the design details. Larry suggested we incorporate crossed horizontal members to provide shape and volume. The backbone was made of four-by-fours as were the leg and arm bones. Two-by-twos and two-by-fours were set perpendicularly across these bones and miter cut at the ends. We finished the arms with stair stringers so they had a zig-zag profile. Larry and my roommate Sigmar decorated the figure by painting a triangular crown including yellow lightening bolts angling off its brow. This time the effigy was about 12 feet tall and the assembly was still pretty modest. It took a couple of weekends to build it.

When we got the man out to Baker Beach on the solstice, it was foggy, windy and cold. About 35 friends and acquaintances were there—we had spread the word. Some people brought flowers, food and drinks. The vibe was similar to the year before—spontaneous, relaxed, not too serious, a glorified family picnic. After the fire I had a sense this might be a ritual, and that we would do it again.

1988, BURNING MAN #3

I've been a carpenter or contractor most of my life and I'm often struck by the 'pop' that happens when a design manifests and all of the pieces fall into place. That pop happened for me during the build of the third man.

Larry wanted to make the figure and the burn bigger, to enlarge the experience. Early design conversations focused on a 30-foot tall figure. To erect and burn something of this scale on a public beach with the help of a large, unrehearsed crowd before the police stopped us was a challenge we recognized—and one that needed the help of some magic. I can't tell you why I decided to keep going, why I engaged a project that called for increasing commitment, sacrifice and risk without tangible reward. The first two burns were a lark. What was the intensification about? Looking back on the third burn, I'm very glad nobody got hurt, because the scale of the thing had definitely created a potentially dangerous situation.

I had the unfortunate tendency to adopt certain friends as father figures. I did this with Larry. He read a lot, expressed ideas with confidence—I looked up to him. Admiring and trusting Larry turned out to be a weakness that would later take its toll.

We built the man in a garage in the Lower Haight that I rented for the storage of my construction gear. It faced south onto an unusually wide sidewalk. The garage was a great space to work. There was a medical center across the street. Being able to work in that space was part of the reason I decided to keep working on the build of the man. I dig wood, building and collaboration. I was designing and constructing something very unusual, hanging at the shop, moving the project forward.

A few months prior to the solstice, Larry, Mike Acker and I had breakfast and then went to the garage. Mike and I were partners in Acker & James Construction by then. When we started to discuss the design of the man, Larry became surprisingly aggressive and was antagonistic towards some of Mike's suggestions. He tried to control the build much more than he had before. As Mike and I worked, he'd mostly stand, hands on hips, telling us what to do, or fiddle around over some minor detail, cussing the tools as he worked.

Actually, I was accustomed to Larry wanting to have his way. If I arrived at his apartment to pick him up and he was on the phone, he'd stay on it. He'd take forever to get ready. He'd forget where he put his cigarettes or lighter or sunglasses. To be around Larry was to accommodate him. In 1997 I had to advise him on getting a picture ID so he could fly to New York for a show on Burning Man that I produced at CBGB's. He was like a child in some ways, and that part of his personality was strongly evident in the build of the third man.

The design of the third effigy was the basis for the one still in use today. And it was clear, as soon as we started, that this one was not going to be a friendly little statue. At a 30-foot scale, there was a need for true structural integrity. And it would need to fit in my 20-foot long shop while we built it. It had to be constructed in modules. We fabricated the legs, torso, body, arms and head separately, and planned on transporting them to the beach and assembling them there. The arms were hinged so that they could be raised once the figure was standing. Larry made some bamboo lanterns and copper strips that would act as wind chimes, all of which would later be located in the pelvis. Mike made a tube filled with fireworks that would be placed inside the head. We stapled burlap inside the lumber frame that would hold newspaper and soak up the kerosene that we would use to ignite it. The thing got so big we had to build parts of it on the sidewalk. Sometimes the torso or a leg would be on sawhorses, other times the whole figure was assembled across it.

That spring, as we spent every weekend for months working on the figure, we began to call it the Burning Man. It was trademarked a couple of years later. Mike and I were not informed about that huge development in the history of the project.

The day of the burn we met at the garage and loaded the components of the Man onto my primer-grey '74 Dodge pickup. The torso went in the truck bed first and then we put the 20-foot long legs up on the lumber racks along with the arms. Tools, guy wire, rope, kerosene, hardware—it was quite a load. Actually, it looked like something from a gypsy caravan. Driving across the city, I was nervous that the authorities might stop us. The sky was grey and a marine layer hung over the ocean as we approached the beach. I parked on Lincoln Boulevard at a cliff above the northeast end of the Baker Beach, trying to maintain a low profile. We were closer to our burn spot than when we had parked in the parking lot in previous years, but the bad news was that we had to carry everything down a steep trail. My anxiety spiked once we parked and started to unload. We had few volunteers to help expedite the unloading, move and set up of the figure, but any cop who happened by would have seen us. Luckily we got everything down to the beach without incident.

We arranged the Man's parts on the sand and worked to fasten them together. The Man was assembled lying on his back. Some of my builder buddies arrived to help. I was the only one with any tools though, except for Mike who had a few—this was not good. More people arrived and soon there were a lot of volunteers. Despite their generosity, their help yielded mixed results. They didn't know how the thing was put together, they didn't know how it would be erected, they hadn't been at the previous burns—even my carpenter friends weren't sure what to do. People, a lot of them strangers, kept arriving. Cameras rolled. Burning Man was now a public event and all eyes were on me as I scrambled to get the man together. I stayed focused on the assembly despite my fraying nerves. Time was going way too fast

but simultaneously everything seemed to be moving in slow motion. It took a couple of hours to assemble the Man. But then, it was time.

The plan was to lift him in the way a tall extension ladder is lifted at a construction site, though this was a very tall and unusually heavy "ladder." One person "foots" one end of the ladder and another lifts the opposite end while walking towards the "footer." As the Man lay flat on his back we had tied a thick rope with a pulley to his solar plexus and the rope extended out beyond his feet to a stake in the sand. The crowd were to lift up the Man's shoulders until they could lift no higher and we were to then engage the pulley to lift him the rest of the way into the vertical position. We had incorporated plywood baffles like a snow shoes at the ends of his legs that would be anchored in holes we had dug in the sand. On our first attempt the stake holding the pulley failed and nearly impaled the crowd of volunteers—and me, too. In those moments of terror I managed to get people out of the way before the figure slammed down onto the sand.

We decided to abandon the pulley after that and just use the rope, with half the crowd straining against it. We lifted the shoulders. Everybody on the rope shouted, "PULL, PULL, PULL!" and against all odds the Man went up! As I saw the figure standing I felt as though an enormous weight had dropped away. After months of work and planning the Burning Man stood looking down on us. I believe everyone there experienced a moment of real transcendence then. At some point a reporter tried to talk to me but I was too busy for an interview and asked them to follow up later.

We paused and had a smoke. There was a guy banging a gong, some others blowing horns. We were pretty sure the authorities were going to show up, especially given we were on the US Army's Presidio Base and we hadn't asked for permission to do what we were doing. We figured if we got caught we'd explain to our fellow inmates that we had been arrested for art.

It was a cold night and it was very windy. The crowd's attention was focused on the Man and the crashing waves were loud and big. We had soaked the burlap before we raised him and then we started the fire. The wind was so strong it intensified the burn. Large chunks of newspaper and burlap, some flaming, took to the air. Eventually, a charred figure remained. I tried to finish it off by starting a campfire at the base. Someone else climbed the Man and tried to ignite the torso. That's when the cops arrived.

There were four San Francisco City cops. As Larry and I tried to hide in the crowd, I realized the cops were shaking down the guy with the gong and stepped forward. Two of the cops were talking like we'd just robbed a bank and the other two were friendly. After a few threats and negotiations they left when we promised we'd knock it down, finish burning it and go away. We released the guy wires that held it up, let it crash to the sand, sawed it into sections and made a massive bonfire that burned more quickly than expected. After that, people split. I was seriously hung over the next morning but I was so in awe of what we had accomplished I went back to the crime scene to see what was left and pick up any souvenirs. I also wanted to leave the site clean and safe. I found screws, nails, bolts and charred wood chunks and tossed them so they wouldn't find their way into bare feet.

A writer from *Focus* magazine called soon after and I put him in touch with Larry. I was working full time and Larry was unemployed. It seemed logical to ask him to arrange the interview for us. He went on to do the interview without me, and referred to Mike Acker and me as his "cohorts." My trust in Larry was waning.

1989, BURNING MAN #4

Despite the increasing friction with Larry, I agreed to build the Man the next year. I built shelves at a friend's place out by City College in exchange for the use of her

garage. The design was the same except I built each leg in two parts to make it easier to carry them. We also went out to Marin and collected truckloads of willows to weave into the figure. I bored holes into the lumber and pulled the willows through and over the burlap in a crossing pattern.

The night of our preview party, the Man was complete and stretched across sawhorses in the garage, softly lit by cheap work lights. Someone said that Ann Hatch of the Capp Street Project, a significant arts organization, had arrived. Burning Man was getting noticed.

When we headed to the beach we had more help than ever before including members of the San Francisco Cacophony Society who monitored the police radio and were prepared to signal us when the authorities were headed our way. It was sunny and unusually warm. There were 500 people on hand. We assembled the Man as we had the year before, but when we started to raise him one of the leg joints I had constructed failed. He landed on his butt with his head slumped, resting on his chest. There was no practical way to fix him so we tied off the guy wires and left the Man in a sitting position. I felt like he looked—dejected. We got word that the cops were on the way, so we started the fire.

A lot of police arrived quickly, as did the local news. The cops milled through the crowd, not really approaching anyone. Larry and I started an interview with the reporters—Larry spoke eloquently and I turned into a deer-in-the-headlights.

A couple of weeks after Burning Man '89, Larry betrayed our personal friendship in a way that broke it forever.

Months after that, on Labor Day weekend, I attended a wind sculpture festival produced by Mel Lyons in the Black Rock Desert. Mel had once shown Larry and me footage of a giant croquet game he'd performed there using wickets made of white pvc pipe and six-foot diameter rubber balls. He drove around in various vehicles knocking the balls through the wickets. The piece had been covered by *Sports Illustrated* and shared the spirit of many that would appear at Burning Man when it moved to the desert. When I went out I carpooled with friends and took a small cooler of deli food, a six-pack, and a sleeping bag. Fortunately, the weather was good and it was mostly hot and still for three days. The directions on the invitation to the event were spare—travel the edge of the playa for five miles, find an old tire, head to the low point of the mountain range to the east for seven miles. We navigated that flat, cracked clay until we saw encampments. There were about 70 people and several trucks straight out of *Mad Max*. Being with a small group really allowed me to experience the size, the quiet, and, with the mountain ranges surrounding us, the sense of being in another world. Mel had designed human-scale chess pieces on wheels that blew about the desert floor.

1990, BURNING MAN #5

In 1990, I no longer wanted to participate in the build of the Man, nor the organization of its transport and installation. Dan Miller, Larry's roommate, stepped forward and built it at the shop of a sound company. I visited the build but felt completely alienated. So many people, so many faces. I was torn since I had been the architect of the Man since its conception, but I could no longer work with Larry.

I did want to participate in the burn though, and I was one of many who arrived at the cliffs above the north end of Baker Beach to send pieces of the Man down. The cops arrived while I was involved in hauling the components down the cliff. Remarkably, they agreed to let us build our sculpture if we would then remove rather than burn it. But this time was different—there was blood lust. The crowd chanted "Burn the Man! Burn the Man!" Larry decided it shouldn't burn, because breaking

our agreement with the authorities might jeopardize the next Burning Man. Later that night the arms and head ended up in my garage, the torso and legs went to a vacant lot that someone loaned for the preview show. A few weeks later that vacant lot got gentrified and the torso and legs disappeared.

In 1988 I had sought out the San Francisco Cacophony Society to ask for their help with Burning Man, having read about them in the *San Francisco Bay Guardian*. The Society was composed of a group of free spirits who put together events consisting of culture jamming, costuming, exploring, and pushing the cultural envelope. Though there was no beach burn on the solstice in 1990, the Cacophony was planning a Zone Trip to Black Rock Desert on Labor Day, and that is when Burning Man was first sacrificed in the desert.

I made several unsuccessful attempts to reclaim a place in the Burning Man project over the next five years. Politics held sway. I built a few more things for the event—including the main stage at Center Camp in 1996. Resigned, I attended as a tourist several times which quickly led to boredom. In 2006 I returned to help build the Temple.

2007, BURNING MAN #21

On 27 August 2007, Todd Freeman—a close friend and carpenter—and I were helping with the Temple build once again. We were there before the event was open to the public. That night there was a full eclipse of the moon that transformed it into something that looked like a mauve weather balloon floating 300 yards above the playa. We were really high and sitting on Todd's tailgate drinking warm tequila at 3:00. It was balmy. A bus of ravers rolled up and paused to shake booty. There were a lot of bunny suits. We heard someone shouting "the Man's burning." It took a few minutes for us to rally but we hustled out and saw that the Man was indeed aflame.

As we came to learn, Paul Addis, tortured man that he was, had set the Man on fire early in order to protest the direction that the owners of Burning Man had taken. That, as a for-profit corporation, they had compromised Burning Man values and that the event had become largely a giant rave. After being immediately apprehended, the owners of Burning Man went to some lengths to show that the damage done by Addis was of sufficient value that he be charged with nothing less than a felony. He served 13 months for his crime. Sadly, he took his own life shortly thereafter.

Over the years, when my history with Burning Man came up in conversation, people occasionally thanked me. I felt humble and proud when they did. I also felt angry that I was robbed of the opportunity of contributing further. Time and writing this essay have helped me unload this burden. I'm lucky to have met some wonderful people through the acquaintances I've made through Burning Man, including my wife. I've enjoyed and struggled through many experiences at the event with some of my best friends; I'm encouraged by some of the directions Burning Man has taken and disappointed by many others. I have now been absent from Burning Man for six years, my longest stretch by far. Regardless, having worked as a builder since 1975 I can honestly say that I have never built anything as challenging or rewarding as the Burning Man for Baker Beach in 1988.

JERRY JAMES

BLACK ROCK DAWN
STEWART HARVEY

BUILDING A FIRE—1990

With 80 or 90 participants, the first Black Rock Burn was in truth little more than a gathering of friends; humble beginnings for an event that is now an international phenomenon. Not much happened on that first weekend in September—people hung out, cooked meals by the side of their tent or RV, and nearing sundown on Sunday got on the end of a rope to hoist up the 40-foot wooden figure people had driven hundreds of miles to see set on fire. The difference between the 1990 Black Rock Burn and the previous four on Baker Beach in San Francisco was principally the location, an ancient dry lakebed 80 miles north of Reno, but the Black Rock Desert turned out to make all the difference. Had it not been for the good fortune of moving the event to this powerful and inhospitable place, I'm not sure I'd be writing about Burning Man these 20-odd years later.

My son Bryan and I attended 1990's inaugural playa Burn with only a small notion of where we were heading. The Black Rock Desert formed a significant blob on our AAA map, but neither of us had ever seen such a vast expanse. In 1989, we'd attended what turned out to be the final solstice Burn at Baker Beach, because in June of 1990 the authorities intervened. At that time, Burning Man was strictly an underground operation founded by my brother, Larry Harvey, and his associate Jerry James in 1986. Over the next four years, they managed to build a loyal following. In 1989, Larry and Jerry, along with a cadre of carpenter friends, built the Man in seven sections in different places, loaded the sections onto pickups, and then drove to Baker Beach taking separate routes. This was in part because they had never bothered to get anything like an event permit. Baker Beach is part of The Golden Gate National Recreation Area and is thus Federal property, so in 1990 when the Baker Beach Burners appeared with their wooden giant, the authorities were waiting. It was a semi-productive negotiation, which ended with the park police saying, "You can set him up, but you can't set him on fire!"

Prevented from setting fire to their Man in June, Larry and Jerry needed a Plan B. What they got was Plan Z. In sympathy with their dilemma as to where to burn the Man, loyal supporters from San Francisco's Cacophony Society invited them to join their planned Labor Day Weekend party at Nevada's Black Rock Desert. It seemed to make perfect sense. After all, The Zone (Cacophony's name for a place

where anything can happen) was BLM land, who would care if they burned the Man there? A hastily arranged collaboration called Zone Trip #4: Bad Day at Black Rock was under way. When his Uncle Larry called to tell us about their September Burn plans, Bryan and I started packing

The ten-hour journey from Portland, Oregon to the Black Rock Desert in northern Nevada is more than a long transition from city to barren plain. It is a meditation that allows one to shed the comforts and conventions of urban life and embrace existence on an ancient terrain—residential clusters give way to forest and farms; the farms give way to scrub pine and jagged plateaus of Cascade lava; finally, there are only the rolling acres of sage, a haven for coyotes and jack rabbits. Far beyond the sage spreads the alkaline remains of prehistoric bodies of water.

When we reached the turn off from Highway 447 onto Route 34 we were scarcely prepared for what we were about to see. Before us stretched a vast lunar landscape. The Black Rock Desert is a massive alkaline flat that encompasses nearly 1,000 square miles. The playa surface itself is a limitless expanse punctuated by cracks, wheel ruts, and dust rows sculpted by the relentless afternoon winds. We stopped by the side of the road and looked at the tire tracks that made their way out onto the playa and then seemed to vanish. Because the playa is so flat, heat waves radiating from the surface create a mirage effect. An object heading towards you from out of the mirage appears to be floating on a ribbon of sky—very disconcerting. We began tentatively crossing the barren playa. Armed solely with a compass and the coordinates Larry had sent by mail—"Head due east for six miles, and then turn north for four miles"—tentative seemed to be prudent. Slowly we began to gather speed. The hard alkaline floor invites speed, begs for it, so I opened the rental rig up. As we neared its top speed wakes of dust from the sand drifts blasted high on either side of the car, adding to the giddy fantasy of speeding across Mars. But the drifts kept getting deeper, and soon we were nearly upended when a particularly deep one drove the nose of the car downward splashing playa sand over the windshield. It was time to get real.

We hit the six-mile mark and turned northward, or as northward as we could calculate because the compass needle was wandering back and forth. "Can you see anything?" I asked Bryan, who was looking intently at the compass. "Not a thing," he replied. It was mid-afternoon, and there was still plenty of daylight, but the desert can swallow large encampments in its glare. Unless you're within half-a-mile or so of your destination, you can blow right by. As we neared the four-mile point Bryan spotted a glint of sun off the side of a yellow Rider Truck. Ahead of us was a stack of an utterly-out-of-place drums that had apparently been set up by a mysterious playa drummer for some as-yet-to-be-determined performance. To its right was a slender line of vehicles blending seamlessly into the horizon. We altered our course a few degrees and headed for them.

STEWART HARVEY

What we found was pretty skimpy—a handful of vehicles beside an equal number of tents. There were a couple RVs, and one or two VW Vanagons with dream catchers hanging from their mirrors or Grateful Dead stickers on their back windows. Aside from size, the greatest difference in attitude from 1990 and subsequent years was that no one really had a clue as to what their role in the proceedings would be. The camp sported very little of what would eventually be thought of as Burning Man regalia. There was an orange and white parachute draped haphazardly over a pole with a pirate flag, which I suppose was a prototype Center Camp, but it was little more than a visual oddity. This could have been a KOA campground if one were to judge by the blandness of the rigs and the campmates themselves. People were friendly enough, but cloistered in small enclaves. Many were from San Francisco and knew one another. Bryan and I were the outsiders at this gathering, and it would take us a while to get the lay of the land.

There was, of course, the oddly comforting sight of a forty-foot humanoid standing just outside the ring of campers, and the sight of Larry's roommate, Dan Miller, bicycling towards us with a VHS camcorder on his shoulder. It was my first Widelux view of the Burning Man on the Black Rock Desert, but there would be many more to come. The presence of the Man on the flat expanse of the playa seemed completely natural and appropriate to the scale of the place, yet it also had that artificially mythic resemblance to a Hollywood prop from the classic sci-fi era of the 1950s. To my mind it recalled the childhood memory of the stoic and powerful Gort from *The Day the Earth Stood Still.* I had last seen the Man on Baker Beach the year before, and frankly he was something of a rickety mess, but this fellow was a forty-foot masterpiece of elegant proportions and structural grace. It is a glowing testament that this 1990 version of the Man, ignoring a few minor cosmetic embellishments and his ever-enlarging

yearly thematic platform, has remained fundamentally unchanged for over twenty years.

It's hard to overstate how the vastness of the playa adds to the mystique of Burning Man. Certainly the demand for a proportion that can compete with this seemingly endless expanse has influenced the construction of huge sculptures and mammoth theme camps, but scale is only part of the equation. Contact with an ancient landscape can activate primal instincts. Existence is vivid and timeless. One can feel at once small and vulnerable, and yet placidly connected to a greater whole. The small miracle of the Black Rock is that despite the exponential growth of the event over the decades that feeling of kinship to our ancient origins is as real today as it was then. Then as now, the pioneer Burners of 1990 strolled about on a terrain both foreign and familiar, and felt at peace. The desert had opened itself to them and they succumbed to its wide embrace. It's one of the phenomena people talk about when describing their experience at Burning Man—the sense of being alone on a boundless plain, yet bonded to the spirit of an invisible community.

Preparing the Man for burning had always been the principle ceremonial feature of the early events. The procedure on Baker Beach had been to assemble the Man on the spot and then recruit volunteers from the crowd to pull him upright. Here he was already upright, so forty able bodies would need to first lower the Man to be loaded up with accelerant, and then raise him back up. A call was put out for volunteers to line up along a long rope. As Dan Miller barked out "Pull" and "Hold" on his bullhorn, 40 souls lowered and then raised the Man back to upright. It was the first truly communal act of the 1990 Burn, and it was a welcome return to the Baker Beach tradition.

STEWART HARVEY

As the sun dipped towards the horizon a lone drummer began to rhythmically summon people to witness the *raison d'être* of the event. Aside from raising the man an hour or before, there was nothing particularly formal or ceremonial about what was happening.

Now the sky was absolutely clear, the weather placid. Bryan and I, drawn by the beating drum, wandered out towards the crowd that was beginning to assemble by the Man.

The first people to arrive at the Man during this pre-burn assembly were those most involved in bringing Burning Man to the playa—John Law and the members of San Francisco's Cacophony Society. Bryan and I jealously noticed that a few folk were in costume, though many like us were dressed in their best camping casual. Bad Day at Black Rock had originally been conceived as a cocktail party on the desert, and the members of Cacophony arrived ready for costumed reverie. While the remoteness of the playa can often inspire acts of radical self-expression, it was certainly the faux-formal wearing members of Cacophony that established the trend toward costuming at the event. Over the years the costumes have gotten more creative and elaborate, or less so in the case of full nudity, but in either case personal expression is the heart and soul of the event. As for the rest of us novices, we mostly just stood around in our camping clothes and felt like tourists. "Wait 'til next year," we all thought, "We'll show you some desert drag!"

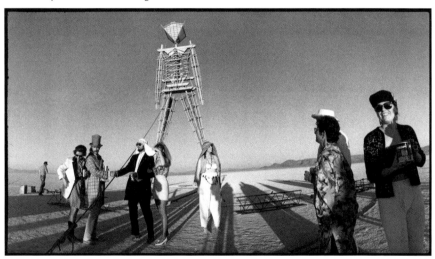

The allure of fire has been with us from our first days on earth, when people sat in caves and stared into a flaming pit hoping for some supernatural sign. We are all subject to fire's attraction, and yet fearful of its deathly embrace. Hell hath no fury if not for scorching flame, and yet the fire beckons—calls us to gather around, to whoop and shout as a giant effigy is immolated before our eyes, or else to stare transfixed, as if given a devastating glimpse into our volcanic origins. We gathered in front of the wooden giant—and awaited the inevitable.

That inaugural 1990 Black Rock Burn was as it had been on Baker Beach the year before—a deceptively simple and incredibly moving reenactment of destruction and rebirth. We gathered and raised the Man by hand. David T. Warren (aka Flamo LaGrande) performed the same ritual lighting of the fire as he had the year before on Baker Beach, and we stood mesmerized as the flames first engulfed and then finally consumed the Man before our very eyes. Then as with all of the Burns to follow—contradictions abound. The Man is consumed by fire and yet lives to be reborn the

following year. The ritual feels both timeless and yet utterly immediate, and it takes place in an environment that is at once otherworldly and oddly familiar. Above all, it simply feels right and real to be there in that moment as the flames transport us to an experience that feels both private and universal.

As we 90 meager souls gathered to witness the act of burning a humanoid figure in 1990, we were just as affected, just as moved, as any Burn that has happened

STEWART HARVEY

since. I know, because I've seen most of them. The size and intensity of the ceremony itself doesn't seem to matter. In the present day, there is an outsized amount of hoopla. There are huge crowds, lots of noise, elaborate pageantry, enormous fireworks, and yet there is a moment—a moment when the fire catches and begins to fully engulf the man-like figure—a moment when there is only the sound of crackling flame consuming wood and the heat from that painfully rapid oxidization on your face. In that moment every Burn is equally personal and powerful. The intimacy between the flaming figure and the gathered multitude creates a mysterious alliance, one that is reliably constant. The look on the faces in a crowd of Burners is exactly the same today as it was those 20-odd years ago.

In many ways the most remarkable thing about the first Black Rock Burn was that it happened at all. The sheer effort involved in transferring the event in just three months from its San Francisco roots to this remote location where everything had to be packed in and taken out was little short of Herculean. It was also merely an extended weekend encounter as opposed to today's two month long city build and clean up. Bryan and I had arrived late on Friday afternoon. We spent most of Saturday establishing our camp and socializing with our neighbors. On Sunday evening people raised and burned the Man, and by early Monday morning he and I were headed back to Portland. Persuading city dwellers to travel hundreds of miles to the vast unknown for a cocktail party and a Man roast might happen once, but under most circumstances it would be unlikely to happen again. Yet something extraordinary had occurred on that Labor Day Weekend in September of 1990—something beyond the Baker Beach experience—some kind of unexplainable synthesis between *what* and *where*. In no uncertain terms Burning Man had found its ideal habitat, a harsh and uncompromising place of extraordinary beauty and limitless potential for spawning a unique culture. Bryan and I left the playa with a strong feeling that both the event and we would be coming back.

FANNING THE FLAMES 1991 & 1993

The second year of Burning Man on the playa was in many ways a repetition of its predecessor, but there were significant differences as well. Although Bryan and I missed the 1992 event, the elements of growth we witnessed in 1991 and 1993 would be unmistakable. In 1990, we had discovered the Black Rock Playa as an important and vital component to the Burning Man pageantry. The Black Rock Desert would in time give birth to Black Rock City which, like the Man himself, would need to be built, disappear, and be rebuilt year after year—without losing its cultural integrity. Of course in 1991 "the city" was pretty much still a cluster of campsites, but

what changed that year, and contributed significantly to the event that was to come, was an attitude people came packing along with their tents. That new attitude can now be summed up in a single overarching concept: *radical self-expression.*

I can remember talking to Larry a few weeks prior to Labor Day in 1991. I wanted to verify that we were actually going back to the Black Rock for the event. He assured me we were, and then he shared with me some of his many visions for what Burning Man might become. Frankly, I've forgotten most of what he said those many years ago, but this notion stuck: he foresaw an event that would be driven as much by the creative urges of its participants as by the ingenuity of its organizers. It's a concept that has baffled and intrigued observers to this day, and it is a dominant factor in the longevity of the event.

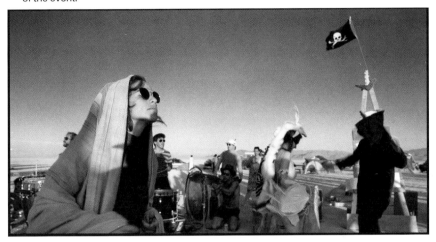

As with the previous year, we arrived to find virtually no communal facilities. There was a minimal Center Camp that consisted mostly of drums and a cobbled together bulletin board for messages, but there were never enough port-a-lets. We lived in random camps next to our cars and shared our food with one another. Most of us didn't have adequate shade structures. But we had something no longer possible at today's event. We were totally free to experience the playa and the weekend on our own terms, and we had all the advantages and disadvantages of being pioneers, able to enjoy a state of autonomy and self-reliance known only to a fortunate few.

In truth, this 1991 playa gathering was a bit of a New Age affair. People erected aboriginal iconography, organized drumming circles and shook the playa with dancing. Although this New Age sensibility was a short-lived phenomenon, and would soon gave way to rave music, interactive art, and mutant vehicles, there is little doubt that in 1991 people came to interact with one another and play.

This was the year for group *participation,* which would evolve into the idea of radical self-expression, and soon become the enduring image of the event.

These days, virgin Burners will often say, "Next year, I'm going to...." It's a telling proclamation that implies that they are planning to come back, or at least are hoping to come back, and that if they do, they are not going to spend their time standing around in a t-shirt and cargo shorts gawking at everything. They are going to make an individual statement. They are going to wear something audacious, build something enormous, and they are going to become *participants* in the ongoing saga of Burning Man. It is the essence of the event. If you aren't dancing, costuming, or emphatically *carrying on*, you're missing the whole point of making the journey.

Though looking at pictures from those early years may reinforce the perception of the event as little more than a dusty incarnation of the Rainbow Gathering, it

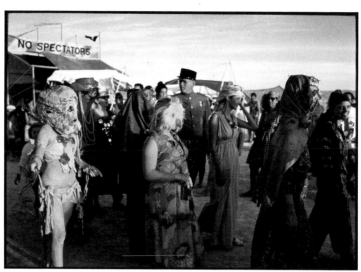

was these New Age Burners who pioneered creative participation as the mainstay of the event. A couple of years later, someone would hang a "No Spectators" sign in Center Camp—a public testament to the new credo that at Burning Man: *There is no audience; Everyone is the show*. It was a ground breaking idea that has been the distinguishing philosophy of Burning Man ever since, and it was the Burners of 1991 who got that party started.

For me, the 1991 Burner desire for self-expression reached its zenith on a windy Saturday afternoon. I was busy tightening our tent supports when a lithe woman wearing multiple layers of white cotton strode by. I grabbed a camera and followed her as she walked out to the Man and climbed up onto one of his legs. With the wind whipping her costume into a gossamer frenzy, she began a slow, acrobatic ballet. For the next half hour, the graceful Crimson Rose (who would go to become a Founding Board Member of today's event), and the Man engaged in the yin and yang of an ancient *pas de deux*. While her spontaneous exhibition wasn't a formal art piece *per se*, there is little doubt in my mind that The Crimson Rose Ballet was the first example of performance art at Burning Man.

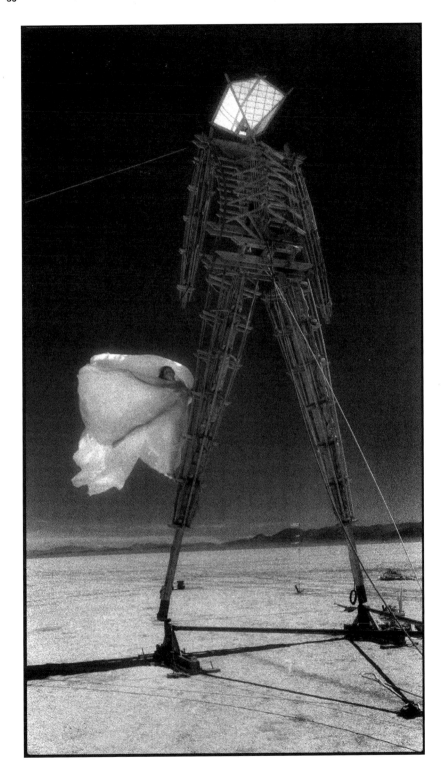

STEWART HARVEY

By the 1991 the ranks of Burning Man attendees had more than doubled, and though audience participation was prefigured in 1990 with Cacophony Society's costuming and the communal raising of the Man, it was these second-year veterans who came armed with the notion that standing around waiting to be entertained was not what Burning Man would be about. One memory that persists about the early Black Rock Burns was just how intimate they felt. It was fundamentally a gathering of insiders and their friends. In the minutes before the ignition of the Man people milled about casually, and enjoyed a proximity and access to every detail of the process that in a subsequent era of safety protocols and concerns for liability would be unimaginable. We came together and raised the Man as people had the year before, and it felt familiar and convivial with a degree of camaraderie that suggested a group of old friends going to dinner.

Burning Man has typically attracted people with shared social values. The Women's Movement had been a forerunner of the 1990s New Age sensibility, and many Burners were also feminists. Janet Lohr, former companion to my brother, and her friends wanted to add something that felt female and nurturing to this overtly Man-centered gathering. They also wanted do something that was equally ancient and ceremonial. What they chose to do was build a kiva-style oven and bake loaves of rotund female shaped bread with the same wood fire that would soon consume the Man. Though the bread distribution never reappeared, impractical in the face of a burgeoning population, many camps exist today solely to gift food or drink to the multitudes. I like to imagine those long ago loaves of bread helped to shape the principle of *gifting* at Burning Man.

In 1991 modest pyrotechnics were added to the Burn, and these blossomed into the extravagant fireworks displays people have come to expect at the modern spectacle. Crimson Rose performed a nude rendition of the ritual ignition of the Man by using traditional fire-dancing paraphernalia, and in that single act she created the prototype for her Fire Conclave performance of fire-spinners and dancers, which now precedes the fire and pyrotechnics at the contemporary Burn. At one point a woman rushed from the crowd and headed towards the flaming figure. She ran straight to the Man and threw something into the flames. I was told later that it was a manila envelope that contained her x-rays. She had recently been diagnosed with cancer, and this was her defiant response. Eleven years later, Bryan having successfully overcome leukemia honored her by throwing his PET and CT scan results into the 2002 flames. These gestures were another in a series of extraordinarily powerful acts that for me defined the importance of individual expression as the core value upon which Burning Man would not only be founded, but which would allow it to flourish. Veteran Burners sometimes complain that today's Burning Man has too many rules, and reminisce about a dimly remembered time when the event was a Wild West monument to the credo of "anything goes." I'm not sure the event was ever so unbridled, but I will say the immediate access we had to the Burn made it a deeply intimate experience. I could easily walk as close to the flaming figure as common sense and the heat on my face would allow. Of course modern safety concerns exist because with the large contemporary population, not everyone at the event will exercise common sense, nor be able to feel their faces for that matter.

I remember taking a parting photo of my brother Larry just at the end of the 1991 Burn. He was getting ready to sever the support wire, which would allow the Man to fall. My brother is notoriously self-conscious in front of the camera, but in that moment he spread his arms and opened himself. It's a simple portrait caught at a rare moment when he was pleased and willing to show it. I love the elements of the picture: his t-shirt from Baker Beach Burn, the leftover ceremonial bread from the kiva oven, and the first of his soon-to-be-famous hats. This one was his original Stetson, called the "Open Road." It had belonged to our father and turned out to be the same model worn by President Lyndon Johnson. Sadly, it was lost in a playa

dust storm a couple of years later, but there would be many more Stetsons to take its place. Bryan and I returned to Portland understanding that his "Hippie Uncle" had somehow found his rather improbable niche.

STEWART HARVEY

STEWART HARVEY

I think of 1993 as a year when individuals made an impression. Walking eastward from our cluster of tents and campers that year, I headed directly towards the stolid wooden giant standing at the apex of the rising sun. Getting up to photograph the sunrise at Burning Man is a habit I acquired my first year on the playa, and one I maintain to the present day. Bryan and I had missed the 1992 Burn, and so I was anxious to reconnect with the playa and witness once again the exquisite solitude of land meeting sky. Initially excited to be the only photographer up that early, I was disappointed to realize a tiny intruder was skirting the glowing ribbon between earth and sky. Even though the fellow was hustling along, I knew there was no possibility he would escape the sweeping lens of the Widelux before the sun finished rising, and so I shot. Today, some 20-plus years later, while I enjoyed this image of the pristine Man uncluttered by throngs of people and their bicycles, it's that resolute hiker on the horizon that resonates in my memory.

The magic of sunrise was reinforced for me again in 1993. I had walked out to the Man in the pre-dawn hour because I'd heard a rumor about a strange creature, which would make a sunrise appearance to dispense coffee to hardy souls brave enough to get up for sunrise. At first, I stood alone, but gradually a few other sleepy heads made their way out, and we stood shivering in the half-light. Finally we spotted a horsey-shaped vehicle bearing what appeared to be a black-clad bovine

superhero followed by his faithful sidekick who was pushing the rig slowly towards us. This was my first sighting of the Java Cow who would become the first of many celebrated characters at Burning Man.

The Java Cow was an invention of Kimric Smythe, who would create several "firsts" for the event. It was Kimric who became the first to load pyrotechnics into the man, and who as the "Exploding Man" would perform during the pre-burn ceremony to many of the early Burns. Although his bovine visage was striking against the playa horizon, the Java Cow's morning ritual was simple and homespun. After his trusted assistant passed out paper cups, and handed him a large thermos retrieved from his trusty steed, the Java Cow intoned, "Does anyone want cream and sugar?" Our scripted reply was, "No sir, we want it black!" With that, the coffee would be poured, and the ceremony was over. Of course looking backwards, it's easy to see the Java Cow as the first of a multitude of such personae who would blossom over the years in the quest for artful self-expression, but there was much more to this beloved critter then meets the camera's eye. For the Java Cow's sunrise ritual reinforced the notion that at Burning Man each individual's creative gesture should be a gift to all.

Today's Theme Art at Burning Man is mandated to be inclusive and interactive, but by 1993 several people were already in the process of establishing that tradition. Aside from the Man himself, the centerpieces of the modern event are its large interactive sculptures. Art comes in many forms at Burning Man, and it can be said that by 1992 playa art had become ever-growing feature of the event. It was even attracting international attention. Event organizer Michael Mikel (aka Danger Ranger) is credited with driving the first art car to Burning Man in 1992. That same year, British artist Selena de la Hey installed three wicker figures on the playa. However, it was Argentine artist Pepe Ozan who would become the first major sculptural artist at Burning Man. His 1993 innovative Lingam series of mud sculptures and elaborate opera sets would dominate art on the playa for years.

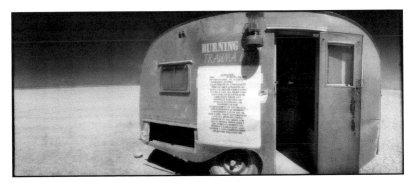

Bryan and I arrived on the playa in 1993 to find a scrappy looking trailer that served as the ticketing booth and gate shack. Here, we would gain entry and be given the official coordinates for finding the encampment, but the trailer also offered vexing information. Next to the door was an announcement to the effect that filming would be going on at the event, and our entry implied our giving permission to be videotaped for commercial purposes. The outside world had gotten wind of the event, and a Hollywood film crew was on the playa intent on making a video of this renegade happening. Suddenly, we were not only going to be the show for one another, we were to be performers in an early form of reality television! As veteran Burners, we were nonplussed.

What happened next was a mixture of annoying intrusion and low comedy. The film crew would scamper around between groups of Burners dragging cameras, cables, and boom mikes. Whenever two or more interesting looking Burners flocked together, there would come the crew. Naturally, whatever spontaneous activity was afoot immediately dissolved into stilted self-consciousness. Now I know nothing about how this episode of *Playa Gone Wild* was supposed to turn out, but I'm pretty sure the filmmakers hoped for more than they got. What they got was several dozen people gathering in center camp to witness a staged act. Someone had scripted some sort of mythic pageant complete with costumes, music, and a large dose of hokum. I can't swear it was a deliberate punking of the Hollywood Rubes, it being the 1990s and all, but I've never seen anything quite like it at Burning Man before or since.

Although there is little doubt many people resented the film crew pushing their way into every activity, in the end, there was a general willingness to tolerate these outsiders with the same spirit of inclusiveness that has evolved into a valued Burning Man tradition. Though common today in the era of YouTube, commercial video seemed to us at the time to undermine the free-spirited spontaneity we all craved. As a photographer, I suddenly felt self-conscious about photographing the proceedings. Something I had never experienced before being, as it were, one of the participants. This was something different. This was the media. As a result, Bryan and I tended to avoid the film crew and stay out of camera range.

The organization that produced Burning Man on the playa in those early years was a triumvirate that consisted of my brother, John Law, and Michael Mikel. It was John who added the first bits of neon to the Man, and as Danger Ranger, Michael had created the Black Rock Rangers the year before. I remember taking a picture of Michael and Larry shortly after the crowd had raised the Man into place for the 1993 burning. In the photo they both have the look of confident organizers. It was a look

that should have signaled in no uncertain terms that Burning Man was on the cusp of adulthood, but such was not the case (that would come a few years later). In truth, Larry and John Law had opposite views on the future of the event. John saw it as an underground creative experiment destined for legendary obscurity, and Larry had a much grander vision. At least that's my outsider's observation of the situation.

Once in awhile in those halcyon days of the event, Larry and I would travel the 12 miles to Gerlach for necessary supplies, or to catch a quick beer at Bruno's. He was usually overloaded with responsibilities during the event, so such a trip allowed us an opportunity to talk. I remember asking him one afternoon before the Burn how long he planned to continue with Burning Man. The question had all of the subtle implications of a father asking his son how long he planned to be the lead singer in his garage band. Larry gave me a look that suggested this particular band might very well be the E-Street Band. "We're just getting started," he said smiling. "I've got plans!"

As we prepared to watch the 1993 Burn, I realized that the event had transitioned from a loose gathering of Cacophony Society friends into a unique entity. By then many of the signature aspects of the event were in place or were prototype activities that were evolving into traditional elements. Self-reliance, participation, individual initiative and invention, performance, costuming, universal inclusion, gifting, interactive art and radical self-expression were all present at the event by 1993, and all were a natural outgrowth of attracting a random gaggle of creative people to this ancient desert incubator. I think of those early years of Burning Man on the Black Rock Playa

as the gestation period for a series of spontaneous acts that led to a profound legacy—an event generated by the idea of allowing individuals the freedom to express their inspired selves.

The weather on that evening seemed relative clear eastward, but there was something odd and uncomfortable lurking along the western horizon. Bryan and I had noticed a weird kind of air stagnation in the late afternoon. There seemed to be a thin veil of dust hanging several feet above the ground throughout most of the evening, and it hung like diffusion over the camp, as everyone got dressed for the Burn. The Holy Terrors of Burning Man, those natural conditions most reviled by modern Burners, are wind, rain, and *dust*. These elements had been relatively absent for the most part the first couple of years. We had afternoon winds in those days, but they were pretty benign by modern standards. That all changed following the 1993 Burn. After the Man had fallen, people rushed in to begin dancing around and over the fallen figure. A tradition that had begun with the earliest—Burns at Baker Beach, and would continue even as the Man and the crowd grew to modern proportions. As we moved forward I became aware that lightning was moving in around us, and the wind had picked up dramatically. I looked nervously down at the metal tripod I was toting and decided it was time to head back to camp.

In those days when the Man went down you lost your primary directional landmark. I had been stumbling forward, head lowered into the wind, towards where I imagined our camp to be, when suddenly I was blinded by dust. What I hadn't realized in the dark was that the gale was pushing a wall of dust directly towards us. This was my first whiteout, and I had absolutely no idea where I was going. Finally, I caught a glimpse of headlights, and a man kneeling next to his Datsun pickup frantically trying to stake down his tent. We secured his tent, and I hopped into the pickup to ride out the dust storm.

Twenty minutes later, the whiteout subsided, and I walked out into the darkness looking for our campsite. That's when the torrential rain hit. When it rains hard on the playa, everything turns to sticky clay. The only thing to do is to hunker down in the closest shelter and wait for it to dry out. I waited out the rain in a camper van full of Burners. Fortunately, they had plenty of beer. However, the Hollywood intruders, panicky at the thought of getting their expensive gear soaked, tossed everything into their rental truck and made a run for it. We saw them as we headed for home the following morning. In their blind frenzy to escape the wind and rain, they had driven straight into the path of the storm. Ironically they ended up stranded for the night, their trunk mired to its axels in playa muck. It was there for all to pity as people headed for home. As for Bryan and the Band of Burners who had been

dancing around the fallen Man, when the dust and rain hit, they just took off their shoes, covered their heads, and kept right on dancing. It's the way veterans deal with the weather at Burning Man.

Looking back on those first years on the playa, I'm left with a compelling question: How does a gathering of like-minded renegades transform itself into a national phenomenon? Parsing the relationship between the Burning Man and the Black Rock Playa seems one way to understand the growth and evolution of the event: The desert is a vast, harsh environment, a place where survival is a genuine issue. It conjures for us a sense of primal wonder and a deep respect for natural forces. It also feels boundless. Everything on the playa needs to be large in order to achieve significance. The event, on the other hand, compels us to participate in an instant community, and to be self-expressive. "Here is your big canvas," the event suggests, "now do something big with it." The experiment succeeds because an enormous primitive space encourages limitless creativity and unrestricted scale. *Build it bigger, build it bolder, build it better—* the desert seems to say. It's the playa that encourages us to dream large and to stretch our imaginations, and this feeds the world's perception of the event.

Today, over 20 years after Bryan and I first ventured onto the Black Rock Desert, I still enjoy nothing better than wandering out onto the pre-dawn playa to gaze up at the same ocean of fading stars that were part of the sky when the desert was created—the same stars that formed a ceiling for this place in the prehistoric world. The desert was a vast sea of water called Lake Lahontan in the Pleistocene era—back when humans were merely a cosmic dream. That was a world thousands of years removed from our own, but you can still feel its presence in the shifting playa sand and the timeless wind. These days, for a week in late summer, the arid remnants of that once abundant lake hosts what will briefly become one of the largest cities in the state of Nevada, And while the ancient waters have long gone, and the New Age totems of those early Burns have morphed into the neon towers of today's temporary metropolis—the future of Burning Man is as brilliant today as ever, and the horizon glows bright with undreamed possibilities.

STEWART HARVEY

KEEPING IT STRANGE
WILLIAM L. FOX

Deserts redefine what most people routinely regard as reality. This occurs for two reasons: severely arid lands offer few objective visual clues based on our experiences elsewhere, and they present steep challenges to our neurophysiology. The genus homo evolved during more than two million years in more temperate places such as forests, open woodlands and savannas where, in order to survive, they developed a sense of scale based on the size and spacing of trees relative to their own size. As a result of these hard-wired abilities, when people first enter a desert from the outside—when, say, they drive from Los Angeles to Las Vegas—they find it difficult if not impossible to gauge distances accurately, which leads them to attempt astonishing follies, such as strolling over to the nearby hills with their children, not realizing these are actually miles away. No familiar vegetation is in sight with which to scale themselves. The results are often embarrassing (rescue by authorities), and sometimes deadly.

The perceptual difficulties in deserts are abetted by low humidity, which slows the bluing of the landscape over distance much more slowly than we expect. Additionally, deserts tend to be brown, tan, or red in color—the hues of exposed dirt and rock—and our sense of distance that is predicated upon shifts in the spectrum is completely thrown off. Deserts also often appear to outsiders as if they look the same in all directions, or isotropic. This is a perfect recipe for getting lost. You might think you know where you are in the desert, hence how to function there, but in reality you probably know neither. Cognitive dissonance in isotropic spaces is, in fact, part of the attraction of a desert. Many people instinctively seek a challenge in nature, and opportunities for such abound in the arid lands of the world.

Those who live in deserts can become accustomed to them, rescale themselves correctly to what most of us would consider to be a barren landscape, and avoid getting lost (literally and metaphorically). Most desert dwellers, however, are not as adept at surviving in deserts as, say, African Tuaregs or Australian Aboriginals living in the bush. Most desert people actually live in cities near water, be that Las Vegas or Cairo. Contrary to conventional wisdom, even more Aboriginal people now live in cities than in the outback. If anything, our ability to live in and understand deserts, even as more of the world experiences desertification, is decreasing.

Playas are the *ne plus ultra* of deserts, and what we do on them tends to be more extreme than what we do in deserts in general, and certainly more so than in most temperate and wooded locales. Playas are sinks into which water flows and finds no outlet. Water that comes in either evaporates or sinks into the ground, leaving behind alkali, salt and other minerals. Depending on their exact circumstances, sinks in the United States can be known as dry lake beds, salt flats, clay pans or mud flats. In Africa they are *sabkhas*, in Iran a *takyr*, in Spanish the word is *playa*, which means "beach," a particularly appropriate term when the human imagination is at play upon the dazzling surfaces at events such as Burning Man. Playas can be only a few dozen feet across, or as extensive as the Salar de Uyuni in Boliva at 4,085 square miles. The popular maxim of temperate wilderness, and even of jungles, is that if you follow flowing water downhill, eventually you will find human settlement. This law utterly fails in playa country, where, if you follow water downhill, it's likely you'll end up standing out on a salt flat far from civilization.

The 1,000-square mile Black Rock Desert that is host to Burning Man has a central playa that occupies more than 200 square miles. Along with the Carson Sink in Nevada and the Great Salt Lake Desert in Utah, which includes the Bonneville Salt Flats, it is one of the largest playas in North America. All three are in Nevada

and Utah's basin-and-range, the last physiographic province of North America to be discovered, crossed or mapped. To drive or walk across any of these daunting spaces, to camp on them, even to try and map them, is one of the most challenging landscape engagements a human can experience outside of the polar regions. When Burning Man was moved from a beach in San Francisco to a beach in northwestern Nevada in 1991, a commitment to cognitive dislocations was realized: the playa is a stern environment that has necessitated the creation of the largest annual desert education program in the world. People from temperate climates often do not know how to dress and hydrate in the desert, or how to exercise a leave-no-trace ethic when inhabiting such a landscape—or even how to avoid accidents caused by encounters with wildlife on the roads leading out to the playa.

Despite and perhaps in part because of such challenges, playas in general and the Black Rock Desert in particular are extraordinarily beautiful places. This means the playa fits the definition of a sublime landscape, of course, which is to say a place where Nature with a capital 'N' is overwhelmingly larger than a person, is beautiful but dangerous, and thus requires proactive measures to avoid being subsumed by it. This existential condition, plus the playa's alien visual reality and the sense of accomplishment derived by successfully surviving it, lead to several specific behaviors, the consumption of strong spirits, narcotics, hallucinogens and other mind-altering substances among them.

If cognitive dislocations in extreme environments can produce everything from severe balance problems and navigational challenges to existential despair, they can also foster awe at the sublime scale of the universe. The disjunction between what we expect in landscapes and their realities—for example, the difference between perceived and absolute distances in open vistas—can also lead to a creativity unfettered by the objective correlatives that would otherwise contradict the visual appearances of our inventions. This is partly why exposure to sublime landscapes can be inspirational to artists, from the nineteenth-century painter J.M.W. Turner, who lashed himself to a ship's mast during a storm off the coast of England, to the contemporary sculptor Leo Villareal, who wandered the playa during his first visit to Burning Man, lost in the dark and hoping like hell to find his tent in the midst of several thousand other humps of nylon.

Turner's experience at sea, as well as during storms in the Alps, led him to create paintings based on vortical swirls of paint that expressed the extreme movement of atmosphere, a beautiful but threatening condition of Nature. In effect, Turner sought to disorient the viewer in order to produce an emotional state equivalent to that he experienced in the cognitive dissonance of the storms. Villareal, in order to orient himself at night on the playa, began to create light sculptures at his camps. Now he constructs elaborate environments of light inside museums, hotels and other public spaces, which seek to break viewers' expectations of interior spaces. The two artists were inspired by sublime conditions in very different ways, yet the responses from both were based on perceptual orientation, a not uncommon reaction among artists who have experienced the sublime.

In the broadest sense, humans seek to create new knowledge by putting in close juxtaposition two previously unrelated things. That's a primary driver of art— via similes and metaphor—as well as science. Concatenate physics and biology and you get molecular genetics, for example. This mental proclivity may eventually be proven to be the only ability that makes us human as opposed to other primates or mammals. Putting ourselves in a beautiful place that is hazardous to our health counts as bringing together two disparate circumstances that can produce new emotions, beliefs or ideas. All this is to say that attending Burning Man for the first time takes someone to a new mental space. It's possible, then, to submit that Burning Man is a cognitive neurophysical event: it has literally changed the minds

Black Rock Desert
Photo: Scott Robert Hudson

KEEPING IT STRANGE

WILLIAM L. FOX

of many of its participants. If new and powerful experiences of the sublime can be conducive to creativity, however, a key question concerns the staying power of Burning Man in these cognitive terms for its participants. Humans are notoriously adaptive to new and strange surroundings, and playas offer no exception. To what extent do people learn how to scale and map themselves onto the Black Rock, thus lowering their sense of dislocation and perhaps site-specific creativity over time?

Without generalizing several hundred thousand individual experiences into a trope, it's possible to report a few things that returning participants have noted in common. One is simply that Nature retains its capital first letter over time. An alkali whiteout at midnight during a full moon is immobilizing, even if it's not a new experience: the lack of a horizon, or even sight of your own feet, can suddenly equal crippling nausea. A rainstorm on the playa always turns the desert dust into glue, a binder that immobilizes everything mechanical. Although the weather is never the same from year to year, there is always the heat. Burning Man's medical stations see hundreds of cases of dehydration and heat exhaustion each year. Likewise, some of the cultural components of the festival remain constant, traditions such as the nightly procession of the Lamplighters and the burning of the Man itself. Those and other signifiers become a performative infrastructure against which other artworks change over time. Perhaps the most significant example of a permanently evolving tradition is the Temple, which has been reincarnated in various years as increasingly elaborate structures designed by artist David Best from the scrap armatures of wooden dinosaur models and other wooden elements. More recent Temples designed by other teams have looked less like something from the set of a sci-fi movie (a media genre that has depended on the desert's lack of objective correlatives in order to maintain fictional environments), and more like something Daniel Libeskind would have built. The Temple of Flux from 2010 was a good example of the latter, a sophisticated angular deployment of lumber with jagged edges that offered no easy comparisons to existing architectural models.

The evolution of the Temple is a sign that the festival can continue to be a valid site for production of serious contemporary art and architecture. But as adventuresome as the designs have been, they are part of the elaborate annual physical armature of the event created within the Burning Man organization, and are more spectacle-based than most individual works of art tend to be. In part in order to maintain a balance between the two—a stable infrastructure and continued aesthetic challenge—the organizers of Burning Man began awarding grants to artists and teams applying for assistance with projects. The Burning Man website, as of April 2014, reported that approximately $800,000 was available to fund typically 35–40 projects. The grants are used to fund "work that stands on its own as physical, sculptural installation, independent of performances or activities, although these may accompany the installation." The funded works often tend to be large sculptures with an element of fantasy. Unlike the temples, which regularly evoke a genuine sense of the alien, the granted projects can sometimes appear more whimsical than serious. I would argue that the playa demands art made of sterner stuff, and that the primary goal should be to Keep It Strange, that principle being the fundamental reality of human responses out on the Big Empty.

Contemporary artworks made on playas have a notable, albeit short history. Jean-Claude Tinguely and his partner Niki Saint-Phalle built a series of exploding machines in their hotel room on the Las Vegas Strip in 1962, then ignited them on national television in Jean Dry Lake just south of Las Vegas (*Study for an End of the World, No. 2*). Six years later, Michael Heizer went to the same playa and carved a long lightning-like trench on it titled *Rift*. That was the first part of *Nine Nevada Depressions*, a series of earthworks on playas that culminated later that year with three incisions made some 400 miles to the north on the Black Rock, Smoke Creek, and Massacre Dry Lake

playas. Nancy Holt, Lita Albuquerque and others subsequently made major works of art on the arid flats of Nevada, Utah and California. Today there is an international residency program run in Wendover, Utah by the Center for Land Use; the major attraction for artists working there is the adjacent Bonneville Salt Flats. Projects on playas—from wind-driven autonomous drawing machines rolling around the alkali to photocartographic prints—derive metaphoric resonance as human artifacts imposed upon such fiercely empty natural surfaces.

The single most successful large-scale recent playa art project in the world may be Anthony Gormley's *Inside Australia*, installed in 2003 on the dry bed of Lake Ballard in Western Australia, an even more remote and difficult site to access for audiences than the Black Rock Desert. The work consists of 51 life-height human figurative sculptures based on digital scans of the residents of the nearby town of Menzies. The data was digitally reduced in the horizontal dimension by two-thirds before being used to guide the casting of the sculptures in stainless steel. The results were then finished with a gray pebbly texture. The data distortion produced stick-like vertical figures that were each placed roughly 2450 feet apart from one another. The consequent visual field allowed a spectator to fully see only one figure at a time, the rest appearing merely as black marks in the distance, thin as hairs and barely visible in the harsh light.

In Gormley's words: "I wanted to try to find the human equivalent for this geological place. I think human memory is part of place, and place a dimension of memory." What makes Gormley's project significant is that it possesses a strong and universal idea that is manifested through a technologically advanced means, but that nonetheless retains a recognizable tie to the human form on the playa, even as it distorts and extends it. The objects appear almost as if it were their own shadows made manifest, a delicate but striking response to the immense light of the playa. Gormley has Kept It Strange by distorting the figures and challenging our ability to place them visually within the vast space. As a result, *Inside Australia* has become an international destination for thousands of viewers despite its remote location.

In recent years, Burning Man projects have become familiar to many repeat visitors. The street layout of Black Rock City first deployed in 1997 is no longer a random maze, and the site is fenced off. By definition the space is no longer wild, and therefore its strangeness greatly diminished. The normalization of space, the repeated motifs of the artworks, and the increasing number of visitors who are more spectators than participants has begun to erode the dissonance, thus the ability of the event to spark unexpected responses.

A new development for the organization that may change this dynamic is apparent in the interest expressed in purchasing Fly Ranch, a 4,000-acre spread located on a smaller playa behind the hills to the north of the current site of the festival, and then to soon thereafter acquire or obtain use via permits from the BLM for another five square miles of the adjacent Hualapai Playa. The combined property of more than 11 square-miles of desert, geothermal hot springs, and playa would provide the Burning Man organization with a site to build a conference center and a solar energy facility. But more than anything else, it could offer an unparalleled blank slate for the creation of playa art for the long term, not just for the duration of the festival on the Black Rock Desert. Comparisons to such mainstream sites such as the Donald Judd collection in Marfa, the Storm King Art Center, and other sculpture parks around the world would be inevitable. This presents a conundrum: an organization dedicated to the creative disruption of social and personal norms through an ephemeral festival that then establishes a fixed point of operation with a standing sculpture collection.

The idea, according to the Burning Man organization, is to "develop a partnership of Burning Man artists, and internationally known sculptors, and land artists to create an outdoor large art park," and for the site to include selected sculptures from the festival

and those based on artists residencies. This is a departure from the organization's philosophy of non-hierarchical inclusion, and it is possible to see two strands of artmaking develop in the future, one for the festival and another for the ranch. This bifurcation should offer a literally expanded field in which a broader range of artists can afford to develop more considered projects over longer stretches of time, as the results would be maintained for longer periods. An artist such as Anthony Gormley might not be able to attend Burning Man to erect a project for only a week, and with an audience limited only to those able to attend during the festival—cost effectiveness alone would prohibit an artwork of a magnitude comparable to that on Lake Ballard—but he and other artists might be interested and able to create major works if they were available to an audience for years at a time, and to people unable or unwilling to endure the rigors of the festival.

Burning Man as a for-profit business finally converted itself legally in 2013 into a subsidiary of the nonprofit parent organization. Its for-profit status allowed the organization to grow during earlier years, but now that Black Rock City is larger than Carson City, the capital of Nevada, a new economic model is necessary in order to maintain the conjoined economic and philosophic basis of the festival. Our society only offers three legally-viable avenues through which to conduct large businesses: for-profit, not-for-profit, and government. Continuing to grow a city as a for-profit business, given current tax structures and governmental regulations, both local and federal, can be problematic economically and politically. Creating a traditional government, on the other hand, would run counter to the shared philosophy of the founders, not to mention participants, many of whom have already been skeptical of the organization's corporate structure for years. The founders have been urged by potential funders—including myself and others—since at least the early 1990s to consider changing the organization's legal status to that of a non-profit, and they have done so, marking the shift by calling the new organizational framework the Burning Man Project.

By whatever name or legal definition, Burning Man has always been about dislocating one's sense of business-as-usual by promoting the spirit of "radical" inclusion, self-reliance, and self-expression. It has done so through devotion to a gift economy, civic responsibility, a worldwide communal effort based on participation and immediacy, and hewing closely to the wilderness philosophy of Leave No Trace. Those are keywords from the organization's formally declared ten key principles. While the Burning Man website avers that those ideas will guide the development of Fly Ranch, perhaps the organizers will be willing to tinker with those principles on the new property. Some of the invited artists, for example, may not be self-reliant, or interested in communal participation, but completely focused on creating something truly strange on Hualapai Playa. And, assuming that you agree that new art is an attribute of a healthy society, this will benefit us all in the long run while not damaging the philosophical integrity of the festival.

The Burning Man Project proposes to expand the philosophical umbrella of the founders over a variety of enterprises so broad as to encompass virtually every facet of society, from education and business to arts and culture in the most inclusive definition. That's all well and good, but it's a continuing process of normalization, not of Keeping It Strange. The open-ended question is whether a habit of mind borne of cognitive dissonance on a playa is robust enough to survive the transition. One way to at least increase the chances is to keep the ever-expanding Burner community anchored to the physical reality of the playa as a reminder of how creativity can be renewed through radical confusion. Ironically, creating a permanent facility for artworks with a longer lifespan may do exactly that by offering artists a more sustained engagement with the perceptual difficulties of a desert.

SOURCES

For a fuller discussion of "cognitive dissonance in isotropic spaces," readers can consult the author's *The Void, the Grid & the Sign: Traversing the Great Basin* (2000), and for a history of the art and other acts committed on dry lake beds *Playaworks: The Myth of the Empty* (2002).

Seminal works on human neurophysiology, perception, and art, are Jay Appleton's *The Experience of Landscape* (revised, 1996), which is foundational to the later and more encompassing *The Art Instinct* (2010) by the late Dennis Dutton.

A description of Anthony Gormley's *Inside Australia*, and the quotation used in the text, can be found at: http://www.antonygormley.com/sculpture/item-view/id/248

Information about the Black Rock Project's Fly Ranch proposal appears here: http://flyranchproject.org

WILLIAM L. FOX

BEDFELLOWS
TONY PEREZ

Bruno's
Photo: Brian Kelly

Judge Phil always had sound advice. He was the local judge in the least populated county in the nation that from time to time would still rely on frontier justice. I sought him out because no one knew the locals better than he did and I needed a voice of reason in the growing jitters between them and the annual crew of the Department of Public Works of Burning Man. We were the desert carnies who set up and struck Black Rock City and every summer we would wedge ourselves into their small town of Gerlach, Nevada for about ten weeks of the year. We were the unlikeliest of roommates—every summer we would come blaring into this quiet town like a car alarm at 6:00, and the complaints were mounting. "What are we going to do, Judge Phil? Are we going to get run out of town?"

He looked up from his whisky flask and regarded me.

You've never been here through the winter, have you? It gets downright boring! The thickest gossip we get is whose pipes froze and burst. But when you guys get here it's like someone dumped Tabasco into the eggs and everyone has plenty to talk about! Why do ya think Bruno's fills up with locals when you guys do that 'zombie walk' through town every evening on your way to dinner? Most of them have never seen the likes, and many just love to hate you. Make no mistake; they'd miss the hell out of you if you didn't come back! You guys give them the gift of having something new to complain about.

It was true. When our crew lined up for our meals served in the banquet room of Bruno's, we were the main attraction. It was the flash point of two cultures colliding— the locals on one side of the bar, all lassoed to their drinks, necks craning, and eyes popping, and our desert rat crew on the other, leathered and torn, singing tattooed city songs and laughing as we'd make our way to the waiting steam tables of chicken

fried steak. It was a weirdly offbeat and lively room that was worlds apart and in the middle of nowhere in a pint-sized home-style country club. I always felt better after talking with Judge Phil.

The crews that build and strike Burning Man haven't always spent the summer seasons living in Gerlach. Back in the days of yore, we camped out on a leased 80-acre parcel of scrub-brush prairie behind the desert curtain that was about 12 miles north of the Burning Man site. It was completely off the grid without electricity, water, phone service of any kind, or any structure at all. It was so remote that after weeks of camping there, even the lights of Gerlach felt blinding when we would roll into town. One year, when I returned to my apartment in San Francisco after three months out, I had been away for so long that the refrigerator light scared the shit out of me! I would actually have to think to remember the flush the toilet. Out there, even news was filtered out through the dust, and only the biggest of headlines would make its way out to our ears—always laced with outrageous "playa rumors." When Michael Jackson died, the story arrived piggy backed on another scoop that Dolly Parton had too. Our inquiries into any fact finding at all just bounced back off the mountains to mock us. But we didn't care. Somehow news didn't matter as much out in the desert. Even the enormous shock wave of 9-11 took only a day or so to waft into the vacant winds.

For several seasons, this was how we managed our crews and we liked camping that way. It was rough and tumble and we were dug in with the snakes and scorpions, but we were good at it and it tempered our steel. Trouble shooting every turn of one's life with broke down trucks and busted zippers will make you clever. It was a certain ilk that was attracted to this style of desert living. We were a group set apart and tasked in a backdrop of thorn-baked extremes. We were self-appointed misfits who found a place of permission to bang our own drums, and somewhere in the madness, we were still able to pull off building the amazing early cities of Burning Man, and make them disappear afterwards. The Black Rock Desert playa was so vast that it would evaporate your ego as quick as a water drip on a hot sidewalk. None of us even dreamed that it was populated. We had little regard that we might be setting up camp in the back yard of others and had no idea that many eyes were on us. The locals with their secluded families had gone relatively undisturbed for over 200 years in this uncharted planet, so newcomers—especially of our sort—were generally misunderstood and unwelcome. Neither we, nor the locals, had any inkling that we would be getting into a strange bed ride together that was going to last possibly decades—a giant bed might as well be the planet Mars.

The road to our bedfellowship with the locals started in 1998 when the organizers of Burning Man were getting fed up with carting everything over Donner pass to the Black Rock playa every year, and leased that 80-acre parcel of land in the Walapai valley. I remember that for a majority of the locals, "there went the neighborhood!" Before, we were an annoying "cult" that came out in kooky vans and busses, banged drums, and did who knows what out on that playa, but now we were the goddamn next door neighbors! Suspicion and tension clicked up several notches. At the gas pump in Gerlach you'd catch a local hunter glaring at you over his mirrored sunglasses and spit a warning shot across your bow. Sometimes you'd get the full grill of an oversized Ford pickup looming in your rear view mirror about ten feet off your ass, and sometimes things could get a bit freezy if you stepped into a bar for a beer. The leader of our crew at the time was Will Roger and feeling the pinch closing from all directions said, "Well, it's time we threw a BBQ and met the neighbors." We intended to take root on this land and wanted to shake some hands.

Rocketing in our midst in those days—and still amongst us presently—was a larger than life, crazy-haired devilish sort of man named Flash. He had been a prominent cog in the inception of Burning Man since its Cacophony-fueled birth. I've

known him for about 18 years now, and still do not know his real name. I've never even wondered. Flash is Flash—a wiry ageless sort that will fill any size room with a booming husky voice and an infectious laugh. Talking to you he will clap both hands down hard on your shoulders and capture you with his keen eyes and weathered face. Add the scruff of a full-length grey beard to that, and one might say that he resembled a well-rested Rip Van Winkle who has just shot out of bed and washed down a fist full of vitamins with about ten cups of coffee. Flash had been a clever camp cook for many Burning Man seasons in its arduous origins, and he also had won the hearts of many of the locals with his magnetic personality, so Will asked him if he wanted to run the BBQ. Flash replied in his gravelly Rhode Island accent, "Suuure! We can dig a hole and bury a pig with hot coals Texas style. Takes about a day and the meat just falls off the bones!" Sounded great and the invitations went out.

Deep Nevada country folk still believe in simpler times where a man is trusted on his word and a business deal can be settled by a handshake. Judge Phil had settled many a dispute in this manner. People still wave to one another as their pickups pass on the highway, and they also respect the gesture of an earnest invitation from a new neighbor to come visit a new home (along with the promise of plenty of food and beer.) So, come Sunday, we had quite a few show up, the cars and trucks trickling in with locals in their Sunday best, carrying various casseroles, Swedish meatballs, green jello and so on to the tables. There were fumbling greetings and handshakes all around, and soon our pop-up shade was filled with the edginess of a junior high school dance with the locals on one side and us on the other waiting for something to happen. Anticipating the awkwardness, Will had stacked the deck with high-test margarita igloos in the back of his pickup and coolers full of beer and cocktails were served. Pecking around for small talk, conversations led to the highlight of the afternoon, the much-anticipated buried BBQ pig that the well-known Flash had prepared, "Texas style!"

Flash had not worked alone on this. He had enlisted the help of a local named Lloyd who had taken a shine to us and was one of our first local friends. He was a fun-lover, a scruffy sort who grew up in these wilds. He ran on a higher octane amplifier in those days and at times would tend to over achieve, so when Flash asked for some help to dig a BBQ pit for a pig, Lloyd came steaming back to our ranch the next day on this huge decrepit 1930s Caterpillar back hoe plunging along while belching black smoke. It was louder than a Second World War army tank and looked as if it were rattling itself to pieces as it smashed its way to our camp, and we could see that the front loader was heaped with giant boulders! There was no stopping him and moments later we had an army trench cleaved into the ground, half filled with huge granite rocks. Running out of time and options, the fire was lit, the pig wrapped and set, and dirt shoveled on top in the manner of a proper burial. What could possibly go wrong? It was no surprise, but an eternal embarrassment when the moment had finally arrived with the shovels digging down—all eyes following each troweled stroke—and when uncovered, all that was left of that pig was maybe just enough ash to fill an urn. Eyes met in astonishment, then stifled snorts of laughter, as it was plain that there would be no "Texas Style" BBQ with meat falling of the bones today. The credulous hippies couldn't even get that right. It had not even been a proper burial for the doomed pig. It had been a brutish cremation. It became a bit ghastly when part of the jawbone was uncovered with some of the teeth still intact.

I would have liked to have actually put those ashes into an urn on that day. It would now be proudly displayed in a glass case in the San Francisco office with some sort of plaque on it commemorating Burning Man's first local BBQ and the pig that "took one for the team!" All fingers pointed at Flash. Flash pointed at Lloyd. Lloyd pointed back at Flash. Aie yie yie! So, now what to do?! There were only so

many Swedish meatballs. The manager of the Empire Store, Don Lawson was there and saw opportunity knocking, so he strolled over to Will and said, "I have a freezer full of elk steaks back at the store. Shall I go get 'em?" Feeling the crowd turn on us, Will said, "Hell, yea! Let's do it."

Moments later a truck roared off to Empire leaving all with an extra two hours, (it was 40-some miles to Empire), and little recourse left than to continue drinking on rumbling stomachs. It was several more Budweisers and many nervous glances down Jackson Lane until Mr. Lawson's truck was finally spotted and a weary cheer rose up. The smoker was sparked and what was left of our pride was saved. More than a few were getting sloshed at this point, and one guy in particular. He was one of the locals that was a vehement hater of Burning Man, and was very vocal about it. He had been bragging around town that he was going to come to our BBQ to thumb his nose while drinking free hippie beer. And so he did. By the time the steaks finally hit the plates, he was three sheets and tripping over his own boot heels. I remember him coming up to me, his face looking scalded and wild with a greasy comb over and smudged glasses. He stuck his mouth about one click from my nose and farted his buzzard breath at me. "I hate all you fuckin' hippies and it'll be a glad day when Burning Man gets run out of my back yard!" He then spun into the food table launching the green jello and caromed off toward the parked cars and trucks. Moments later the whole awkward assembly was being pelted with dirt and gravel being spun from the wheels of his dirty white pick up truck as Mr. Buzzard Breath peeled out of the scene, fishtailing down Jackson Lane and out on to highway 34 tearing south to Gerlach. About half an hour later, news flashed into the camp that someone had crashed and rolled a white pick up south on 34 and looked like he was hurt and needed help.

It always takes a common cause to bring even the strangest of bedfellows into a zipper of cooperation, and several folk bounded to their cars and trucks and hastened off with Will and I leading the pack in his pickup. A short while later we rolled up on a severely bashed up truck that had miraculously landed on its wheels after rolling and smashing the roof and windshield. Mr. Buzzard Breath was out there, hotter than a hornet and wildly raging around the truck. He had a bleeding head wound that he had tied a dirty rag around like a red badge of courage and his smudged glasses were long gong, but besides that, he seemed in one piece. It does seem true that drunken people survive accidents better. Seeing us "fucking hippies" pulled up on the scene first, he got even madder and started screaming and flinging tools and rocks at us—whatever he could find. "I don't need your fucking help you fucking hippies!" Will and I backed to a safe distance and stood wondering what to do, if anything. In the meantime, we just leaned up against truck and enjoyed the one-man shit show.

One by one, the cars and trucks from our BBQ started rolling up, and as folk got out with jaws agape, their expressions quickly turned to hidden grins and exchanged glances as they shared in the outlandish humor that should have been the dark scene of an automobile accident. Obviously no legs or arms were broken and cracked ribs wouldn't be discovered until the worst hangover of his life, but for the moment, we all silently agreed that the best thing to do for the time was to just let him be. Without even realizing it, we had stumbled onto the first pastures of common ground with our neighbors—the sardonic and quirky sense of humor of the rugged minded. Nobody even asked him if he was all right. We just sat back and watched the drunk and psychotic Mr. Buzzard Breath as he set out to change his one and only flat tire, another miracle by the way. From time to time, someone would shout over to him offering help, and was only met with, "Fuck you! I don't need any help! Leave me alone, goddamn it!" No one even noticed or cared that we were blocking highway 34 because any new incoming vehicle would just stop,

turn off their motor, get out and join in, and unbeknownst to us we were making acquaintances that would last for many years to come. It was around this time that I went to Will and said, "You know, we still have the margarita igloos in the back of your truck...." "Anybody want a margarita?!" Out came the red Solo cups and soon to follow were some chairs, and then some leftover tater tot casserole. Then after a snort or two, there were many chairs and quite a few folks sitting or standing around, and I'm surprised that we didn't get a campfire going right there on highway 34! Now *that* is how you break the ice with the locals in the high Nevada desert. It's fitting that the common ground that we all found would be out on everyone's highway, and we rocked on until the igloos and beer ran out. By the way, Mr. Buzzard Breath finally did manage to change his tire and we were so busy chewing the fat with newfound friends that only a few noticed when he squeezed himself through the driver's window, got his smashed truck started and roared off to Gerlach leaving broken shards all the way. Come to think of it, that was the last I ever saw of him.

And so, we had broke ground into a new home in the desert, and the early years to follow were to harbor many howling moon bent beginnings. We had many lessons that had to be branded into our hides and away from critical eyes. But I knew that times would change and the white light of scrutiny would soon cast its beam. I remember one night when spirits where soaring and we were slam dancing in the dust to our ranch band called "The Suicidal Bunnies" I turned to Will and said, "You know, they won't let us get away with this shit forever. And they didn't. As our event grew and matured, so did the crew. A circle of tents and a broken down bus camping out in the high prairie was one thing, but housing a rapidly growing crew with basic needs was another. Essentially, we had outgrown our bivouac lifestyle and needed a shower. It was as if Mom was calling from the back porch telling us to come down from the tree house and come in to get some dinner and a bath. But growth and change always come with resistance. After all, a tree house is where secrets are kept. It's hidden away from the glare of parents and the rolling eyes of the sassy neighbor girl. You don't have to wash your hands or change your socks, and a can of Beef-a-Roni is grand. I remember saying that it would take a Sheriff's badge to pry me out of the happy camp I had built over the years. A camp like that would turn a small thing like taking a wiz in the middle of the night into a religious experience. The top of your head would come off and genuflect to the eternity of a zillion stars.

Well, the Sheriff's badge finally did show up and the day came where my beloved trailer found itself being dragged behind my truck like a dog choking on a leash, grinding on its thirsty axles all the way to Bruno's trailer park in Gerlach. I remember thinking that this was a recipe for disaster, bringing feral alley cats into a small town of sleepy right wing seniors. There was apprehension on both sides and the Sheriff was a nervous man. It only took about 15 minutes for the first call to be made, and yes, it involved my beloved trailer.

About two seasons before this incident, my trailer lost its door to an 85 mph blizzard during the winter. I would imagine the door ended up somewhere around Winnemucca. That spring when we took our annual trip to the ranch to see what survived, we discovered the wreckage of my doorless trailer and I spent the afternoon ridding it of rats, mice, a bird's nest and a porcupine that looked at me as if to say, "Dude, the door was open!" When the dust finally settled from the porcupine fiasco that involved three guys, a giant tarp and the Benny Hill theme song, I was still faced with the challenge of a trailer without a door. Anyone who has spent time dealing with trailers can tell you that a person just can't walk into an RV store and buy a replacement door. It's a special order custom-made deal that costs way more than my old trailer was worth. So, my buddy Tex and I

strapped on our nail bags and headed to the junk pile to find scrap wood to build another door. Kicking around in the dust and splinters, Tex finally flipped over a plank and discovered gold. It was a badly warped piece of plywood that had some colorful spray paint graffiti on it. It looked like a shapely and busty naked woman wearing nothing but thigh high fishnets. She might have been pretty except that in the middle of her oversized face was just one giant eye. She was a Cyclops! It was erotic, creepy, weird and hilarious all at the same time. Tex and I exchanged glances and no discussion was needed. Of course this was to be my door, and a few carpentry hours later, I had what I thought was the coolest trailer in the fleet No one ever did find out who drew it, it was a gift from the gods. But, no matter, I was enjoying the built-in conversation piece and reveled in the myriad of reactions it inspired, especially the ones from "art critics." There were those who considered it to be in poor taste, you know. But, who's to say that a naked Cyclops wearing fishnets, a la spray paint graffiti, is tacky? The door was there to stay, and regardless of opinion, she became part of the family.

I'm not sure which part of the door, if not all, offended the rancher lady across the street from Gerlach's trailer park, but legend holds that her ranting down the telephone could be heard by everybody in the office. I hadn't even unhitched yet. My thoughts were that if this lady was upset about my trailer, how was she going to take it when the full hammer of DPW rode into town like ghouls riding broomsticks? We had a long road ahead of us. After a lot of fuss and grandstanding discussions about censorship, the lines were drawn and the issue was solved by shade cloth wrapped on the surrounding fence of the trailer park to obscure the view of the lady. I made my own smart-ass gesture by putting black tape x's over her nipples and crotch. It was ludicrous. Weeks later I had an afterthought that we all had assumed it was the nudity that had offended our neighbor lady. Who knows? She may have come from a long line of Cyclops. She may have been a Cyclops herself! I never did see her. I remember imagining her answering the door with a big angry eye, and us feeling awful because we didn't know. Behind her on the mantle would be several pictures of her family—all smiles with big Cyclops eyes beaming....

My "tacky" trailer door did make a few nervous on her maiden voyage to Burning Man, where she and I joined First Camp as we always have. Edgy eyes were on Larry Harvey when he first spied the piece, but all was well when he picked up on the humor and gave it the nod. Just a wave of his hand was all the assuagement my Cyclops needed and she could now display herself unabashedly to all who gazed, her gargantuan unblinking eye a ghastly upset to any erotic thoughts one might have entertained.

It looked like the DPW staff of Burning Man was going to be spending its summer seasons in Gerlach for good, and the outlandish and peculiar road to co-existence had begun. After ten-plus years, we've even grown to like each other, and I have personally made some friends for life. We still have gripes and squabbles, like any community, but the crew has piped down, and the locals have opened up. As the first of the alumni start showing up in the early summer, the locals have come to set their calendars by it. "I guess it's that time of year," they say. For soon the mornings brought the bizarre spectacle of tall bikes and tatters as the sleep-deprived but happy crew did their zombie walk down Main Street into the rising desert sun.

I know what it was that brought me back to the Nevada high desert. I know what it was because I could feel it. The desert has its lovers that won't stay away. It's a siren, dangerous, beautiful. It's the goddess of permission letting your spirits run. It breaches your trust in perception, which unlocks your mind. It's a spinning lure. Over time this lure has attracted many fish and as different as they can be, they all have the high desert in common. They're drawn by the open spaces and big skies. They wish to escape the constraints of a crowded mindset and ride high in

the saddle. They are brash people of free spirit. Like Cowboy Carl likes to say, "Out here you can think a thought the whole way through." No wonder a small group of city fish fell to the hook and made the trek to that open space to watch their fires grow. It seemed a place where they could thrive—where no one would forbid or cast judgment. What they didn't know was that there were already many fish before them who also wished to hide from the eyes of judges.

The first time I passed through the town of Gerlach, what I saw was a tiny burg that sat at the edge of the massive scape of the Black Rock Desert, and from a distance, looked to be no more than a patch of shrub squatting at the base of an old burnt out mountain. As we trolled through at the break of dawn, I was thinking that a ghost town like this would be a place where nothing ever happened, with few people to meet. I was wrong. We all had much to learn. The fact was that albeit things seemed desolate, the mighty locals had cast their network of folk over these lands generations ago, and every square mile was indeed spoken for. As our annual dance with the flames grew, our followers bared brazen markings and unusual actions that brought offense to the old time country folk. For some, we had just stepped out of the creepy closets of their nightmares.

At one of the town hall meetings that dealt with our growing residence in the community, one of the townspeople shot up out of her seat jabbing her finger towards us and exclaiming through clenched teeth, "I don't want to live next to that!!" Was she thinking that Satan's disciples had arrived next door? Probably, and there weren't enough lifetimes to change that. But after many spins around our tilted axel, the road to co-existence has slowly gotten worn. We come to find that we have things in common after all. We all need big hats to keep the blazing sun off our brows, and we all have to work a bit harder to stand up to the demons of the harsh desert. Over the years the locals have watched us grow into a thriving entity surrounded by good, honest work. We became members of the desert elite with our craggy step and toughened skin. We became desert builders erecting colossal, beautiful things, and setting up massive citywide campgrounds—all in just a few weeks time.

Anyone pulling into the town of Gerlach sees right away that amongst the scanty toss of buildings, most of them are bars. "Five bars and no churches" was the slogan of the prouder of the locals. I guess that over the decades, anyone who had the gumption to tough it out in that deep desert had whisky on their minds, not the Good Book. Sharing those hankerings I've sat on all of their barstools over time. I'm a seasoned regular now, but years ago, when the crews of Burning Man started showing up; some of the salty regulars were a tough bunch and not too ready to shake a hand. I had a ponytail back then, and a thing like that really did make a difference. Once when I was chatting up a couple of skeptic ranchers at the bar, I hit them with one of my better jokes, and one of them actually did a spit take with his beer! Slapping my shoulder he said, "You're all right for a long hair!" I shuddered to think that even ten years ago they would have run my hippie ass out of town.

My long hair had been a point of contention before. The first time I set foot in Bruno I was tossed out on my ear because of it, a case of mistaken identity. Apparently the day before, a hotheaded drunk had been in the restaurant and got into a belligerent argument with the waitress calling her the "C" word. He also had a long black ponytail and I guess sort of resembled me. That's all Bruno needed to charge my table when he saw me sitting there, menu in hand. I was like an unsuspecting cow on a train track when this large and furious Italian man came at me, his tremendous nose filling my face as he jammed a finger into my chest and blasted broken English at me point blank, the only words I could make out being "Motha fucka!" and "Cocka sucka!" Then, as if I were in a Bugs Bunny cartoon, he grabbed the scruff of my shirt and the back of my belt, picked me up and heaved

me through the door old western style. I landed in a heap in the parking lot. "What the hell kind of town is this?" I sobbed through rattled tears. The next day, Flinn and Will went and straightened it out, but he still glared at me for years—up until the summer I cut my hair.

This wouldn't be the last time we would get the occasional kick in the pants from the locals. But amidst their distain there would be the slow growing root of respect. Many years later I was having a beer at Joe's one afternoon. As I sat and talked with the bartender, I noticed these two silver haired cowboys propped at the other end of the bar, standing and leaning on their elbows, hats pushed back, with boot and spur up on the foot rail. These men were real cowboys—50 years in the saddle probably, fully dressed out in western fancy, and pearl-handled six guns shining on their hips. Nobody seemed to notice that there were men with guns in the bar—this was Nevada. I started noticing that the one standing closer had been cutting his eyes toward me and I could feel his judgment. I sat wondering what sort of disdain or maybe outright hatred this old timer might be harboring toward me as he kept shooting his powder-burned glances at me. Sure enough, as they finished their Buds and paid up, I knew he had a piece to settle and here it came. I could even hear his spurs jingling as he stepped toward me. Then he spoke in a deep drawl;

"You work for that Burning Man, don't you?"
"Yes I do." I answered.
"You know, I don't give a fuck about your Burning Man. I tolerate it at best, and I don't give a fuck about art or your crazy naked hippie party. But I do respect that you put up that nine mile fence in one day like you do."

With that, he pinched the brim of his hat with a nod, and walked out the door. I don't know if I can place my reaction. I was a man who was expecting a pie in the face and got a kiss instead. There was no mistaking the hearty fabric of true respect. Here was a man who probably resented most everything we stood for. I imagine he would spit on the ground at just the site of our tattooed, pierced-up, longhaired hippie ways. But he was also a man who knew the sight of hard work and knew the hardship of swinging a hammer in the high desert sun. And he was most certainly a man who had built a fence or two. Witnessing our feats, I guess he finally had to come to terms with the things that we had in common after all. I can just imagine him up in the pass overlooking the City site, pickup pulled of the side of the road, binoculars up to his eyes muttering under his breath, "Look at them hippies go!"

My art teacher once told me that black was black, but the darkness of a desert winter night seems blacker, especially when seen behind the shortsighted beams of your headlights miles from the glow of any town. The night sky domes over you with the freeze of outer space. You feel as if you are crawling on an icy rock that's been stripped of its atmosphere and nothing is close, and you're thanking the Gods that the engine is warm and there's gas in the tank. These were some of my lonely thoughts as I drove the moonless highway into the arctic outpost of Gerlach in January. I really didn't have much work-related reason to make the trip other than seasons of invitations from local friends and the need to let my city ears ring with some vacancy. I guess I was yearning for some of that small town winter boredom that Judge Phil had mentioned. Judge Phil had been leading me on....

As always it was a nervous half hour farther than imagined, but at last I finally crested the pass over Empire and saw the Gerlach lights. Even they seemed frozen. I slowed around the final turn to see my summer town transformed into an icescape with whipping snow replacing the dust and blowing across the otherwise familiar neon of the bars. I was thinking of walking in and surprising the lonesome bartender at Joe's and having a nice quiet nightcap. Maybe someone might still be hanging out

to play a game of pool. But even in the dead of winter the desert was a bewilderment as I pulled up on a jammed parking lot with the bar overflowing!

Stepping into this noisy bar was like stepping into a jungle of a thousand sweaty howler monkeys. It was as muggy as a locker room, with a wet blanket of shrieks and laughter, and the shout race was on. Everyone was hollering at each other, and you wondered if anyone heard a damn word. Not likely. My plans for a quiet game of pool in "boring" winter Gerlach changed as I got out of my truck and wove my way through the mash of bodies unnoticed. Apparently the winter freeze didn't matter as the door remained propped open like it was a hot summer night. I knew why as I approached the entrance and was hit by a miasma of swamp gas. All I was thinking was who were all these people and what the hell was going on? Not a stranger to crowds, I wormed my way to the bar and finally caught the bartender's eye—the only person I recognized.

"Hey Cindy! How bout a beer?"
"Wow! Coyote! What the hell are you doing here?"
"Thought I'd make a winter trip to Gerlach. What's the deal with all these people?"
"They're the gas pipe line workers who have been out here for the last two years. They finally finished the line and got their checks today. They're all out of here in the next couple of days."

It was a huge government pipeline project that was set to pipe natural gas out of Wyoming to who knows where. Nevada was routinely the host of big messy government projects that would get routed far from public scrutiny.

Then it hit me: why the bar vibe seemed so creepy. The bar was 99 per cent men! Large, grubby, hard-hitting, wild-eyed, greasy-browed working men, and all of them drunk! I backed into a corner perch with my beer and sat to watch the madness. Then I saw the trouble. This kind of trouble is as old as mankind. It's the original trouble. It was two racy and rambunctious girls weaving and flirting their way through the crowd. They were dressed up trailer park naughty with stringy bleached hair and cakes of awful makeup that looked to have been smeared on in a hurry. They were both wearing shabby corsets that hoisted up every inch of cleavage they could muster—one of them approaching cantaloupe proportions. It was tits on a platter as they squeezed through this mob of macho, mashing their boobs into every chest they passed. Clearly, both of them were getting off on a room full of horny bulls that wanted them and I suspected they were the types that got off on men fighting. More than suspected....

I shrank closer into my corner and set my watch. I was thinking 20 minutes tops before the brawl. It only took two. The foray started with a sucker punch and the scene that followed had all the bad action of a cheap Hollywood Western bar fight. You could almost hear the banjo music playing as bottles smashed and barstools flew. As with most bar fights, things ended up in a rabid pig pile, and the first offender was bulldozed through the door. Through the frosted windows, I could see him staggering and slipping on the icy road, shaking his fist and bellowing. Watching him I knew that it wasn't over. The bar had no such concern, though, and just like hitting the pause button, went right back to howler monkey madness.

This time it really did take about 20 minutes when flashing lights caught my eye out the window. They were the bouncing headlights of a bashed up pickup truck skidding around the corner, wheels spinning and engine roaring as it jumped the main road and headed straight for the bar. Several bodies barely jumped out of the way as BOOM the truck crashed into the front wall of the building splintering it and sending a bloody blast of smashed glass and debris into the bar and onto everyone!

Tony Perez (The Bard of the Desert)
Photo: Brian Kelly

Chaos ensued and the now bloody faced driver of the truck jumped out like a vicious badger and started swinging a bat at everything. He was pig piled again and things had finally gone through the wormhole of ridiculousness. So much for that boring winter night in Gerlach!

Everything finally settled down when the Sheriff was summoned out of bed and our bloody-faced badger went to Reno in cuffs. The rest of the evening was a wash out as the furious club owner closed the bar, wondering if his roof might collapse, and I finished my beer from an unseen corner. I remember thinking that the real cause of that fight was those two trashy girls, who were nowhere to be found, by the way. But any bartender who would have had the gumption to kick them out would have had every pipe worker in northwest Nevada ready to kick his ass! The west is still wild, my friends.

Thinking of that night, I am glad that those pipe workers had their wild time during the winter and away from our crew—away from the women of our crew, more specifically. We have some strong girls who come out every year and swing hammers, spin wrenches, drive trucks and weld shit. They're powerful and beautiful and many of them have an extra set of ovaries, and I can only wonder how it may have played out with that amount of wattage jumper cabled into that scene. But that's the beauty of our desert story. It's a wild and open place where wayward seeds can blow in and germinate sturdy flora of many kinds—be it a cowboy in a saddle or a steampunker on a tall bike. It will always be a work in progress for folk on either side to look beyond the leather of another and see how starkly similar they really are. We all have the threads of open spirits woven into our souls and wish to sing our peerless songs.

Every year the Playa Restoration Crew opens the doors of the Black Rock Saloon (our faithful club house) on the last week of operations and packs the place with a talent show. Long-standing traditions of outrageous antics and hilarious and talented acts of all kinds brings them in from all points. It's a wondrous scene to see a full spectrum of country and city folk—decked out in their best and embracing the crazy hand of fate that brought such unlikely fish together. Looking around the room, you see smiles and laughter, all talking and greeting, accepting the colors and markings of creatures from different planets, forgetting any judgments for the time, and just having good old fashioned fun in the high northern desert of Gerlach, Nevada—strange bedfellows indeed!

TONY PEREZ

THE LAST COMPANY TOWN
BY JESSICA BRUDER / CORRESPONDENT / 13 JUNE 2011

Empire, Nev., is the far end of the real estate bust's ripple effect. The nation's biggest wallboard manufacturer is shutting the gypsum-mining town because there's not enough of a market for its product anymore.

The CHRISTIAN SCIENCE

MONITOR

EMPIRE, NEV.

This mining town of 300 people clings like a burr to the back of the Black Rock Desert. For years, it was marked on state Highway 447 by a two-story sign reading, "Welcome to Nowhere."

On 20 June, that tongue-in-cheek greeting will become a fact. Empire, Nev., will transform into a ghost town. An eight-foot chain-link fence crowned with barbed wire will seal off the 136-acre plot. Even the local ZIP Code, 89405, will be discontinued.

Many towns have been scarred by the recession, but Empire will be the first to completely disappear. For only a few days more it will remain the last intact example of an American icon: the company town.

Since 1948, the United States Gypsum Corporation (USG), which is the nation's largest drywall manufacturer, has held title to all of Empire: four dusty streets lined with cottonwoods, elms, and silver poplars, dozens of low-slung houses, a community hall, a swimming pool, a cracked tennis court, and a nine-hole golf course called Burning Sands. The company also owns the town's drywall plant and the nearby gypsum quarry, a 264-acre gouge in the foot of the Selenite mountain range six miles to the south.

The end of Empire began just before Christmas, when dozens of workers in steel-toed shoes and hard hats filed into the community hall for a mandatory 7:30 am meeting. Mike Spihlman, the gypsum plant's soft-spoken manager, delivered the news to a room of stunned faces: Empire was shutting down. "I had to stand in front of 92 people and say 'Not only do you not have a job anymore, you don't have a house anymore,'" Mr. Spihlman recalled.

USG, known for its Sheetrock-brand products, has posted losses of about $1.5 billion over the past three years. The red ink is a result of "weak market conditions and extraordinarily low shipping volumes," former chief executive William C. Foote told investors in October. Beneath the jargon is a simpler story: What Empire makes is not in high demand anymore. The housing construction slump has continued too long for the plant to hold on. By the end of 2010, wallboard sales had dropped more than 50 per cent since 2006, when the industry peaked and USG had $297 million in profits. Manufacturers are getting desperate now. On 3 November, USG announced plans to hike drywall prices the following month by 25 per cent, a Hail Mary pass to stimulate profits. The move rippled across the industry as other wallboard manufacturers followed suit. (USG's price increase was later revised and rolled out in two installments: 20 per cent in March and an additional 15 per cent in May.)

"Every day we made it was a day closer to economic recovery. But [the recession] just outlasted us," says Steve Conley, who began working here in the early 1970s. He rose to become quarry foreman, the same title once held by his father, Bud, who retired in 1987 after 33 years of service. "I was born in a haul truck," the younger Mr. Conley jokes, adding more soberly: "This is my home."

Until January, the quarry was a noisy place. Blasts of ANFO, an explosive, punctuated the still mountain air, dislodging white, chalky chunks of ore from five terraced pits, the largest a half-mile across. A fleet of haul trucks shuttled 60-ton batches of gypsum six miles up the highway to the factory, where workers pulverized it, cooked it up past 500°F. in massive kettles, and shaped it into the wallboard delivered for construction across the American West. Before the miners used trucks, they ferried 1,800-pound payloads along an aerial tram in colossal steel buckets, trailing blotches of spilled powder below.

By some accounts, the Empire facility known here as "the gyp" encompasses the longest continuously operating mine in the country. The mining claim, originally established by Pacific Portland Cement Co., dates to 1910.

Now the quarry is silent, its roads blocked off with gravel berms to discourage trespassers. The factory has been empty since 31 January. And Empire, a scrap of green in the desert, is already starting to fade. Lawns once immaculately tended are choked with weeds. A fence is rising around the perimeter. Residents say it makes Empire look like a "concentration camp." If someone doesn't find a new use for this place, the town will eventually vanish. When dust blows in from the desert, no one will be here to sweep it away. It will start erasing signs of human habitation in a place that has been settled since 1923, when miners established a tent city.

By the end of May, all but a handful of workers had already made the forced exodus. Before they left, many tossed their corporate hard hats high into the branches of a neighborhood tree, creating an impromptu monument to their lives here.

Those lives are all about to change drastically, because leaving Empire doesn't mean just moving down the road. Jobs in the immediate vicinity are scarce. Empire is located in one of the remotest corners of Nevada, which has long led the nation in unemployment. Apart from Gerlach a neighboring hamlet with fewer than 200 people that shares its schools with Empire the nearest town, Nixon, is 60 miles to the south on a reservation owned by the Pyramid Lake Paiute Tribe.

Calvin Ryle began working in Empire on 1 July, 1971. In January, he helped bring the last piece of drywall off the line. Standing beside a conveyor belt in the factory, where his son also worked as a maintenance mechanic and his daughter-in-law as a quality-lab technician,

M. Ryle raised his hand and pressed the stop button for the last time.

"I've been here for 39 years and seven months," Ryle said at the time.

As the plant's quality supervisor and former general foreman, he set the record for longest continuous service "I've never missed a single day, never been injured." Shutting down the conveyor belt brought him to tears. "The worst thing you can hear in a board plant is silence," Ryle said. "You're a part of building America. It's not just making Sheetrock here."

The plant's maintenance foreman, Aaron Constable, watched Ryle administer those last rites. "He actually stood there and cried," Mr. Constable recalled. "He's up there at the main start-stop station. When they said, 'You go ahead and shut her down,' it took him some while before he actually pushed the button."

At its height, Empire was home to more than 750 people, as noted in the July 1961 issue of USG's in-house magazine, *Gypsum News.* "The folks who make their homes in Empire are one big happy family," the magazine reported.

By many residents' accounts, that was still true until the end. Empire was an extended family, with the kind of intimacy and security not to mention the gossip and lack of privacy that comes with close quarters.

"We've got the neighborhood watch program," Constable explained in the January interview. "Your neighbors watch you whether you want them to or not."

For decades, Empire was largely insulated from the troubles of the outside world. Here, you could rent a company-owned home for $250 a month, or an apartment for as little as $110. Water, cable TV, sewer, trash, and Internet service were all provided on the company dime. Workers were awarded gold-colored construction helmets when they reached 25 years of service and wore them with pride. No one bothered to lock cars or homes. Kids had the run of the neighborhood, but were still in hollering distance come dinnertime.

There were some rough patches. In 1993 and 2001, USG filed for bankruptcy. The second episode followed personal injury claims related to asbestos exposure, totaling millions of dollars. Both times, the company emerged and regained profitability, leaving Empire unscathed.

During the 1970s, the plant at Empire went through layoffs and shortened shifts. Some apartments were boarded up, but the town survived. "We just tightened up our belts," says Sunny DeForest, the plant's former human resources supervisor.

M. DeForest retired in 2007 after more than 42 years at the plant and now lives with her husband, another former USG worker, in a home across the highway from Empire. Their house is not on company property, but it relies on USG's infrastructure for electricity. They plan to stick around. "We've got a brick house, and you don't move brick houses so easily," DeForest says wryly. She's not sure what they'll do, however, if the power gets cut.

Her daughter, Tammy Sparkes, is also in a hard place. In October, after returning from a tour of duty as a military ordnance officer in Kuwait, Ms Sparkes used her savings to buy the Empire Store, the only place to get groceries for miles, sprucing it up with new flooring, a fresh coat of paint, and a couple of cafe tables. Sparkes owns the building but leases the land from USG, which also supplies the power and water. With most of her customers gone, she's struggling to make it to August, when the annual Burning Man festival, held in the nearby desert, brings a wave of thousands of colorful, albeit temporary, patrons.

"I always liked that store. It's neat, because it's a community thing. You know everybody within a day. I had all the employees I needed," Sparkes says. In December, one of those employees called her tearfully to tell her the town was going away. "I was devastated," she recalls.

Empire's troubles have also rippled out to Gerlach, where the regional school system that served 73 students this year anticipates just a dozen next fall. Twenty staffers are losing their jobs. One teacher and two aides will remain in a three-room schoolhouse. "We are blessed to have this much, by the sounds of things," Judy Conley, the school secretary, wrote in an e-mail.

In the midst of the crisis, there's an upside: Many of Empire's displaced workers have landed safely. The same economy that was flattened by the housing crash has seen gold prices skyrocket, and Nevada's mines are hiring. Barrick Gold Corporation owns several Nevada sites and hired more than a dozen Empire employees, including Constable.

"Sad to say, the best thing that could have happened to us was the gypsum plant shutting down," he said in a May e-mail. Constable has already been promoted to supervisor. He was able to use his USG severance pay, one month for each of his 28 years, to buy a house with his wife in Spring Creek, Nev.. "Some of us live within eyesight of each other," he wrote of Empire's resettled refugees.

Others haven't had it so easy. "I threw out a few résumés, haven't gotten any bites," former supply chain manager Dan Moran said in January between bites of chicken-fried steak at Bruno's Country Club, the only restaurant in Gerlach. "I might just end up cutting firewood for a living." As of last month, he was still planning to start a firewood business near Reno, Nev..

Ryle, who pushed the button to shut down the factory in January, said at the time that he planned to stay as long as he could: "I'm a company person.... I've always worked here." But what is a company man when his company doesn't want him anymore? At 62, Ryle isn't sure if he'll work again: "You feel like you gave them a lot and, when it came down to the end, they didn't give you nothing."

There's talk that, if the economy recovers, USG could reopen the idled plant, but Ryle doesn't think that will happen. He plans to leave his gold hard hat, once a badge of honor, in the house where he spent the past four decades when he goes.

But he's not leaving everything behind. He says he'll transplant the rosebushes and a tree from his front yard when he moves to Fernley, Nev., where he just bought his first home.

"I planted that tree, so I'll dig that one up. They don't care," Ryle says. "And it's my tree. I'll fill in the hole, anyway."

JESSICA BRUDER

THE SECRET LANGUAGE OF BURNING MAN
ADRIAN ROBERTS

There I was, at a cocktail party in New York City, and—as often happens amongst members of the Burner community—the conversation turned to (what else?) Burning Man. "Sparkle ponies," "darkwads," "MOOP," "gifting," and "blue rooms" were thrown about, and for the outsiders there each term needed an explanation. Even "playa," a word that Burners take for granted, had to be defined for the uninitiated in the Default World.

It was there that I realized just how much of a secret language there is at Burning Man—and unless you've experienced it (TTITD) for yourself, much can get lost in translation.

It certainly says something about the exclusive culture of Burning Man that so many unique terms and phrases originate from an event that only exists for one week a year. But there's a reason we maintain the "Playa Lingo" column in the Black Rock City newspaper (from 1995–2007 *Piss Clear*, since 2010 *BRC Weekly*)— there is never a shortage of material. In fact, I often joke that the only reason I still publish a newspaper on the playa is to document all the new slang terms and phrases that are born annually.

I have been asked how the items for "Playa Lingo" originated—whether they just sort of happened, or if we actually sat around camp and tried to come up with names for things. For the most part, slang develops organically and comically. Some of the items in the "Playa Lingo" column start as inside jokes in individual camps. But many are the result of intentional attempts to create them.

I freely admit that as writers and editors, there are times when we *do* try to come up with names for things. For instance, one year it seemed like *nobody* was illuminating themselves at night, so we had a rash of accidents when people were run over or knocked down. We decided we needed to come up with a derogatory term for the perpetrators. We sat around camp lobbing ideas until we finally came up with the term "darkie." It wasn't until we sobered up the next day when we realized that term sounded racist, and that's when we came up with the term "darkwad" instead, a play on "dorkwad." We immediately published this term in *Piss Clear*, and started trying to make this term "a thing," using it in conversation every chance we got. Over the years, the term even spawned variations, such as "darktard."

The origins of other terms remain a mystery. Where did "sparkle pony" come from? It was originally a derogatory term for a high-maintenance playa princess who looks cute in furry leg warmers and hot pants, brings more skimpy costumes and glitter than water or camping gear, and somehow avoids doing any work in her camp. But in recent years, the term has gone from being a Black Rock City slur to— at least in some Burner circles—a term of defiant pride for attractive female Burners.

Since 1995, we have collected and documented the unique lexicon of Black Rock City. While some terms have been short-lived—one year's camp in-joke or just a punny turn of phrase—others have become a permanent part of the "secret language of Burners." Herein, in alphabetical order, is an annotated list of some of our favorite—and most enduring—bits of "Playa Lingo." And yes, we will admit, there is an over-abundance of terms that start with the words "burn" and "playa."

If you've never been to Burning Man, at least you can follow along while trapped at a cocktail party with a bunch of Burners!

A
Assplanade: cheeky slang term for the last street in Black Rock City.

B
back-burnered: when your former Esplanade theme camp gets placed deeper into the city on the back streets instead.
black & tan: someone who works as both Gate staff and as a Black Rock Ranger, hence wearing the colors of each, respectively.
Black Rock Homeless Shelter: derogatory term for the Center Camp Café, due to its reputation for being a place where ill-prepared Burners go to hang out, especially if they didn't bring their own shade structure or camp.
BLM parking: the rows of BLM officer vehicles sitting outside of popular theme camps and dance areas.
blue room: slang term for the porta-potties, making it sound more like a VIP lounge than a toilet.
blue room bolt: ditching an unwanted companion while they're inside a porta-potty.
blue taper: an overzealous Burner who puts a Burning Man logo made out of blue painters' tape on their car, van or RV. Seen as a naive move, due to it advertising the fact that you might have illegal substances in your vehicle.
blue-arming: the act of reaching into a porta-potty toilet in order to retrieve something that you accidentally dropped in, such as a flashlight or drug vial.
boosh cannon: slang term for a flamethrower or propane cannon.
bro-ners: a play on "bros," a relatively recent derogatory term for men who exhibit entitled, "douchebag" behavior at Burning Man, and treat the event the same way they do any other festival, rave or nightclub.
burgin: a first-year Burner, a contraction of Burner virgin.
burn notice: when you tell your employer that you need time off from work the week before and the two days after Labor Day every year, no exceptions.
burn-again virgin: a formerly-jaded veteran Burner who remembers why they fell in love with Burning Man in the first place.
burnerd: an annoying person who won't shut the fuck up about Burning Man.
burnerpreneur: someone who creates a business catering to Burner culture.
burnicle: that annoying person in the camp next to you that won't stop coming around, mooching all of your booze, drugs, food, water, etc..
burnier-than-thou: when a person thinks they are the epitome of Burner culture (whatever that is) and that everyone else at Burning Man is just bunch of frat boys, hippies, WASPs, suburbanites, yuppies, etc..

C
camp potato: the person who never seems to leave camp, and is always sitting in a camp chair underneath a shade structure.
circle jerk: anyone who participates in an annoying drum circle.
cracker crack: the texture of your ass after reacting with alkali dust over a few days.

creepy guy hug: that awkwardly uncomfortable, overly-physical hug given to a woman by a seemingly-friendly, often middle-aged guy, in a thinly-veiled effort for him to cop a feel.
cuddle puddle: a group of people lounging around in a pile while rolling on Ecstasy.

D
daisy ducking: female version of shirtcocking, i.e. wearing a shirt but with no pants, so named because Daisy Duck wears no pants.
darkwad: any idiot who walks or rides around at night without any kind of illumination.
"drink some water!": the BRC version of "fuck you!": usually directed at cranky people acting like assholes.
drive-by art: a subpar piece of art out in deep playa that you don't even need to get off your bike or art car to inspect further. Usually pretty, but not interactive. You can roll by and slowly gawk, then move on to the next thing.
dusty munchkins: the semi-feral children that run loose around the playa.

E
e-nnoying: what people rolling on Ecstasy usually are, especially to people who are NOT rolling on Ecstasy.
e-tards: derogatory term for someone on Ecstasy.
Early Departure Pass: leaving Black Rock City before the Saturday night burning of the Man.
Esplanade TV: the constantly entertaining and non-stop parade of people, art cars, and interactivity that one witnesses when sitting curbside on the Esplanade.
exodus coma: what happens when Burners who fall asleep in their cars waiting for the next pulse during Exodus.
fafffing: fucking around for fucking forever: what your campmates do when you're trying to leave camp. Veteran Burners know that often the key to ever actually leaving your camp is to follow the "leave a man behind" rule whenever trying to organize a group of people to go somewhere.

F
family rubies: sunburnt genitalia.
filthy santa: any naked, hairy, overweight, middle-aged man who dresses up their genitalia like a god-damn Christmas tree.
"fuck yr burn!": popular BRC expression amongst members of the DPW and other jaded veterans: used in place of the more generic "fuck you."

G
Gatestapo: slang term for surly Gate staff.
gift shark: someone who promotes the gift economy but won't stop reminding you of the gift they gave you.
glamping: glamorous camping, what many citizens of Black Rock City aspire to.
golfer: derogatory term for any self-important Black Rock City LLC staff member driving around in an undecorated golf cart.

H

hippie trap: playa art with no real message, seemingly designed with the sole purpose to lure drugged-out Burners to hang out inside or around it, simply to stare at its pretty lights or decorative features.

hippiecrit: the sort of Burner who has dreadlocks and henna tattoos, but also has fake tits and drives a gas-guzzling SUV.

I

"it's Burning Man!": generic, catch-all excuse for just about anything that goes wrong or not according to plan while in Black Rock City.

J

jack-on-the-spot: masturbating in the porta-potty.

K

ketamolicane: the name of the end-product of pooling all of your camp's powder-based narcotics into one single bag, thereby extending the shared supply with all contributors.

L

long-term parking: slang for when vehicles get impounded by the Burning Man DMV for mutant vehicle violations, such as driving too fast or not having the proper permit.

M

MIP: matter in place, when that item you lost in camp that you've been hunting for is exactly where you left it.

P

pissography: the writing of words in urine on the playa. Usually done by males, but can also be performed by extremely talented females.

playa bling: particularly artistic and well-made Burning Man jewelry.

playa cred: the social currency of reputation by which camps obtain their requested placement year after year.

playa time: the strange bending and folding of time that seems to happen once you're in Black Rock City. One of the reasons events never seem to start on time (or at all) and everyone always is late for everything.

playa vampire: a Burner who parties all night and then sleeps all day.

playafied: have everything you own covered by a thin layer of alkali playa dust. The condition something gets after being brought to Black Rock City. See also: "blessed by the playa gods."

playafried: the feeling one gets immediately after Burning Man; the worn-out, post-playa depression that one has upon returning to the Default World.

playamourous: a temporary state of having multiple sexual or romantic partners while at Burning Man.

playasexual: someone who pushes their own sexual boundaries, whether experimenting with unfamiliar sex practices or exploring alternate sexualities, while at Black Rock City.

playatitus: the "sickness" one has upon returning to the Default World and calling in sick to work on Tuesday.

playavangelist: wild-eyed Burners who won't shut the fuck up about Burning Man until everyone they meet has gone at least once. They usually exasperate people into not *ever* going.

poly-camporous: anyone who divides their time between two or more camps while in Black Rock City.

procrasturbation: when one intentionally and pleasurably delays getting something important done for their camp.

R

radical self-entitlement: what happens when one assumes that Burning Man is a socialist experiment and that they can help themselves to anything in any camp.

radical self-promotion: what happens when Burners or theme camps use Burning Man as a platform to promote themselves, the DJ collective, or their brand. See also: "theme camp identity branding."

ranker: anyone who has been going to Burning Man for ten years or longer.

Reality Camp: slang term for the Default World upon re-entry after Burning Man.

rebarred: when your ankles or shins get scraped by rebar stakes.

S

sausage camp: slang term for camp full of straight guys, but no women.

second-year fever: the experience one has after going to Burning Man for the first time, where they won't shut up about the event, and spend every day planning giant projects that will end up falling far short of plans and expectations.

second-year scholar: a second-year Burner with attitude who acts like a pretentious know-it-all because they're already been to Burning Man once.

self-gifting: slang term for theft and stealing.

shirtcocker: someone at Burning Man who wears a shirt, but with no pants. An increasingly rarity in Black Rock City, as most shirtcockers got shamed out of existence.

sit-downers: those assholes at the Burn who bum everyone out by constantly yelling "sit down!"

sleeper camps: camps that reserve "theme camp placement" in an effort to secure playa real estate, but ultimately have little to no interactivity: it's just a wall of RVs.

sobrietol: the "pretend drug" you say that you're on when taking a night off from imbibing in any alcohol or other substances.

sparkle pony: a young, hot burner who doesn't set up camp, never cooks a meal, doesn't bring gifts, doesn't bring their own drugs, barely brings their own water... but will dance in their underwear in front of your camp because you know, that's their gift!

specticipating: the act of participating by being a spectator.

stealth virgin: a first-year Burner who acts so much like jaded veteran, that you'd never suspect that they've never been to Burning Man before.

stupid desert cult: what Burning Man seems like to anyone confronted by a playavangelist.

Often used by veterans when speaking to overly-excited first- and second-year Burners.

T

"the playa provides": stupid quote coined by some lazy-ass sparkle pony trying to romantically justify their pitiful lack of preparation.

ticket holder: a derogatory term for someone who treats Burning Man like any other entertainment event.

tossing a camp: slang term for when law enforcement officials raid a camp for search and seizure, in order to look for illegal drugs.

trailer chaser: someone who will sleep with you just so they can crash in your air-conditioned RV for the night, instead of their own hot dusty tent.

TTITD: acronym for "That Thing In The Desert." Used when one wants to discuss Burning Man with other people "in the know," but doesn't want other non-Burners to know that they're talking about Burning Man, due to the many, often-erroneous pre-conceived notions that others have about the event.

V

vanity schwag: playa gifts that bear the name and/or logo of the gift-giver or their theme camp.

vapor camp: a cool theme camp you heard or read about, but can't seem to actually find. Often the empty space of a theme camp whose organizers couldn't get their shit together.

Y

yahoo: any non-participatory, spectating, rude, or leering person at Burning Man.

EVERYONE GO PISS ON THE GROUND STAKE—THE STORY OF DR. MEGAVOLT AT BURNING MAN

DR. AUSTIN RICHARDS

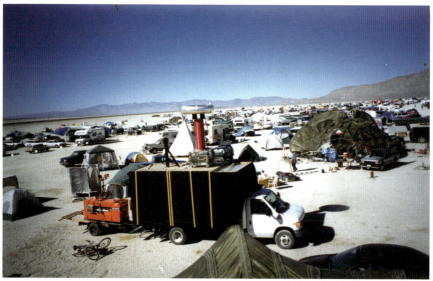

The Megavolt truck, 1999
Photo: Austin Richards

I have been building Tesla Coils since 1981. I built a big one in 1992, and first brought it out to Burning Man in 1998, along with a metal suit I created to protect me from the 13-foot long high-voltage discharges from the machine. I ended up doing nine years of Megavolt shows at Burning Man, and became quite well known there. The title of this article was inspired by the strange things we did to make the shows successful. In 2001 I asked my campmates to urinate on a piece of rebar driven deep into the playa surface to improve the electrical connection of my Tesla Coil. Many did, women included, though we did not allow this activity to be photographed. Electrically speaking, Burning Man is one of the absolute WORST environments in the world for a Tesla Coil, or any high voltage machine. Playa dust is a very poor electrical conductor when it is dry; the stuff is corrosive to many metals used in electronics, and gets into everything. My Tesla coil has critical moving parts exposed to the elements, and the main coil is a PVC air duct wrapped with ordinary electrician's wire. This coil assembly gets a million volts impressed across its length, which pushes the insulation to its limit. When the coil has been set up on the playa surface or even close to ground level, there is a fair amount of windblown dust that lands on it all day and gets under the wire turns. There is also always a small amount of moisture in the air out there, and after sunset, it condenses on the coil and mixes with the dust to make a slightly conductive layer. Chaos ensues when the machine is run hard in a dusty state—flashover and arcs occur and slowly burn the wire insulation. It's happened over and over again—the Tesla Coil is in constant need of field repairs out there.

Spiritually speaking, Burning Man is one of the *best* environments in the world for a Tesla coil. Tesla coils like the one that zaps Dr. Megavolt have no real practical use. Nikola Tesla invented the device to transmit electrical power

through the air at a time when copper was extremely expensive (compared to today) and the cost of an extensive copper power cable infrastructure was prohibitive. But it was a failure: Tesla coils don't work very well as power transmitters—there is too much power lost to space and dissipated in the ground. However, Tesla coils are fine entertainment devices, producing bright, loud discharges that evoke real lightning.

Many animals feel a primal fear in the presence of lightning. We have evolved to fear dangerous things, and lightning is very, very dangerous. It is a force that has been worshipped for thousands of years of recorded history, and probably since the dawn of man. Thunder gods are always prominent in every pantheon that has one: Zeus in Greek mythology, Thor in Norse, and Cauac in the classical Mayan culture. The participants at Burning Man, already out of their comfort zone in so many ways, are primed to feel this delicious fear.

1999

It's night in West Oakland, California, late August. The freeway roars in the distance. We work under the yellow-orange streetlight coming over the high wall around an industrial space that was once a metal plating company, then an abandoned Hazmat site poisoned with chromium and other toxic metals, and now an illegal living space for various East Bay characters. The Ryder box truck I've rented is getting a subtle transformation that will add four inches of height to it. A platform made of plywood and two-by-fours takes shape on the roof, held down by six yellow nylon cargo straps. Later that week, an employee of Ryder reports it to the company, and weeks later I get a nastygram from the company: no putting stuff on the roof. The platform stays attached during the nine-hour drive to Burning Man, the straps humming in the wind and sounding like an Aeolian harp. The platform is eight feet by 16 feet, just big enough for a Tesla Coil and a performer.

It is night in Nevada two days later, my third year at Burning Man, often considered the best year for veterans of the event. The dust is almost non-existent, the playa surface slightly dusty and hard—like the concrete slab in the basement of the Victorian home I grew up in. We are working on a dome in the dark. Some of the cars in our camp have their headlights pointing at us, and I am using my new Home Depot ladder and work lights. The people with me are a mixture of new friends and old. My girlfriend, 13 years older than me, is working on the dome, handing us tools and fasteners. She is high energy but also high maintenance. That night, she forgets to drink water and gets seriously dehydrated, then after recovering starts a trend of drinking way too much water all day and all night, necessitating constant broad daylight urination on the playa in front of all my friends (but that is how it is—there were rarely any porta-potties within 300 yards of wherever we happened to be). The truck with the platform is our RV. The dome crew is made up of friends who live in the West Oakland industrial space. I have only known them for two years, and my relationship with my girlfriend is about four months old and already winding down. The next day the Tesla coil goes on the roof, courtesy of the original Megavolt crew, a group of Bay Area creative types.

That night I experienced a feeling like the first time a rock band has a breakthrough show, where they sense fame and success coming at them fast. I was on top of the roof platform as the truck drove slowly down the back streets of Burning Man, towing a running construction-site generator. People came running from hundreds of yards away, cheering wildly. I felt the energy of the crowd surge through me like the electricity I was bathed in. The coil worked perfectly and does not stop working perfectly for the next four days. Compared to the year before, the

first year of Megavolt at Burning Man, this was a walk in the park. The previous year I had been consumed with fixing the myriad failures of my system since I had not provided a proper electrical ground.

A day later, John Behrens puts together a pyrotechnic effect, a charge of pyro powder in an aluminum foil packet that looks like a triangular turnover. The packet is mounted to the end of a metal rod with a wire igniter worked into its end—when the Tesla Coil discharges strike the wire, they will arc across a gap in the center of the packet of powder and ignite it. He gets up on the roof in the suit and holds the scepter out. A huge and shower of sparks goes off in his face, temporarily blinding him. The crowd goes crazy. It is the best side of him, the go-to guy on a rock tour, who earlier that day met up with a friend from the Bay Area roadie/tech crew crowd over at their camp and got some pyro powder. John provided a huge amount of production experience and personal energy to get Megavolt out there in 1999 and make the event a success for the team.

Over the next four days, we conduct a virtual "grid search" of the streets of Black Rock City. We drive up almost every street, because almost *no one* is out on the playa. The weather is so cold out there (20–30°F right before dawn) that all the poor saps who thought they were going to a burning hot desert find out just how inadequate their skimpy clothing is. Thousands of people shiver in their thin sleeping bags as we drive by. Many of them come running out in spite of the cold, and some of them end up following us around on foot for four hours, almost to the point of being stalkers, showering us with gifts, hounding us like fans with bad cases of Beatlemania.

The night of the Burn, we drive out to the burn circle early before the crowd settles in around us. People are swarming around the truck, waiting for the party to start. There are 14 of us on the roof of the truck along with the Tesla Coil; it was never designed to hold weight like that, but the platform distributes the weight to the back where the steel roll-up door-frame provides massive amounts of support. I make sure everyone is around the edges. Six skinny teenagers are sitting on the roof of my truck's cab, crumpling it in, but luckily not permanently. I kick them off, but nicely. They are very sweet and innocent acting and it is hard to get mad at them—they all look about 17. An officious Ranger runs out to the truck and shouts at me that if I start the Tesla Coil show before the Burn he is authorized to confiscate my generator. I tell him "Bullshit" through my bullhorn and I whip the crowd up against him. This is a typical Ranger in the early days of the event—a wimpy nerd who gets a little power and lets it go to his head. Tonight John will perform in the suit, while I run the coil and watch for safety issues. Megavolt is really dangerous—a fact lost on many of the ignorant hippies who think that the high voltage electricity right in front of them is somehow safe. They are reasoning in their muddy THC-compromised way: "Hey, that guy is up there in a costume getting hit by it, man! It's free energy!" Years later my entertainment lawyer asks why I didn't perform more in the suit in those early days at Burning Man. Only now, older and perhaps wiser, do I realize that I had stage anxiety, not because I was worried about the show being a flop, but because I just couldn't (yet) handle being in the high beams of the crowd energy directed at Dr. Megavolt.

1998 and 1999 were very significant years for Burning Man, not only because of the rapid growth in the population, but also because the tech crowd was discovering the festival and bringing their talents to bear on it. Suddenly fire and traditional fire art had some stiff competition for people's attention. A number of engineers were making elaborate art cars and bikes with high tech lighting, especially electroluminescent wire, and there were complex laser and LED light shows, and flaming sculptures. The hippie flavor of Burning Man was morphing into something different. The early days of the festival were marked by drum circles, bonfires and bad sunburn. I had first heard about Burning Man in 1992

from some of the folks at Survival Research Laboratory, who told me it was a hippie festival and not worth my time. I tend to agree after seeing pictures from the early years. Also, there was almost *no shade*! Burning Man 1999 was so much fun that I thought of little else until it was time for Burning Man 2000.

After the experience in 1999, I applied for and received a substantially larger art grant from Burning Man to be the "eyes" of the Man in 2000. I also got ten artist's tickets that I used to support a much larger crew. The theme that year was the human body, and art projects that invoked body parts and organs were getting funding. I assembled the best Megavolt crew we ever had at Burning Man, all friends from the Bay Area, all Burning Man veterans with endless energy and enthusiasm. We went out with two Tesla Coils, a bigger truck, a bigger generator and a large, placed campsite. The two coils were like eyes staring up at the sky, if you used your imagination and pictured looking down on them from above. John Behrens and Greg Solberg had built a second coil based on my coil design. It was (nearly) electrically the same as my coil, but with a number of excellent improvements in terms of portability and weight. We installed matching 56-inch diameter toroids on the units. The visual effect was stunning, especially after two years of shows with a ghetto toroid made of an old, oddly-shaped truck inner tube covered with crinkly aluminum foil. This new coil rode in the front of the truck, and my coil was mounted on the back. When both coils fired together, black smoke poured out of the diesel generator's exhaust in a barking roar, and a 50-foot long cloud of ions formed around the roof of the truck, pierced by 13-foot discharges.

My act has been copied many times over the years, but as far as I know, I'm the first person to wear a metal suit next to a large Tesla Coil looking to get struck by the discharges. The first time I did this stunt was in March of 1997 in Orinda, CA. I was hanging out with friends in Oakland that spring and trying to find an outlet for an artistic side through technology as a graduate student in physics. The metal suit was the best idea I had, and it came from watching the operators of the large Van De Graaff generator at the Boston Museum of Science running that machine from a giant dome-topped cylindrical "birdcage." The Van De Graaff machine hit the cage with 2.5 million volts. Because of the very rapid time scale of the discharge, an electrical phenomenon called the "skin effect" kept the electrical fields inside the cage near zero—the person inside did not receive a shock, even when touching the inside of the cage. I realized that I could make a suit that would protect me from a Tesla Coil's electricity—it would be the equivalent of a metal cage shrunk down to body size.

A high school student in Orinda had a large Tesla Coil he had created after seeing the big coil I had built in 1992 at UC Berkleley's physics department. We went out to his house in Orinda to test the suit with his coil. The large Tesla Coil I had built five years earlier with a UC Berkleley undergraduate named Paul O'Leary was in the repair shop with a burned-up secondary winding, a serious nuisance. We started out in his garage with a small coil that made five-foot discharges. I was able to stand next to the machine and take the discharges with no effect. The ozone smell was overpowering; it felt a bit like being really close to a tiger in the jungle, smelling that powerful male cat smell, and trying to hold very still so as to not get eaten. The coil's discharges seemed to be probing the defenses of the suit, crawling along the birdcage face, but miraculously failing to enter the birdcage front door, which I had accidentally left open. My mouth was just a few inches from a fat blue cobra's head of electricity. I thought: "What if the discharges shoot into my mouth and out my ears like in that final scene in *Raiders of the Lost Ark* where the Nazi troops get zapped by Old-Testament-style wrath of God?" But electrical death stayed out of the cage, restrained by the laws of physics that govern the motion of electrical charges through air and metal.

DR. AUSTIN RICHARDS (AKA DR. MEGAVOLT)

Original Megavolt suit concept on a napkin from Mel's Diner, Berkeley, CA, 1997
Drawing: Austin Richards

electrical suit concept 2/97
Berkeley, CA

We went to the backyard, where the coil was set up. It was about nine feet tall and sent discharges at least 15 feet through the air. I asked the student to give me a short burst, then talk to me and ask me if I felt it. He fired the coil for about a half second. I felt no electrical shock at all, and at that moment an excellent feeling stole over me. I knew I could show off this trick to others, that it was something people had not seen or heard of before, a new thing to do with Tesla Coils that put a human spin on them. I asked him to let it rip and spent the next 20 minutes trying out different experiments. The best one was standing on a wooden lounge chair and watching the current flow down the wood's surface, burning a smoking black trench. How could something so destructive pass harmlessly on the surface of a metal suit with a person inside?

The idea of a metal suit protecting a person from a large Tesla Coil was an original idea[1], and I am proud of it, but it's admittedly an idea that is not of much interest to the scientific community. Some of the physics faculty at UC Berkeley said things like: "Well, Austin, it's just nineteenth-century physics, you know, the skin effect and high frequency currents." They were of course right, but the real value of a metal suit and a Tesla Coil is in show business, not the physics research business. That's why I find myself in 2013 still performing this show for audiences worldwide. People have always wanted to see this live—it's an intense experience for me and an audience.

Hearing the negative comments from the physics faculty is when I first knew that I needed to leave academia. My creative energy wasn't properly focused on the right things in my life to be a research professor, buried in a windowless lab, writing grant proposals, fighting over diminishing funding resources, having to keep my libertarian politics to myself around liberal colleagues, and so on. It's not my destiny to be that person and I am glad I figured it out when I did, before going out to try to find a faculty job, or worse yet, actually getting a faculty job. My thesis work was almost purely academically oriented, which was not a good start to an industrial career, and it took me about two years to transition, but today I have a very satisfying and lucrative career in infrared camera technology and I don't regret not being a professor for an instant.

When I went to Burning Man for the first time in 1996, I participated as a Ranger. Aside from a few magical moments, like riding my bike for 30 seconds straight on perfectly flat playa with my eyes closed the whole time, or meeting a very pretty girl who happened to have a shaved head like Sinead O'Connor, I hated the experience, though most of the misery was my own fault. It was so unexpected, the intense light, heat and dryness, and I was so poorly prepared, with nothing but a sleeping bag and a blue tarp attached to the roof rack of my Jetta sedan flapping all night in the wind. The city was tiny compared to today and had very little shade anywhere, and no ice for sale! Most people were completely knocked out with sunburn, windburn and overheated bodies, and the event was extremely disorganized and chaotic at night. The night of the Burn, people stole bicycles and threw them on bonfires made of burning sofas. It smelled like a war zone with black choking smoke at ground level everywhere. At one point, some crazy person drove a pickup truck by at high speed, 20 feet from where I was trying to sleep in my miserable hovel. I got very ill with electrolyte depletion because I didn't eat for three days straight, and when it was over, I was pretty well convinced I was never going again.

I skipped Burning Man in 1997, and the week prior to Labor Day was spent in South Africa with a girlfriend, the event entirely forgotten. But then Chris Campbell, a friend from Oakland and a huge supporter of the Tesla Coil project since the beginning, urged me to let him take the coil out to the playa in 1998. He and his girlfriend drove to Santa Barbara, picked up the suit and the coil, drive them back to Oakland, then to Burning Man, then did that all in reverse on the way back

for a total round trip of about 2,000 miles. I wasn't going to go out at all, but at the last minute I decided to go with a friend and surprised Chris and the others in the camp. We camped in a dome-based camp called Toxixity, pronounced Toxic City. The coil was set up right next to it. We lived in the dome, which was blazing hot in the daytime. Chris' girlfriend cut slits in the dome cover to let out the heat (against our wishes, I might add, because we lost all protection from the dust and rain that made the floor into a muddy mess). I was very, very fortunate that Chris made that massive effort to get the coil out there, because even though it worked poorly, it ran long enough and well enough to be seen by Lady Bee, then the Burning Man senior staff member responsible for funded art at Burning Man.

2001

I can't sleep. I want to get up and start loading the truck, but it is 4:00. I live in a very tightly packed little compound of cheap Sears Roebuck prefab houses, rented to us by a miserly old landlord who donates his money, *my* rent money, to some annoying missionary charity overseas. At 6:00, I finally get up and start loading the truck. The coil is already on its way to Burning Man in a communal rental truck. All I have to do is load the truck with my own personal stuff, and boy, is it a nice crib.... I have an antique mahogany sewing cabinet next to my bed, an antique poster map of the world, a queen-sized bed all set up. A bachelor's pad for Burning Man.

23:00 that same night in Sparks, NV. I am falling asleep on my feet after an 11-hour drive. The hotel clerk gives me the room keys and tells the next people through the door that they are now fully booked (my luck—I have had so many serendipitous moments like that). This is the beginning of the best year of Burning Man yet. John is working for the Nigerian singer Sade this summer as a cameraman on her tour. His absence brings relief from what is becoming an increasingly contentious relationship over the future of Megavolt. Under the surface, we have been struggling for control of the act. I own the website and have already begun the task of trademarking the name, and I made the first suit and the coil and came up with the name, but John now owns a coil like mine that I helped him design, only better: lighter weight, simpler design, with some strange overcomplicated control box that John built. As I lay awake much later that night, thinking about the drive-in, I am thinking about how to move things forward with the act. I need and am getting a legal agreement together, an agreement that takes me a year to get signed. I am determined to forever associate my name, Austin Richards, with the identity of Dr. Megavolt, and I have worked at it, joining up with a crew of Burning Man stalwarts called the SINdicate, who are mostly LA-based. There is a real buzz within the variety act subculture of the entertainment world about Megavolt, and the soul of the event has migrated away from the hippie Bay Area flavor of the early years to a much hipper showbusiness vibe.

Four days later, 1:00: the wind has finally died down. It is warm and dusty, the surface like lunar crust under the feet of the standing-room only audience. Go-go dancers dance in cages next to the coil. A naked man drums in a bigger cage, controlling the Tesla Coil with an air hose system I devise. He plays the coil like a percussion instrument by blowing into the hose held in his mouth. I jump up and down on a small circular exercise trampoline in my suit, holding a burning stick of wood in my hands. The Subjugator, a giant nightmare of a radio-controlled robot, spins its claw furiously near the coil. The discharges follow the claws around in what looks like a struggle with an insane electric blue octopus of electricity. This is it, the best Burning Man Megavolt show that was and will ever be. It is downhill from here for Burning Man itself (in my opinion), but I don't know it yet.

In 2002, I met my future wife Victoria and invited her to come out to Burning Man with me. We camped with The Mutaytor, a drum and dance band from LA. The Mutaytor was like a cult—the members labored in the hot sun every day out there, setting up the stage, rehearsing, then performing at night. Their leader was Matty Nash, a drummer and forceful personality who co-owned the Mutaytor brand with his wife Christine. The Mutaytor performers were perpetually exhausted, doing a lot of things the hard way, like renting a truck in LA and overloading it to the point where it was unsafe to drive. We got pulled into the endless work one memorable night when it rained, and everyone scrambled to cover the drumsets with tarps. John and I were starting to have some major conflicts over the way that we conducted the business of Megavolt at Burning Man. On one occasion, he wanted to rehearse the show on a fantastically hot day, when I was completely wiped out from the heat. I could see his point of view, but I was starting to regret having to share the decision making. I never imagined that Megavolt would get as big as it has or attract as much attention. The shows at Burning Man were starting to take on gravity. The Mutaytor wanted Megavolt to be part of the band and tour with them. Victoria and I, along with everyone else in the camp, ended up being roadies for The Mutaytor that year, and the two of us decided to not repeat that experience again, or ever tour with Mutaytor.

The novelty was wearing off after doing Megavolt at Burning Man for four years in a row and the harsh conditions were getting much harder to ignore. Burning Man attracts a certain personality type that loves to bond with other people during periods of hardship. These people venture out in huge rain and dust storms, taking refuge in passing art cars, ducking into tents or RVs, crouching down inside art installations waiting for the tempest outside to subside. I am not one of these people. The bad weather conditions at Burning Man always stop me dead in my tracks, make Megavolt shows impossible, and put me in a bleak mood, making me wonder why I am there. There must be a tremendous freedom in going to Burning Man with nothing more than a tent and a backpack. For my sins, I go with 6000 pounds of gear in a huge truck, towing a big generator. All that equipment requires weeks of work to clean and repair afterwards. Bad weather allows many people to have the best times of their life there, covered in dust, filthy and sunburned. The place is a perfect antidote for cubical life. But that stuff takes away from my experience—I like to be clean and dry and hydrated, and I hate getting sunburned.

But still I pressed on, feeling like I had to keep doing Megavolt at Burning Man to keep my place in the cultural hierarchy of the event. Plus, my entire social life now revolved around Burning Man and the people I had met through it. Burning Man 2002 was fun for Victoria and I, but so many people had seen Megavolt by then that the act was feeling stale. The audiences would not stick around for nearly as long as they had in prior years, since there were now so many other very interesting shows and spectacles competing for their attention. The plan for 2003 was to do an installation on the playa called the Cult of Saint Elmo. It would be interactive in a way that Megavolt wasn't. People would get inside a cage that would be struck by lightning bolts from a large Van De Graaff generator I was building. The generator was not working by the time Burning Man rolled around, so we ended up using John and Greg's coil next to a metal cage made out of wood and chicken wire. The themes of the Cult were anything to do with the word Elmo. We had a poster with a picture of St. Elmo's Fire, the phenomenon of corona discharge seen on ship's masts during electrical storms. We mixed in references to the 80s movie St. Elmo's Fire, and Elmo from Sesame Street. The installation did not really ever get finished, but we got a huge boost from the efforts of Playa Kitten and her friends who made a crucifix of Tickle Me Elmo dolls and other assorted props. Someone stole my strobe light out of the tent, and there was a sense of entropy about the installation. But the

coil ran very well, and hundreds of people went into the cage and experienced the electricity close up.

We took a few years off and did not go back until 2006. The general atmosphere at Burning Man that year was reminiscent of 1996—there was a sense of violence and chaos in the air in the nighttime towards the end of the week that was periodically very unpleasant. It seemed to us that there were a lot more people who were drunk or high on methamphetamine—not a good vibe at all. Law enforcement had cracked down on marijuana use, with its telltale smelly smoke blowing downwind that made it easy to arrest people in their tents. The event had grown substantially since we had last attempted a mobile Tesla Coil platform in 2000; now the playa was vastly more crowded at night with onlookers and other art installations. We drove around performing shows with the truck, and had a number of problems with the equipment. We also had a very small crew for a two-coil truck, which made it hard to maintain safety and security. My coil was incorrectly tuned and was discharging up and down the secondary winding until I retuned it. I never could solve the problem of the power generator we had rented, which kept shutting down whenever the Tesla Coils would strike a performer at close range. Maybe some circuitry was sensing a ground fault and was shutting down the generator to protect it. The tension between John and I was reaching a boiling point. He continually fought me on the driving issue—he did not want to have to drive the truck during the shows. He and his girlfriend were performing as Dr. and Mistress Megavolt. I was too, with my new bride, Victoria. The identity of Megavolt was a valuable commodity, so doubling up was problematic, and there was a conflict brewing over the ownership of the Megavolt identity. I also felt, rightly or wrongly, that I was doing more of the hard work in the hot sun while John flirted with girls in the camp. This was not entirely fair, but it was my perception at the time and it put a damper on the experience. After that year, I thought I was finished with Megavolt shows at Burning Man. John and I dissolved our working relationship and I now had complete control of Megavolt.

2011

Night falls and there is not a breath of wind. The temperature is perfect, maybe 80°F. This is my twelfth year out here. The previous year, 2010, was the return of Megavolt to the playa after a four year break. It was very successful and we got a lot of good HD footage of the shows.

But that was last year. This time I am more on my own out there than I have been in years. Friends and campmates from years past have come and gone. Victoria hasn't come out with me this time, and my old friends are all camping somewhere else or haven't gone this year. I am camping with Area 51, a large group of friendly people from the southeast, especially Atlanta. But I don't know them at all. The only old-time crew member is Dannen Harris, a great friend who unfortunately is not camping with us. The Tesla Coil is right on the Esplanade, a perfect location to attract an audience. The big seventy-kilowatt generator that runs the coil is a hundred feet away. Some fat jerk named Big Daddy has locked the access panel to the generator controls, taken the key away and hidden it, and left camp for the evening. I can't run the coil. The padlock is sturdy, and cutting through it with the tools I have would be a serious chore. I am livid. The coil is set up and ready to go, and I am itching to do a Megavolt show. My friend Scott Hanes and his girlfriend are my crew, along with Dannen. Once again, it is a small crew which always makes the shows much harder to manage.

The next night. The city is almost unrecognizable viewed through the eyes of someone who was there in 1996. It's grown like a weed, like Las Vegas and Reno,

Austin Richards performing at Burning Man, 2010
Photo: Johan Wingborg

massively popular now. There is never really any darkness now—the light pollution is everywhere and lasts all night every night. The sounds and music is all-chaotic and never stops. Scott, my main crewmember and Tesla Coil operator, starts the motor on the coil's spark gap. I stand next to him in my Megavolt suit, waiting to see if the coil works properly. If it doesn't, I may have to get out of the suit and go find my tools. But it works perfectly. Years of shows have taught me many lessons about how to make this machine "walk and talk." I mount the small stage and start the show. A crowd of maybe 100 people gather, but a lot of folks just walk or ride their bikes right on by. I gamely go on with the show, but inside I am grieving. Ten years ago, the coil was set up in much the same location and the crowds were 5–6 times bigger. Now I am competing with a homespun version of the Las Vegas Strip. The kids out here are ten years younger now, and they have web-surfing attention spans, or at least that is what I say to myself. The truth is that my coil is a little blip of sound and light in a vast ocean, and Megavolt seems to have left the building.

Will Megavolt ever go back to Burning Man? I don't want to say never, but it seems unlikely. At this point, I am waiting for a new festival to emerge, a festival with 10,000 people or so, in a location without endless dust. I'll take Megavolt there and "reboot" its festival incarnation. Money no object, I will create Dr. Megavolt's Laboratory, a fun house of high voltage devices and tricks. My sons were born in February of 2013. They will inherit Dr. Megavolt, if they want it, and we will go to this future festival when they are old enough.

NOTES

1. As far as I know, no one has ever produced documentation of a performance like this with a Tesla Coil prior to my attempting it. Men in metal suits clean extra high voltage power lines that are electrified, getting lowered onto them via helicopter. They experience something similar to Dr. MegaVolt when they are charging the helicopter through a metal rod they hold out to the line. I did not invent the metal suit that protects one from high voltage discharges or electric fields—that idea has been around since the 1950s.

DR. AUSTIN RICHARDS (AKA DR. MEGAVOLT)

Austin Richards performing at Burning Man, 2011
Photo: Eli Reiman

EVERYONE GO PISS ON THE GROUND STAKE—THE STORY OF DR. MEGAVOLT AT BURNING MAN

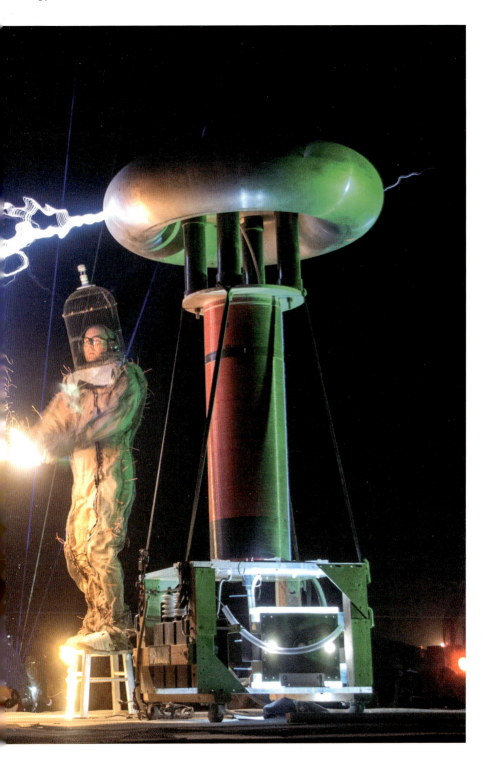

DR. AUSTIN RICHARDS (AKA DR. MEGAVOLT)

WITHIN YOU AND WITHOUT YOU
BRYAN TEDRICK

My father had a close friend when I was growing up. In the book *Pihkal* by Alexander and Ann Shulgrin he is referred to as "Adam." He was a pioneering therapist experimenting with the use of psychedelics and my father and stepmother were in one of his "families." A cast of curious characters involved in the human potential movement came through their home on the San Francisco Bay and as a teenager I was introduced to their magic. All of this was engaged responsibly, not recreationally, with an eye on self-discovery and experiencing the sacred.

One particular trip opened my mind to the beauty and divine engineering in all things natural. The graceful structure of a feather, the perfect geometry of a shell and the mesmerizing luminosity of a cat's eye lead me to understand that there is a divine intelligence behind all natural things. At the time, I could only describe this order as the presence of a "Divine Architect." Later, I found books describing the "Golden Mean" and the mathematics inherent in life. This world is not "by chance," and my faith in divine order has never wavered. I remember being shown some man-made items on that trip too, and laughed out loud at man's clumsy attempt to create. I felt as if I had been introduced to the profound secrets of beauty but also was humbled by my inability to ever create objects as perfect as those of divine origin.

When the trip ended, my stepmother gave me a gift, something she had bought previously, a silver scarab necklace. I had no idea at the time that the ancient Egyptians considered the dung beetle sacred because it took mere dung and rolled it into perfect spheres: a metaphor for God creating the Heavens. I felt she had unwittingly initiated me into an order of builders. That is what I now consider myself, a builder.

Sculpture is perhaps the highest expression allowed a builder since it is not required to function. I highly value architecture and the making of utilitarian items, as they carry pragmatic beauty and are part of our tactile, daily existence. For me, in terms of process, making sculpture is more exciting because it's never clear what's going to happen—the outcome is unknown. There is a fluid process of in-the-moment decisions that trumps the predictable execution of a planned design. When sculpting, if a better idea surfaces, it is possible, and liberating, to follow that idea.

I got depressed after that trip, though. I wished I could spin my shell as perfectly as the nautilus, or bloom as beautifully as the iris. There I was, a tiny, clumsy human in a universe as vast as it was unfathomable. I manifested nothing particularly worthy. I was dust in the wind. There came a moment when I gave a drawing to someone who had given me a ride hitchhiking and I remember feeling unusually good about it. That was the beginning of my rebound, and whenever I encounter bouts of depression I remember to engage the act of giving to escape.

As an older person, I now see that skills take time to develop and that the great struggle of the artist is not so much imagining something to make but having the means to manifest the idea. I "see" many beautiful things in my mind but my hands lack the dexterity and materials the necessary plasticity to make these visions live in three dimensions. In my 50s, I am finally at a place where the studio is staged, my craftsmanship has improved, and I've developed more patience and can do mature work. Nature is still unsurpassable. But now, I do the work and wonder how close I can get.

Adam's adopted son and his girlfriend were allowed to build and live in a cabin on some property my father owned on the Mattole River in Humboldt County. I remember spending the summer there near them, between my junior and senior years of high school. Sleeping under the stars, bathing in the river, cooking over a

fire and drinking fresh water from a spring helped me realize that the essentials of life were really very simple, pleasurable and beautiful. I set my course to buy my own country property and learn how to build a home. After escaping the confines of high school I went to work at a shipyard as a rigger and saved every penny I could until I had enough to make a down payment on unimproved land on the South Fork of the Gualala River in Sonoma County. Miles from anyone, I built a quirky cabin with used lumber and hand split redwood shakes. Living a life unfettered by urban concerns and immersed in nature's beauty, I remember joyfully dancing a jig on a fallen log smiling at my good fortune. I was 21 years old.

Adam had given me his copy of the *Tao Te Ching*. I imagined myself a young Taoist, wandering through the forest and streams, meditating in the beauty surrounding me. I felt wise to place myself there. To this day, retreats to my cabin are calming and full of peace. It is a place that remains constant, a nucleus in a storm. There is little to foul the perfection beyond my own mind.

One experience with mushrooms cleansed my perception when the internal struggles were deep. Focusing on my breath, I slowly vibrated my breathing into deep, chest centered chanting, which (with eyes closed) opened ever so slowly a heart-centered flower. At full bloom, this flower poured forth warm, lava like fluid, enveloping me. My realization was that at the core of Life is an inextinguishable fount of creativity, an inexhaustible desire to be. By relaxing the active mind, and becoming a perfect witness, we can find benevolent energy lying beneath everything. Adages such as "do nothing and everything is done" and "the further one travels the less one knows" made sense. "Love is at the center" became my mantra. The great cosmic joke was that we think we need to strive for enlightenment when in reality we are already there. The searching is actually the obstacle. Perfect awareness is your birthright; the trick is recognizing it. The truth is we are all manifestations of the great source and cannot be otherwise. Life is an ever-flowing river of creative juice and I was tapped in!

I studied sculpture at the San Francisco Art Institute. My stepmother studied painting at UC Berkeley with Hans Hoffman, and she recommended it as the best school for art. I learned to weld there, and after graduation started a small business combining my wood-working and metal skills. I made custom gates, among other things, and landed my first public art commission in 1995 when I was asked to design and build the Sacramento Convention Center gates. By the time I ventured to Burning Man in 2005, I had several other public art commissions under my belt and was making large work with steel and simple kinetic movement. I paid cash for a ticket that year and went alone on a scouting mission. I lasted only three days before returning home, as I was unprepared to camp in that extreme environment. I was surprised at how loose the scene was: parasoled ladies in pink panties peddling about as I stood in my blue jeans, cotton shirt and sun hat. Many people gave me dirty looks assuming I was just another middle-aged male voyeur. Fortunately, I had brought my art portfolio along and when I shared it some people who had been rude to me prior apologized.

There are lots of limitations when it comes to making public art—codes and public safety issues typically restrict kinetic sculpture, and concern for positive public opinion can diminish any edginess in content. There are not many clients or galleries interested in, or able to show, monumental sculpture. Trying to continue to work bigger, get my work seen, and make whatever the hell I wanted to, I headed to the playa. Many people over the years had encouraged me to go but the responsibilities of home and family made it difficult. Frustrated with the gallery circuit, I needed an outlet to do what I imagined, not what would fit through a doorway and appeal to the general public. Tales of mad playa creativity hooked my curiosity and I didn't want to miss out on something really important, but I

BRYAN TEDRICK

was also very skeptical. To my surprise, I found kindred souls there who seemed to be working on a parallel path. The general consciousness of Black Rock citizens was a definite step up from normal. I felt I indeed had "come home" and almost couldn't believe the perfect fit Black Rock City was for a sculptor inspired by nature and making large work in steel Scale and content were unlimited and uncensored. What an appreciative audience! After my first trip to the desert, I made plans to return with sculpture, the best gift I could offer that inspired community.

In 2007 I was wading through Gualala river water on a hot summer day. I was not sure about returning to Black Rock City after having taken my first sculpture, *Sirbent*, out the year before. It was a fishlike creature with the head of a snake that balanced on a spike and turned when pushed—it was also the largest object I could haul on my single axle trailer. After it was installed people immediately jumped on top to ride it. I'd never thought of doing that, and I couldn't believe anyone was bold enough to risk injury climbing that spiky, wobbling mass of wood and steel. One indelible image remains of a bald, nude man atop *Sirbent* wearing only a blue scarf pretending to surf the air. Miraculously, *Sirbent* survived the week and no major injuries occurred.

Feet in the water, I knew I had missed the deadline for grant applications—Lady Bee, Burning Man's chief curator had encouraged me to apply after seeing *Sirbent*— and there were only a couple of months left to make something. I was trying to figure out why I would want to leave my beautiful river landscape for camping in the dust and heat? I wasn't going to get paid, so all expenses would have to come out of my pocket. I was weighing up staying or going when I noticed the play of electric blue damselflies and chuckled to myself as I imagined how cool it would be to be able to ride one. Before long, I was making a 30-foot kinetic damselfly for people to ride.

I stole a bentwood chair from my mother that I was supposed to repair and bolted it between the eyes to be a seat for a single rider—their weight counterbalanced a heavy, long tail and allowed the sculpture to swing easily. The entire structure rested on a vertical steel post and rotated 360 degrees. I bought 12-inch diameter glass globes with LED lights for the eyes, and smeared a thick layer of silicone on them to keep them from breaking. Battery powered LED lights also lit the tail, so between the eyes and tail you could see *Damselfly* at night. Somehow, I managed to pack it all on a trailer and drove to the desert to set it up the weekend before the gates opened. I used hydraulic jacks and manpower—I had not yet connected with other artists or the Burning Man staff to manage the use of a forklift. I was on my own with limited resources. As the dust cleared and the week began it became apparent that my sculpture was a hit. My campmates would hang out at the piece in order to meet girls. We nicknamed the piece "damsel catcher." All we had to do was mention our affiliation with it and we were in. Going to the BRC post office to mail a letter I got the usual run around and no help until I mentioned *Damselfly*. I was immediately brought behind the scenes, introduced to insiders, my stamp was taken care of. Artists were exalted at BRC, and that was a new phenomenon for me.

Not everyone respected the sculpture, though. I heard that someone ran a radio-controlled machine directly into it at full speed (30 miles per hour?) and bent the legs. By Friday, several people had climbed aboard at once and at some point someone jerked the tail up and down (not round and round as designed) and it buckled. I knew this was a potential weak spot in the sculpture but thought it would survive a week at least. I was wrong. In my rush to complete the piece on time I neglected to add diagonal bracing. I actually packed up and went home, feeling defeated, and wondered if I would ever return. I checked my messages on the way home and discovered my sister had called to tell me the San Francisco Chronicle had printed a big photograph of *Damselfly*. The article and the published image

TOP
Spread Eagle, 2008
Photo: AJPN Anthony Peterson

BOTTOM
Portal of Evolution, 2009
Photo: Rob Boal

BRYAN TEDRICK

Coyote, 2013
Photo: Duncan Rawlinson

WITHIN YOU AND WITHOUT YOU

lifted my spirits and reinvigorated my interest in making more work for the desert. I decided not to miss the deadline for grants again. Burning Man was offering me the chance to realize my artistic promise.

2008. The theme was American Dream. I was into making animals and decided to make an eagle. Not an American Eagle so much as a divine eagle that symbolized a connection to the source of all life. An older American Indian friend of mine told me the eagle was the most direct way to send prayers to the Great Spirit. The design of *Spread Eagle* was simple enough. I wanted to make it interactive and build it at human scale. At galleries and museums the "no touching" rule always drove me crazy. Sculpture is a tactile art after all. I created a 6-foot circle at the center of the piece that neatly framed the human body. I had a playful bed in which to engage spontaneous abstraction. I wanted to make a strong visual interplay of light, shadow, line and texture—these are as vital as concept in good sculpture. I used materials lying around the studio as well as newly purchased stainless steel and steel. Suspending the circle from above, I began attaching the wing parts, going back and forth from one side to the other to keep the work balanced. When I cut something, I cut two and threw one piece into a pile destined for the other side. I achieved the curvature of the wing form spontaneously, measuring by eye, and then I would plot points and duplicate the form on the opposite side. Abstract passages were also created spontaneously, but I was careful to roughly match both sides visually and weight-wise. Slight variations between the two sides improved the natural look, added visual unpredictability, and kept the piece from looking like a stiff, machine-made, perfectly symmetrical object. When it was done it was perfectly balanced, and the 38-foot wide wings were placed on a bearing which allowed them to rotate in the wind. *Spread Eagle* was a crowd favorite that year, too.

2010. The theme was Metropolis. I like the challenge of relating my sculpture to the annual theme of Burning Man. It gives me some parameters, a framework. That year I received a grant and decided to make something architectural. In the vast horizontal expanse of the playa small sculptures are visually lost, but vertical shapes serve to contrast that horizontality and act as excellent vantage points. Minarets are desert lighthouses, beacons that guide and protect. They are performance platforms, places where song can project. Phallic in their verticality, they were the perfect inspiration.

Minaret ended up being 48 feet tall and weighed about ten tons. It was the largest sculpture I had made. I needed a trucking service to get it out to Burning Man. In the building process I had to design with assembly in mind and create reasonable shipping shapes. The 40-foot long pipe that formed the core of *Minaret* was far too big to ship to my studio in one piece so I collaborated with a metal fabrication company in Stockton that cut it into seven equal sections that could be sent. I was able to lift them with a chainfall on a trolley and roll them around by hand, working on them individually as needed. I also collaborated with Sudhu Tewari, who designed a sound and lighting system. Red, green and blue LED lights were placed at each flange and the interior became an echo chamber for magical sounds. Jesse Hillyer helped that year—he painted snake-like scales on the upper sections. His elaborate stencils were a lesson in patience and fine detail. I did the welding alone, for several months. There was a lot of crawling inside tubes in awkward positions, and long days of doing nothing but laying down welds to a beefy foundation. There were moments of spontaneity during the welding of the stainless steel dome but the project was mostly about the challenges of fabrication—unavoidable at that scale. My nephew Daniel brought friends with chainsaws from Big Sur to shape the redwood that would bolt onto the steel plates that sprung from the pipe trunk. In full collaborative mode, we made a late decision to add an arm 20 feet or so above ground level for aerial artists.

BRYAN TEDRICK

I'm typically a reclusive artist who likes to have my own way, but *Minaret* required a multi-disciplinary crew that helped to create not just a sculpture, but an interactive performance stage. This is a goal at Burning Man, to expand networks and become a greater community; to make art that involves many people sharing their efforts and skills. I love working alone in the peaceful solitude of my studio but there are greater things achievable when artists join forces, and with large-scale art it's beyond my limits to do everything myself. Typical of most art projects playa bound we finished *Minaret* at the last moment. With the help of Burning Man's heavy equipment and all the planning and effort, we efficiently erected the sculpture at Keyhole (Esplanade and 6 o'clock) in only five hours and it stood proud and impervious throughout the event. Participants clung and crawled their way up the stalk evoking a bizarre Hieronymus Bosch-like world. Spontaneous aerial shows and musical performances took place. Heartfelt ink messages left in the dome proved Minaret had also served as a sanctuary and place of reflection.

In moments when I have spare time at the studio, I weld scrap steel together in a mindless fashion focusing on the harmony of the two pieces being joined rather than the final outcome. This process is sensory rather than analytical. I enjoy the open-ended evolution and delight in surprise changes to the work. Chance plays a major key in the orchestration of combining harmonious parts as I use what is at hand and do the best I can. I am often pushed into fresh visual territory. Sometimes I struggle to finish a piece; sometimes I nail it straight away. I get a tightening feeling in my solar plexus region when it's not quite right, and a release when it is. Now that I have built sculptures for 30 years I pay less attention to the worry, reminding myself I have a track record of good work and proof that I almost always work my way through difficulties by not giving up.

There are things that are fine, and things that are coarse. At Burning Man I shy away from Whiskey and Whores, and prefer the subtle peace of the teahouse. A purple furred Cadillac blaring electronic "music" interferes with reading Rumi. I often find myself walking away from Black Rock City's stimulating flash and thump in order to breathe in the splendor of a star filled desert night. I understand all things have their place; in this dualistic reality opposites define each other. While each person has a different need for and response to stimuli, I tend to prefer the simplicity of peace and quiet. My sculptural work reflects these moods and personality. I want to help make the world a finer place and if my work can inspire I am gratified. Some have said, "You need to put fire into your pieces" while others have said, "rise above it all" and "stick with the beauty Bryan." I can't please everyone, but I can be true to myself.

My vision of the first Burning Man was a gathering of people who came together on a cold night with individual armloads of firewood, realizing they could make more heat if they collectively built a fire. Story telling, dance and song, and community in general evolved as people gathered together for a common good. Fire is a metaphor for spirit, the energy that animates all matter. I imagine we will all someday realize that we are spirit when we shed this temporary shell. The burning of the "Man" is a grand reenactment of this truth. Regular grants from Burning Man have enabled my sculptural work to reach the scale and content I have dreamed about. The major decisions in life: career, marriage and home have long been set and I feel I need only stay healthy and play my role out.

Minaret at Night, 2010
Photo: Delano@Explorerphoto.com

UNDER THE BIG TOP
AT AMERICAN STEEL STUDIOS:
AN INTERVIEW WITH KAREN CUSOLITO
SAMANTHA KRUKOWSKI

Karen Cusolito and I were scheduled to meet at American Steel Studios on a grey day in the Fall of 2013. I arrived before she did, and so walked the surrounding landscape. It's a rough industrial neighborhood, with broken fences, untended sidewalks and trash thrown unceremoniously into the streets.

Around American Steel Studios
Photo: Samantha Krukowski

Towards the back, in a large yard behind the building, some of the sculptures Karen has built for Burning Man stand as beacons, indicators of the very different world inside.

Karen pulls up just as I've navigated the building site. "Come on, this way," she says, opening a massive 35-foot wide rolling door.

(In a trailer inside the warehouse Karen makes an egg salad sandwich with eggs laid by her chickens. Metal clanks and bangs in the background, there are sounds of welders and hammering. Industrial cranes move across steel trusses. There are four lemons (from Karen's lemon tree) on the counter, which she moves around intermittently. Her phone pings at least once every five minutes. She moves in and out of talking about herself in the third person.)

Samantha Krukowski (SK): So I drove across the new Bay Bridge on my way here, and you told me I should look carefully at the old one as I went. I did—it's a strange ruin.

Karen Cusolito (KC): There are plans to scrap it. It's a travesty because I build things from old things. There is a lot of history encapsulated in that bridge, it's been part of our skyline for generations, and it has connected all of the Bay Area communities for a long time. It should stay here.

 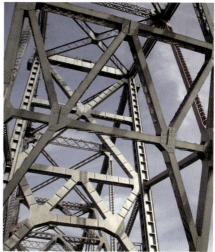

The old Bay Bridge
Photos: Karen Cusolito

SK: You have plans for it?

KC: Nine public agencies own 200 acres where the bridge touches down on the East Bay side. They made a joint public presentation of concepts for the development of that land and they were mortifying—a shopping mall or a dog park next to 15 lanes of moving traffic, on a windy and inhospitable spit of land. After that presentation I poked a few people and told them we needed to inspire an alternative vision.

SK: Who is involved?

KC: One of the key people is Leslie Pritchett. She has contributed hugely to community outreach efforts while simultaneously reframing the public's concept of art. Another is Mark Sinclair. He's an engineer who has guided the execution of many public art and Burning Man installations. When he considered the creative re-use of the old Bay Bridge, he mocked up a series of installations; it was like watching a child playing with the world's largest erector set. The concept of re-using the steel from the old Bay Bridge for creative projects inspired many people to envision endless uses for the steel. Eugene "Jeep" Phillips built a model of a section of the bridge that would function as an interactive museum. Leslie created a non-profit, Friends of the Gateway. Ben Davis designed an exquisite logo and we dug in for more than a year of research, brainstorming, and community building. We looked at projects that were installed around the country and around the world to study their economic impact. The Highline, in New York City, is expected to generate $4 billion in private investment and $900 million in new city revenues over the next 30 years. Christo's The Gates brought in over four million visitors and generated some $254 million in new city revenue. How could Oakland not be interested in a park that has this level of cultural and economical impact on the city? We made a presentation to the agencies, and I was looking around the room and seeing a lot of blank faces. I feared they were not getting it but as we finished, there was applause and commentary that we were the champions they needed inspire the development process. So we have been engaged with them for about four years now. A couple of months ago I was invited to scramble along the top of it to identify sections that could be used in other ways.

SK: What was the plan for the bridge before you climbed it and gave this presentation?

AN INTERVIEW WITH KAREN CUSOLITO BY SAMANTHA KRUKOWSKI

KC: The plan was to cut it into pieces and send them to China. Our vision was creative re-use of the bridge. I would love to disperse the steel throughout the Bay Area, so each community and neighborhood could create its own public art installation with vintage steel. It could be used for the creation of bus shelters and park benches, elegantly and metaphorically creating a connective thread throughout the region with the very same structure that geographically connected us.

SK: Have you been able to talk about this publicly, to promote the project?

KC: Yes, I was finally given the green light to do that. Steven Young set up a Change.org campaign to gather signatures of artists who endorsed preserving this steel, and I created the BayBridgeSteel.org website to capture endorsements from broader demographics; art commissioners from various cities, historians, faculty from the UC Berkeley Landscape Architecture department, long-time residents, and people from a wide array of backgrounds who for their own reasons feel the history of this bridge ought to be celebrated rather than scrapped. The East Bay Express, a local newspaper, got wind of what was up and donated a full-page ad to our campaign.

(Loud grinding, clanging. It's impossible to talk for a few minutes. Karen moves the lemons around, realizes she hasn't begun to eat her sandwich.)

SK: What would be the cost to demolish the old bridge? I heard something like $350 million. Reuse would save the city a lot of money, wouldn't it?

KC: The numbers are extremely high for disassembling it safely, getting it onto barges, and either sending it over to China as scrap or setting it on the ground here for the region to build with. But if it is not sold as scrap there is no revenue to cover costs associated with our proposals—to cover management of the program, store the steel and remove or encapsulate the lead paint.

(She cuts her sandwich and finally takes her first bite.)

SK: You wear a lot of hats. What are the different spaces you negotiate?

KC: I feel like I'm in this really odd space of being an arts advocate with local government, consultant to other arts groups trying to create functioning art spaces, a property manager and an artist. Sometimes I feel schizophrenic, especially when I go through four or more costume changes in a day. I never imagined myself doing what I'm doing right now, but it makes me think that anything is possible. I would guess that about one third of my time each week is spent doing consulting work. I want to do it all, and all of it is really important to me and all of these activities support each other. I end each week equally exhausted and exhilarated.

SK: How clear is it to other people, other communities, that you are combining all of these roles?

KC: Well, for one example, in the spring of 2012, or 2013, I can't recall, I was trailed for two weeks by a Japanese TV crew who thought they were going to come visit me at American Steel Studios to shoot "a day in the life of an artist." The director, Hideharu Watanabe, become aware of me through a piece he'd done on Burning Man the previous year. We met in my office and I started talking about the concept of art, public art, and the various agencies needed to make that happen. I brought up the economy of being an artist. Hideharu shook his head and said, "No, I don't want to hear about politics and economy. Let's just talk about art." I took them on a tour of the American Steel Studios warehouse, introduced them to various tenants, let them see the scale and scope of what people are doing here. I directed them to other West Oakland art spaces. I took them up to the Bay Bridge and explained what was happening with the park and the vision for the

old Bridge steel. Very quickly, Hideharu started seeing how all of these things fit together, how the seemingly small independent or large collective efforts of artists could impact large-scale civic projects, inspire the preservation of history and the celebration of community.

SK: American Steel Studios is an extensive space for the production of all kinds of work, including that of artists who make large projects for Burning Man. You got the building in 2005, right?

KC: Yes, and at that time you could see from this exterior to the other exterior wall—two city blocks away—unimpeded. It was nearly empty. There was just one tenant in the building when my partner and I arrived. We moved in for only eight weeks to build *Passage*, a sculpture of a mother and child that stood 30 and 20 feet respectively. It engaged nearly 100 collaborators in its various construction needs: fabrication, concrete footprint mold-making, methanol flame effects, logistics, production, installation and first aid. Skill sets were enhanced, relationships born, inspiration extended. After we finished the piece we packed up and left. We came back in 2006 to build *Leaping Giants* and moved out after 12 weeks. Then in 2007, we rented an entire bay for the production of *Crude Awakening*, and leased more space to sublet to other artists. The infrastructure here is perfect for large-scale fabricators; drive through truck access, bridge cranes, three-phase power, 22 feet of clearance to the bottom of the bridge crane, 46 feet to the peak of the building. You can do a lot with that!

SK: Tell me about *Crude Awakening*.

KC: I had hoped it was the biggest art project of my life. It engaged a crew of nearly 300 people. The physical and emotional challenges were extraordinary, the schedule was crushing, the logistics of shipping 13 tractor truckloads of art and materials to Black Rock City made many heads spin. We enjoyed the usual welding burns, sleep deprivation and strains on personal relationships. We racked up tens of thousands of people hours, built hundreds of tons of art, drank hundreds of gallons of coffee, met deadlines, puzzled through elaborate logistics, and quietly shouldered the additional stress of 'the unknown,' as we'd have no way to do a dress rehearsal of the oil derrick's consumption by fire. Some were complimentary of the monumental work and performance that showcased our greed for oil, others irate that we'd consumed so many resources in the production of the piece. They did not understand that the materials we used had been very thoughtfully sourced. For example, the fuel used in the Bly cannons that ignited the oil derrick was retired jet fuel.

SK: How many people are working here now?

KC: About 170.

SK: And you have another building, too?

KC: The adjacent building is called the Poplar Warehouse. It one of the most beautiful warehouses I've ever seen, it has a flood of natural light. The space houses artists including painters, photographers, screen printers, costumers and jewelry makers. There is a 6,000 square foot white wall gallery space in which we've had everything from art exhibits and community meetings to parties and weddings. It's a tremendous community asset.

SK: Do you see things changing in this area as a result of American Steel Studios being here?

KC: There is definitely a higher concentration of artists in the area, likely at least in part due to American Steel Studios. However things are changing regardless.

SK: What do you mean by "regardless"?

KC: Well, in October 2010 I accidentally happened upon a West Oakland Specific Plan meeting. A Specific Plan is a federally funded research project to help a city overhaul their marketing, envision what they want their city to become, how they

can maximize what they have and bring in more of what they need. So I went to this meeting, not really sure who the players were or what the program was. The team of consultants was comprised of architects, economists and some city staff. They had proposed that any space in West Oakland that was, by their definition, under-utilized, blighted, vacant or abandoned, be converted into two-story office buildings with rooftop parking. Their proposal had all the charm of a suburban corporate office park. During the breakout session I introduced myself to the economist who was representing the kinds of values inherent in American Steel Studios, and asked, "Who on your committee is charged with the mission of community, art and culture?" She thought for a second and replied, "Actually, no one." I pointed out that their plan was devoid of any community components. I then told her that I run American Steel Studios and she said, verbatim, "Oh yeah, I drove by there once a couple of years ago."

SK: Basically, she knew nothing about it then. Did she even acknowledge what you said?

KC: No way. Here was a consultant who was being handsomely paid to do research to identify the best possible plan for a neighborhood she had only visited once "a couple of years ago."

SK: So what did you do in response?

KC: I texted people furiously during the presentation and I got as many people as I could to show up at subsequent meetings and ask really hard questions, let the consultants know who we are and what we do. At the last public meeting in November 2012, one of the consultants said that Oakland suffers horribly from retail leakage. I stood up and asked, "What do we have here in West Oakland that is unique and different enough to bring people to us? It's not another shopping mall, it's not another suburban office park." I realized quickly I was talking to the wrong person, so I spun around to the audience—my neighbors—and asked, "Who are you people? What do you build, what do you bake, what do you sell? Are you students, nurses, families that live here? Do you rent, do you live and work in West Oakland?"

SK: Were you able to gather these people, these voices, together?

KC: I got a small sample of people together who were equally perplexed and feeling unconsidered. We started a campaign to reach out and get a survey or a census of who our neighbors were. We made a lot of connections we wouldn't have otherwise. Strangely, the meetings for the Specific Plan offered a forum for networking. We collectively inspired the vision for West Oakland, and the good news is we actually got the consultants to write a new chapter dedicated specifically to the arts. Soon after I attended the first meeting, one of my tenants told me they had a meeting with Jeff Chew, of Oakland's Redevelopment Agency, and he asked me to come along. I introduced myself as the Founder of American Steel Studios, and shared my thoughts about the Specific Plan and how it was missing a great number of opportunities to allow Oakland to thrive and that there was a lot of talent and passion among the residents who would love to see that happen. I gave him the example of repurposing the old Bay Bridge. "What if we take part of the Bay Bridge to create a pedestrian walkway over West Grand for the dog walkers, joggers, pedestrians cyclists? It would make a beautiful gateway entrance into West Oakland." He replied, "My God, that's brilliant! You need to come to more of our meetings."

SK: What happened then?

KC: Jeff and a group of city staff took a tour of American Steel Studios. I suspect he was expecting to walk in and find a bunch of pot-smoking hippies doing macramé, but when they arrived the bridge crane was in motion moving tons of steel into a workspace, sparks were flying, work of all kinds was happening all over the place. I

think Jeff left feeling reluctantly impressed. He may in fact have been disappointed to learn that he suddenly had to make room for the arts in the Specific Plan. I was amused when I noticed that in the next few presentations they made they had incorporated my giant sculptures into a sculpture park in front of a corporate office building.

SK: Are there neighborhood initiatives, programs for the community, being offered by American Steel Studios?

KC: We are developing programming that attracts and engages the youth in our neighborhood—programs that will teach skills and build confidence and pride. We have internships where students can choose to work with one of our tenants on a project, or on a project with American Steel Studios, where they learn welding and metalworking. Last summer, we offered our first workshop teaching kids performing theater and circus arts.

SK: You engaged an intersection of art and community early on at Burning Man. All of this community-oriented work clearly relates to how you understood the value systems that support the event.

KC: Yes, I think that what we are able to achieve at Burning Man—expressing our values, creating our own community, building our own city and the infrastructure that best supports us—translates easily to the needs of the so-called "default" civic landscape. When one knows a single sculpture can move an audience of 60,000-plus, how can one not imagine that magic happening at home? My learning curve has been insane. We are very fortunate that organizations such as the Black Rock Arts Foundation [BRAF] were born out of Burning Man. BRAF is the perfect liaison between artists and civic agencies to support public art installations. Installing the kind of work we build into city landscapes is still rather new, both for the city agencies and for the artists. BRAF expertly navigates this process, from the initial concept and RFP to the paperwork, insurance and installation. BRAF's support has been invaluable to a great number of artists, myself included.

SK: Can you talk a bit about your background: where you come from, how you got into art, your experiences as a maker?

KC: My first art studio was in the back of the family station wagon. Armed with safety scissors, colored paper, and crayons, my younger sister and I would pass the time on family road trips making art. Later, at Rhode Island School of Design, I was encouraged to really push my creative horizons, and at Massachusetts College of Art I had a more sobering and realistic exposure to what it meant to actually survive as an artist. When I left the utopia of art school my disappointment was deep.

SK: You moved west at that time?

KC: Yes. The northeast made me feel constricted, like I was wearing a sweater that was too tight. When I moved to San Francisco, I traded that formal sweater for a welding jacket and worked in tiny studio spaces, whatever I could afford. One time my studio was a shipping container in Hunters Point, another time it was an abandoned cottage behind a friend's house in the Excelsior District. I think throughout my life there's been this part of me that has needed to be taken seriously. I'd never be the office girl in the mini skirt, and I think my favorite outfit in school consisted of my white wrestling boots, thermal pants and an old work shirt of my Dad's. I was covered in paint all the time. I always got a seat on the bus. I remember one time I was coming home for Thanksgiving and I had all of my drawing and painting supplies in a wooden wine box with a rope handle, and a big duffel bag full of laundry, and when I got to South Station in Boston, I was schlepping all of this stuff, and this guy walked up to me and said "You are the most beautiful bag lady I've ever seen in my life." I cried.

SK: What was your work like before Burning Man?

KC: I destroyed whatever I made as soon as it was finished. Drawings became drop cloths for murals. Sculptures were taken apart and repurposed, or smashed

Karen on George, from Crude Awakening
Photo: Roger Minkow M.D.

to bits to see what their new disposition might be. For me, the creative process was in the making; the end result was simply a by-product.

SK: You went to Burning Man in 1997 for the first time, and your first project was in 2004?

KC: I actually made some smaller works the first few years I went. I built "personal size" pieces, little sculptures that could fit in my car, most had kinetic solar powered components and they never worked.

SK: What was your first time like on the playa?

KC: The first time I went to Burning Man I went for just one night. I know better now. I was so amazed at what I saw; I was just giddy with joy. I remember just going out and laying naked right on cracked surface of the earth out in deep playa and letting the sun kiss my whole body. It was still, quiet, windless, serene. It was such an amazing sense of freedom, a peacefulness I hadn't experienced since I was a kid. That night I shot what I think is my favorite bit of video. The energy was starting to build because the Man was going to burn in a few hours, and while I didn't know what to expect I could feel the mood starting to change. I was just walking around with my big old school VHS camera and I happened upon a guy standing on top of his van, black leather vest over a shirtless torso, leather pants, emergency flashers flashing. He was up there playing an electric guitar, just wailing out his heart and soul. It sounded like whale calls echoing across a huge space, and I was just blown away at his spontaneous expression. I started filming him. It was so powerful I was so nearly moved to tears. Out of

the corner of my eye I could see the lights starting to come on around edge of the city. I started spinning slowly in a circle, capturing the horizon of Black Rock City that was dotted with lights of color that blurred as I moved, the irregular contours of the mountains behind it and the bright accent mark of the guitar player and his emergency flashers. I spun slowly at first, then faster and faster, the music fading in and out as I spun. It was quite spectacular.

SK: So after that, you had to keep going back?

KC: Actually no. After that first time out, I decided I never wanted to go back. I had a really dismal experience during exodus. I had camped on the perimeter road so, in theory, to leave the event I simply had to drive onto the road and head for the exit. The line was so long, for hours none of the vehicles moved even an inch. I just sat there with the nose of my car at the edge of the road. Hours later, when the cars finally started moving, I tried to pull onto the road and a woman walked up to me, and said, "If you don't turn your car around and go back to the end of the line, my two sons are going to come out here and beat the shit out of you!" Not only was this an abysmal example of child rearing, it stung all of the beauty out of my first visit to Burning Man.

SK: Once you hit the exodus line people can get really nasty. They aren't even out the gate when they start leaving the spirit of the Burn behind.

KC: Yes! People were so aggressive and angry at that point it left a bitter taste in my mouth and I didn't want anything more to do with Burning Man. Obviously, I did go back, and I've been every year since.

SK: I had a similar experience coming out, but it was in Gerlach. Without realizing it, I pulled into the gas station in front of another truck—he was coming in from the other side. The driver got out of his truck and started berating me, wouldn't stop yelling, even when I told him I'd move my car behind his. He called me a lot of names in rapid succession and said "Go ahead, bitch." I got in my car while the gas was flowing, and thought about how I could change the situation to reflect the spirit of the Burn. I told the attendant that I wanted to buy the guy's gas. Everything changed, he came over and just stood in front of me. Then he told me I didn't have to do that, I was an angel. He stood for another moment, lowered his oh-too-cool sunglasses and looked deep into my eyes. Bizarre. Anyway, how long were you out there this year?

KC: Two days. Friday night to Monday afternoon.

SK: Is it typical for you to only go for part of the week?

KC: I haven't been able to spend an entire week there for a while because my entire crew attends the event and leaving the massive ship called American Steel Studios without any crew is unthinkable.

SK: Do you have any favorite camps?

KC: Dismal Camp, for sure. They did an old western town with swinging doors and a wooden sidewalk and skeletal trees carved out of massive 500-ply cardboard. At the time, Walgreens—in its infinite wisdom—was marketing battery-operated parrots that squawked and flapped their wings. But what the Dismal kids had done was pluck out most of the feathers and paint the remainder black and let the batteries run low, so the chirpy squawk of the parrot was transformed into the chilling cry of a vulture. As I was standing at the fence, appreciating the simple, elegant and effective charm of the installation, and suddenly a remote-controlled tumbleweed came charging at me. Another camp I remember consisted of a structure set up next to a friend's campsite. I can't recall what it was supposed to have been, but each time I went to visit, her neighbor was re-erecting the structure because it kept falling down. Each time, I would go over to help. After a few days of this activity and idle chatter, I finally asked him, "What type of work do you do in the default world?" He replied, "I'm a building inspector." Oh, it was deliciously funny because it was true.

AN INTERVIEW WITH KAREN CUSOLITO BY SAMANTHA KRUKOWSKI

SK: Has anyone tried to replicate American Steel Studios, or asked you to help create some sort of franchise?

KC: Yes. I was asked to replicate American Steel Studios at two sites in Southern California and one in Japan. While I don't want to discourage anyone, I do let people know how difficult such an enterprise is. Someone asked if I would make an American Steel Studios in Southern California. They wanted to use a bunch of fruit-sorting barns. I said "Well where is it?" and they said, "Well, it's in this rural area, it's really beautiful, fields and all that" and I said "Well that's great, but where is the concentration of artists?" I told the guy it might not be the best thing for him to hang his hat on.

SK: Given that outside interest, it's really surprising that there isn't a greater understanding of the dynamic relationship between artists and cities here, an awareness and desire to capitalize on the fact that artists historically predate gentrification and are in fact precursors to increased revenue.

KC: It is shocking, in fact. I think the folks in the city are holding their breath waiting for us to leave, they just don't know what to do with us or understand what we can offer.

Maquettes for Achmed, Epiphany and Mumbatu
Photos: Samantha Krukowski

(Karen wants to work for a while. We leave the trailer we've been sitting in, and I follow Karen to a table where she shows me small models she has made for previous works [some wearing nametags] and for works in process. I head out to explore. She gets her apron and her bandana, which she ties it onto her head and pushes it back. Safety glasses come out next, a helmet waits nearby on a table. Before walking around American Steel Studios with my camera, I look back at Karen, intently applying a grinder to metal, sparks flying in a vertical spray. After a few hours have passed. we sit down outside the trailer at a table with scattered chairs.)

SK: This place is unbearably rich. Full of objects, materials, machines, ambition. The sounds in here are so constant, so inspiring, all this effort in a constantly shifting visual, spatial and sonic environment.... How can you ever bear to leave?

KC: You should be here during the build season before Burning Man. You can feel the energy building up, and it's something you take home with you. It keeps you here working until 04:00 in the morning without having any sense of what time it is.

SK: How many of your tenants are involved with Burning Man?

KC: Maybe about 30 per cent. Additional groups show up seasonally to get space for a specific project. In the first couple of years, there were tenants here who had never been to Burning Man, but when they observed what was happening and felt the energy and the crescendo, they decided they had to go see what could possibly make people work that hard without pay. It's powerful.... I mean, you came here to discuss Burning Man for your book, right? You're building a network, your experience has got to be amazing, I can only imagine what people have revealed to you or inspired you with....

SK: It's true, I've met some wonderful people, and many who have contributed to the book are inspired to continue writing, to publish. Some of the people writing for the book I've never met. I'd really like *Playa Dust* to be a generator for more creative output, more extension of Burning Man beyond the playa.

KC: There have been a lot of voices that have emerged from Burning Man, and a lot of creative enterprises and community groups. The Green Man theme in 2007 provided an extraordinary canvas for networking among environmentalists, engineers, builders, people doing R&D to bring more environmentally sound products to light.

SK: What were you doing in 2007?

KC: Well, I spent a few moments trying to convince Larry that it would be the year to build "Chia Man," the Burning Man figure covered in seed matter that sprouted during the week. He obviously didn't go for it.

SK: Tell me another story.

KC: One time, after doing a big project and being totally exhausted, a bunch of us all decided to go out to the hot springs. It took us forever to get there because our car broke down; we had to go off in satellite vehicles like rats running from a sinking ship. This is when I was working on *Passage*, with all of the burning footprints behind the mother and child. In order to keep the footprints flaming I had to constantly pour water into them to make the fuel float up to the top of the water. On the way to the hot springs I fell asleep and when I woke up, the guy next to me said "Hey, go put your feet in the water." What I heard was "Go put water in the feet" and I thought "I can't do that anymore, I'm so done with that." I looked out the window and there was a grassy hill and I thought "Wow, that is the coolest art car I've ever seen." I opened the door and jumped out and it was really dark. I was wearing a fake fur coat and really big boots and I took a few steps and I just started falling. I cartwheeled down and fell into the hot springs. It was warm so I wasn't jolted by cold water but it was disorienting. When I came up a friend went swimming by like a mermaid and sang out "Hello" and I thought where the hell am I? I was so not aware of my bearings but the little grassy hill I saw as the art car seemed like the cutest little thing. I think about the environmental objects that could move around out there, like maybe an iceberg... you could do the polar bear thing....

SK: You are installing a large group of sculptures in Brazil soon, right? You're moving the work you've made at Burning Man into other places. How did the Brazil project evolve?

Karen welding
Photos: Samantha Krukowski

AN INTERVIEW WITH KAREN CUSOLITO BY SAMANTHA KRUKOWSKI

Mumbatu on the Playa
Photo: AJPN Anthony Peterson

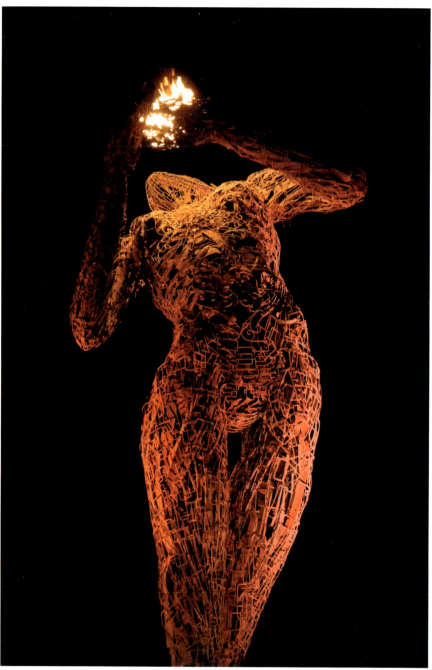

Ecstasy
Photo: Scott Hess

KC: In October of 2011, I got an email from a man in Brazil who had seen my work during a trip to the Bay Area. He expressed interest in buying many of the giant sculptures. He returned a few months later and we met at American Steel Studios. Renato's plan was to put the sculptures on a rainforest reserve he is developing in Brazil. This all sounded picture perfect, but I was skeptical. He understood and invited me to the reserve so I could understand the scope of his project. When I saw the program Renato is running, I was flabbergasted. He has amassed 8,500 hectares wrapped around a 1,000-hectare National Park. There is old growth forest on the property and they have been replanting for more than 30 years. He continues to acquire contiguous parcels as they become available, allowing the forest to continue to grow. He is also doing tremendous community outreach among the local towns and villages through supporting schools by bringing in more teachers and the creation of a considerable number of jobs. Given the strong environmental message of the sculptures, and the sterling commitment the reserve has for the Atlantic Rainforest, it seemed like a perfect match. In fact, I don't think I could have found a better home for them.

SK: So the environment is a really important component of the messages in your work.

KC: We are a species of consumers, and we have had a profound and devastating impact on our environment. We produce a lot of waste and strain many of our planet's delicately balanced systems. Working at American Steel Studios is a natural choice for me: we have taken an underutilized resource and created a new, mutually sustaining ecosystem. We support each other, and the adaptive reuse of a former industrial building also supports the larger city network, helping to regenerate Oakland—not by clearcutting and redeveloping, but naturally, more like a forest, where one tree quietly slips in and grows where another has died, recycling nutrients and strengthening the whole. American Steel, with its industrial infrastructure, also allows me to work with all manner of salvaged materials, minimizing my environmental footprint and allowing me to capture the history and spirit of the elements I incorporate into my work.

(I was Karen's houseguest, and after our conversations we went to her small house not far from American Steel. It stands alone, really, occupying a moment in a larger industrial landscape.)

A DAY IN THE LIFE OF MAKING STUFF
MICHAEL CHRISTIAN

When I was a snotty tot long before I learned about the many glorious high concepts of art, I drew on whatever I could find. It was just a need, it wasn't something I consciously chose to do, I was somehow compelled. I could get lost for hours inside the four corners of a piece of paper. As I got older the paper got bigger, as did my obsessions.

I'm sure there are plenty of ways I could have been analyzed and categorized or medicated for my intensities. Fortunately my parents didn't feel compelled to fix me or make me better. I drew obsessively, so what? Most people I know who have been successful in the arts seem to have felt an emotional switch flip at some point in their lives that deepened their obsessive behavior.

The other day someone told me I was "living the dream." I asked him what dream he meant exactly because working by myself at midnight on a Saturday night didn't feel like much of a dream I remembered having or wanting to have. I mean, I love what I do and don't really think about how much I'm working on a project or how much it overtakes my life or what I am missing at the time or that love that got away or how I have no spare time or.... Ok, maybe sometimes I think those things. But when you fall into what you truly love often nothing else matters. That's bliss. The whole idea of time slowing down, losing yourself—that's why making and building things makes me happy, and there will always be things to build even though, unfortunately, I will never get to finish building everything I want to make.

The reality of what that friend called my "dream" is that I spend many long and uneventful hours working incredibly hard, and sometimes there are waves of creative intoxication, when the juice comes from my pores. I'm almost unconscious, in the flow, just being. That place where self-confidence, practice and discipline become one, and I take off. I try to hold those moments so I can spread them out over time. But seriously its really fucking hard—it's unsustainable. That's why it's called a high. When I'm not feeling the flow, which is a lot of the time, I keep working on my 'practice' that just so happens to mean objects get created.

Conceiving and bringing ideas into material form is creative problem solving, and I love making new discoveries through necessity. I'm often building my way through a puzzle or a maze. It's like playing a video game—making choices and seeing how ideas and expectations affect how you navigate through situations that arise. I usually begin a project with a simple sketch or a doodle that inspires me. I take it and push it around, expanding and contracting it on paper as much as I can until I reach a place where I think it can become three-dimensional. I don't think about whether it will be large or small. I usually just have an image and then begin to scale it to a human body to see what the proportion might be. Scale can be volume as well, so I ask myself how loud a piece should be, or what its tone will be like. Ideally I end up with something harmonic.

But when you move from two to three dimensions, this is where things take a turn. The work starts floating weightless on paper or a computer screen. When physical materials come into play, they are heavy, bound by gravity. You get to grab onto something and move it around, and it becomes another kind of sensory experience. It's like the difference between recorded music and playing an instrument. The idea of sex, or sex itself.

The goals and intentions I have relative to my work are a puzzling territory. Once I achieve my goals then what? The further I push my capacity to accomplish more—bigger projects, longer projects, unexpected projects—the more difficult the recovery time. The high of completion is always met with an equal low of depletion.

For many years I believed that the most important thing was to achieve goals I set for myself, but doing that really feels like chasing a dragon. It borders on addiction. After a lot of chasing I've realized my best meditation lies in the process of building and not in the end moment. I really don't ever want to say I've mastered something.

I remember for a time period being drawn towards nihilism. What was the everything and nothing—what meaning did any of it hold? I was consumed with the concept of the void, that place where all questions would get lost and all meaning would disintegrate. I did touch that place and it was big and cold and dark and empty, and it exploded my skin, the container of my body, the wrapping of my mind. After that I decided to go along with the whole "my name is bla bla" and "this is called a what not" and "we live on a this here so I could have a tether." Tethers are important when you are in the business of building and destroying your reality with regularity. I accepted that I didn't know shit and would always need to learn more, even if what I did know was written in the most beautiful Sanskrit and aligned my chakras into cosmic antennae that gave me constant orgasms, I'd still not know and I'd be ok with that. Being in the service of the power of gravity is plenty empowering to my spirit connection with the universe. I remember wondering once what would happen if I ran out of ideas. Would that mean I had sold out? I figured if I was still unsure everything was probably ok. The upside of my profession is that I'll never figure any of it out so I have job security for life. Making art can be incredibly self-indulgent.

I moved to the Bay Area in the early 90s when the energy of the arts of San Francisco was ripe. There was a wide acceptance of and space for creative happenings and wonderfully expressive performances throughout the city. Much of the progressive spirit that permeated the city was in a large part due to the impact of the LGBT communities during the 70s and 80s, which challenged and changed the cultural landscape. Radical phaeries, punk rockers, an exploding rave and underground music scene, tech geeks birthing the dot com era, organizations like Survival Research Laboratories, Sisters of Perpetual Indulgence and The Cacophony Society had proliferated for years and cross-fertilized many things, including that event called Burning Man. During that time The Cacophony Society took Burning Man to the desert and created a temporary autonomous zone where many of these communities joined together. The free movement of beliefs and ideas was intoxicating to me. It all fell apart around 2000 with the dot com bust, when there was a mass exodus of artists and the city began to transform into more of the tourist destination it is today. Burning Man, to its credit or discredit depending on who you talk to, filled a vacuum and continues to wave its flag though the radicalism of the Bay Area had passed on.

When I got to California my intention was to move past the artist /object dialogue. I wanted to change the context of my work, how it was being experienced and get beyond the idea that there is an artist who creates art and an observer who appreciates/views it. I was fortunate to be in the Bay Area when there was a maker/ DIY movement—not a recognized movement just one that was the result of a lot of people with the same kinds of ideas at the same time in the same place. There was resonance for me, an emphasis on the doing not the done.

I was approached by Burning Man in 1996 to build something for the event, but I hesitated. I thought the whole thing was kind of lowbrow relative to creating art. I was from an institution/gallery art world so participating in a festival felt like I would be selling work at a street or craft fair in the form of home and yard décor. I was an 'artist' after all. I thought about it though, and decided I should do it. I was given the opportunity to make something for a giant blacktop and get paid to do it. I've always loved blacktops. I didn't think my artistic life would evolve in that path, but then, I wanted to be an accountant when I was young. I'm often off the mark when it comes to stuff like that.

MICHAEL CHRISTIAN

Bone Arch
Photo: Michael Christian

So I ended up loading some tools and scrap metal from the construction site where I was working and headed out with a new friend who needed a ride who wanted to help out. Someone said some bones had been collected for us but this was a gross exaggeration; there weren't many. My cohort was luckily quite resourceful when it came to the art of scavenging. In just a couple of days he managed to fill my pickup with several loads of bones because he had located animal graveyards that

were disclosed to him by the locals he had befriended on his daily adventures in the landscape. What amazed me most about the sculpture that emerged was how many volunteers were willing to contribute their energy towards making it come to life. My favorite gift was a 01:00 massage from a stranger. She showed up at the base of the sculpture with her table and insisted I come down from the scaffolding to take a break for a treatment. Within five days there was a 28-foot archway up dressed in bones.

I wanted to make work that was more immediately accessible for people than that which was exhibited with limited spatial and temporal access. And I wanted to show off what I could do. I succeeded at both, but I hadn't anticipated how the active participation of others in my creative process would so profoundly affect me.

Building on the playa was unique because I was in the middle of nowhere with few–to-no resources. I thrive in an environment of uncertainty where improvisation and adaptability have to be a part of your creative process. The playa was an excellent training ground for learning how to build in severe conditions, but even more important it provided a formidable education in learning how to let go.

I worked on another sculpture for Burning Man in 1999 called *Orbit* and built it mostly on site. We were working in front of Center Camp, in front of the keyhole. We wanted to build during the event so people could walk by everyday, see the progress and offer support. We finished on Wednesday, and enjoyed watching people interact with it. I was really breaking down barriers I was previously constrained by— I wasn't an artist in his studio making work for presentation, I was out in the desert making accessible work that offered a shared experience for me and for those who were around it.

I needed the help of an engineer friend of mine to get *Orbit* done. We developed an intricate design with three independent globes inside each other, spinning at different speeds. It worked similarly to a watch—with the second hand the central piece closest to the core. *Orbit* was complicated—the mechanisms were machined prior to the event and we left the assembly and final design of the globes for the desert. The night before we finished, a big windstorm rolled through and broke all the gear mechanisms. I was crushed. The whole design depended on those mechanisms and there was no way to repair them at that point. I remember looking at the piece and being so incredibly pissed off that it had failed after all the time we had spent on it that I couldn't imagine making it to the end of the week. My friend the engineer looked at me and said "I think it works better this way." "Fuck you!" was my response.

In the end I was able to fix the outer globe so it spun at a slow speed. I took solace in knowing that at least part of it would work. But literally five minutes after I fixed it, while I was still removing my gear from the site, a guy walked up and grabbed the globe and spun it. My efforts had been entirely futile—he busted the thing. All I could do is laugh the kind of laugh that is one step past crying.

Unwittingly, before the failure, I made some changes in the design of the piece that helped it towards an early demise. I was welding underneath the globe looking up into the shapes against the backdrop of the sky. I realized from that vantage point you could experience the piece in a completely different way because it revealed its density. Because of this discovery, I ended up lifting the piece up a foot higher so it was possible to lie underneath it. It was what people call a happy accident, but I prefer to say it was about listening and paying attention to what the piece was saying. Because of my discovery and design alteration, the guy who ended up breaking the motor was able to get under it. He spun the three globes in different directions and laughed at the circus of shapes flying around above him. It was perfect. In the end he had realized the full potential of the piece and without knowing had completed it for me.

He was one of many who have shown up and unknowingly provided remedies for difficult crossroads I have reached in my work. It seems there are people who regularly show up in my life when I need them or am ready for them to appear to

MICHAEL CHRISTIAN

give me guidance. I'm sure I don't always clearly recognize or appreciate this when it happens. But usually, I am able to get out of my own way so that things fall into place, the universe provides, shit gets done. I've always been a strong believer that people can manifest things into being. I do it for a living so I guess I would believe this by now. But I have to be present enough every day to know what I manifest through fear or chaos instead of just having to step over some shit in the road that's in my way. Sometimes it's nothing more than shit that gets in the way of progress. ten years later *Orbit* evolved into a piece called *Home*.

Home at night
Photo: Erich Remash

One of my favorite sculptures for the playa was titled *Klimax*. In Greek "klimax" means a staircase or ladder. So I was thinking about climbing steps, about engaging a passage on the way to something. I realized that people were basically destroying what I was making through enthusiastic appreciation. I got it—people were just another element to consider, like rain, sun or wind. Instead of trying to prevent these elements from acting against the work, I decided to anticipate their participation, imagine them as additive rather than subtractive.

My initial strategy was something like "I will now begin bending pipes." I bent one and then more to create ladder shapes that went everywhere and nowhere. I figured it out as I went. I wanted to experience the freedom of creative expression without much intention and then perhaps transmit this to someone who interacted with the piece. It sounded good in theory, but it became incredibly confusing making parts without seeing a whole.

I was working one night with a friend who volunteered to help. We had been struggling with one section for the whole day and finally came to a point of resolution. Then we got some pizza, around midnight I think. After, we went back to finish *Klimax* and when I looked at the piece it was wrong. I took out my saw and cut off a big metal piece. My friend was stunned and decided it was time for him to leave me in my obsessed state. I worked into the morning. When my friend came back he looked at me with approval—he understood why I brought my saw out. It was a small and esoteric experience but in that moment I lived in my truth fully. I knew what needed to be done and followed through.

Sculptures often become memory banks for recording all of the adventures I have had while building them. I see a weld years later and recall what I was feeling when I made it. Unspoken stories accompany each piece. I tend to listen in on the

Klimax, 2003
Photo: Michael Christian

conversations people have around my work. I'm curious about what they think. They are so different from my own. One year I spent the night in my box truck, next to the piece I was working on. I woke to the sounds of voices— two men having a spirited conversation about what the unfinished sculpture meant to each of them. They were really eloquent. I decided I was finished with the piece after that. If those two could pull that much from what I had offered I figured it was enough and I could work out my issues with whether it was 'perfect' another day. It's nice to be able to be both obsessive and able to let things be.

If you need a good hit to your ego ask kids what they think of your work. They are the best critics. They haven't formed a vocabulary around "art" yet so they are brutally honest. "Why did you make it like that? That looks stupid." I need to keep my work in an open and receptive space instead of closing it up in my world. It keeps me

Flock in front of San Francisco City Hall, 2005
Photo: Stewart Harvey

MICHAEL CHRISTIAN

Keynote, 2003
Photo: Ales Prikryl—www.DustToAshes.com

from creating Plop Art, you know, art that falls out of an artist's ass with little concern for where it lands. Mirrors might be associated with vanity but they don't lie—it's all looking back at you. Physical objects are like mirrors. I made it. I chose to make it. I can't just hit delete. It's there. It's the reveal that is attractive, the more I resist the more I need to engage it.

I installed a piece I made for Burning Man 2001 in front of the San Francisco City Hall and was wondering how it would appear there, in a completely different landscape. I didn't really know what would happen until the day it was installed. It was a toss up. But it was ok. It looked like it was just passing through. I think the reason it worked was that it was built in the open empty space of the Black Rock Desert so it came without points of reference for where it had been or where it was going. On the playa there is no front, back or specific direction from which to approach objects. There is no backdrop, no signage, just a vacuum. The piece ended up being installed in eight different locations and each time it was ok. The playa gives work mobility and extension somehow.

I like to think of building sculptures as a form of bartering. What do I have to offer? Asking this requires me to question if there is value in what I'm producing. In 2000 we had been erupting these 200-foot high kerosene propane cocktails into the sky next to the big stick man before he somehow caught fire and caused people to bum rush and surround us in a mob. In that moment of chaos a friend walked up to me and asked if we had any fuel left in our fire cannons because one of the four elevated wooden balls that were part of the big burning ceremony hoopla had failed to light and was only smoldering on the ground.

This is what I call a good barter. We ended up having to lean the giant flamethrower at a 45-degree angle to get the maximum amount of flame to light the ball. We were just about to let it rip when this fireman comes over in what I thought would be a check in like a "What the fuck are you doing" scenario. To my surprise he asked me what he could do to assist. What could he do to assist? My first answer was "Tell us to stop because this was an incredibly stupid thing we were doing and people could die." I suggested that maybe he could do some crowd control and

push some of the several hundred people in the possible line of fire back so they might only have their hair singed. I'm sure I wasn't so convincing operating highly flammable fuels dressed in my finest polyester moo moos. I remember pausing for just a brief moment to take in the beauty and immediacy of our absurdly delightful no holds barred experience. This one was particularly sweet as months later in the city I was introduced to a woman who thanked me for being part of the crew that lit that lone ball. She shared that a group had placed their friend's ashes in the ball to have a ceremony that wouldn't have happened otherwise. I cried.

On a good day I like to think of myself as an artist but I'm still very uncomfortable with the title as it lies on the borderline of being and becoming. I seem to stumble most when I start to believe in the idea of me being some thing or attached to ideas or words that are not my truth. I'm sort of an anti-artist's artist. I'm not evolved enough to work without ego, but the main reason I make these sculptures is because it's awesome to build shit and have people feel good experiencing what you build. Once you start to believe in your importance or the significance of what you are engaging you begin to lose connection with your experience and become an outsider to your own work. You are no longer in it but observing yourself in it and that's a slippery slope.

WHAT EXACTLY IS A PEE FUNNEL?
ZOE PLATEK

Pee Funnel Camp logo
Logo: Vivienne Scholl

A cup, a tube and some caulk; a Burning Man artifact; a commodity; a ticket to ride; an equalizer; a view of the demography of Burning Man; an advertising gimmick; and a tool that allows a woman to aim her pee, or pee into a bottle. Ergo, The Pee Funnel.

Pee Funnel Camp was born out of necessity and emotion. As the creator of Pee Funnel Camp there's no way to tell the story of the camp without including my personal story. Burning Man makes me feel more at home than anywhere else while simultaneously making me feel more alienated than I do anywhere else. Some of this is due to my love of commerce and advertising. A large part is due to gender.

During my first year—1998—my neighbors were a photographer and his model wife. Much of their experience on the playa was marked by the preparation for and shooting of photos of her skipping naked or mostly naked across the playa into the sunset. I'm sure they were beautiful photos. This experience and now countless others drove home the sad reality that there are some parts of American culture that I'd rather live without, and that are not ameliorated by the experience of being in Black Rock City—in fact sometimes they are exaggerated there.

At Burning Man I've watched women trade their bodies in various degrees for things they needed done around their camp. I have talked to countless artists, theme camp organizers and high-level participants, and noted with shame and dismay that the number of productive male participants far outweighs the number of productive female participants (boy was I happy when the Flaming Lotus Girls made it out there!). I see a dynamic in which men work really hard to create a camp or a project, hoping that if they do it will be filled to the brim with hot naked bitches—and women work really hard to lose weight and tan and get their hair done so that they can get a free ride with one or more of those men. It's a reflection of The Way Things Work in the default world—but somehow through the lens of Burning Man it's magnified to disgusting. I feel that this is largely related to the lack of commerce: without money other things must be assigned value and traded. Money is an equalizer. A week at Burning Man isn't long enough for people to learn a new system of commerce,

therefore we revert to the old ways: prostitution. Maybe it's so offensive to me because no one brings it up—a glaringly non-transcendent piece of Burning Man culture is just left out there hanging.

I didn't want my Burning Man contribution to be based on the shape of my body or the way that I look. I vowed that if I ever got involved I'd discover another way. I find some irony in this considering Pee Funnel Camp is very much about the female body and very reliant upon design and branding. I am now sought after as a desirable celebrity on the playa and I did not show my tits to get there.

During my third year at Burning Man I enviously watched my boyfriend pee into a bottle while I walked my well-hydrated self to the port-a-potties in the cold twice a night, ruining my sleep cycle and rendering my experience of the event less sparkly than his. Half-drunk he joked "We should get you a funnel." Aha!

Using materials I had on hand I crafted a working funnel from a cup, a length of PVC, and some caulk. Magically, the first design worked. I tested it under a strong faucet, and figured if a funnel could handle that without overflow it could handle a desperate drunken pee. The design hasn't changed much since. I am amazed by this now that I'm more familiar with plastic and realize what a difficult task it is to adhere PVC and HDPE. No other combination of adhesives and plastics I have tested has worked. For Burning Man 2001 I made 100 of these things and printed one handwritten sign that I taped up at the end of the row of potties closest to where I was camped. I called them Pee Funnels and the camp Pee Funnel Camp. My Pee Funnels were gone by Wednesday. In 2002 I brought 250 and advertised on a whole row of potties. The next year 500. It wasn't long before I was making 10,000 per year and had two dispensers on each side of the city, a tertiary dispenser attached to an art car, and in addition an ad for every port-a-potty (of which there are some 1,500). We now have an animated El-Wire sign, a hot pink shade structure, and logos, logos, logos! We've given out over 40,000 Pee Funnels and counting.

Pee Funnel Camp is a really, really, really good idea. So good, I have trouble with taking it in or letting it go. We've had many members over the years, always between five and 15 people, and it's always had a strict monarchical camp structure. I am at the helm. If I had a dollar for every time I've heard "We love you Pee Funnel Camp" or "You are a genius" I'd be a wealthy woman. To this day I'm not sure how to take the praise, other than working it for plane rides, dates, line skips and other VIP perks. My solution to the emotional awkwardness I feel towards my success is just to work harder for Burning Man because by being in constant giving mode I never have to sit back and receive. There have been years where I made every funnel and hung up every ad myself. I don't know whether the product is the real draw, or the advertising—or both. Throughout the years I've had many imitators—everything from Poo Funnel Camp (I'm still not sure it actually exists—we tried to serve them with cease and desist papers one year but couldn't track them down) to other copycats aping our advertising.

Pee Funnel Camp has received a lot of help and broken a lot of rules because it is Burning Man famous. I've become accustomed to relying on the notoriety of the camp as a marker of my worth and trading that value with others. I've networked with other theme camp/art project organizers and am always able to get in early, get to the front of the line, have a private session, get on the plane, and get that piss-poor mutant vehicle licensed for both day and night. There's a strict class hierarchy at Burning Man and other than the Org and Staff, theme camp organizers are at the top. Once I recognized this I spent a few years ballin'—living the high life, working it for as much as I could get. These days though I'm over being associated with pee and sometimes tire of my playa address being in every port-a-potty (brings a new spin to "for a good time, call..."). I lay low and don't announce myself. Maybe the notoriety is just another testament to the efficacy of advertising.

ZOE PLATEK

Zoe with Pee Funnel
Photo: Ulrich Buddemeier

I, and whatever group of people I've convinced to be a part of Pee Funnel Camp (some have spent up to eight years with PFC, others are one-hit wonders) spend weekends for a month or two making Pee Funnels—so my run-up to Burning Man involves a factory production line—except drugs and alcohol are allowed and encouraged. The work is rough on the hands and all of us end up with injury. I drill all of the holes with a drill press, and I caulk every Pee Funnel on both sides of the seal myself. Other workers are tube cutters and tube stuffers. There are lots of tube, hole, and caulk jokes involved. Once we get to Burning Man these all become pee jokes.

The handmade design is iconic and has cemented the Pee Funnel as a Burning Man artifact. It's certainly not perfect—the tube is not flush with the cup and therefore it doesn't drain fully. The funnels are inconsistent (though we estimate a failure rate of lower than 1 per cent) and last anywhere between one day and ten years. The cost per piece to change the design is prohibitive without having them machine manufactured, and so far I've avoided that step because it is the one thing that separates Pee Funnels from being actual commodities. I have tried all of the models of "pro" pee funnels and I definitely have my favorite (which I will not disclose without being paid by the manufacturer), though I still think that my model works better for home use. I have been approached by one of the makers of "pro" pee funnels asking me to use their funnels at Burning Man, offering to supply for free to spread brand awareness among the Burner market. I turned them down because they don't work as well as mine, even though they are more portable. Nobody would probably care or notice anymore if Pee Funnel Camp handed out "pro" funnels, marketed products from the default world. Burning Man has gotten really lax about decommodification. There are Purell hand sanitizers outside every row of port-a-potties, which amuses me because playa dust is a better sterilizer anyway and Purell is brilliant at getting their useless product in front of so many people.

In 2007, the Burning Man theme was "The Green Man" and it emphasized humanity's relationship to nature. A large proportion of Pee Funnel customers are progressive and eco-conscious, and I can't help but notice Burning Man's misguided emphasis on greening the event. I always like some good fun so this is how that year went: "Yay! Pee Funnels! I've been looking for you guys all day!" "You've found us! Would you like a Pee Funnel?" "Yes, PLEASE, oh wow I can't wait!"

WHAT EXACTLY IS A PEE FUNNEL?

"Here you are. Now—a little about the Pee Funnel. The cup is made of recyclable plastic, though plastic just downgrades in quality with each recycle so you really won't ever be able to make anything as nice and pliable as this cup with it again. Plus HDPE is only about 5 per cent recyclable. The tube is made of PVC. PVC has the most toxic lifecycle of any substance on this planet and it does not biodegrade. It will break down eventually, but probably not for millions of years. If you take care of it, your Pee Funnel should last the whole week."

The sight of their falling faces as they took their ecologically abominable gifts was priceless. The realization that they cared, yet hadn't put two and two together on their own, reinforced my belief that Burners will not be on the forefront of slowing climate change and pollution. One of these women, who I educated about plastics and their toxicity, complains bitterly every year that I do not seek out a more eco-friendly solution. My response is that when Burning Man stops burning fuel just for show I will examine my options.

Twelve years of Pee Funnel Camp have left me with many unique stories. I met a woman on the playa who ran back to camp to bring me a book. She had to leave Burning Man her first year due to dehydration, but she came back her second year and photo documented all of her pee by taking pictures of the jugs she filled the whole week. She breathlessly told me that without the Pee Funnel her work would not have been possible. Another year a woman came by who was struggling with losing her sight. She was pacing the distances between corners so that if she went fully blind she could still come to Burning Man. She told me that not having to get herself to the potties at night made the difference and the Pee Funnel was the reason. A disabled woman came by last year with some serious bomb-ass fat wheelchair tires—sporting the same Pee Funnel she'd been using for four years. This year a MTF transsexual stopped by camp to pick up her Pee Funnel and to tell me that when she had visited two years ago she was heartwarmed when she told me that she was coming by six months prior to her surgery and didn't need one yet, and I responded without missing a beat "Congratulations honey, take two and save them!" Every few years I threaten that it will be my last, which results in droves coming by to personally thank me and make me aware of what a phenomenal difference the Pee Funnel has made in their Burning Man experience.

I thought to advertise to men because of one customer I will never forget. He brazenly told all of Pee Funnel Camp that he needed a Pee Funnel. When we asked for whom—he said "For me, dammit, I'm too small to aim into a bottle and I keep getting piss in my tent!" When we expressed some disbelief he proudly dropped his pants. He had an innie! I'd never seen a penis like that. Three or four years later a very intoxicated man came by. He told us he was on a number of missions and he listed them out for us. One of them was that he *had to* get a Pee Funnel for his male tent mate who was too small to piss in a bottle and who made their tent smell like pee. I've always wondered if he was talking about the same man who came by and dropped his pants.

That same year I had an exchange with another woman who had recently transitioned from male to female (she had undergone the surgery with just enough time to heal for Burning Man). I love transsexual customers. She was overjoyed to get a Pee Funnel and promptly wrote her name on the playa with pee and belted out in a high-pitched voice "FUCK I MISSED DOING THAT!"

I was also visited by two young people who I assumed were women. They were there to talk about the ads, which they said were sexist. Their claim was that the ads were all targeted towards women, and that those that weren't implied ownership, as in "get a Pee Funnel for your ladyfriend." They then began to ask hypothetical questions about gender using gender assignations that I was simply not familiar with. They went far beyond "bio male, gendered female" or "complete androgen

resistance"—I didn't even know what some of the words they used meant. When I began to respond to them I realized they were wrong. The criticisms about the Pee Funnel ads may have been true some years ago, but they were there the year I actually included ads for men. It was the year that I got the privilege of hanging up Pee Funnel ads at Comfort and Joy because the gay male demographic is the only one I have left to seduce. It was the year where most of the ads were neutral and more ads were actually targeted towards men than towards women. I threw a full set of the ads in their laps and they leafed through them. I heard one of them chuckle and say "These are GREAT!" They quickly changed their tune and left. I never thought I'd have to work that hard for the feminist market.

I once had to kick someone out of Pee Funnel Camp for being inappropriate with the customers. The members of Pee Funnel Camp are carefully screened to avoid two different reoccurring scenarios. In the first, members are overwhelmed by the constant flow of women and eventually lose a sense of the women as individuals and begin to see them all as one great woman, standing for the whole. This often causes them to use the customers as a scapegoat for their issues with women. There's nothing wrong with teasing, flirting or being snarky—but I draw the line at personal attacks. The second involves women with poor self-esteem or body image problems who have a meltdown in the face of a constant flow of nearly naked women. The "looks-as-worth" mentality that pervades Burning Man rears its head and women are often commodified and sorted by worth either by themselves or by others. Being immersed in this vibe can be overwhelming even for women with the highest self-regard. The person I kicked out stood in front of the camp making sexist and inappropriate comments including personal attacks at the Pee Funnel Customers. I was surprised to see this side come out of him, but that's Burning Man.

The camp has usually maintained a high male-to-female ratio. We've had customers expect otherwise and criticize us for it, as if only females should be involved. Men and lesbians enjoy the constant flow of female customers, and I enjoy having a camp full of men.

Hazing Pee Funnel customers has become a sport at Pee Funnel Camp. Our setup is a litmus test for stupidity—because for the smart people it is self-service, but for those who can't quite figure out what a Pee Funnel Dispenser is or how to get a Pee Funnel from it—they get the full force of our snark. "You guys provide such a great service to this city," can only be heard so many times before our sarcasm starts to leak out. My favorite: a camp full of first-time Pee Funnelers came up with the ultimate game: "Hey, can I get a Pee Funnel?" "Sure... do you know what size you are?" (they are all identically sized). I'm in the back of camp laughing my ass off and placing cash bets on their responses. 100% of women said "small." 99% of men said "large"—except those few who said "EXTRA LARGE BABY!"

Occasionally, and less frequently now than when Burning Man was younger, we have visitors who mistake the theme of our camp as golden showers or watersports. Most of them have never "come out" as being interested in that kind of sexual play, and it's another snarky form of entertainment to watch their faces fall as they out themselves and are rejected by a group of judgmental assholes in just a few moments.

I love stories of Pee Funnels used for things that have nothing to do with gender or peeing. The most common is "Hey, this could double as a beer bong!" My fresh campmates reply to this "Just make sure you use it for that first!" and I mumble jadedly to myself "Go ahead! Pour a solvent through non-food grade PVC into your body!" It's always surprising to me that the FDA has trained people to be so trusting they don't even consider material consequences. I see Pee Funnels at bars on playa everywhere. I see people funneling their cooler water into a jug to use for showering, gasoline into a generator, and I once saw someone drawing colored lines on a fire with a funnel full of what I believe was cupric chloride (don't try this at home).

When I decided to use the notoriety of Pee Funnel Camp to protest the Burning Man Organization's policy that included me as a theme camp organizer without including me as a strategist and collaborator, there was a massive response to my poorly thought out PR stunt. The Org botched how tickets were sold, and all of a sudden I was responsible for purchasing all the tickets for my camp within a short time. If I didn't buy them then, I would not have access to them, and by purchasing the tickets I was taking full contractual responsibility for how they were used. I was upset. This wasn't capitalism (here is a resource, you buy it—you do with it as you wish), this was extortion (if you want to have a working Theme Camp—pay us and do as we say). I commiserated with dozens of other upset theme camp organizers. The choices made by the Org around ticketing had a direct effect on budgeting for theme camps—yet we never got a vote. For a moment, I let my personal politics get the best of me. I had had it with communist government.

I pretended to scalp tickets and then created a misleading plea which I mass e-mailed to theme camp/art project organizers. I hired people to blanket the online Burner landscape with it and seed controversial discussions. The website with the plea received over 6,000 hits in 48 hours—months after Burning Man people were still debating my motives online. Fans were upset at me for "dragging the good name of Pee Funnel Camp" through the mud (as though it is not mine to do with as I choose). Someone went through the trouble of printing out anti-PFC ads and hanging them in a few rows of potties. It occurred to me that though I came up with the idea and realized it (with much help) for over a decade, the community feels as if it has ownership and stake in Pee Funnel Camp. I've seeded brand love in a space where advertising is not allowed. People have a personal relationship to the intellectual property of Pee Funnel Camp.

One year later, the Org and I have ignored our relationship back to cold, distant, mutual disagreement... yet tolerance. The 2013 theme was "Cargo Cult"—and the Pee Funnels and Pee Funnel Camp, loved and reviled as we have been, fit perfectly into that. This was the last year of the handmade Pee Funnel design and the year we burned the Pee Funnel Dispensers. We advertised it as our last, and the city was abuzz with that rumor. Now the Pee Funnel is a scarce artifact. Find the Pee Funnel. Use the Pee Funnel. Worship the Pee Funnel.

Pee Funnel Camp predates my career in advertising. I learned enough from my PFC experience to develop a career in viral and social online marketing. The Pee Funnel advertising is humorous, relevant, and, until recently, it occurred in a space where it had no competition with clutter. When I first began hanging ads on the potties various officials told me I had to take them down. I smiled and said I would, but never did. Eventually they stopped bothering me. Now other people hang ads on the potties, which pisses me off. I didn't trailblaze through rules just to have trespassers take my real estate. I always chuckle when I look at the Ten Principles— because praise, notoriety and worth has been assigned to me by the Burning Man community for doing something that is Against the Rules relative to "commercial sponsorships, transactions or advertising." Advertising and commodity are what the Pee Funnel is all about.

We create over a dozen new ads each year, and there is usually a set of 30–50 different ads that go up on the port-a-potties. They are always printed on hot pink paper that stands out against the dingy potty green or blue. Most of the ads are one third of a page, some are full page or half page. 2012 was the first year that I had non-PFC volunteers help with hanging up the signs. I am very grateful to them. It is not a pretty job. I may not get to see much of Burning Man some years, but I have seen the inside of every potty on the playa. Sometimes people are so taken with the ads that their expectations for Pee Funnels are ridiculous. Some who make it to Pee Funnel Camp after years of reading our hype are utterly disappointed to find just a

cup, tube, and some caulk. I'm always curious about what exactly their expectations were but am usually too busy laughing to ask. This year a man stopped by for a packet of the signs to help him in his guerilla art project; he just doesn't see a port-a-potty as complete without an ad for Pee Funnel Camp hanging on it—so he will take those ads and grace potties around the world with them.

One year I tired of only seeing female customers and so adjusted the advertising and targeted not only women but men as well. I counted the customers and saw a marked increase in male attendance at our camp. In 2012 I began advertising the Pee Funnel directly to men because they tend to share bottles or use bottles with really small necks or just don't want to touch any bottle part with their love wand. Men came in droves. For a community that eschews commerce and marketing, Burners sure are susceptible to advertising.

True irony and back to that decommodification principle (is that even a word? Are we sure all the port-a-potties aren't going to get removed?); Burning Man taught me how to create a cottage industry. At first I funded everything myself, but over time began to rely upon camp donations, and then Kickstarter donations. There is nothing stopping me from financially benefitting from the Pee Funnel (I have not; in fact I'm a good $20,000 down from all I've spent on PFC over the years). I could just charge $1.50 a pop donation pre-event and be making 10x profit. This might be a much better story if I did.

Instead, it is time for me to expand Pee Funnel Camp to service the default world. I was approached at Burning Man 2013 by both a plastics engineer to begin talks for commissioning and manufacturing my own model of Pee Funnel, as well as a manufacturer of an existing UK "pro" model of Pee Funnel (still not as good as the handmade ones) which I will begin marketing in the United States. Look for them at pfunnel.com.

My goal for Pee Funnel Camp has always been blind, stubborn *full market saturation*. I've accepted that there are some women who simply choose not to use a Pee Funnel (crazy broads!), and some men who can't see the value of trying one out. That said, what's keeping me from my goal is not conversion but production and distribution. There are still plenty of people at Burning Man who want a Pee Funnel and don't get one. Therefore: my work continues.

I still have those moments, in the middle of the night, half-drunk, high on Burning Man, avoiding the weather. Nature calls and I answer by reflexively grabbing a Pee Funnel and a one-gallon jug. Mid-stream I detach for an instant and catch myself saying out loud *"Whoever invented these things is a fucking genius!"*

Metropeelis

Pee Funnel Camp

Pee Funnel Camp

Come get your **Pee Funnel** at **Athens + 3:13** or visit our 2nd piss yellow Pee Funnel Dispenser on the **9:00 Promenade near the Esplanade.**
Look for our logos and the big yellow Pee Funnel Dispensers!
This sign will come home with us, we love it when you write on them.

A Pee Funnel Ad, 2010, Metropolis
Graphic: Zoe Platek

LADIES!
Hungover? Tripping?
'Fraid ya might lose your lunch if ya lift the lid?

Pee Funnel Camp

Piss in the urinal with your very own
PEE FUNNEL!
or look for our piss yellow dispenser at
Look for our logos and the big yellow Pee Funnel Dispensers

The most popular Pee Funnel Ad with the ladies
Graphic: Zoe Platek

Come on down to and for your very own Pee Funnel!
Or, pick one up from our 2nd piss yellow dispenser at + near the potties!
Look for our logos and the big yellow Pee Funnel Dispensers!
DO NOT LEAVE FULL PEE BOTTLES IN THE POTTIES OR ANYWHERE ELSE FOR THAT MATTER.

The most popular Pee Funnel Ad with the gents
Graphic: Rick Hargett

ZOE PLATEK

ENGAGING THE ENCOURAGING PRIESTESS OR SELF-MARRIAGE BECOMES YOU IN THE DUST

L. GABRIELLE PENABAZ

You are stuck with yourself in an arranged marriage. Yes, you are married to yourself, even if you are traditionally married to someone else. It may as well be a loving union, you and yourself. Do it right. Throw the damned party. Get a registry. We know who'll keep the toaster when you're having a spat. 'Til death do you part, right? Marry Yourself! Go on. Have the wedding... to yourself.

Or maybe you already have and don't realize it. What's a wedding anyway? It's usually like repeating a New Year's resolution at an overpriced party so you can be held accountable forever or until you squirm out of your commitment. But ultimately, it is about commitment. The desire for a wedding is different than wanting to be married. A wedding is a performance, complete with rehearsals, and the true meaning of marriage can get lost in the staging. The day-to-day maintenance of marriage is a condition you live with.

For those people who declare their intent for a certain kind of life and follow through without formal observance, congratulations. For the rest of us who could use an objective boost in life, a full-on wedding to the self may be just what the priestess ordered. In either case, whether you are clear as a bell or wandering aimlessly through life, ritualizing your goals and values in a ceremony produces results that range from sweet appreciation to shattering life changes.

How do I know this? After marrying over 1,000 people to themselves, I've learned a few things as the "Encouraging Priestess." While I'm actually ordained to marry people to others, a license isn't necessary for nuptials to the self. I created a one-on-one performance art piece that's like a Lost Vegas Quickie Wedding complete with multiple-choice vows, costumes, bouquets, cake, photos and rings. Participants arrive with a variety of intentions and expectations, but as at Burning Man, being open to surprises improves the experience. It can be absurd, chillingly profound or both. You could marry yourself without me. I encourage it. But after marrying myself, all by myself, a long time ago, I feel that having someone facilitate the ceremony, at least the first time, is invaluable. Most people like the idea but would never go through with it if they didn't run into my makeshift chapels at festivals. Marrying yourself as an artwork releases the shackles of convention and religion.

How did I come up with this idea? In 1999, I progressed out of a tedious day-job rut into a rewarding work situation, but entered a mediocre relationship. The familiar haze of destructive complacency loomed overhead. On one hand, I triumphed—surviving through performance art, music and event creation. On the other, depression leaked into the cliché of falling in love with someone who only "liked" me. Something drastic had to be done.

Two forces emerged in my life. One was the desire to go to Burning Man and the other was the crazy notion to wed myself that I picked up from Rob Brezsny, the syndicated astrologer, writer and irrepressible optimist. The passions are still connected and evolving. Burning Man stories floated around me for a year until casual interest turned into fervent planning. A mecca for twisted minds that create beautiful, strange experiences completely obsessed me. Certainly these, my people, would welcome my visions of self-wedded bliss. Brezsny's words of pronoia, his opposite of paranoia, offered both inspiration and structure for a plan of action. I pictured placid blue skies kissing flat, cracked land and a big white dress. I decided to marry myself at Burning Man. The playa provides, it is said, and I am still learning that it does, but not necessarily the way you expect it might.

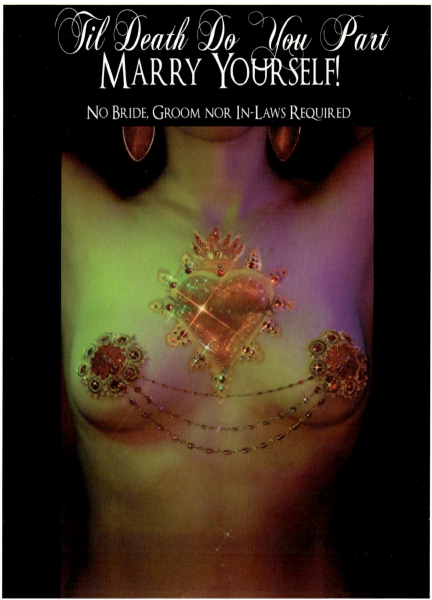

Poster

For an ordinary Western woman, a wedding may be the only day of her life when being worshipped is sanctioned in social normalcy—worship as an exhaust valve for the ego. The need to feel heard and seen, at least once in your life, can be monstrous. Otherwise, weddings might only be a piece of paper. While the groom is an integral part of the Western wedding, he is generally not in the spotlight. Where is his wild headdress and ominous chariot? When does an American man get to feel like a beautiful creature?

Entertainers satisfy the need to be worshipped and perceived as beautiful by being onstage. However, the realm of ritual uses performative techniques to

Gabrielle

take a prayer farther. I needed to set an emotional standard above and beyond affirmations. Ritual and its preparation do something to your heart and mind that a few passing words cannot. A wedding is a performance of intention. And if I couldn't budge my boyfriend's mind, I could improve mine. Radical self-reliance, a Burning Man principle, begins with this kind of thinking.

In the summer of 2000, I aimed west from New York City. The itinerary included California before finally heading out to the Burn. Fate, flaky people and frantic phone calls changed my accommodation from the planned Culver City couch to a classy property in Beverly Hills belonging to my long-estranged friend, Steve. I was a little embarrassed to call him but I soon got over it. I had a desert wedding to plan.

A reality check, after more research and thinking, produced simple questions. Will there be shade during 100-degree days? Will I marry myself in a tent? What other venues are available? Is there any privacy? Will my vision of a big white dress turn cumbersome and sad in a tent or will I simply sweat to death in the blazing sun, pretending it's okay? If it's cold at night, will a coat make the dress moot? What if everyone is always hungover and doesn't want to deal with my idea? Should I proceed totally alone? What the hell am I really going to do? Fear led to an awkward request.

Steve agreed to let me marry myself in his fancy backyard. When I asked, he raised an eyebrow and laughed, "sure." I had hoped he'd be impressed with my deep thoughts, so my ego stung a little, but I realized he was one of those people who'd already married himself in life but without all the brouhaha. Instead of poking him for emotional support, I fixated on figuring things out now that my venue was chosen. I would arrive at the Burn a happily wedded woman.

Even a wedding with only one person requires lots of planning. Location matters. It affects everything. It forces a deadline. It also introduces limitations. There was no table out there, just sprawling green lawn. I decided on a picnic-style setting with fabric on the ground. This meant a vase might tumble. Holding flowers might be burdensome if I had to read. Just petals? Imagining a spiritual moment with challenging props was becoming a drag. Revelations followed. The dress search was deeply influenced by place. Offstage, I normally dress in black, comfortable clothes like a gothic Che Guevara, but that dark green landscape invited contrast, and I fell in love with red. All day long while I sought the dress, I noticed red cars, rouged signs, and vermilion details in average things.

The dress found me at the end of a long day, on a rack in between different styles and colors. It had different layers of sheer fabric and they looked fiery. I realized I wanted the four elements at my wedding—Fire, Water, Air and Earth. The dress was like nothing in my closet. It was bright and form fitting with a sweetheart neckline. I loved it. It was in my price range and size, confirming the universe wanted me to have it. It was also knee length, boding well for post-wedding use. Everything said yes.

The rest came easily. People are braver in costume, even subtle ones. I think this is why the Victorian meringue gown has become a tradition. Before Queen Victoria splashed into the collective imagination, a stylish outfit sufficed for a wedding. The right ensemble translates into special powers, which is good to have when facing commitments.

The ring turned up in a new age shop where I was looking for stones to symbolize "Earth." It was an ample silver band embedded with clear quartz and it had a nice weight. A ring is a reminder of wedding vows, so it's important to actually like it and wear it. I chose some other stones to include, too. As a companion to the fabric, I chose a Herkimer diamond, a symbol of strength and clarity. A large rose quartz signified harmony, and a cobalt blue slab of Lapiz Lazuli worked the unlikely combination of protection and mirth.

I wanted some part of the ceremony to be nurturing and frivolous. Food filled this niche nicely. A triple cream brie with a few crackers and oozing chocolate cake, both good with homemade absinthe (symbolizing flow and instinct for "Water"), all became the feast and personal wedding cake. The backyard property delivered the "Air" element. I wore my mother's earrings and Steve lent me fabric and serving items, so I had "something borrowed and something blue" to go with the old and all the new. Following the traditional poem was unintentional but I realized it offered structure, always helpful for emotional intentions and mental journeys.

A rehearsal in my head posed some questions. Will I say it out loud? Memorize a speech? What about the neighbors? Will they cramp my style? Yes, you can have cold feet about marrying yourself. A lavish, golden pen and a small, stately black leather journal helped, because writing makes for honesty. I couldn't lie to the journal—large enough to hold the rite, but small enough to carry around and document reactions. I should have taken photographs, but strangely it didn't occur to me to do so. All the pictures were made of written words, but I noticed the faux pas afterwards.

This had to be easier with someone else. If it went well, I vowed to help other people get through this marriage business. A spiritual midwife, usher, mind-traffic controller; a pychopomp, a priest, a host, a guide—I got it. I dressed myself and gathered everything: the picnic fabric, the stones, little dishes, a fork, a glass, a small pitcher of water for the absinthe and a bag of freshly decimated rose petals. The hot sun beamed on the semi circle of items, while I reviewed the written ceremony. I laughed because this would have been fine at the Burn, I thought. Here I was alone, sweating, suddenly hoping to just get it over with in Beverly Hills.

L. GABRIELLE PENABAZ

My mind raced with noisy criticisms. "You've spent a lot of money, you'll regret this later." Kinder thoughts prevailed. "Shut up. Can we make this fun now?" I closed my eyes and breathed deeply. What I really needed was a divorce with my past selves. The sun baked me in the red dress while I recreated a cartoon version of a banishing ritual from a class I took, long ago. I perused my past and picked out mean, old images of myself, and visions of people who've brought me down and shaped my fears. I heaved each image (some of them kicking and screaming) into an imaginary orb. Concentrating intently, I counted to three and... blammo! I blew it up into the farthest reaches of outer space, destroying every molecule as I knew it. I poured some water into the absinthe, which changes it from dark to light and took a sip. I was able to relax in Beverly Hills. Amused, I wrote down these refreshing visualizations into the little journal and continued on.

The vows I most remember are at the core of some of the popular ones in the performance art version. "I forgive myself," is at the top of the list. These were spoken out loud, boldly facing the fear of neighborly opinion. I vowed to be vigilant about habits, to kick my own ass into gear (so it's not done for me), to advocate better for myself in relationships, and to always look for the best in situations and in others. I have since failed myself here and there, but having performed the vows means the good voices in my head are louder, bolstered by color and actions. I donned the ring and pronounced myself married to me. After some cheese, cake and absinthe, I inhaled the air with purpose. A little sunburned, I went inside and washed the dishes.

In retrospect, I also should have taken myself out somewhere. The anticlimax developed one of the most important ideas behind the performance. Celebration is punctuation. Put a proper ending on it. Gathering your crap and doing dishes just after you marry yourself is a little sad if there's nothing else to follow. Dishes washed, the marriage began in earnest.

The first Burning Man experience is always the most magical, even if parts of it are terrible. Mine had ups and downs—the relentless beauty of the art and the end of the depressing-boyfriend heartache were my strongest memories, but that year the event had the worst weather of any of its incarnations up until this writing. Look up the year 2000, dust storms and destruction of villages. I would have had to really get my act together early in the week to manage an outdoor wedding, and finding a venue would not have been so easy. Instinct had paid off and my first Burn was the conscious honeymoon I'd envisioned.

Eight years later, I entered a contest to exhibit a "one-on-one" performance art piece in a prestigious British festival. The wedding-to-the-self idea finally formed as an act, complete with the encouraging priestess. But after a few voting rounds, it didn't win a spot. I had forged the written proposal and proof-of-concept video, and it was not to be discarded. I took it to the House of Collection, an ornate home-gallery-party space, in Brooklyn.

I bit off more than I could chew with the first event—handling all the party details as well as creating homemade absinthe for the bar. I shopped and assembled performance items by myself—costumes, adjustable toy rings, clipboards and pens. I wrote and printed the vows, made sign-up sheets. At the same time I was inventing my character. My focus was divided going in. I spent a few hours greeting guests, catching up with friends and talking about the ritual they came to experience. People actually started leaving. I started.

The rococo dressing room in the back played its part and was fortified with a brocade fainting couch, mirrors, and *objets d'art*, all dripping with silk and lace. Plastic sheeting covered the vows to protect them from spilled drinks and apathy. Yet, I wasn't sure how to begin. So I called over my trusted friend and burlesque performer, Velocity Chyaldd, as my first victim. Burlesque performers are methodical

Til Death Do You Part - Marry Yourself!　　　　　　　　www.Encouraging Priestess.com

VOWS

Blanks are for you to fill in as you wish. Use the back of this page if you need.
Do you have any vows you would like to use? Write them down. What's important to you?
What would you like the Priestess to guide you through? Is there any feeling you would like to ritualize?

PLEASE CHECK OR WRITE 5 VOWS TOTAL

You may begin with a Quick Emotional Cleanse, – (AKA - Zippy Exorcism or "Divorce" from old selves)

*List things you would like to release here:*_____

I promise to:

	Forgive Myself
	Never deceive myself
	Release old images of myself that make me feel unattractive
	Accept that I can make serious mistakes and be downright human
	Never Cast A Curse on Myself (Even in those little moments when you call yourself "stupid" or "clumsy")
	Love Myself like I love those whom I most treasure
	Know My Genius and Do Things to Remind Myself of It
	Cherish My Strange Wonder
	Obey My Small Voice That Knows The Truth and What's Right
	Do the Right Thing so I can live with myself in peace
	Find Myself Gorgeous and Mysterious When I Need That Boost and Nobody is Around
	Kick my own ass when I need it and not expect others to do it for me
	Expect the best from myself - in spite of any old voices (parents/teachers/etc) who tell me different
	Feel wealthy and be generous even when I feel broke
	Understand my own signals for when I need help – and get the help I need
	I will fix imbalances instead of accepting blindly or flipping out
	Rethink my situation (ex: values, jobs, and relationships) when my identity is at stake
	I will release my pain on a regular basis through (add word:　　　　　ex: writing, crying)
	Evaluate what is important and embrace the outcome. Life is short.
	Accept that I am totally responsible for my own happiness.
	I will take steps on a regular basis to achieve harmony around me.
	Bring sweetness into my life even when it seems far-fetched.

After today, you may want to create wedding rituals on your own.
Some suggestions to keep the flame alive:
Gifts to yourself that remind you of your vows. Find a proper place to put them so they serve as reminders.
Something to wear every day is good - rings are the norm, but even a perfume can remind you of your vows.
Something to read - inspiring quote or something you have written.
A list of things to release and things to bring into your life. A thing to taste to heighten your sense to the moment.
A closing statement to solidify the ritual.

The House of St. Eve　　　　　　　　　　　　　　www.TheSaintEve.com

Vows

L. GABRIELLE PENABAZ

individuals who navigate byzantine clothing and props without falling over. She patiently let me talk through my madness

Okay, here are bouquets to choose from. There are some costumes, but... you look great. I say the vows and you repeat after me. Then I pronounce you married to yourself and take your picture. Um. Oh! You get a glass of bubbly and personal wedding cake. Geneva made these red velvet cupcakes. I think there are 'just married' balloons out there but they might have put helium in the wrong ones. Take one if you like, anyway.

Another friend and burlesque performer, Amber Ray, watched over the murmur in the other room. She had originally offered to be a human bouquet, complete with flower covered head and bosom, but saw I needed help, and she began quietly arranging the bouquets and filled a champagne glass. Another friend, Geneva, prepared a cupcake to serve with a napkin. It was so soothing to have the support. After this event, I decided to always have assistance and call them "Host-Guides." When Velocity presented her vow sheet, it was uncomfortable. For her to repeat after me, into my eyes, seemed like she was marrying me. "Do you want to say these in front of that mirror?" I asked. "Ohh. That's much more powerful." She examined herself in the mirror. "You whisper them in my ear. I'll say them to my own face."

Relieved, I asked her, "Hey, do you want a little exorcism of past selves?" "Oh yeah!" She put the flowers down and turned with purpose, arms at her sides, ready for the fight. Her instincts were so good. My performance art piece was born with these fabulous midwives. The mini exorcism/divorce-of-past-selves was similar to the one I did at my ceremony. I raised my hands to my chest like I was holding a basketball, and asked Velocity to imagine a floating orb. I said, "This is your psychic trash can. I want you to stop and really think about moments that have hurt you and haunt you. They're past now. Roll them up and throw them away." Her eyes widened slowly as she lifted her arms before violently hurling her several pieces of invisible trash into the orb until she grew quiet.

"Ready?" I asked. Staring into her eyes, still holding the orb, I said each word progressively louder, "One, two, three, BOOM!" and clapped my hands in front her eyes. "Whew! Shake it out," I said, and we shook like wet dogs until I said, "Breathe," passing my hands firmly along her arms, turning her around, and then passing my hands along her back, I flicked any spare energy needing to be tossed. With authority, I turned her to me, hugged her tight and whispered, "Okay. Let's start."

I didn't know it at the time but those who go through the mini-divorce always have a better wedding. At the very least, it centers the mind. I brought her to the mirror and said, "And now you will marry that beautiful girl. Repeat after me." I became a ghost in her ear as the vows took hold in her eyes. I learned my place. The humility was satisfying; very different from playing a concert. My accomplishment lay in ushering a complete experience, not just generating applause.

When she was done, the girls and I cheered and hugged with loud congratulations, a personal wedding photo, cake and bubbly. When I opened the door to announce she'd just gotten married, the party crowd roared with thunderous applause. Over the course of the evening, I tried slightly different tactics with each participant. Some said the vows to me, but the mirror folks had a much better time of it. I learned so much about preparation, staff, my limitations and my power. At the end of the night, several guests asked when I was doing it again.

Since that first time, I have performed this work with the title, "'Til Death Do You Part—MARRY YOURSELF!" at many locations. It's grown to the point where I've presided over ceremonies in private homes. Is it art? Discuss. I've offered the piece at large-scale events like Figment, the open-air, well-attended art festival

on Governor's Island in New York. Figment was my first experience with a wide variety of cultures, classes and ages. The performances there required shepherding a great number of visitors through the process, usually with children in tow. They signed up for a ride but got their minds blown instead. Meanwhile, my mind was blown when a father and his nine-year-old son spent hours with the vows and then returned as each other's ring bearers. Hearing my first child participant vow to "Cherish my strange wonder" left a powerful mark on me, and left me feeling useful in the world.

In New Orleans there were two different incarnations. The first was at an art-world biennial on Halloween, so nobody wanted to work that night. Performing this beast by myself again confirmed my commitment to never do it alone. Another year at a vampire event, attendees were as game as they were at an art-fetish event in London. In both cases I expected drunks to stumble through it but to my astonishment, they were game and continually, deeply touched. In London, I expected condescension, but was deeply surprised by those who nearly ran away at the Host-Guide desk because they took the vows so seriously. The recently wedded were quick to recommend it. "It's performance art," the Host-Guides purred to the uninitiated. Tales of fussing over the participant in costumes, rings, cake and "alternative bouquets" worked on most people. But there was real fear in some eyes there.

Each ceremony upped the ante on bouquets, which included bedazzled light sabers, a spray of doll heads, tarted-up weapons and flowery sceptres. The gold, spray-painted broccoli in London was so popular it stank up the hot little chapel room, but nobody cared and I was not allowed to throw it away until the very bitter end. I fell in love with the 60-year-old lesbian couple, celebrating their thirtieth anniversary. I thought of all they might have gone through in a conventional world. One partner wore brilliant scarves, holding her lover's ring. The other dressed like Joan of Arc, bearing the most elaborate sword.

I performed the ceremonies for several days in a row at one of the Chashama galleries in New York. It was in a tiny space on a sparsely populated street, and with the exception of the few who knew to find us, almost everybody ran into us unexpectedly on their way elsewhere. My favorite participant was blind drunk and maybe homeless, with no idea what he was in for, but he nearly cried during his orb toss and loved his plastic sheet-covered vows. "I can keep these?" he asked. "Of course. It's your wedding and that's your contract with yourself," the Host Guides replied, handing him cake. He came back the next day, less drunk, and filled out more vows. Looking back on the Chashama wedding photos, you'd never know it from the beaming faces, but luring people to participate took a lot of cajoling. Costumes in the window made the biggest difference because they summoned the mindset needed for our woo-woo art thing.

The polar opposite of Burning Man, this was, since Burners arrive ready for soul searching. They gear up for epiphanies all year long, dressed to meet divinity. While performing "Marry Yourself!" seems natural at the Burn, I hesitated for years to take it out there because it's a lot of work on top of camp duties and cross-country prep. The more times I went to the playa, the more I hesitated, but I finally gave in on my tenth Burn.

Let's just say that during my eleventh Burn, the second time I did the performance, things went much smoother. I was invited by the Burning Man Organization to include it in The Burning Man Project, as part of their outreach of Burning Man principles. With my excellent friends and Host-Guides, Alex Lyle and Pippin, the chapel was built, the jewel-toned fabrics were draped, and many of the ushering details were handled so I could focus on the priestessing. I invented new intros to suit each person, taking time to intuit what they needed. For those

who wanted comedic vows, improvising was especially fun, working to make it meaningful as well. For the serious-minded, I was especially nurturing.

Many participants took time to immerse themselves. Burners already wear something expressive, so I didn't even bother with costumes. I just amped up the bouquets to be especially playful and Alex added Host-Guide magic, like the washing of hands with freshly poured rose water. In a dusty desert, that was one of the more powerful ways to switch attitudes into a ritual mindset. Almost everyone performed the banishing. Explaining the idea was easy, cajoling unnecessary.

But the first time I performed "'Til Death Do You Part—MARRY YOURSELF!" at Burning Man the year before, it was like I forgot everything I knew. I should have known better. My old camp, Whiskey and Whores, let me do the weddings in their humongous tent. While that was kind, what really worked best was a cozy chapel space. The bar made sense because of the toast. But the vibe didn't work the way I imagined. Intimacy evaporated in the large room with a stage and a stripper pole. It was too late to quit when people started arriving.

The stage seemed like a natural choice but it was weird. Participants repeated their vows into a microphone while a trained audience cheered them on when spurred. This seemed like a good idea at the time, sort of like a traditional marriage where everyone hears the bride and groom's vows, but it should come as no surprise that the Whiskey and Whores camp had a tendency to attract drunkards. The best moments happened with natural extroverts, but many just froze on the mic. They didn't get much out of it and sheepishly went through the motions. One guy stripped, so I mc'd the insanity but it intimidated others.

For the banishings, we moved a bit away from the microphone, encouraging a fun zapping motion to amuse the audience while ridding the demons with a modicum of privacy. When you start hurling pain into the orb, it can become important. Those moments worked in spite of the setbacks. The most memorable participant was a skeptical girl who hugged me tightly afterwards, genuinely astonished at her reaction. "This is real," she said.

But the mirror was missing. They weren't marrying themselves, they were putting on a show for a distracted audience. Privacy is the crux of the piece, even for the jokers. If you're too self-conscious there's no room to surprise yourself. The mirror is important because the truth happens in your eyes. This is where art and life intersect, where even the silly vows stick with you. Making a vow to eat more chocolate cake suddenly takes on power.

It doesn't need to be somber, but art should make you feel something strong. Indifference is death to art and love alike. If someone treats the whole thing as a total lark, I play along and we have a blast, like with the robot couple who never removed their masks, grunting the entire time. They had a fantastic time and the cheers were genuine—success! It's more like improv than ballet, but as a performer, I like a solid reaction. I kicked myself at the tepid results because I wasn't new at any of this. I hoped someone had gotten something out of it, but it felt like a disaster.

We packed up early that first year, but before leaving I performed one last quiet wedding with the organizer for Whiskey and Whores, my friend Nicole P., who was looking forward to marrying herself after a year of difficult work and relationship changes. I was glad she missed our bizarre stage version of "MARRY YOURSELF!" setting up camp all day. She emerged in a ferocious, cleavage driven, body-hugging dress and heels. She carefully filled out her vows, adding a few of her own, ready to rock the banishing in the theatrical space that's rarely hers alone. She closed her eyes, aiming her palms at the space between my hands until I could practically see the darkness leaving her, filling our invented orb. "One, two three, BOOM!" I felt that one in my chest.

Breathless, I guided her toward the mirror behind the bar, where no bartenders were left to interfere. With my hand on her back, I spoke her vows quietly into her ear, making sure she didn't cheat and look away from her own eyes. Monitoring eye contact is one of my most important tasks as Priestess. Avoid marrying the curtains! When people connect with their eyes, it's not uncommon for them to break into tears. Tall and poised, Nicole kept her eyes forward on the bride, saturating each vow with significance. I pronounced her married to herself. We shared a drink, hugged and parted. A few days later I ran into Nicole, wearing her ring. She said that a woman came after we'd gone, seeking a personal wedding, sad that we weren't there. Nicole did the ceremony with her. She found stuff we left behind, offering the participant a lost ring and a sheet of multiple-choice vows to fill out. Only knowing one version, she officiated the ritual she had found so moving an hour before. Nicole held the imaginary orb in her hands as she spoke about the woman's banishing of past selves, hurts and pains. She kept her participant's eyes in the mirror. "Was that all right? I really enjoyed doing it, I hope you don't mind."

My eyes filled with sweet tears that must be the stuff of motherhood. I hugged and thanked her for making me feel better about "the disaster," but also for the sweetest confirmation of my vow, ten years before, to abet people through self-weddings. The inadvertent passing of the torch brought the work to a new and beautiful level, and the most passionate, unwritten vow was kept. My marriage, though sometimes rocky, is a success. The playa does provide.

L. GABRIELLE PENABAZ

THE GREAT CANADIAN BEAVER EATING CONTEST: AN ORAL HISTORY

ANNA ROMANOVSKA

MartinJay and Pollyanna at BM, 2001

The rumour goes that the Great Canadian Beaver Eating Contest (GCBEC) is the finest gift ever given by Canadians to Black Rock City. Two long-time burners, who go by the names Wicked Sunshine and Leopard Queen, started the event, which by now has become legendary across the Burning Man community. What follows is personal reflections from Pollyanna, a participant in the GCBEC. She writes about how taking part in the event affected her perception of intimacy and identity. Included also are first-hand stories of Pollyanna's partner MartinJay's experience, and a few more of their friends' memory snippets.

Followed by the story of beginnings of the GCBEC retold by founder and muse of the event, Leopard Queen.

POLLYANNA'S STORY: ON BECOMING AN EXHIBITIONIST AND VOYEUR AT GCBEC

Pollyanna is my playa name. I chose the name because I wanted to come across as a non-threatening person when rangering during the event. With MartinJay, my partner, I started attending Burning Man in 2001. That first year we may have seen a GCBEC sign near our camp, but we had no idea what it implied. Back then, MartinJay and I were innocent tourists who were keen on going a bit crazy in the

midst of the dusty city, so it was small wonder that we missed a cue here and there. My illustration *MartinJay and Pollyanna at BM in 2001* portrays how blissfully happy and ignorant MartinJay and I looked at Burning Man that year.

MartinJay returned to the playa by himself in 2003, when the GCBEC event was still being held at the Gigsville camp with the Skynrd Boys operating security. In 2004 the event was transferred to the Lost Penguin camp. By that time the line-up of hopeful contestants and curiosity seekers was huge, stretching out onto the Esplanade. But, according to MartinJay, one woman found a way to get around that. She showed up buck naked and was quickly ushered inside.

By 2005, MartinJay and I had become established citizens of Black Rock City, but when in that year he suggested we actually participate in the GCBEC I was overcome by a rush of mixed feelings. Since I dislike contests and often succumb to shyness I found myself weighing the prospect of fresh pleasures against the likelihood of acute embarrassment. Many of our friends would be participating either as voyeurs, exhibitionists or volunteers so I could expect to feel more comfortable than usual about stretching my boundaries. Besides, I always considered Burning Man as an ideal environment for "experiential and transformative learning."

In 2005 the GCBEC was held at the Playa Q camp. It did nothing to allay my anxiety when MartinJay, standing in queue beside me, was suddenly pulled away on a security detail. Nor was MartinJay very happy to think that I would be competing without him, so he cut his duties short and rejoined me by slipping into the tent through the back.

Before the opening of the 2005 contest, our friend Catch (who works as a professional nurse in the real world) addressed the participants of the GCBEC on the topic of safe sex. Wanting to share her knowledge as well as her pharmacy supplies in appropriate attire, Catch appeared in a naughty silk nurse outfit with white thigh-highs and some strappy high heels.

Armed with a box of condoms, she gave a short demo on how to make a dental dam by cutting a condom—preferably unlubricated—down one side. Catch handed out quite a few condoms, answered some questions, and then left the assembly intending to return to her home camp. Outside, one of the Rangers implored Catch to return to the tent, saying that for someone so delicious it was simply not the time to leave.

Catch told me that she took his point to heart. Back inside, tactfully but with some eagerness Catch and her new partner asked consent to share a patch of unclaimed mattress. For Catch it was always an exciting experience to get to know a new partner in a public forum, especially when they know what they are doing, and because this particular Ranger went far beyond the call of duty that night, Catch was afterwards awarded a "personal massager" for her impressive vocalizations.

Before the event got underway in earnest, Wicked Sunshine in the role of the Masturbator of Ceremonies, took the mic and rhymed off the contest rules. There would be NO fellatio, coitus or other forms of penetrative sex allowed. Anyone caught doing anything other than cunnilingus would be disqualified. At the end of his little speech the Masturbator rang a bell and yelled "GO!"

Sudden Disruption, a voyeur during the contest in 2005, has posted a vivid description of the contest on his blog:

> During these first minutes there was lots of laughing and smart remarks. To be honest, the situation wasn't very erotic. Then some couples started getting serious. These were the hard core performers (pun intended). They didn't seem shy at all. For others it was more like gymnastics. These "performers" were all about position. They changed it every few seconds so it came off as a bit of a comic dance. In some cases, the ladies were being held in the air or were hanging from the poles of the tent. With other couples, the woman did most of

Nurse Catch giving a speech on safe sex during GCBEC, 2005

the "performing." But some weren't acting at all. Or maybe they were, just doing a great job at it. It's hard to tell. I've noticed that public sex often uses comedy to deflect other emotion. It seems that if they are laughing, they don't have to deal with that fine line between erotic and obscene. That's how it was in the tent.[1]

Reading this post for the first time, I realized that Sudden Disruption must have been watching me as well. I too remember seeing the well-choreographed routines and thinking to myself, so much time and effort put into rehearsing pleasure.

In 2006, MartinJay and I once again participated in GCBEC, and as before our friend Mental Floss DJ'd the event, making him more a volunteer than a direct participant. He found his role intriguing because he had often served as the focus entertainment, but at GCBEC he was definitely displaced to the margin. He also had to care more about the music he played and how it fit with the environment and the mood of the participants. In his words:

It was cool to see everyone get past the initial nervousness after first entering the room, but I think the excitement from those who were already comfortable spread quickly. It was also interesting to see who of my friends showed up and participated. Either they were more exhibitionist than I realized, or their behavior was a testament to how the Burn can make people open up and be comfortable with themselves and around others.

In 2006 an even longer queue formed outside the tent. Some people didn't seem to know what the contest was about, while others seemed reluctant or faint-hearted. Obviously the line could use some trimming, so one of the Lost Penguins went through with a flashlight. He asked each couple in turn, "Are you ready to get naked

and really perform? We don't have room for slackers." At one point he challenged a lesbian couple, claiming the event was for heteros only. They pleaded and promised to deliver, but he insisted they weren't qualified. They walked off in a huff, proving that even Burning Man has its prudish moments.[2]

MartinJay and I wandered to the front of the queue where our friend Love-on-Wheels was guarding the entrance. He let us in and we ended up in the large, enclosed space, the floor being covered with carpets and mattresses. A few couples were already there but we did not recognize them. We had arrived much too early, so MartinJay, once again, decided to help with security. I chose a mattress and sat down. I knew it would be a long wait and hoped to see somebody I knew. After a while, time stopped for me and I felt increasingly lonely sitting on an empty mattress in the midst of this mounting erotic tension. I reflected on one of the paradoxes of Burning Man. There are moments when an individual, even though surrounded by friendly celebrants, can plunge into utter loneliness, despite the fact that one of the guiding principles of the event is radical inclusion. I recalled my friends telling stories about deep insecurities that can surface abruptly in the midst of the event, leading to a painful sense of alienation under the billowing pleasure dome.

Around me were couples who seemed to care only for one another and did not engage in conversations with other couples. Still all alone, I was working very hard on letting go of my insecurities. I did not feel aroused at all and I questioned my decision to participate. I kept reminding myself that MartinJay would return before the event started and in the meantime it was okay to sit pretty, all by myself, while the rest of the crowd cheerfully assumed the roles of voyeurs or exhibitionists. I watched these gorgeous people, eager to play and primed to win. Some stretched, warming up for acrobatic acts, while others tried out a few choreographed moves, looking like synchronized swimmers turned upside down. Some couples checked out the mattresses and the surrounding area, or kissed their partners. Some chatted, adjusted their costumes, and made space for couples who had just arrived. For the moment I had assumed the role of a voyeur. Watching all of these activities entertained and finally relaxed me and I noticed a warm, insistent, satisfying, fuzzy sexual energy starting to coil in my belly. Some would say that my Kundalini was waking up.

My friend ThailandRg and her boyfriend Corey came in and landed beside me. I was so happy to see people I knew and even more so to have enough space on the double mattress for them to play and warm up. I was ready now to interact. Eventually MartinJay returned and all four of us assumed the best possible positions in the packed space. My whole system was exhilarated in anticipation, my insecurities quite forgotten. ThailandRg and I were lying on our backs, while MartinJay and Corey crouched at our feet waiting for the start. ThailandRg told me recently when recalling the moment: "I'll never forget—you and me on our backs, MartinJay and Corey at our feet waiting for the start, and you leaned over to me with a flask and asked if I'd like a sip of scotch in your beautiful accent." Indeed, that moment set a bond. The space was thick with sexual energy—so much so that if you had thrown a dildo in the air it would not have dropped to the ground.

Then the Masturbator of Ceremonies reminded us about the rules, and as the astronaut countdown started, my whole being got as open and as revealed as it could possibly be. At the end of the countdown, the opening song for GCBEC 2006 lifted the roof. Mental Floss had put on the Canadian National Anthem performed by the Canadian rock band Big Sugar. The epic sounds just flew through me and my aroused being and kicked my crotch. Before MartinJay's tongue got where it was supposed to go, I was overcome by the intense feeling of how much I belonged there at that moment, how I had overcome my insecurities and feelings of loneliness, and how proud I was to be among my Canadian friends who had created such a fantastic and wicked game at Black Rock City.

ANNA ROMANOVSKA

VOYEURS INSPIRE EXHIBITIONISTS: LEOPARD QUEEN'S STORY

I first found out about Burning Man in 1997 when my friend Sunshine showed me an article about it in *WIRED*. After reading the article, I knew I had to make it to the playa—I did so the following year. When I returned home from the event, I told Sunshine he had to go to Burning Man, so both he and my friend Spurz joined me in making the trek down from Toronto the following year. And so, 1999 was my second year at Burning Man and we all ended up camping with Gigsville—a village I had camped and fallen in love with the year previous.

At the end of the 1999 Burn we were driving back to Las Vegas to return our rental RV, and it was then we all decided we should come up with a Canadian theme camp. One of our initial ideas was to construct a big dome and dress it up like an igloo. All of us would dress like Mounties (Royal Canadian Mounted Police), and we would serve Screech at the bar. We were coming up with tons of ideas and then I blurted out "Why don't we do a Great Canadian Beaver Eating Contest?!" Sunshine, being a big fan of the female anatomy, was all: "Oh my god, a Great Canadian Beaver Eating Contest! Yes!" And so instantly, we decided we would make that our project for the next year.

We actually ended up doing a whole Canadian-themed camp with several other villains, which we called Club Seal. The GCBEC was to be an event that we held at Club Seal in Gigsville. We had several Americans in our group, and a favorite moment was when we ended up giving proper spelling pronunciation lessons to this crew (think: out, about, cheque, etc.). When they passed we made them into honorary Canadians. This was part of the Club Seal initiation.

Club Seal was a fairly open space and we realized we would need both an enclosed space and security in order to host the event safely. We were very fortunate that the folks over at the Wheel of Misfortune camp had a secured, walled-in space and thanks to Sunshine's outreach they offered to host the event. The boys over at Camp Skynyrd stepped up and offered to take care of security—they figured there would be people trying to crawl under the walls to gain entrance, and they were right. We were so fortunate for their presence, as it turned out that hundreds of people showed up for the event. Without the Wheel of Misfortune and Camp Skynyrd I'm not sure it would have been possible to have pulled off the very first GCBEC.

At the beginning of the week of the event, Wicked Sunshine approached random friendly camps to ask if he could borrow a mattress or two. I don't know if he told them what they would be used for, and I don't know who helped him or how he transported the mattresses to the event location. He needed as many mattresses as he could get, since more mattresses meant more contestants. Sunshine also needed security and many volunteers. Some of the Black Rock Rangers and others happily filled the role of security.

One of our steadfast rules for the GCBEC was that there were to be no single men admitted as part of the audience, because of the potential for things to get weird—and obviously, no single man could possibly enter as a contestant! I mean, all you had to do if you wanted to attend was to find a woman to accompany you. If you couldn't find a woman to go with you, then it wasn't the right place to be. I am fond of saying "If you can't find a woman to accompany you to the GCBEC, your shit just ain't right." I still stand by this assertion. A woman's agreement to accompany a man to the event became our litmus test for admittance—it was also our main criterion for allowing people in as our audience. We knew we had to create a safe and comfortable environment in order for the event to be a success.

Another important consideration in setting up the event was to make sure that there was a buffer zone of at least three feet between the audience and the contestants. We wanted to have some open physical space that was a boundary line that prevented audience members from edging into the contestant's area—the simple fact was that

you either attended the GCBEC as a contestant or as an audience member and those lines did not blur. To this end, we always ensured that the contestants entered the space and got settled first. The audience size was determined by the space that was left over. We tried hard to set a space where everyone could have a good time without experiencing creepy vibes or any uninvited physical interloping.

One of the first mandates we determined for GCBEC was that it would be an event for the enjoyment of voyeurs and exhibitionists alike. The audience was there to cheer on the contestants, and though they were discouraged from getting sexual during the actual contest, they were certainly welcome to watch and enjoy it! We modeled this concept on play parties—there were people who were just there to watch and not interested in touching anyone or getting involved in play, but were voyeurs enjoying the scenery. The exhibitionists were there because they dug having someone watch them, it turned them on. Without a voyeur, there was nothing for the exhibitionist, and without an audience, there was no contest. So, the GCBEC was set up to satisfy all of these needs.

I have been asked about the inclusion of the audience more than a few times— you know the routine: "Hey, BM is about participation and the GCBEC audience isn't participating!" I respectfully disagree as those in the audience were participating as voyeurs and as cheerleaders. Whenever anyone brings up the whole "BM is all about the participation" angle, I point out that at the actual Burn very few people get to participate; most are on the perimeter enjoying the spectacle. They participate by being there, by being the crowd, and by feeding off and into the energy of setting fire to the Man.

I can't remember exactly how long the contest lasted, but two hours is probably about right. We decided to have five judges in order to eliminate the possibility of a stalemate. Contestants were strongly encouraged to bribe judges. There were a few rules the contestants had to follow, and these were announced by our Masturbator of Ceremonies at the start of the event. They included the following: contestants were free to employ the use of facial features, tongues and mouths in their beaver eating, but there were to be no toys, and no penetration with fingers, hands or genitals. The judging criteria was based on the contestants' enthusiasm, hairstyle—think below the belly-button, feel free to get creative! Costuming, use of nose, and overall performance and creativity were likewise rewarded. We were asked more than once whether there could be fellatio, or reciprocation from the "eatee" to the "eater," but that would really just be a pole-smoking contest. This was a beaver eating contest— open to any combination of women and men—women/women, men/women, it's all good—but it's not at all about dick. It's about beaver, and female pleasure.

People would always ask, "How do you pick the winner?" The truth is that the winner always let him or herself be known. You always knew who had won the contest—it was actually pretty obvious to a judge. One year we had a three-way— two women and one man set up a trapeze. It was a circus act. Every year, people got more ornate—we were often told: "We have been practicing all year for this contest!" There were custom costumes, the waxing and colouring of hair-down-there was beyond imaginative. The contestants of the GCBEC really were amazing!

I have trouble relating to the fact that people have issues with the human body, that there are still wild hang-ups with body image, and with sexuality. I don't anticipate people who have problems celebrating our physical selves and our sensuality—which is what the GCBEC is all about at its core. In the days leading up to the first contest in 2000, several women came up to me and expressed a lot of negativity relative to the nature of the event. I was told: "I think it's disgusting what you're doing" and "It's going be a train wreck." After hearing several iterations of this, I got nervous, thinking, "Oh my god, maybe this is a mistake, maybe they're right!" I really second-guessed myself—the last thing I wanted was for the GCBEC

Wicked Sunshine at BM, 2006

to become a full-blown orgy. But the actual event—well, it was just really wonderful, beautiful, incredibly loving and warm.

The best story I have about the GCBEC took place on the Friday after the very first event. A couple came to Gisgville to find me and share their story. They told me:

> You know, we have been married 25 years now, and our sex life has kind of declined. It isn't that hot and heavy anymore, we aren't having a satisfying sex life, and we didn't know if we maybe needed to open up our relationship and start exploring with other people to inject the heat back into it. Then we went to GCBEC last night as contestants. When we got out of the event, we had to run back to our tent because we were so turned on! We had the hottest sex we've had in the last 15 years! All of a sudden we found love with each other again... the event rekindled our sexuality and we wanted to come and thank you.

Their words were so heartfelt, and so much the opposite of the warnings I got leading up to the event. It made me feel great to hear from them given the early negativity—afterwards it was all positivity, people were saying "Oh, it was so amazing, and my wife and I—or my husband and I—we totally reconnected in a new way!"

It was a roller coaster ride going into the event. At points I got discouraged, and then after it was very much a boost. So much of the pornography and sexuality that we see is all about a man's satisfaction and pleasure, it's rarely focused on a woman's experience. That was a big part of the idea behind GCBEC that it would be about finding pleasure for the woman, and celebrating that pleasure. The act of going down on *her*, celebrating the female anatomy and the female orgasm. To that end, I feel that the GCBEC was and is all about the empowerment and education of feeling good and positive with and about our bodies and our sexuality, exploring our senses, and being able to freely share that with our partners. It is extremely satisfying to know that some folks came away from the Great Canadian Beaver Eating Contest with just that sort of experience, because that really is the energy and intent with which it was originally conceived.

For exhibitionists and voyeurs alike—GCBEC in action

TO YOU A DEW

Alas, that blissful frolic of 2006 was to be the last Great Canadian Beaver Eating Contest held at Black Rock City. For personal reasons neither Leopard Queen nor Wicked Sunshine, the chief animators of the event, were able to return to the playa in subsequent years, and thus far no-one has emerged to take their place. It seems that something always stands in the way when there is talk of resurrecting the event. One year it might be the lack of a fully enclosed space, another year the absence of security, of mattresses, or of an engaging DJ.

But let us take the optimistic view. Let us assume that a coy little notion is even now incubating somewhere deep in the velvet folds of the feminine psyche. There it is being softened, enhanced and transformed. Perhaps the event, being woman-centered, will in its next manifestation dispense with the burlesque competitive element. It could be renamed a "feast" or a "festival" —anything but a contest. Then again, perhaps the GCBEF is just biding its time until it can burst forth in a mighty orgasmic shower of sparks that ignite beaver eating frenzies right across this continent, from Flipside in Texas to MooseMan in Ontario, from FireFly in Vermont to the Lakes of Fire in Michigan.

**Original illustrations by the author.*

NOTES

1. Sudden Disruption, "Lost Penguin's Great Canadian Beaver Eating Contest," 2005, http://suddendisruption.blogspot.ca/2008/07/00-birds-eye-view-theme-psyche-favorite.html. Accessed: 30 December 2012.

2. Sudden Disruption, accessed: 30 December 2012.

ANNA ROMANOVSKA

KICKING UP DUST WITH THE SPACE COWBOYS
ANDREA LUNDQUIST

The Space Cowboys started as innocently as most camps, approximately 15 years ago. The common memory is that the camp started in 1997. Or was it 1996? Some friends had gone the year before, and the stories they brought back were like recruitment catnip. A couple of type-As in the group started doing research on Burning Man, and really locked into the idea that it was not a spectator event, that people who went were participants, responsible for co-creating the event. The bulk of research was done by an engineer and an engine hobbyist, so it made sense that their ambitions were quickly set on building a vehicle of some sort.

The vehicle would be at the center of the nascent camp, but the group still needed a theme. Because the vehicle they'd created—a tall, two wheeled contraption ridden from a saddle and steered by a pair of ropes hanging from each side— vaguely resembled a horse, and probably because Piedmont on Haight Street was having a sale on their sheer shiny silver fabric that would become outfits for the riders, the idea of the Space Cowboys was settled on. The Space Cowboys had crash-landed at Burning Man, and had decided to explore, celebrate and sample before rebuilding their rocket and blasting off into the sunset. Really, that first camp didn't have much else beyond a few people in tight silver pants and sparkly cowboy hats, and the mechanical horse named Glory.

The next year, the group got better real estate. We were camped at Center Camp, next to a barter bar, Starlust Lounge. The Space Cowboys' possibilities grew a little bit when we were able to borrow a sound system and create an impromptu dance party at the neighboring bar. That was our first taste of our true potential, and we went home from the playa with new ideas about a bigger bar, bigger sound system, and more parties.

We returned to the playa the following year with our most ambitious plan yet. We'd purchased a sound system, built our own bar (complete with saloon doors) and planned to house it all under a three-story shade structure erected with borrowed scaffolding. We were open every day, with the highlight of our week being the first ever Black Rock Hoe Down on Saturday Night after the Burn. We had a line up of our own DJs, who train-wrecked through the best party anyone in the group had ever seen.

The next evolution of the camp was The Beast. It was built while the camp was down the corner at 10 o'clock and Oblivion or whatever the outer edge of the world was called back then. Again, having ambitious, type-A freaks fueled by a chemically enhanced cocktail of creativity and inspiration, the gear heads in the group constructed a monstrosity of steel that looked like offspring from an unholy union between a train and an erector set. The best thing we can say about The Beast is that no one died. Its body rots somewhere in the hills of Geyserville. But it did lay the groundwork for the group's biggest accomplishment. After a few years building the same camp and throwing the same party, boredom set in—often the foundation for new, stupid, and sometimes stupidly brilliant ideas. We heard that the German government was selling off unused stock of Mercedes Unimogs that had belonged to the former East German military. Someone knew a guy who knew a guy, and $5,000 later our Unimog was delivered to the Port of Oakland.

Because none of us had a garage big enough, and because weekly street cleaning tickets were still cheaper than the cost of a rental, we did all the modifications to the Mog in front of a Cowboy's house on 18th Street in the Mission. Over the course of a

summer, the 70s era standard issue radio truck became a mobile DJ sound system, complete with an amp cabinet, fold-out subwoofers, front-mounted three-ways, and a DJ coffin with turntables secured with a mesh of bungee cables that would keep the records from skipping while the Mog was in motion. The cherry on top was a custom plexiglass dome hovering over the top like something out of a 1950s sci-fi movie.

When it made its debut on the playa in 2001, the Mog was probably the first mobile DJ sound system anyone had seen. It was certainly the loudest. On its maiden voyage, a circuit around the Esplanade, the Mog was like a giant mechanical pied piper. Burners, some looking like rats, ran screaming from their camps or open playa, cheering and smiling, and falling in behind us to dance. We rolled all over the playa, creating impromptu parties wherever we went, or plugging into other camps' sound systems to expand their parties. There was no competition, no complaints. We brought the party, and people were stoked.

My first year on the playa was with the Space Cowboys in 2002. A friend from college introduced me to the crew in a whiskey-fueled dance bender at a club in SF the year before. The next day everyone I met at the club went to Golden Gate park to play kickball. The simple kickball outing included a keg, a generator, a full DJ set up including speakers and turntables, and these weird canisters. There were a few dozen 30-somethings who preceded hipsters kicking away at their game. Everyone wore RIPE labeled schwag and a few cowboy hats. It was an interesting and eclectic combo of personalities that would soon become my family.

Before going to the playa I was schooled by the Cowboys who had been going for several years. There was gear to buy, costumes to prepare, bikes to acquire and outfit. Headlamps, goggles, boots, camelbacks, fluvogs—and I didn't even have a smart phone yet. Within the camp there was a huge list of infrastructure details: truck rental, transportation, kitchen and common areas, tarps, scaffolding. Then there were art projects, art cars, performances and events. We spent all summer, or at least 90 per cent of July and August getting the Unimog ready, building motorized ponies, memorizing choreography, prepping the huge screens for the ridiculous amount of technology we were bringing to the desert. CRT projectors, video software, laptops, monitors, speakers, turntables. An entire trailer of equipment, tools, cables, generators, back ups of *everything*. I learned what rebar is, what not to do, what to be sure to do, and who had done what. I had never welded or studied axels before moving to SF. I had not used a jigsaw or bent rebar stakes. I shopped at JoAnn Fabrics like I knew what I was doing. I cut patterns, spray painted a lot of things silver, and soldered electroluminescent wire. By the time we actually arrived and drove through the gates and rang the bell and rolled on the ground (really? Did I have to?) it was almost anti-climactic. I was here! Yay! Now it was time to spend 12 hours setting up my tent and shade structure, get the ponies off the trailer, get a beer in a koozie, sunscreen, drink some water, unload something else, make out with this guy, find a "something specific" in the trailer, put gas in the art car.... I felt compelled to task every second I was out there. There was so much to do.

Over the years the shenanigans of the Cowboys preceded the actual shenanigans. We made friends with a neighboring camp, Space Lounge. The night before the big Space Lounge party, the camp blew their janky ass sound system that was cobbled together by non-powered speakers and mismatched amps. Some of the Loungers were catching a midday beer at the Space Cowboy bar and lamenting their fate that they blew their shit and would have to cancel the somewhat legendary Thursday night blowout at the Space Lounge camp—always located at the end of 2 o'clock. Mind you, this was back when all sound camps on the two and ten axels were of more or less equal size, and the corner camps were of a more modest disposition and big name international DJs were yet to be imported to the playa. So the ten and two streets were teeming with people that would vote with their feet where to go, and

the geodesic dome covered with CDs was a wonderful place where they broke the rules of the 'gift economy' and ran a barter bar where the stories told could fill a book chapter—a bar that the Cowboys loved to frequent.

Back in these smaller days, people had no issue biking to halls of repute stocked with local DJs. After overhearing the Loungers' predicament at the bar, some of the Cowboys generously offered the use of their sound system—which would require shutting down the Space Cowboys camp for Thursday night, sacrificing all DJ slots in the process. But how to get the sound all the way across the playa from the outskirts of 10 o'clock to 2 o'clock? Luckily the Space Lounge art car Martha made her debut on the playa that year. Adorned with flame-throwers and modified 'wings', she could carry 30-plus folks at the standard 5mph pace. When Martha returned to Space Lounge camp, there was a dust storm and the sight of her adorned with Loungers, Cowboys, and bass cabinets trundling through the dust-speckled fray inspired a camp-wide cheer. The Thursday night party went OFF thanks to the Cowboys! Space Lounge elected to intentionally close their entire theme camp down on Friday night to join the Cowboys at the Hoe Down. The camp was abandoned, and a small Sharpied sign read: "We're out partying with the Space Cowboys!" The lights were left on so people could still bike up, but all the Loungers were gone, the only thing there was the sign. This started the tradition of Space Lounge shutting down on Friday night to join with the Cowboys, which ultimately paved the road for deeper mixing of our crews. It led to neighboring camp assignments on the playa for a few years, co-habitation, even marriages, and the fusion of two great groups of people. When the guys and girls of Space Lounge later decided to break down their camp, the Cowboys inherited several of their crew into the Space Cowboy family.

The Space Cowboys were my team, my crew, my family. Our neighbors were our friends. The name recognition was instant anywhere on the playa. Everyone wanted to know where the Hoe Down was going to be, where would the Mog be for the Burn? We were camped at the outskirts of 2 o'clock for a few years. Our art projects and party were also there. Center Camp seemed like a very inconvenient and far place to go for daily errands. We had art cars, so it became a trip to the store for everyone. There was often yelling. "MARTHA IS LEAVING FOR CENTER CAMP! IF YOU NEED ICE GIVE US $$ NOW" or "GET YOUR EMPTY CANS ON THE TRUCK, WE'RE GOING TO RECYCLE CAMP!" Yelling got people to obey, and having a bullhorn was cool. Yelling into a bullhorn was one way to herd the cats. Having a bullhorn became a trend that could be seen (and heard) all over the playa.

When you saw a Space Cowboy they were usually wearing some article of clothing with RIPE in an orange oval. Just like the stickers on avocados. We began using this symbol after an innocent supermarket prank. Someone grabbed a roll of RIPE stickers on their way to the playa then ran around sticking them on people one night at a party. Everyone giggled, everyone wanted one. Flirting, drinking, sticking stickers on new and old friends. Then one of the smart ones put the stickers on some cables. Now we knew which speaker cables were ours! The stickers went on speakers, gear, cars, cords, records, tools, shoes, hats, wristbands, glasses. Then the avatar was born. RIPE patches were made. T-shirts, hats, boxers, hoodies and baby onesies. Everyone got RIPE gear, we made it in silver, red, black, camouflage. The gear became a calling card, like a fraternity sweatshirt. Wearing it all over the city turned heads and opened doors: that's what I was told.

Being part of Cowboy Camp meant parties, DJs, schedules and planned appearances. There were camps to find, dance floors to grace, addresses to locate, people to meet, lovers to find, and music to hear. There were bbqs with the neighbors, fire performances at art pieces, rendezvous to blow shit up deep out at that one "piece." Everything was random with a schedule. Playa Time was a weird twilight zone. There really are only two times of day when you're pretty

sure what time it is at Burning Man: sunrise and sunset. Seeing sunrise was sometimes a panic. Sunglasses? Where is my bike? Fuck, my tent is going to be hot. Did I put that thing away? Is my cooler in the shade? How much ice is left? The opposite feeling of calm came over while watching the sunset. That meant party time! The light is perfectly purple pink salmon loveliness. Everyone smiles, and is happy to be there at that moment. Sunset is probably the one time of day where you know that almost everyone at Burning Man is awake.

Some years the Cowboys were not so good at schedules. As Burning Man grew and more camps got sound systems more camps got mobile art cars. The playa got louder. There were parties every night, on every corner of Black Rock City. The Cowboy schedule became habitual for a few seasons with Wednesday being the first big night out with the Mog at the Earth Guardians camp. This became a tradition for this guy named Lorin, with really long hair, to play on the Mog. Thursday was Space Lounge, Friday was the Hoe Down, Saturday was the Burn and Sunday was the Temple. Cowboy camp moved from the far reaches of 2 o'clock to the coveted real estate of the Esplanade. We were next to Carp & Death Guild. We battled folks in Thunderdome, and won most of the time. We brought the Mog to Black Sabbath pancake breakfast on Sunday and watched them construct the Ramp of Death—a modified bike ramp, plywood and a milk crate. Bikers were heckled, the ramp was lit on fire. Girls wrestled in the dirt and Ozzy provided the soundtrack. We were supposed to be breaking down camp but how could you sober up then? Black Sabbath Breakfast was one of my favorite "only on the playa" moments.

Year after year the ideas grew and the phrase "You know what we should do?" was heard more often than not. We faced the ridiculous task of funding. We needed speakers, tires, domes, rent money for somewhere to store the Mog, cash for gas and insurance. We were not the first camp to throw a Burning Man fundraiser, but we were very good at it. Our parties were not desperate, they were deliberate. They were innovative. SCAM—Space Cowboys AM—started at 10:00 and ended at 18:00. Breakfast of Champions turned New Years Eve into a New Years Day marathon. Halloween developed into Ghost Ship. These SF events now attract over 5,000 people annually.

There have been hundreds of different folks who have camped with the Cowboys over the years. Some were friends of cousins from Canada who we never heard from again, others became so enthralled that they moved to SF thinking that we rolled Space Cowboy style in the city 24/7. This is of course not the case. Burning Man was an annual vacation, where we worked our asses off and partied equally ass-less. After the playa we would return to the city and our daily lives, jobs, homes, families and routines. But we had this constant reminder of responsibility that enabled us to have a Space Cowboy presence in San Francisco year round. We started bringing the Mog out to local events. Decompression, Love Parade, club nights at Mighty, Barneveld, driving her up to Tahoe for Snowfest, down to LA for a corporate gig. The upkeep, maintenance and long-term operating costs of Unimog had not been determined when the vehicle was first purchased and transformed. As our participation in more events grew, so did the liability. We established Space Cowboys, LLC in 2007 as a means to share that liability. In case the Mog ran someone over, it wouldn't fall under the driver's insurance. It was a friendly agreement of paperwork amongst friends, leaders and decision makers.

The business had no mission statement, no formal articles of incorporation, and no operating agreement. Meetings were held at the 500 Club, taxes were filed, franchise board dues paid. In 2008 we held the first Ghost Ship on Treasure Island for Halloween. It was a test of wills, patience, and citywide bureaucracy and a bit of Burning Man everywhere you looked. Some called it the playa icecapades. We invited art cars, art installations, DJs, theme camps and, for $20, anyone could come

and wait in line at the door. It was a sell out. The fire marshal was not happy with us. But our 1,500 friends sure were. No one got hurt, everyone had an amazing time, and the success was off the charts. People drank, the bars ran out of cups. There were silly stories in every corner, rain, cops (real! Not a costume) and amazing people with creative costumes rivaling the parade of people in the Castro. And the best part, now we had cash! We could pay for the Mog 2.0 overhaul bills, playa expenses, rent, past debt, new speakers and gear. A month later we hosted our Breakfast of Champions party on New Years Day. We had to deal with more lines around the building; thousands of happy dancers, friends, partiers and musicians crammed into one building. And even more cash! We started to contribute to outside projects: we donated to BRAF, sponsored AIDS Lifecycle riders and teams. We were able to use the seed money from one party to help finance the next. In 2010 we began releasing a weekly podcast of the music recorded at our parties, by our DJs and by our DJ friends all over the globe. The RIPEcast has slowly grown to 1,500-plus downloads a week, with thousands more streaming and sharing all over the social media music networks. It's a happy thought to know that a café in Amsterdam is playing a RIPEcast set, or that small beach bar in Thailand streams the sets every day. The Space Cowboy name has been used for thousands of other ventures: movies, bands, video games, prom themes. We are happy to share the exploration of the cosmos with any like-minded bandits.

As our success in the large-scale event world of San Francisco grew, our reputation on the playa remained unassuming. We brought out a small but heartfelt camp, and strove to throw an awesome hoe down at some of the coolest pieces of art out there. We participated with the Artery tours and visited our friends' camps. Our DJs hopped around to other sound camps, and the worlds at 10 and 2 o'clock grew to massive proportions. We had no desire to compete with the big names and the elaborate stages. We didn't print out a schedule of events before the playa because we liked to figure it out on the fly. We had 'special guests' who hung out with us because they liked us, not because we paid them or bought their tickets. No one knew our DJs' names, but everyone knew the Space Cowboys. It was marketing and branding that no one could buy, plan or predict. Our reputation, history and street creds were delivered in earnest and anonymity.

The sell-out of 2011 did not affect the Space Cowboys. When the lottery was announced in 2012 the Cowboys did not score so well, and only one third of our campmates who wanted tickets were able to purchase them. The Burning Man Organization did some legwork and research and allocated more tickets to us. When we met to discuss our plans for 2012 it was more of a hug and mug fest. Pizza and beers and "What the hell do you want to do?" Some folks wanted to do Fourth of Juplaya, and a few folks were dead set on the Burn. Would the Mog go to both? Neither? There was no clear decision, no mass momentum either way. The ticketing decisions of the Org definitely affected the Space Cowboys, and I think it killed the already weaning impetus of the crew. We weren't upset, and the initial "Fuck You Burning Man" wore off pretty quickly after the lottery announcements were made. Someone in our crew created a Craigslist ad, posted it in the Vacation Rentals section. FOR RENT: One Burning Man Camp. For a mere $42,000 you could have it all—the Mog, our kitchen, tents, chairs, name, reputation, placement and kick backs. The ad caused a ripple in the already overly sensitive SF burner community. We laughed our asses off, our friends reposted it all over Facebook. We got some calls, eventually took down the post, and assured the Org that we were not actually selling our theme camp and the posting was a joke. We were happy to laugh about it, and for many it was the first time anyone really got a good belly laugh out of the entire unfortunate and frustrating experience of the lottery ticketing.

What happens now? Rest assured the Cowboys will keep going to Burning Man. The LLC will continue. Maybe the Mog will miss a year or two, and maybe our numbers will dwindle. People can't stay away, and we've become accustomed to making plans for the following year while in exodus of another. The parties will continue, they now possess a momentum all of their own. Halloween will continue to happen every October, just as New Years Day happens every year. Ghost Ship and Breakfast of Champions will keep going until they don't. Whether or not Burning Man continues is not up to the Space Cowboys, or vice versa We'll continue down our happy little trails up and down northern California, and invite you to join us.

When you prepare for Burning Man you know only two things for certain; it will be dusty, and the Space Cowboys will be there to peel your caps back. Every year since we bothered to count the Space Cowboys have been the break beating heart of Black Rock City. But have you ever wondered what it would take to fill these boots? Now you and 20 of your ass-kicking-est homies can find out if you have the epic stones required to *be* the Space Cowboys at Burning Man 2012. Like making the roster of an NBA team, fighting your way to the top of a Korean crime Triad, or drinking an entire bottle of Cobra-Scorpion whiskey in one sitting, many have tried but only a moderate number have succeeded. This year we're giving a group of 21 brave (and monied) individuals the opportunity to put up or shut up. Think you can do what we do? You pony up $2,000.00 USD each and you'll get the shot. The jumpsuits, the hats, the vehicles, the shitty bar, the drugs but, you'll need to bring the attitude. Prepare to step up and shoulder the expectations of literally generations of Black Rock City Citizenry. Will you be aloof enough, cranky enough, crazy enough, cracked-out enough to uphold the tradition of (very disputably) the most storied camp of assholes the playa has ever seen and (mostly) heard?

BEGOGGLED IN THE THEATRE OF AWE: ELECTRONIC DANCE MUSIC CULTURE AT BURNING MAN

GRAHAM ST. JOHN

It was at a cocktail party at camp Daguerrodrome—aka Low Expectations—near the intersection of Faith and Sublime. I was on my maiden Burn—2003—and every moment, every sound, every word, seemed magnified in neon. Not unlike the on-the-spot admonishment Larry Harvey dealt me about that evil word "rave." In passing, I had mentioned a book I was then editing called *Rave Culture and Religion*,[1] but dropping the "R word" in the presence of Burning Man's founder and chief visionary was like flashing a *muleta* at a bull. His hackled response was understandable I knew even then, although my awareness of the issue expanded as I dove into the history and culture of electronic dance music (EDM) at Burning Man over subsequent years. In 2003, we were dancing in the dust clouds of a decade of discord over the presence of EDM and its chief agent: the DJ, a figure loved and loathed in equal measure. "Rave camps" had long been disputed on the playa—a source of antinomy expressed in art skirmishes, desert jousts and heated conflagrations. But this wasn't just an internal controversy. The legal status of "raves" threatened already tentative arrangements with law enforcement and licensing bodies whose ongoing approvals the city relies upon to function and flourish. After the successful passage of the Illicit Drug Anti-Proliferation Act of 2003—formerly known as the "RAVE Act," Senator Joe Biden's sponsored effort to "Reduce America's Vulnerability to Ecstasy"—police were empowered to impose heavy penalties on the organizers of events where "controlled substances" were found to be in use. Having become synonymous with these "substances," here was a word that literally killed the vibe.

Burning Man has never been a rave, but in 2003 Black Rock City was blanketed with the polyphonic ambiance of electrosonics after dark. With my ears still ringing from Larry's rant, I wandered only a few feet from Daguerrodrome to encounter a euphoric dance party lasting well into the night. At House of Lotus, and various other camps scattered around the clock, burners, in all their blinking absurdity and cognitive dissidence, were increasing their vulnerability to the possibilities of the wholly other. And the more I investigated, the more I discovered that EDM was embedded in the soundscape of Black Rock City, especially at its outer conurbations at 10 o'clock and 2 o'clock, the coordinates for a gathering storm. Yet there was nothing singular about what I was hearing in this optimal bohemia where at any moment one may be seduced or assaulted by noise filtered from the daily circus. A plucked banjo, a naked black metal outfit, Barry White, Jethro Tull and Peaches competed for attention as I rode through the neighborhood on a Persian carpet. There were other sounds too. A few days in and I'd grown accustomed to the accent of jubilation, a cacophonous poetry that rose from every street corner, and the crack of a whip, repeated as a random leather-chapped shemale unleashed nine of her best across my virgin butt. It's a common feeling among denizens of BRC that *all* of one's senses are smarting, that one *feels more alive* in this city than at any other time or place in one's life. Over days, a blizzard of sensory impressions accumulates to form a synesthetic avalanche under which one falls, and from which one may not return without being irrevocably changed. Here I focus specifically on music, and in particular EDM. And while there are multiple styles—i.e. techno, house, trance, drum 'n' bass, and dubstep—in 2003 I appeared to have accessed an advanced realm of sonic hybridization, organic and technical in nature.

I was perplexed and intrigued. Something unique was going down on this frontier unsettlement. Entire camps were dedicated to symbiotic sound soldering the

demented mechanics of which saw a variety of styles performed and mixed in ways that assisted the process in which one becomes unrecognizable even to one's self. These playa-identities encounter other altered selves in a city where the performers most capable of mixing diverse styles appear to enjoy considerable cachet. It struck me that this bizarre hipster universe was remarkably similar to other accomplished nadirs of stylistic profusion and influence in the history of EDM, like New York's Paradise Garage or Ibiza and Goa in the late 1980s. Only here we find a scene, indeed a city, founded on projects that employ and combine multiple media—from sculpture to mechanical, fire, circus and the body, to video and sound art—although an ocularcentric aesthetic appears to shape policy effecting the distribution of subsidies for the production of art at Burning Man. Yet fusion and diversity is endogenous to Burning Man, cultivated through "radical inclusion" and "radical self expression," among the Ten Principals in operation in this "promiscuous carnival of souls, a metaphysical fleamarket, a demolition derby of reality constructs colliding in a parched void." Burning Man's resident *techgnostic*, Erik Davis, who wrote those lines, has offered speculation on what he called the "cults" of Burning Man—"experience," "intoxicants," "flicker," "juxtapose" and "meaningless chaos"—described as "cultural patterns" which are refractions of Californian spiritual counterculture that perform, miscegenate and multiply in Black Rock City.[2] While Davis doesn't name formations sired from the union of these tendencies, others have surveyed the contours of the communities of "ritual without dogma" arising in BRC, such as the Flaming Lotus Girls, The Fire Conclave, Pepi Ozan's Operas, and The Temples.[3] Yet, existing research offers little attention to sound arts, nor the tempestuous career of EDM at Burning Man. Curiously, in *On the Edge of Utopia*, Rachel Bowditch makes no reference to this conflict, perhaps unsurprising in a project committed to the visual art form. While some won't consider burner-sonics as arts of "performance and ritual," in his *The Tribes of Burning Man*, journalist Steven Jones investigates a network of art "tribes" that have thrived within and proliferated beyond the trash fence during the 2005–2010 "renaissance."[4] While there is a tendency to prostrate himself before DJs as godlike objects of worship, Jones offers useful details relative to the ways sonic arts have grown integral to popular projects rippling across the playa, and moreover the synergy of EDM with fire, sculpture, and mutant vehicles.

While its status as a rave is disputed, evidence for what was once dubbed "the ultimate metarave" was in ample supply by my second trip to BRC in 2006.[5] It was amplified in the wake of the torching of BRC's eponymous figure when the city's inhabitants and hundreds of mutant vehicles—many with their own DJs queuing up the sonic apocalypse—encircled the Man in a scene approximating the Drive-In at the End of Time. Packed with fireworks and mortar-rockets, the figure eventually cascaded with sparks and succumbed to a spectacular series of detonations, its demise willed by the bold and the sumptuous whose paroxysms produced a mushroom cloud of fine white dust observable from space. It had been suggested by two of my Daguerrodrome comrades that "the burning of the Man opens up opportunities to embody a popular dance orgasm facilitated by modern technologies."[6] In the aftermath of the 2006 blaze I explored these opportunities, hazarding into a Space Cowboys wagon circle and Hoe Down. Kitted out with a quality sound rig, video projectors, screens, radio transmitters, onboard generators and an orange bomber dome under which a vinyl-playing DJ took position, the Space Cowboys Unimog All-Terrain Audio Visual Assault Vehicle (ATAVAV) has been described as "the largest off-road sound system in the world."[7] As an outrageous accomplishment in sensory technology, bass and breaks propagated across the alkaline desert night, animating multitudes wired-up and el-wired.

But Black Rock City is one mother of distractions, and catching my eye in deep playa there appeared a gigantic haystack winking in green luminescence. As I orbited

the mystery, I determined that it was no mirage. An object 200 feet long, 100 feet wide and 50 feet high, *Uchronia* was an installation funded by Belgian artists and built using rejected timber from a Canadian lumber mill by dozens of volunteers. Used in the title of Charles Renouvier's 1876 novel *Uchronie* (*L'Utopie dans l'histoire*) and replacing *topos* (from "utopia," which literally means "no place") with *chronos* (time) to generate a word that literally means *no time*, "uchronic" refers to an "alternate history" that enables its observers to challenge their "reality." For its creators, *Uchronia* was a "portal, showing us what the world could be like if creativity ruled supreme" and time was hung differently.[8] What one observer described as a "giant's haystack twisted into a computer model of a wave with curved entrances on three sides,"[9] was an intentional parallel-world posing the question to its Uchronian occupants in the fashion alternate histories pose for their readers: "What if?" With the desert night a welcome reprieve from the frying sun and whiteouts, and its occupants bathed in neon-green, what would become more widely known as "the Belgian Waffle" was a dance club. And, on the final night, it burned. With its image seared into my retinas for weeks, *Uchronia* became a cavernous conflagration, an allegory of impermanence, the flaming whispers of which engulfed all who witnessed. In the wake of its desolation, on the celebratory margins of its dissolution, sensual acts of beauty transpired in blinking conclaves upon the playa. In its remarkably short life, surely it was one of the most fabulous clubs ever created.

TECHNO GHETTO

This offers quite a contrast to earlier years. EDM was first amplified at Burning Man in 1992 when a small "rave camp" appeared a mile from the main encampment "glomming parasitically onto the Porta-Johns."[10] The camp was organized by Psychic TV member Craig Ellenwood of the early East Oakland acid party crew Mr Floppy's Flophouse. The headline act was Goa Gil, who played from Aphex Twin's "Digeridoo" on digital audio tape to no more than 25 people. Also playing to hardly anybody were Brad Tumbleweed, Dave Synthesis (aka "Dsyn"), Craig and Terbo Ted, who has the mantle of being the first person to play a DJ set at Burning Man.[11] Ted said to me: "I played on Friday afternoon to literally no one, with only ten miles of dust in front of me. It was awesome." While he didn't recall precisely, the first track was probably some "spacey stuff" from a Jean Michel Jarre 12 inch from Craig Ellenwood's record pile, "a record he was willing to sacrifice to the elements." It was "literally a sound check." [12]

The set up the following year was equally primitive. Charles Gadeken recalled: "I remember going out to the rave camp, it was five guys, a van, a couple of big speakers, a cardboard box covered in tin foil, colored lights and a strobe light. It was all cool."[13]

The general reception, however, was much cooler. Ted recalls that the punk— add your own prefix: anarcho, cyber, steam, neuro, shotgun, etc.—sensibility predominating at Burning Man held DJ culture complicit with "consumer society and a stain on an otherwise anarchistic, art-oriented event."

On one morning near sunrise in 1993, a hippie dude came up to me while I was playing music on the sound system and held up a knife towards me and yelled "Are you crazy?" And I said "No, you're the one with a knife." Then he said he was going to cut me or the speakers. So I turned the music down, ditched the decks and circled far and wide off into the desert. He tried to cut the speaker cones with his knife but they had metal grills on the front, he looked like a fool and gave up and wandered off. I put on a cassette of Squeeze's "Black Coffee in Bed" as he walked away.

The Organisation insisted that the techno reservationists maintain their isolation a mile from Main Camp between 1992–1996 during which time the camp evolved

into a kind of outlaw satellite of Black Rock City. Over the following two years, San Francisco's DIY music and culture collective SPaZ orchestrated the sounds exclusively. It was extreme, eclectic and haphazard. Cofounder Terbo Ted recalls that at one point in 1993 "we put on a cassette of the Eagles' "Hotel California" by request of these two cowboys who rode in from the desert on horseback: they were thrilled." According to fellow cofounder Aaron, that same year "a wind storm blew down our speaker stacks, but they were still plugged in and we never stopped playing."[14] Listed as the official "rave" in the Burning Man brochure for 1994, SPaZ would have a great influence on sound system culture at the festival. In these years, SPaZ, members of which later initiated the Autonomous Mutant Festival, were effectively encouraging Burning Man to be "more like the UK festival vibe where anybody could bring their sound, big or small." In 1995, Wicked sound system, the UK-derived outfit that held full moon parties on beaches and parks around the Bay Area between 1991–1996, arrived with their turbo rig. Cofounder Garth recalled playing "for four days and nights through hail, wind, rain and electrical storms."[15] North America's first free party techno sound system, Pirate Audio, also appeared that year. On the windblown frontiers of EDM, in this nascent vibrant ghetto accommodating the eclectic, experimental and inclusive sounds of SPaZ, the dionysian house sounds of Wicked, and other sounds besides, Burning Man had begun to attract a variety of socio-sonic aesthetics, paving the way for the mega-vibe it would later become.

Besides the sometimes sizable distinctions between habitués and proponents of varying dance music aesthetics and practices—from the inclusive to the more proprietary—a stand-off developed in this period between those who'd fashioned themselves as more or less authentic denizens of the playa and those they held as little more than raving interlopers. Ted remembers, "ravers were always pariahs at Burning Man in my day.... It's like we were the poor people on the wrong side of the tracks and the wrong side of the man." Ted's brainchild, the Techno Ghetto, appeared in 1996 as a legitimate outer suburb of BRC. Gaining the support of organizers, Ted designed the Techno Ghetto as a "fractalized imprint" of Main Camp. "We were into pre-planned zoning, using surveying flags to plot out an orbital city with sound systems on the outer ring and encampments in the center." Ghetto sound systems included SPaZ, CCC, Gateway and Wicked.

But things didn't go according to plan out in the Ghetto. Ted recalled the Ghetto was an:

abysmal failure... DiY gone mad.... Music snobbery and cliquishness and DiY anarchist tendencies prevented an orderly camp from forming and the resulting spread-too-thin sprawl proved to be dangerous in an era when cars were still driving at every vector on the playa at high speeds in dust storm white outs.

He alluded to a tragic incident in 1996 when three people were seriously injured sleeping in their tent near the Gateway sound system, one in a coma for months, after they were collected by a night driver. Together with an apparent perception that the "rave" was giving Burning Man a bad name in official circles, and how electronic music was perceived as disturbing chatter for many participants,[16] this incident generated an unofficial "anti-rave policy." What's more, the darkening mood was signalled by a "gift" that dropped out of the sky. In the last days of the event, a gyrocopter passed over what remained of the Ghetto, releasing its payload near the dance floor. At his first Burn, Simon Ghahary took up the story: "Everybody was in party mood and happy, and everyone was waving and all of a sudden the gyrocopter dropped this bag, which really took our imagination." The delighted ravers rushed over only to find that a fresh bag of shit had exploded at ground zero."[17]

According to Garth, Burning Man had the porta-potties removed from the Techno Ghetto before the festival ended. "When people started crapping on the desert for lack of options, someone carried over a bag of it to main camp…. Burning Man was so enraged by this they flew over and apparently dropped it on one camp." Out beyond the Man, deprived of sleep and sanity, denizens of the Ghetto were deep in the playa, and even deeper in shit.

ALL'S FAIR IN LOVE AND AWE

Any decent history of the DJ would recognize his—for typically male—role as an outlaw, a breaker of rules, in defiance of convention, pushing boundaries, including those associated with aesthetics and decibel policies; transgressions innovative for some, threatening to others. Culture hero or serial pest, at Burning Man the cowboy DJ is an ambivalent figure. I can't give this issue the depth it deserves here, but the scrap between ravers and their adversaries was dramatized in a performance in which Goa Gil came to loggerheads with a giant pedal-powered flamethrowing drill and margarita maker called the Veg-O-Matic of the Apocalypse—or more to the point, anti-rave crusader Jim Mason, who was pedaling the beast. Robert Gelman reported on this scene:

> It's straight out of hell, suggesting engineering from the industrial revolution transported to Fritz Lang's Metropolis. Part vehicle, part flame-thrower, part earth drilling device, I envision this machine being used to battle creatures in a 1950s monster movie, or to torture souls of the damned in the realm of Satan.[18]

With a pressurized gas-charger blasting flames as far as 70 feet from its barrel, and a gathering mob inciting it to greater acts of destruction, the Veg-O-Matic was known to burn installations in its path following the demise of the Man. On its post-Burn rampage, when the Veg-O-Matic rolled into the first Community Dance in 1997, Mason found Goa Gil directly in his path:

> The crew of the machine is tilting the flamethrower's barrel up at the console. Gil is staring down the 12-foot barrel of this jet powered char-broiler. I had to remind myself that this is theatre, or is it? I'm still not sure. "Burn it!" the mob chants, "Burn THEM!" Like an opposing pacifist army, the ravers are standing their ground, some shouting in defiance of the threat, some in disbelief that this could really be happening. Chicken John, like the demented circus ringmaster that he is, issues his now-familiar warning over the bullhorn ["Stand Aside"]. We seem to have traveled back centuries in time. I don't remember ever feeling farther from home than this.[19]

Forty-six, a sadhu and legend of the Goa scene, years before the emergence of "darkpsy," Gil had been selecting from the darkest entries in psychedelic trance, in a ritual that he has characterized as apocalyptic.[20] Loading up from his "divine dozen" arsenal over seven hours, Gil was doubtlessly inciting detractors to acts of symbolic, if not physical, violence. He may well have been playing from Pleiadians' *U.F.O.* or Psychopod's *Headlines* at the moment the mob arrived to deliver their demand: Led Zeppelin *or* the flame. But the scene Mason and his supporters crashed was no glowstick picnic. The champion and his army of Anti-Ravers rode out to slay the dragon at the gates, only to find the Dark Yogi summoning Kali the Destroyer. Little wonder Gelman thought he'd landed amid an epic conflict. It was perhaps in this moment—when Gil stood his ground, even turned the volume up, in the face of obliteration—that ravers gained a foothold at Burning Man. "Stairway

to Heaven" was never played. With that said, psychedelic trance maintained minimal credence at Burning Man subsequent to this period. While Space Elevator became the most well known dedicated psytrance camp, that sound was effectively drowned out by a fusion of breaks, dub and electro house.

That was some years off, for in the late 1990s, the battle of the boombox was just beginning. Veteran of the frontier shit-storm, Ghahary was vaguely declarative after his first Burn. "After that, you'd want to put the Burning Man out wouldn't you." The playa appears to have been an ideal laboratory for Ghahary, designer of the Pod speaker system and founder of label-house Blue Room Released. Ghahary was drawn to Burning Man since, like the psychedelic parties he'd been hosting in the UK and elsewhere since c. 1992, the space "defies reason" because there, one's experience is not proscribed. Offering background on his design praxis, Ghahary explained that "the vessels that emit sound are just as important as the sound experience," weighing in against detractors: "people thought we just turned up partied and played music. But everything was orchestrated as an art project, it's just that it has sound.... Sometimes people argue that sound is not as dramatic as sculpture or paint. It simply just hasn't got the history. But sound is a complete sensory experience." For 1998, with the assistance of Nick Crayson, Adam Antennae Ohana, Cyril Noir, among others, including crew from the Russ Street Warehouse, Ghahary designed the geodesic Blue Room Molecule dome.

We imagined the Molecule to be highly charged. We wanted to create a space within the Molecule to reflect the kinetic and creative energy that the property of the Blue Room Molecule might contain. Because we could not build a complete sphere, we built a submerged sphere, so half we imagined was underground and one half overground. So we executed that by creating a geodesic dome. So this idea of a molecule was manifested.

That year, Ghahary arrived with a San Francisco-style fire engine that he acquired with Crayson. Sprayed blue with intricate decals and motifs like "play loud" and "CAUTION! HEAVY TECHNO", it was a vehicle of protest. Filled with water, the engine was used to create a mud bath on the open playa near the Molecule. But the engine had another purpose. Ghahary and Crayson trucked around the playa recruiting burners to their newly established 420 Division, practising fire drill procedures. Unfortunately for them, on the night of the Burn, the team dwindled down to Ghahary and Crayson, who were left with their hoses dangling. En route to douse the Man, they "were intercepted by two security cars that didn't take it at all in good humor." Chuckling at the absurdity of the moment, Gahary admits "in hindsight, it probably wasn't the cleverest idea, but it was quite funny." Still laughing, he added, "We got banned from Burning Man after that."

Credibility is hard won on the frontiers of art. A cultural war continued to rage over the validity of arrant loudsters, "monotonous computer loop music," and the presence of some of the highest paid EDM brand names like Paul Oakenfold, Tiesto, Carl Cox and Infected Mushroom,[21] many flying in on the rockstar-junket, and departing quick smart to maintain touring schedules. For many acts, appearances at Burning Man serve to boost credence and brand energy. When the biggest names in commercial dance music perform "45-minute showcase sets to massive crowds at MTV-Beach-Party-style setups" before racing off to their next venue, we may very well have arrived at "the EDM equivalent of putting a Starbucks or H&M on the Esplanade." Writer and musician ST Frequency—aka Stephen C. Thomas—went on to state that he'd prefer "something a little more eclectic and unexpected, like funky industrial bluegrass, or ambient dub-zydeco... [to] a cacophony of 22 different epic trance records 'blowing up' from every imaginable direction."[22] Observing that which flickers in the shadows in the "High Desert Carnival Realm," Jonathan Zap meditates upon how a successful journey through Burning Man requires hard work, or perhaps *hard play* in the form

of intentional self-incendiary actions. For Zap, this requires more than simply burning one's self up to yet "another of the golden oldies of the Babylon Matrix phonograph, that... combo of blasting music and intoxication in a socially dense environment." With equal parts Jung and Crowley, he claims that this "is the zone on the planet that comes closest to being a Logos Beheld—a place where our psychic intentions become realized as communal dreamscapes.... As in a communal telepathic dreamscape, where those with the most focused psychic intentions create the most mutation."[23]

But sound camps are themselves mutations, undergoing constant adaptations in accordance with the social axioms of this incendiary realm. The Number One rule among these camps appears to be that DJs, as with other artists, are never paid for their performances. Not unlike commercial dance festivals, camps like Opulent Temple announce line-ups in advance on websites and on Facebook pages, effectively promoting headline acts like Infected Mushroom, who have drawn some of the most adulatory and sycophantic crowds in recent years. Such patronage feeds the ire of those who've long railed against the advent of the spectacle, where participants grow to behave more like *audiences*, whose division from *artists* is consequential to an apparatus that lifts celebrities on to stages that expand in size and height. The growing presence of party monsters and itinerant gawkers was a problem raised by art critic Mark Van Proyen concerned about the "Ibiza set" and other "tourists" swamping the city—i.e., those who behave like *flâneurs* of the playa, are more like visitors than locals, observers than participants.[24] It has been noted that Larry Harvey has never been to Opulent Temple.[25] But when entertainers like Infected Mushroom, who once appeared on a cover story in *Vogue Italia* wearing suits, boast of their appearances at Burning Man alongside their sell-out headline shows at Miami's Ultra Music Festival, as they do on their website, is it any wonder?

Where Black Rock City serves as a prestige-building export zone for some EDM artists whose agendas compete with the noncommodified social art agenda of Burning Man, we might begin to understand why Peter Lamborn Wilson—aka Hakim Bey and scribe of the *Temporary Autonomous Zone*[26]—has been reproachful of electronic music. Actually, Bey dislikes most recorded music. The Opulent Temple et al. would be anathema to his "insurrectionary" agenda—just further evidence of the immiserating world of mediation from which one is entreated to disappear. In Bey's screed, a turntablist does not preside over the *festal*, i.e., the social grounds of that which is characterized as "Immediatism," an outsider art project with strong Situationist influences aimed to dissolve "the gulf between the production and consumption of art."[27] Bey's "ontological anarchy" had an indubitable impact among burners.[28] It provided the poetic architecture for many ravers in the 1990s, despite the incompatibility of the techno rave's artifice with what Bey has held as appropriate responses to mediation. Consistent with an apparent desire to return to pre-First World War technology, Wilson maintains his contempt for recorded music that he characterizes as "a tombstone for live performance." In his "Back to 1911 Movement Manifesto," he complains:

> If we have to hear a recording let it be a 1911-style shellac disc or even wax cylinder, cranked up by hand, not electricity—a magic music box to baffle the dog with its master's voice—a cabinet of aural marvels.[29]

In a jeremiad launched against "headphones and computers," he claimed that "we let stars sing for us—we let machines come between us and the divine musician within us.... Music now lacks all *sociality* except the ersatz of mass consumption to hear *live* music sometimes."[30] Surely those EDM enthusiasts who've replayed and remixed the poetry of the TAZ—a sizable population of his readers—deserve a more nuanced critique, and yet for Bey no distinction is drawn between styles of recorded music. In Bey's screed, there is no acknowledgment of independent

music and event industries, no attention to cultures of the remix, the visionary depth of multimedia assemblages, nor an understanding of how EDM technologies have been redirected from the purposes of control and command. Bey's approach may warrant an equal measure of reproach since the effort to understand what protagonists have long been raving about is entirely absent from writings subsequent to the TAZ. Just as Harvey has apparently never visited OT, Bey has apparently never been to a rave. With his head in the sands of 1911, he consigns himself to history, claiming that the "full play of Imagination becomes possible only *without* modern technology, because tech has become the heartless *operation* of Capital, which hates all forms of *sharing.*"[31] I doubt this would be an acceptable, or even possible, position for the habitués of the open source laboratory for ontological anarchism that is BRC, regardless of their attitudes towards EDM.

An implicit myth of authenticity comes into view as the whiteouts lift. In electronic dance music *liveness* is a hotly debated issue especially since production and performance practices are inseparable and skilled DJs provide performances that are unique to each occasion. This is not the place to revisit such debates, but these conversations are not irrelevant to Burning Man where communities of volunteers collaborate to facilitate these performances. It appears that long held views about immediatism, community and interactivity have informed logics by which "dance camps" are adjudicated illegitimate candidates for BRC arts funding. These views are doubtlessly fueled by the rising presence of rock star electrotainment, whose audiences are anathema to the "inclusive, community logic" of artistic "prosumption" that has been intentionally encouraged by Burning Man since 2000.[32] This is a complicated topic since the democratisation of musicianship enabled by technics, DJ performance techniques, the Internet and optimised dancefloor "vibes" have augmented prosumer environments unparalleled in popular music. Defenders of policy might indicate that dance camps do not compare favorably with intentionally interactive work like that of Peter Hudson, such as his 2007 Homouroboros, a zoetrope of monkeys powered by drum beating and bike pedaling participants. Dance camps hosting artists who are feted, elevated and inflated are held to contravene what are more than often implicit working models of anarcho-folk community—communities that work under the tacit assumption that, as expressed by Ananda Coomraswamy in *Transformation of Nature in Art*, and cribbed by Bey, the artist is not a special kind of person, but each person is a special kind of artist.[33] And yet protagonists might well contend that in these interstices where occupants are animate in dance and altered together in wide-grinned abandon, the scene holds a carnivalesque and improvisational logic of it its own. There appears to be something universally artful about that.

A RHYTHM REMORSELESS

In the last gasp of the twentieth century, a host of EDM-oriented outfits with different agendas and styles descended on the playa. The momentum picked up in 1998. Several hardcore outfits, including New York's Blackkat, The Army of Love, SPaZ and Arcane—outfits who would subsequently head to the AMF—collaborated on a community sound system that year. With its series of geodesic domes and bars, including a large dance dome and a bar dome made of CDs, Space Lounge also appeared in 1998—a haven for funky SF house and new school breaks. Holding free Full Moon Gatherings in the Mojave since 1993, LA's Moontribe also threw down, with Moontribe artists performing for three consecutive nights next to The Temple of Rudra, with the final party drawing 2,000 people following Pepe Ozan's opera.

Through this period, Michael Gosney resolved to fuse disparate sound outfits in a united front called Community Dance, a compromise promoted on Gosney's

Radio-V as a "techno tribal ritual celebration."[34] Over three years (1997–1999) these pre-Millennial rituals saw the collaboration of CCC, Anon Salon, Koinonea, Sacred Dance Society, Dimension 7, LA's Tonka sound system, Blue Room and other techno tribes hosting decidedly psychedelic line-ups. After the incident with Gil, the 1998 Community Dance featured a Flying Saucer installation. In 1999, the final Community Dance staged a recreation of the Banbury Crop Circle. The camp was a concerted response to claims that "rave camps" were bereft of the artistic vision and principled behavior that characterized Burning Man. According to designer Landon Elmore, the camp was a full size replica of the original Banbury Crop Circle. He stated, "We painted the circle onto the playa floor using earth-based pigments mixed with water and a plant-based glue.... The idea was to have the Community Dance on top of the painted crop circle, so that all of the dancers would 'erase' the markings from the playa floor. 'Leaving no trace', which worked perfectly!"[35]

Rave camps had transitioned to large scale sound-art camps in all but name. The amplification of electronic dance music was afforded legitimacy as a result of the innocuously titled Community Dance, but the pranks did not let-up at the turn of the Millennium. In 2000, probably harboring memories of Blue Room's forlorn attempt to "put the man out," as some kind of aesthetic reprisal, the Burning Scouts of America decided to perform their community service at Radio-V's Flying Saucer, where they threatened to douse the sound equipment. The Burning Scouts enlisted among their number those who were "too cool, dumb, weak, punk or gay to have made it in the Boy or Girl Scouts."[36] Apparently they also included those who weren't into loud raves all night long. The CCC's Brad "Santosh" Olsen—founder of San Francisco's annual How Weird Street Faire—remembers the scene on Sunday morning:

> They appeared walking around our camp, coming at us banging on pots and pans, no expressions on their faces, as they slowly made their way over to our RV. They must have thought: Sunday morning, we're all crashed out and they were going to teach us what making a racket was all about! We looked on in amazement. When [one assailant] attempted to come into the RV, someone threw old bath water at him and we closed the door. After they left we came out and noticed that they pulled down our art and banners and vandalized the camp. We broke our camp and slowly drove over to the CCC system on the other side where DJ Perez (Perry Ferrel from Jane's Addiction) was just coming on (and so were we).[37]

With the indubitable ubiquity of amplified electrosonics, the BORG had to find solutions with concessions to all parties. Bass travels multi-directionally and carries easily across the playa where it cannot be contained effectively. As is stated on Burning Man's "Sound Policy" page, this physical situation "gives sound as an art form an unfair advantage over other art forms." In recognition, in the early 2000s, the BORG began implementing a policy restricting large sound installations to the Large-Scale Sound Art Zone at the city's limits on both sides where "a maximum power amplification of 300 watts is permitted, producing sound amplification not to exceed 90 decibels, when measured at 20 feet from the source."[38] What was once a source of absolute contempt—ghettoized one mile from Main Camp—was eventually accommodated via zoning guidelines. Excessive sound remains a persistent source of disturbance among BRC residents, however. While Burning Man's Number One rule is that "Neighbors should talk to one another when sound becomes a problem and try to resolve the issue through direct communication," Black Rock Rangers are frequently called in to perform volume checks and mediate disputes, and they will disable sound equipment should their warnings go unheeded.[39]

With names like Lush, Sol System, Sound of Mind, House of Lotus, Oacious, Green Gorilla Lounge and Pink Mammoth, Large-Scale Sound Art camps became

permanent fixtures of BRC. The audio-visual aesthetics, style and duration of venues have varied considerably. From Emerald City 2000, the one-time extravaganza funded by eccentric inventor Patrick Flanagan with Joegh Bullock and Michael Gosney providing the entertainment, to the long running Root Society. From performance and fire art troupes like El Circo with their post-apocalyptic "dreamtime imagery" and Bag End sound system to the afternoon groovement at the Deep End. From salacious theme camps like Bianca's Smut Shack and Illuminaughty, to the Rhythm Society's Blyss Abyss, Lemuria and Area 51.

The Opulent Temple (OT) is among BRC's longest operating and largest dance camps on the playa. Steered by Syd Gris with help from dozens of core volunteers, the camp started in 2003, and moved to the corner of 2 o'clock and Esplanade by 2005. The OT was built on the perennial shores of tension and release, and I surfed those waters in 2008 when English DJ Lee Coombs was coming on. It was only Thursday night, but thousands had turned out to be turned inside out. A master of the build, Coombs was aggregating immeasurable tension, like a pressure cooker, before the floodgates finally opened and the playa-massive erupted. At the OT, you know that moment has arrived as DJ-controlled flames blast out from the O-pod, a special chamber that is part steampunk time machine and alchemist's laboratory. Opulent Temple emerged in the year of the theme Beyond Belief and has maintained its role as a "sacred dance" camp. Other large-scale art and music camps with similar spiritual pretences were encountered on the playa that year, including the Church of WOW, the Sacred Water Temple, and Connexus Cathedral where weddings and parties were held inside a neon cathedral. In his outline of the 2003 art theme, Harvey inquired: "How does the sacred exist, and where might it be found?"[40] Habitués of the night were answering with their feet, as the Opulent Temple grew to be among the most popular venues on the playa. Paraphrasing Erik Erikson, cited in Harvey's 2003 art theme explanation, those gravitating to these temples in which one could worship one's own body and that of others were being "lifted up to the very bosom of the divine." Sound art camps flourished in this period, their success a combination of ingenuity, shared vision, independent funding sources, and dedication to a collective project operating on burner principles year round.

The Space Cowboys predate the Opulent Temple by several years. Founded in 1997, the Space Cowboys had allies in the Space Lounge, with whom they merged by the end of 2002. By 2012 Space Cowboys had become sought after proponents of breaks, house and nu-funk. Cofounder Peter Kimelman (aka PK) offers insight on the way Space Cowboys operate distinct from other outfits:

> The Space Cowboys, like Space Lounge and other early camps, threw parties that were much more than just a large sound system, they had bars, artworks and tried to have a "vibe" that got people to stay for hours on end (Distrikt and Disco Knights still follow that model). We didn't publish line-ups as the focus was on the crew, even when international celebrity DJs played it was kept quiet as they were just friends we knew. We still follow that tradition today.[42]

A week on the playa used to pan out rather differently than it does today. In the late 1990s and early 2000s it was not uncommon for camps to focus their energy on one night. Space Lounge did Thursdays, the Cowboys did Fridays, False Profit eventually took Tuesday etc.... Camps focused on a particular sound/vibe and tried not to compete with each other. Plug 3 did hip-hop and the Church of Funk did funk, Space Lounge did a funkier side of house/breaks and Space Cowboys had a slightly harder style.

PK further stated that the Space Cowboys are "proud in our role as a strong element of the community that continues to provide support to artists and is able to self-fund our activities through the hard work of our collective members."[43] Space

Opulent Temple, 2008
Photo: "Playarazzi" Andy Pischalnikoff

Cowboys would become an exemplary sound art organization that has successfully raised funds for its playa time operations through year-round events in the Bay Area, hosting Breakfast of Champions on New Year's Day since 1999, and running Snow Fest at Squaw Valley, Ghost Ship (the annual Halloween party on Treasure Island) and their annual Cinco de Mayo fundraiser.

In 2001, the Space Cowboys' Unimog became the first large-scale sound vehicle on the playa. With the Unimog, Space Cowboys began their practice of building sound installations on the open playa, basically ruling the playa for years. Playing vinyl in these conditions while mobile requires an enclosed area to protect equipment from dust and a suspension system to prevent skipping. Since the Mog featured these elements the Space Cowboys held a design advantage over other art cars with DJs. Over the next decade, with the advent of CDJs, mutant disco vehicles had grown ubiquitous, from the Garage Mahal, a double-decker bus with DJ booth, dance floor and crows nest, to the shape and location shifting vehicles of the DI5ORIENT EXPRESS, to the massive bass of Robot Heart. Some vehicles feature stadium sized sound systems, and their reception is mixed and not necessarily welcome, especially when rogue units maraud quiet areas of BRC. To deal with this, the DMV implemented sound level ordinance for mutant vehicles with a 100db limit at the top end, and limit performance to areas beyond 10 o'clock and 2 o'clock.

INSTANT DISCO: ROLLING IN DEEP PLAYA

The Space Cowboys' Unimog was not only the first mutant sound vehicle on the playa, it was the first to use an FM transmitter, syncing its rig with that of other mobile units. The transmitter was first used in 2003, when the Hoe Down was transported out to Zach Coffin's Temple of Gravity. This development allowed for radically versatile operations and mobilized immediacy. Today, some of the most adored outfits on the playa are mobile mutants. Each year the outlandish character of these moving multimedia installations exceeds that experienced in previous years. These sound art armadas hump their thump into deep playa, out past 10 o'clock and 2 o'clock. Years after the demise of the Techno Ghetto, the deep has again become the canvas for alliances sounder than before. Ranging out to drum up the sun, these mutant motorcades feature vehicles with varying purposes. Some provide the sound, others lights and screens, others are engines of fire, and yet others hold purposes left only to the imagination. In recent times, many of the thousands who are moved to experience this itinerant disco inferno gravitate to Robot Heart, a mobile cabinet of aural marvels whose crystal clear bass blankets the deep; a sound attracting a blush of mutant vehicles. In 2012, Robot Heart was linking up with the DeepSbass sound system of the Dancetronauts, the Disco Space Shuttle and others. Some of these dalliances maybe as tasteless as easycheese squeezed onto a stale crumpet. Australian burner Ben Dixon offered me tales of such obnoxious interventions in 2012, which he said were "not helped by the fact that the smaller systems on some cars were being pushed way into distortion in a stupid DJ look-at-me loud-off."[44] He was, however, generally impressed with the "instant party" like that starring El Pulpo Mecanico, a giant motorized octopus belching flames in time to the beating of the Heart Deco Express.

Riding into the deep, waves of BRC occupants capitulate to multisensory broadsides to which a legion of decorated mutants have conspired. In collaborative mobilisations, sound armadas have gathered strength at the city limits, a theatre for frontier art as interactive as it is intercorporeal. Military metaphors offer ebullient weight to this allied objective—not so much to conquer the other, but to vanquish one's fear of others, and indeed otherness. Launching a barrage of sonic and visual

transmissions from its inception in 2001, it is no small detail that the Space Cowboy's ATAVAV was modified from a 1973 Mercedes-Benz NATO communications vehicle. Modified and re-enlisted for service in this new theatre of awe, it does not roll alone. It may have been a short-lived project, but the Disco Duck is lodged in my mind as astoundingly audacious. I encountered this marvel at sunrise in 2008 out beyond 10 o'clock. A mobile three-level club in the form of a yellow bath-time duck had unloaded its cargo of weird humanity to greet the rising sun. During the night, with green laser eyes, fire-spitting Mohawk, and a blinking fur-lined double-decker auxiliary bus, the Duck became a fabulous mobile beacon. But now, with morning sunlight refracted off its golden glitter-ball head, the Duck was exposed in all its splendor.

What wasn't so detectable was the fact that this marvel was built on the chassis of an armored amphibious assault vehicle. Instruments of warfare transmuted into pleasure machines, the Unimog and the Disco Duck reminded me of the work of legendary industrial-sculpture collective Mutoid Waste Co., renowned for recruiting war machines for radical assaults on the senses. Throwing the first acid house warehouse raves in London at the old Coach Station and mutating the refuse of modern culture into the marvelous, these salvage-situationists had been instrumental conspirators in London's reclamational sensibility. Throughout the mid to late 1980s, and into the 1990s, the Mutoids had been busy revivifying obsolescence and transforming forgotten landscapes into objects and sites of beauty, stirring those who came to witness, and dance, with a passion to make some noise. In London and across Europe, furnishing squatted buildings with anthropomorphic engines, mutated bike parts, and transmuted Russian MiG 21s, and raising subterranean spaces of difference where all became a spectacle to each other, they incited fellowship and inspired the imagination.

I felt something of this energy in both the ATAVAV and the Duck, but 2008 also saw the arrival of Mutoid Waste Co. artists themselves, including co-founder Joe Rush. It was an auspicious occasion, especially since they had been mutating cars, trucks and tanks since the early 1980s, including a series of Car Henge projects that started at Glastonbury and reached as far as Australia, in the work of Robin Mutoid Cook. At Burning Man, their motorized animatronic fire-breathing horse and covered wagon Spaghetti West 10, and a pair of dinosaur-like mechanical beasts— the Dino-Dumper and the Clamp-O-Saurus—were imports described as "one-third *Little House On The Prairie* and two-thirds Horseman Of The Apocalypse."[45]

RESIDUAL BURN

Finally, I'm drawn to discuss the quintessentially *liminal* sensibility of Burning Man. DJ Spooky once referred to Burning Man as a context for "the prolonged present."[46] Out there, he claimed, the demarcation lines we've all been conditioned to accept dissolve.... Time blurs, you lose all of these strictures of New York, waking up, or going back to sleep, people, parties, events blur, scenes blur, camps blur.[47]

The experience is typical. Playa life is an altered reality in which day and night, waking consciousness and dream states, domestic space and public thoroughfares, wicked laughter and familiar faces merge in a disorienting carnivalesque. Dwelling inside this cauldron for a week one can feel the atmosphere, taste color, see sound. On the playa, *now* is an extended experience lasting longer than most other moments in the lives of participants, generating a powerful compulsion among the devoted to replay the playa, time and again, year after year, often sculpting, modifying and optimizing this liminality to suit their personal pleasures, dreams and visions. In making the return journey, pilgrims are not only revisiting the same place but are re-accessing the same time. But it is a "time" that is not so much a duration as a "time

out of time," an "eternal presence" reminiscent of that explored by Roy Rappaport in those intensive ritual phases in which one experiences "the sheer successionless duration of the absolute changelessness of what recurs, the successionless duration of what is neither preceded nor succeeded, which is 'neither coming nor passing away,' but always was and always will be."[48] Awash with synchronized melodies and off-beat rhythms, under the rule of the sun and the heat of controlled burns, in the ambience of electroluminescent wire, playing chicken with a fleet of motorized tarts, in the cool stare of an indigenous androgyne, in this "successionless duration," one returns, to revisit Rappaport, "ever again to what never changes": *playa time*.[49]

In Black Rock City, one grows acutely aware that what never changes is change itself. But what happens when banana time sneaks out at carnival's end? When elements of "the quick and the changeless" steal back to the "default" world? When impermanence gets an encore? Burning Man clearly leaves a compelling impression on its inhabitants, many of whom reboot eternity the year round in a proliferation of Burn-inspired intercalary events. The event is at the center of a burgeoning creative counter-cultural industry whose mission is to make now last longer, to facilitate the distribution of playa time across time and space. As the commitment to extending artistic practices, ethos and identity beyond Burning Man possesses a reverse correspondence to that of "leaving no trace" on the playa, fundraisers, fêtes, spores and other residual burns immolate and mutate the present across the continent and further afield. Bay Area dance clubs are integral to prolonging the sounds and styles of BRC, from venues like 1015 Folsom, Sublounge and Mighty in SOMISSPRO, EndUp, The Independent and Kelly's Mission Rock, to art spaces like SomArts Cultural Center and CELLspace, the Sand by Ton parties at the American Steel warehouse in Oakland, along with parties in countless warehouse spaces.

Drunk on playa time, wrapped in glow fur under dusty lampshade hats, the burn'd— think learn'd—parade the streets of San Francisco, from the How Weird Street Faire in May to the Heat the Street Faire (Decompression) in October, a begoggled masquerade where the "second life" of Mikhail Bakhtin's carnivalesque floods the thoroughfares and habitats of the first.[50] As this strange pedagogy revivifies local lifestyle it seems reasonable to assume that one's "social time," to again cite Rappaport, becomes enchanted by the ecstatic theater of "cosmic time."[51] Details have begun emerging on the dissemination of Burning Man's inclusive community logic beyond its geographic boundaries[52] about how the neotribal *jouissance* ebbs back into its progenitor,[53] a city revivified by social art projects that are ecstatic, utopian, gnostic, geek, queer, punk and much, much more. While "post-Burnum Depression" is a common feature of re-entry, "a fragile rainbow covenant still lingers in the Burner's imagination."[54] As burner-tribes have cultivated variant socio-aesthetics re/optimized annually for more than a quarter of a century, and as burner sensibilities proliferate beyond an event horizon charted and scaled repeatedly over this period, a great deal more can be articulated about the expanding liminal horizons of Burning Man. The name of Vancouver's regional event, Recompression, or Recom, the OT's after party, might reveal something of the protracted liminality sought and lived. New York's Freak Factory, Santa Barbara's Clan Destino, Montreal's taBURNak!, and collectives like Space Cowboys and Heart Décor, regional events like Australia's Burning Seed, Spain's Nowhere and other vibrant nodes in the international movement, might illustrate what post-Burn liminalisation looks, sounds and feels like. And the endless torrent of information on Facebook, the bloggersphere, and the Twitterverse illustrate how burner aesthetics is coded. Yet, amidst this accelerating and expanding presence, this prolongation of the prolonged present, this vexatious virtualization of the vibe, what becomes of Burning Man, whose spirit is its own ephemerality?

NOTES

1. St John, Graham, ed., *Rave Culture and Religion*, New York: Routledge, 2004.
2. Davis, Erik, "Beyond Belief: The Cults of Burning Man," Lee Gilmore and Mark Van Proyen, eds., *Afterburn: Reflections on Burning Man*, Albuquerque: The University of New Mexico Press, 2005, p. 17.
3. See Bowditch, Rachel, *On the Edge of Utopia: Performance and Ritual at Burning Man*, Chicago: University of Chicago Press, 2010; and Gilmore, Lee, *Theater in a Crowded Fire: Ritual and Spirituality at the Burning Man Festival*, Berkeley: University of California Press, 2010.
4. Jones, Steven T, *The Tribes of Burning Man: How an Experimental City in the Desert Is Shaping the New American Counterculture*. CCC Publishing. 2011.
5. Gosney, Michael, "Community Dance Genesis," 1998 (http://www.radiov.com/communitydance/genesis.htm, accessed 10 November 2007).
6. Kozinets, Robert V. and John F. Sherry, Jr, "Dancing on Common Ground: Exploring the Sacred at Burning Man," Graham St John, ed., *Rave Culture and Religion*, New York and London: Routledge, 2004, p. 293.
7. http://www.spacecowboys.org/pages/about, accessed 12 October 2012.
8. http://www.uchronians.org/, accessed 12 October 2012.
9. May, Meredith, "The Burning Man Festival: Hot Spots at the Burn," *San Francisco Chronicle*, 3 September 2006.
10. Doherty, Brian, *This is Burning Man: The Rise of a New American Underground*, New York: Little, Brown and Company, 2004, p. 66.
11. We've come a long way from that moment to 2013 when hundreds of playa-recorded DJ sets are uploaded on Soundcloud and listed at http://www.rockstarlibrarian.com/?p=1713.
12. Terbo Ted, all email correspondence, 13–17 February 2007.
13. Gadeken, Charles, A., "Burning Man 93," 1993 (http://www.burningart.com/ch/burningman93.html, accessed 12 October 2012).
14. Aaron, all email correspondence, 11 February 2007.
15. Garth, all email correspondence, 17 January 2007.
16. Including Brian Doherty, who recounts hostilities in *This is Burning Man* (pp. 171–173).
17. Simon Ghahary, interviewed on Skype, 21 January 2012. In 1996, Ghahary, founder of Blue Room Recordings, had flown in Danish psychedelic artists Koxbox to shoot a promotional video. I'm not sure about the video, but they did record *Live at Burning Man 1996* (of which no more than 20 vinyl test pressings were made).
18. Gelman, Robert, B., "Trial by Fire: A Burning Man Experience," 1997 (http://bgamedia.com/writing/trialbyfire.html).
19. Gelman, "Trial by Fire: A Burning Man Experience."
20. See St John, Graham, "DJ Goa Gil: Kalifornian Exile, Dark Yogi and Dreaded Anomaly," *Dancecult: Journal of Electronic Dance Music Culture* 3(1), 2011, pp. 97–128. (https://dj.dancecult.net/index.php/dancecult/article/view/318, accessed, 4 December 2012)
21. See, for instance, the 2005 post-Burn discussion "Rave Camps Too Loud" on tribe.net: http://bm.tribe.net/m/thread/281d6446-efd8-4356-b6f7-3b79e650a419 (accessed 10 October 2012).
22. ST Frequency. A comment "The musical burn," 2007, on *Reality Sandwich*: http://www.realitysandwich.com/node/574 (accessed 10 October 2012).
23. Zap, Jonathan, "Incendiary Person in the Desert Carnival Realm (A Burning Man Story)," 2012, *Reality Sandwich*: http://www.realitysandwich.com/incendiary_person_desert_carnival_realm (accessed 20 October 2012).
24. Gilmore, Lee, "Desert Pilgrimage: Liminality, Transformation, and the Other at the Burning Man Festival," William H. Swatos, Jr. ed., *On the Road to Being There: Studies in Pilgrimage and Tourism in Late Modernity*, Leiden: Brill, 2006, pp. 125–158.
25. Jones, *The Tribes of Burning Man*.
26. Bey, Hakim, *TAZ: The Temporary Autonomous Zone—Ontological Anarchy and Poetic Terrorism*. New York: Autonomedia, 1991.
27. Bey, Hakim, *Immediatism*. Scotland: AK Press, 1994, p. 8.
28. Gilmore, *Theater in a Crowded Fire*, p. 22.
29. Wilson, Peter Lamborn, "Back to 1911 Movement Manifesto: Music," *OVO*, 4 November, 2011 (http://ovo127.com/2011/11/04/peter-lamborn-wilson-back-to-1911-movement-manifesto-music, accessed 20 October 2012).
30. Wilson, "Back to 1911 Movement Manifesto: Music."
31. Wilson, Peter Lamborn. 2011. "Back to 1911 Movement Manifesto: Telephone," *OVO*, 4 November, 2011. (http://ovo127.com/2011/11/04/peter-lamborn-wilson-%E2%80%93-back-to-1911-movement-manifesto-telephone, accessed 20 October 2012).
32. Chen, Katherine K., "Artistic Prosumption: Cocreative Destruction at Burning Man," *American Behavioral Scientist* 56(4), 2012, p. 570–595.
33. Ananda Coomraswamy, *Transformation of Nature in Art*.
34. Gosney, Michael, "Community Dance Genesis," 1998 (http://www.radiov.com/communitydance/genesis.htm, accessed 10 November 2007).
35. Landon Elmore, email correspondence, 5 November 2007.
36. http://www.burningman.com/whatisburningman/2000/00_camp_vill.html, accessed 8 October 2012.
37. Brad "Santosh" Olsen, all email correspondence, 8 November 2007.
38. http://www.burningman.com/on_the_playa/sound_systems/policy.html.
39. http://www.burningman.com/on_the_playa/sound_systems/policy.html.
40. "2003 Art Theme: Beyond Belief" (http://www.burningman.com/whatisburningman/2003/03_theme.html).
41. "2003 Art Theme: Beyond Belief"
42. Peter Kimelman (PK), all email correspondence 31 October 2012.
43. Ben Dickson, email correspondence, 25 October 2012.
44. http://www.burningman.com/whatisburningman/2008/08_art_funded.html#mutoid.
45. Miller, Paul (aka DJ Spooky), "The Prolonged Present," 2007 (http://www.realitysandwich.com/node/574, accessed 10 October 2012).
46. Miller, "The Prolonged Present."
47. Rappaport, Roy, *Ritual and Religion in the Making of Humanity*, Cambridge: Cambridge University Press, 1999, p. 231.
48. Rappaport, *Ritual and Religion in the Making of Humanity*, p. 231.
49. Bakhtin, Mikhail, *Rabelais and His World*, MIT Press, 1968 [1944], p. 7.
50. Rappaport, *Ritual and Religion in the Making of Humanity*.
51. Chen, "Artistic Prosumption: Cocreative Destruction at Burning Man," 2012, p. 586.
52. Jones, *The Tribes of Burning Man*.
53. Zap, "Incendiary Person in the Desert Carnival Realm (A Burning Man Story)."

GRAHAM ST. JOHN

FIRE
RACHEL BOWDITCH

> Shiva dances and destroys the world with his mate Kali, the all devouring. [...]
> The current age is considered the Kali Yuga (Age of Kali), another apt symbol of
> the current situation in mythic terms. We are demolishing the inner myths and
> old structures, to make way for the new.[1]

Uchronia burning
Photo: Scott Hess

Themes have changed, people have come and gone, but the one constant element
has been fire—the essence of Burning Man. It was fire that drew those first
participants to Baker Beach in San Francisco in 1986 and it is fire that continues
to draw over 60,000 participants to the Black Rock Desert today. Burning Man has
evolved into the largest venue for fire arts and fire performance in the world. At
Burning Man, fire installations, fire breathing, fire dancing, and fire eating have
emerged from the periphery to become an international performance medium
that is predominantly concentrated on the West Coast of the United States. The
event is a magnet for fire artists and performers who engage risks that are rarely
seen in more conventional settings. Night in Black Rock City is a carnival of fiery
delight. Fire artists, the Fire Conclave, and the construction of the Man show how
the Burning Man community's relationship to fire has evolved over the years—
why participants are drawn towards the burning of the Man and the Temple, how
Burning Man has become an incubator for the emergence of new forms of fire
performance and tools that extend beyond the desert and why fire continues to
compel, inspire and fascinate us.

Hazel Rossotti notes in *Fire* (1993) that the element is often represented in the
arts because of its inherent symbolism and power to evoke passion and desire; to
inspire vitality and curiosity; to provoke destruction; to represent purity; and to give
comfort—all at the same time. Since the beginnings of human culture, there has been
an intimate relationship between fire and ritual. Part of the fascination with fire is its

variability and unpredictability. Fire has many attributes: "With its power to warm, to light, to comfort, and to destroy utterly, it is little wonder that fire was worshipped as well as used, and that even today, fire has many religious and social, as well as utilitarian applications."[2]

Throughout the world, people assemble and celebrate around bonfires and burn effigies. The British celebrate Guy Fawkes Night on 5 November;[3] the Gaelic celebrate Beltane on 1 May;[4] Germans burn a straw effigy of Judas on Easter's Eve; the Yaqui burn piles of Judas masks (chapayekam) at the climax of their Easter celebrations;[5] Ravana is burned in the many Ramlilas of North India;[6] and in the US Southwest, there is the burning of the Zozobra effigy in the Fiesta of Santa Fe, New Mexico.[7] Whether or not Burning Man founder Larry Harvey had any knowledge of these precedents, his Man too is a figure of purification, celebration, destruction and rebirth. Harvey has his own relationship with the Man:

> He doesn't represent anything. The Man is a fixed point so that everything else around can be free to be spontaneous and chaotic. It certainly has to do with change. [...] Fire is huge, it always has been. We started with essentially the two first human technologies: fire and the lever. The elemental—well, it is just primal. Gathering around a fire has a potent psychological effect on people and I think it always will.[8]

What is fire beyond a chemical reaction? Gaston Bachelard, in *The Psychoanalysis of Fire* (1964), approaches fire as an element possessing multiple personalities. Inherently ambiguous, it is intimate, passionate, and loving—the hearth, the candle, and the stove—yet also angry, dangerous, and deadly: "It is a pleasure for the good child sitting by the hearth; yet it punishes any disobedience when the child wishes to play too close to its flames."[9] Indeed, the first thing we teach a child about fire is to stay away from it. But flames captivate us; they are calming and relaxing, and allow us to enter into a deep state of reflection. Bachelard calls this intoxication the "Empedocles Complex": "Fire suggests the desire to change, to speed up the passage of time, to bring all of life to its conclusion, to its hereafter."[10] For Bachelard, destruction is more than change—it is a renewal. Bachelard further argues that humans harbor a secret desire for "an apotheosis through fire [...] the call of the all-consuming funeral pyre, of the inner funeral pyre."[11]

Crimson Rose, one of the six founding Burning Man Board Members, first attended Burning Man in 1991 and at that time she was one of the few people, in the Bay Area, playing with fire. Rose began dancing with fire when a friend told her to stick her fingers in a bowl of alcohol and touch a candle, a practice called 'fire contact.' Rose believes that playing with fire touches our primal fears—it is seductive, dangerous and unpredictable. Performers come in contact with fire and emerge apparently unscathed. Dancing with fire, a performer is in what Csikszentmihalyi would call 'flow,' the total fusion of action and awareness; any break in this flow (or concentration) could result in severe burns (1975). In *Fire Eating: A Manual of Instruction*, Benjamin Mack warns that the act is so dangerous that his advice is to "Try sword swallowing. The swords taste better and you don't have to worry about the wind."[12]

THE MYTH OF THE PHOENIX

When I interviewed participants in 2004, 2005 and 2008 many referred to a phoenix rising out of its own ashes—the desire to burn the old to make way for the new; the cycle of death and rebirth; the opportunity to reinvent oneself anew each year. The phoenix, according to mythology, is a bird reborn from its own ashes. Thought

Fire Ring, 2010
Photo: Delano@Explorerphoto.com

to be the size of an eagle, a peacock or heron, only one phoenix exists at a time and has a lifespan of between 500 and 1,400 years. When a phoenix senses that death is near, it builds a pyre of aromatic wood (some myths say cinnamon bark), then it sets the pyre on fire and is consumed by its own flames. Out of the ashes a new bird is born. This myth is told and pictured in many cultures, including the Chinese (Feng-Huang); Japanese (Ho-oo); Russian (Firebird); Egyptian (Benu); and Native American (Yel).[13] In each version, the bird is identified with the sun; some depict it engulfed in flames, while others think of it as a bird of shining colors—the Egyptians depicted it as a bird of brilliant shades of red.

Eric Newton, a performer in the Burning Man performance troupe Cirque Berserk, captured the spirit of the phoenix when he reflected on his experience with fire there: "It is kind of a rebirth. It is the celebration of our lives and our collective spirit. And then starting all over again from the ashes."[14] Chris Sia, a performer in El Circo, credits Burning Man with changing his life. "This is my temple.... It is my Hajj."[15] Rich Szpigiel (aka Sparky), a former performer in the Burning Man performance troupe AWD/Xeno believes that Harvey's personal ritual became the transpersonal. Many people were affected emotionally and psychologically by the very basic concept of burning the old to make way for the new. "Everybody wants to burn him or herself down and start over again. Everybody wants to be reborn. By giving yourself to this transformative process, by taking control and putting yourself in this environment, you are actually relinquishing control. That is the paradox."[16]

BALANCE OF FIRES: FIRE OBJECTS AND SCULPTURE

Burning Man has long been changing how artists conceptualize and construct their work, inviting them to make art that will be burned and destroyed. Cynthia Kiki Pettit, Dan Das Mann, Syd Klinge, Charlie Smith and the Flaming Lotus Girls, among others, are all known at Burning Man for their ambitious work as fire artists.

In 1998, veteran Burning Man artist Dan Das Mann created the *One Tree* sculpture out of recycled copper pipe. *One Tree* was a social watering hole and gathering place during the day, spouting water out of its leaves; at night, it spouted fire.[17] For the 'Body' themed Burning Man, Syd Klinge and Charlie Smith designed *Hearth* (2000), an enormous heart made of steel that was filled with wood and that kept burning throughout the week, serving both as a meeting point and a place to get warm during the chilly desert evenings. In 2001, Cynthia Kiki Pettit created a work entitled *FireFall*, a sculpture of metal, ceramic, water and fire.

One of the most well known collectives of fire artists is the Flaming Lotus Girls, who have been among the recipients of the Burning Man organization's [BMO] theme-based artists' grants. Founded in 1999, the collective of metal sculptors from San Francisco dedicated themselves to pushing the boundaries of fire art. Each year their fire installations grow in ambition and scale.[18] *Seven Sisters* (2004) consisted of seven large fire-breathing metal installations. The central sculpture, *Electra,* used nitrogen, kerosene and propane to propel flames a hundred feet in the air. The installation cost $13,500; $8,500 came from the BMO and the artists raised $5,000 on their own. Each performance of *Electra* used up between 400 and 500 gallons of propane and cost about $5,000 total for the week. During the performance of *Seven Sisters*, 15 people were needed to operate the controls; there were two control boxes with one person at each tank in case of an emergency. Another fire suit-clad member called 'the human fire extinguisher' was situated near *Electra* in case something went wrong. As Colinne Hemrich noted, "Once the kerosene gets shot, the nitrogen is the propellant that shoots the kerosene through and the propane is the igniter. Once that goes flying in the air, if we have a misfire you have probably 10 gallons of kerosene just flying through the air like hairspray and it is pretty dangerous for the crowd."[19] All of the work created by The Flaming Lotus Girls pushes the limits of audience interactivity as spectators wander through, under and around the flaming metal structures. Each year the fire installations on the playa grow in complexity, scale and ambition.

PROMETHEUS RISING: THE FIRE CONCLAVE

Fire performance involves Caillois' four types of play: *agon* (competition)—the competition to create complex choreography and invent new tools; *alea* (chance)—playing with fire is inherently risky; *mimicry*—the development of personas and costuming; and *ilinx* (disorientation)—primarily for the spectators—a fire performer must be in control at all times.[20] Dancing with fire requires speed, endurance, strength, memory, skill and ingenuity. According to Russian avant-garde director Vsevolod Meyerhold, skilled fire artists are the perfect performers. Meyerhold's ideal was that the performer would develop an acute awareness of his or her body in space through rigorous training, and the resultant body would become a finely tuned musical instrument: "The body is a machine, and it must discover the center of gravity, equilibrium, stability, coordination of bodily movements, orientation in space, and gesture as the result of the motion of the entire body. [Performing] becomes colored by the agility of sportsmen."[21] Focus, balance, stability, and coordination, along with a heightened awareness of the body in space—all of these are required of fire performers.

The most popular fire performance tool at Burning Man is poi, derived from the Maori of New Zealand.[22] While poi is a traditional part of Maori culture, lighting poi on fire is not and is a practice that developed outside of New Zealand. Fire poi are made of Kevlar wicks attached to ropes or chains. The wicks are soaked in fuel, usually paraffin, kerosene or white gas. The playa is full of poi, staff, flaming

hula hoops, stilt-walkers with fire wings, fire jump ropes, fire fingers, fire bowls, fire costumes, fire hoop skirts, fire breathing, fire swords, fire fans, fire double staff, crossed staff, flaming geometric shapes, fire chains and fire eating. Crimson Rose has noticed that every year new innovative structures are invented such as headdresses, umbrellas, and objects that twirl, to name a few.[23]

Serpent Mother, the Flaming Lotus Girls, 2006
Photo: Carolyn Miller

The number of fire performers on the playa has increased exponentially. In 1997, Rose created the Fire Conclave, a group of fire performers who dance around the Man before he burns. In 2001, Rose realized the Conclave was getting too big. She went to Seattle, Portland, New York and Los Angeles to find a representative from each region, called a *Shin*, which means "mother fire" in Hebrew, "hot" or "fire" or "extra spicy" in Japanese. The first year there were only four Shins; in 2013 there were 28. The responsibility of a Shin is to be their group leader and provide Rose with the safety rules that the group will follow as well as a list of the performers' names: "The Shin has to have enough responsibility and respect to command their group. [...] If someone in the group messes up they have to answer for it."[24]

By 2013, the Fire Conclave had grown into the largest gathering of fire performers in the country, if not the world. It had 1,600 members—performers, fire safety personnel who manage the great circle, and the sentinels, who stand between each group and distribute the initial flame. The Conclave members hail from all over the United States as well as international locations such as Japan, South Africa, France and Australia, among others.

Rose established the Fire Conclave Council (FCC) in 2010 with two veteran fire performers who have run fire troupes, Tabasco Mills from Seattle and Qathi Gallagher Hart, aka Q, from Portland. Q, a full time student studying Animated Arts at Pacific Northwest College of Art in Portland Oregon (in 2013), learned how to dance with fire in Seattle in 1999 and attended Burning Man for the first time in 2000. She has been part of the Fire Conclave since 2000 and has worked with several groups including Animated Fusion, Pyrosutra, The Treasure Chests, Cirque de Flambe. She served as the Shin of the Northwest Fire Conclave from 2004–2005 and in 2007, and participated in the Luminferous Procession from 2007–2012.[25] Tabasco learned to eat fire in 1995 but didn't start performing until 1997. He remembers, "I got a lesson from one of the people that owned an entertainment business that I worked for (doing

Fire Dancer in the Fire Conclave, 2006
Photo: Scott London

kids' parties mostly). Then I bought a book to learn how to do it correctly."[26] He attended Burning Man for the first time in 1998 and started the fire troupe Pyrosutra in 2000.

In 2005, Q moved to Oakland where she became involved with the fire community and collaborated on several community fire projects with Rose. In early 2007, when Q returned to Seattle, Crimson Rose asked her if she'd be interested in participating with the Procession by gathering a small group of fire performers to join the Lamplighters and drum ensemble to lead the fire from the cauldron to the Man. She has been participating in the Procession ever since.[27] At one point, Q decided she wanted to go back to school and Rose wanted to know why. Q told her "I want your job!" Rose encouraged her in that direction. Part of Rose's intention in the establishment of the FCC was to begin the gradual transition to the next generation of leaders. Q speculates that her invitation to the FCC was the result of her decade of work with the Fire Conclave, her active membership in fire performance and arts communities, her experience as a production designer, her interest and demonstration of and commitment to a "lifestyle of integrity."[28]

Over the years, both Q and Tabasco have transitioned from fire performers to organizers and administrators. Q says, "Well, I'm no longer totally gobsmacked by the immenseness of Burning Man and I'm no longer fire dancing. I'd say I've completely flip-flopped the relationship I had with it 13 years ago, in that now I'm contributing to the Fire Conclave from an organizational perspective rather than the point of view a dancer. [...] As a fire dancer I didn't yet understand that the Fire Conclave is more than the fire dancing itself. The Fire Conclave is also the Procession (which I now manage), the raising of the Man's Arms, the pyrotechnics, even the way the Man base structure burns and the fall of the Man is designed. The Fire Conclave Council calls the show working in concert with the many teams that make the spectacle function."[29] Tabasco's aims as a FCC member are to reach out to the fire community and create the largest fire performer show out there. "We

coach, motivate, and organize. I started working with Crimson in the Fire Conclave in 1999 and in 2004 when I moved to the Bay Area and convinced her to let me help. I have worked with her over the years helping to manage and create policy."[30] Tabasco and Q evenly share their responsibilities with the FCC with the oversight of Rose—absorbing her institutional knowledge. Q marvels that more she understands the inner workings of the Conclave, the more in awe of Rose she becomes; of her prowess as an organizer, art director and production designer.[31] The FCC designs, directs, manages and produces a 1,600 person fire performance and pyrotechnic display for Burn Night. They handle the big picture of how it'll build in energy, down to the minutia of where fuel buckets are placed.[32]

During the year, the Council is active managing communications, schedules, databases, and spreadsheets as well as the 28 Shins who audition their groups. Q explains that the FCC reviews and decides on the performance groups each year, offering critical feedback on their performances up to final preparations leading up to Burn night. During the event, Q and Tabasco meet with as many Shins as they can, lead safety meetings and stage-manage the many performances that make up the whole of Fire Conclave's Burn Night.[33]

Q views Burning Man as a great platform on which to show off, a place for fire dancers who have been practicing all year to perfect their routines as well as a venue for sharing and learning new techniques. Q believes Burning Man provides a unique opportunity for fire performers to converge in one place at one time in front of a unique audience:

> Burning Man has a very tough, seasoned and jaded crowd that is also exceptionally open to the energy a dancer brings and offers through performance. In my experiences the opportunity to break down the fourth wall and engage an audience is unique to Burning Man, offering an opportunity to feed directly from what the audience is giving a performer. It's a powerful and special exchange that I've not experienced elsewhere.[34]

CROSSING THE THRESHOLD: GETTING INTO THE GREAT CIRCLE

In the beginning, Rose allowed anyone who was proficient at spinning fire into the circle; over time, her standards have become stricter and entry into the Fire Conclave is now more competitive. Rose has experimented over the years with different criteria for inclusion in the Conclave from holding in-person auditions, auditions on the playa, or submitting a DVD sample of choreographed work, the criterion for 2013. Rose, along with Tabasco and Q look for originality and innovation. "Everyone is borrowing from everyone else. Some stuff works, some stuff doesn't. You really have to have the wow factor. We look for interesting transitions. We have limited real estate within the confines of the Great Circle. We are always thinking about the safety aspects."[35]

In 2012, 28 fire groups were admitted into the Conclave through a curated process and there is a limit to 50 performers per group.

The audition process, Rose admits, had been loose but with the creation of the FCC, they fine-tuned the process to make it more efficient. Rose noticed that:

> To keep a group together is very hard. It takes a lot of commitment. People's lives shift. They start getting gigs and touring. Burning Man helps to launch them. It is a way to get their start. Returning to Burning Man is a homecoming. Each group learns from each other. The Conclave is an incubator for the development of fire performance in the United States and the world.[36]

The only year the Conclave did not occur was 2007 when a tremendous whiteout forced its cancellation. Rose said, "It was a tough decision to make. With no visibility, the priority was to release the Man. It was a good lesson."[37] Conclave members are required to sign in at Fire Conclave Convergence upon arrival on the playa. FCC holds safety meetings with the shins on Friday night before the Burn called a "Shindig" to go over details. The Shins are held to a safety standard and are expected to create a dynamic show. They are connected to Rose via radio and she sends the signal to light up the Conclave—she serves as the stage manager for the performance.

Rose, Tabasco, and Q concur that the biggest challenge for fire performers today away from the playa are permitting and city regulations. Most cities have difficult and expensive permitting with increasingly strict regulations, if any at all—in many places it's illegal to "perform" without a permit. Some communities are making headway with Fire Marshalls by forging relationships in which clear demonstration of safety is presented. Unfortunately, this is not the case for many cities. According to Rose, the entire fire dancing community would be enhanced if reasonable permitting were attainable and affordable.[38] Most fire laws are very strict but Reno and Las Vegas are becoming increasingly tolerant. Rose believes this is due to their proximity to Burning Man.

AXIS MUNDI AND THE CONSTRUCTION
OF THE ULTIMATE EFFIGY: THE MAN

The effigy of the Man stands at the center of Black Rock City on an altar around which the mythology and belief system of the Burning Man community revolves, similar to other geographic locations designated as the focal point of a people: To'wa Yallanne is the sacred center of the world to the Zuni; Mt. Agung is the "naval of the earth" for the Balinese; and the Kaaba at Mecca the focal point of Islam. The 2003 theme, "Beyond Belief" explicitly named the Man as the axis mundi on the Black Rock City map. In an interview with his alter-ego, Darryl Van Rhey, Harvey stated that the Man:

> Forms an absolute center; a sort of hub or fixed axis around which everything else is free to revolve. [...] He stands at the end of a monumental avenue that is lined with wooden spires. [...] It harks back to an historic moment when science, art and politics were all one thing, all united in a single sacramental act. All over the world, at the very dawn of civilized history, we see evidence of this. Great temples, axis mundi—"world navels"—dominated public space. The days before the burning are a kind of Saturnalia.[39]

Surveying of Black Rock City starts at the beginning of August when the location of "ground zero"—the Man—is established. The entire city radiates out from this single, metaphysical point in space. At first, an ordinary wooden stake was used to break ground but soon the builders began to ceremonialize the action, using a golden stake to mark the axis mundi.[40]

Countercultures emerge, according to sociologist Milton Yinger, when a society's myths and symbols lose their meaning.[41] The lack of meaningful symbols in our culture may explain how the icon of the Man emerged as a powerful symbol around which the Burning Man community coalesced. Early on, Harvey noticed that the Man's face, an inverted triangle, corresponded to the basic pattern of eyes and mouth in a human face. He realized it was a universal primal image that was simple yet significant.[42] Primary shapes such as circles, triangles and squares are often charged with mythological and symbolic meaning in rituals, and their simplicity and accessibility is considered the source of their power. For Harvey, the ritual around the

Man himself recapitulates a form of primordial experience that transcends culture. Initially, participants gave birth to the Man through a symbolic gesture—by pulling on a rope attached to his navel, like an umbilical cord.[43]

2007 was one year when the relationships between fire, destruction, and the Man got complicated. On Tuesday 28 August 2007, at approximately 2:58, Rose was sitting at First Camp watching the lunar eclipse when she noticed fire trucks racing towards the Man: "I just happened to be up and sitting on the deck at First Camp when I started to see emergency vehicles race towards the Man."[44] The Man had been torched by old-time burner, Paul Addis, a 35-year-old San Francisco playwright, as an act of rebellion against the BMO. He climbed up the shade cloth before anybody saw him and set the Man ablaze. Rose, who has known Addis for about 15 years, said, "He was totally pissed off that we had sold out and it was not like the good old days. Yeah, it is not like the good old days. I think he was trying to draw attention to himself."[45]

Addis defended his action in an interview with *Wired*'s Miyoko Ohtake as a "badly needed reality check for the desert art festival."[46] Later, he claimed full responsibility: "Burning Man has turned into an 'Alterna-Disney,' and the act was a protest against the Man's increasing commercialization." Addis, a member of the anarchist organization, Black Rock Intelligence, claimed, "This was a Black Rock Intelligence operation. But since the group has been disbanded, they can make no claim to responsibility. [...] I am their sole surviving member."[47] Addis felt that Burning Man had lost all spontaneity: "The Burning Man organization doesn't have any sense of humor anymore and that streams and trickles down to the participants themselves." He criticized participants, "What are they doing when they come back to the cities? Nothing. They go blow their wads for seven days at Burning Man and then go back to their jobs. They don't do anything else for the rest of the year."[48]

Addis showed his rebellious side early on in his history with Burning Man—in 1997, he pulled his first prank on the playa by attaching giant silver balls between the Man's legs. His 2007 act, he said, was his attempt to recapture the original spirit of the event: "This was not an act of vengeance, it was one of love."[49] Addis felt his act of arson was a reminder of why the event started in the first place, an act of radical self-expression, which he believes is no longer possible at Burning Man. Interestingly, many participants had been talking about pulling this prank for years before Addis finally succeeded.

The fire was doused within half an hour. The Man was severely charred and there was some structural damage but he remained standing. For safety reasons, he was removed from his pedestal. "It was strange to have the event without the central icon of the Man anchoring the city," Rose recalls.[50] Burning Man 2007 continued despite the effacement and displacement of the event's central effigy. Rose admits, "It was definitely one of the worst nights of my life. We had joked about it for years, and then it happened. It showed me that the Man crew and the pavilion crew were not going to allow somebody to take their energy away."[51] By the time the organizers woke up the next morning, the builders had started remaking their Man on their own. Harvey did not want to have the Man rebuilt. In his opinion, the Man should have been lowered, cut into pieces with a chainsaw, and then distributed throughout the entire community. That to him would have been a symbolic and appropriate gesture. In Harvey's opinion, rebuilding the Man confirmed Addis's belief that the event had become too corporate.

The toll exacted by Addis's act was emotional as well as financial. According to LLC Board Member, Harley K. Dubois, the early burn broke the spirit of the Black Rock Rangers, the peacekeeping entity of Black Rock City. The group had to be completely restructured in 2008 because the rangers on duty had worked overtime to deal with the crisis.[52] Some participants supported Addis and shouted "Burn the

Man!" Others saw the act as disrespectful to the event and the organizers. The early burn prompted some Burners to rethink their relationship and attachment to the Man, which was one of Addis's goals:

> Why are you really out there? If the burning of the Man means something, if it brings you some sort of cathartic connection, then build your own thing and burn it down. Don't be a passive audience member. Cross the line.[53]

Addis was arrested and jailed on felony charges of arson and destruction of property by Pershing County, as well as with a misdemeanor for the possession of fireworks and resisting a police officer. He posted a $25,632 bond and was released. Addis's arraignment on these charges was scheduled for 25 September 2007 at the Pershing County courthouse, where he was charged with first-degree arson, destruction of property and the reckless endangerment of human life. He was released on bail and arrested eight weeks after the Burning Man incident for attempted arson at Grace Cathedral in San Francisco.[54] Addis served a two-year prison sentence in a Nevada prison. In October 2012, he tragically took his own life by jumping in front of a BART train in San Francisco at 42 years of age.[55]

THE TWO BURNS: THE MAN AND THE TEMPLE

There are two big ceremonial burns at Burning Man—the burn of the Man on Saturday night and the burn of the Temple Burn on Sunday night. The two burns are very different. The burning of the Man is a wild party while the burning of the temple is a spiritual experience. Temple Crew member and builder William Dire Wolfe appreciates the distinction between the temple and the rest of Burning Man. When the temple burns, people are crying and mourning; they are silent and somber. I asked Wolfe about the relationship between the Man and the Temple:

> The central atmosphere at the burning of the temple is one of quiet, whereas the Burning Man is more about "let's all release and scream." The circle around the temple, people are crying, people are still mourning. They put their stuff in the temple, and they are going to watch it burn. They are going to release something. There are people partying too, but sometimes it is totally silent and somber. David's temples have all had perfect acoustics, not by design just by chance. I played my guitar out there, and I thought the sound was just going to be dead but it just rings inside of it. I would bring my guitar to the Temple of Tears and just play, and people would come in and start crying.[56]

I asked temple architect David Best whether there was any competition between the temple and the Man. He replied:

> Looking at the Man and looking at where the temple is at, they [the Burning Man organization] could have fought the temple. [...] There might be a year that they make 100 temples, but there will only be *one* temple, and that's the temple where people go to put their son's ashes, their dog's ashes, their dad's ashes, or their mother's. There is only one. And I think they've [the Burning Man founders] seen that. They are my friends, not adversaries.[57]

The fire used to ignite the Man is symbolic and varies little from year to year. Before Burning Man opens the gates, the interior of the Man is loaded with burlap soaked in wax that acts as a fire accelerant. The day the Man burns, the Man, Base, and

Pyro crews load the Man with fireworks and the Black Rock Rangers surround its base. As the day progresses several rings of activity form around the Man—the first ring 75 feet around the Man is reserved for the Pyro Crew. Next is the Great Circle, where the Fire Conclave performs. Then there is a ring with 15 rows of people seated around the Great Circle on blankets, lawn chairs, or directly on the playa. This ring is filled about two hours before the Burn. Surrounding the seated circle, participants stand about 40 rows deep. Beyond that, there is a ring of illuminated art cars and buses playing loud music of all kinds. Another ring of parked bicycles and art cars is behind that—a parking lot of sorts.

A ritual of capturing fire by the sun, invented by Rose in the mid-1990s as a personal ritual dedication to the Man, now marks the official start of Burning Man. Each year, the week begins with the Opening Fire Ceremony at sunset on Monday at the Center Camp cauldron, El Diabla. Using a wand made of paper and a silver disk, Rose ignites the wand through the magnified reflection of the sun. Drawing a crowd of several hundred, the ritual is accompanied often by drumming. Rose symbolically transfers the flame to the cauldron, which is kept alive all week.

On burn night, the flame is symbolically transferred to the Luminferous, a metal sculpture designed by Tabasco and his crew, Iron Monkeys, from its position at Center Camp into the Great Circle igniting the Fire Conclave. The Luminferous is transported by the Lamplighters and accompanied by the Processional Consortium, a procession of over 100 members clad in white gowns that toward down the 6 o'clock promenade towards the Great Circle. [58]

Once the flame reaches the Great Circle, the sentinels distribute the flame around the Conclave in a choreographed fashion. The Man's arms go up and then the Fire Conclave lights up. Rose signals via radio to the Helmsmen for each group to perform their choreographed works and then zaka follows—five minutes of free-form fire dancing. Once the Conclave fires are extinguished, fireworks are triggered by the pyro-crew and they erupt out of the man's head. The Man is ignited and flames consume him. The heat and light reflect on playa-covered skin and faces forging a deep bond of communitas among participants. As the Man implodes and collapses onto the pyre, and the perimeter is released, participants surge towards the flame running in a counter-clockwise circle fusing the intensity of heat and flame on skin. Some remain around the pyre, others drift back towards various destinations around the city. The ritual is complete, until next year.

THE PHOENIX: REBORN FROM THE ASHES

2011 marked a significant transition for Burning Man. The LLC board members shifted their attention beyond the desert and in 2011 established the non-profit Burning Man Project to extend the core principles from the desert event into a larger, global initiative. The establishment of the Burning Man Project represents a significant reorganization and gradual transition of power within the organization—the most significant shift being the hire of English native Charlie Dolman as Event Operations Director. The transition of power from the elders to the next generation is slowly unfolding. Rose acknowledges,

Not everyone can come to the desert event. There just isn't room. The roads can't handle more traffic. It is more than the one week in the desert; our core values are spreading everywhere in the world. There are bigger things that we [the LLC] want to do. We are slowing down a bit and there is a gradual transition of power. The essence of Burning Man is not just what happens in that one week. How do we emphasize that? How do we go beyond that one week? There are 140 regionals all over the world. How can we work with these groups? Tickets are limited. The event

TOP
The Lamplighters escorting the Luminferous to the Great Circle and Fire Conclave
Photo: Gabe Kirchheimer

BOTTOM
The rings surrounding the Man, 2010
Photo: Scott London

in the desert will continue to happen but it is happening all over the world. Maybe attending the desert event is like going to Mecca—you don't go every year. When you attend the desert event, you get recharged and bring the core values back into your own community. The Burning Man Project is taking a larger worldview. This is the future of Burning Man.[59]

While the future of the desert festival remains uncertain—like a phoenix it is building its own pyre to be consumed by flames and reborn as a new entity. A significant shift for Burning Man looms on the horizon—whether the festival will reinvent itself to accommodate this transition, only the future will tell.

RACHEL BOWDITCH

NOTES

1. Sargent, Denny, *Global Ritualism: Myth and Magic Around the World*, St. Paul, Minn.: Llewellyn, 1993, p.169.

2. See Rossotti, Hazel, *Fire*, Oxford/New York: Oxford University Press, 1993, p. 3. Fire played an important role in the development of religion, and many cultures evolved deities associated with fire. To name only a few: the Egyptian goddess Sekhet, who represented destructive heat; the Japanese fire goddess who lived in a volcano, worshipped by the Ainu; the Icelandic Surtr, a god of volcanic fire; the Hindu goddess Devi, who dwells in natural fires; the Greek goddess Hestia and her Roman counterpart Vesta, who presided over the hearth and home; and the Yoruba Shango, the god of thunder. Agni, the Vedic god of fire, is often depicted with two faces, one good and one evil. His three limbs represent the sun, promoting growth and fertility; lightning, promoting vengeance; and earthly fire, promoting humanity and warmth (Rossotti, *Fire*, p. 241). The Zoroastrians of Iran also worship fire. Zoroaster, the founding prophet of the religion, engaged in spiritual contemplation on a mountaintop and escaped unscathed when the entire mountain was destroyed by fire (Heesterman, J.C., *The Broken World of Sacrifice: An Essay on Ancient Indian Ritual*, Chicago: University of Chicago Press, 1993, p.71). For his followers, fire symbolized both sacred purification and transport of their prayer to their god. Fire is also essential to carnival. The Roman Carnival ended with the fire festival of Moccoli ('candle stumps'), a grand pageant along the Corso in Rome with each participant carrying a paper lantern illuminated by a burning candle. The entire Corso is flooded with the glow of illuminated candles and torches, and the objective of Moccoli is for participants to blow out each other's candles and yell, "Sia ammazzato"— "You're murdered!" (Goethe in Alessandro Falassi, *Time Out of Time: Essays on the Festival*, Albuquerque: University of New Mexico Press, 1987, p. 32). Symbolic death is a recurrent theme of Carnival as it is at Burning Man.

3. Commemorating the discovery of the Gunpowder Plot on 5 November 1606, Guy Fawkes Night has been celebrated in the UK ever since. The current celebrations take the form of a series of torch-lit processions through town. Effigies of Guy Fawkes and Pope Paul V, who became head of the Roman Catholic Church in 1605, are featured every year (see Sharpe, James, *Remember, Remember: A Cultural History of Guy Fawkes Day*, Cambridge: Harvard University Press, 2005).

4. Beltane is a specifically Gaelic holiday celebrated on 1 May. Large bonfires herald the arrival of summer in the hope of good harvest, prosperity and well being to all. Need-fires, as they were called, were built to purify cattle of disease and the plague—villages would rush their cattle through the fires to purify the animals as well as themselves. The festival persisted widely until the 1950s and is still celebrated in some places (Adams, G.B., & Alan Gailey, "The Bonfire in North Irish Tradition," *Folklore*, Vol. 88, No.1, 1977, p. 5).

5. Schechner, Richard, *The Future of Ritual: Writings on Culture and Performance*, London; New York: Routledge, 1993, p.113.

6. As Richard Schechner notes in *The Future of Ritual*, "Ravana's cremation signals his final surrender to Rama and his release from his demonic self " (p.149).

7. Burning the Zozobra—a 50-foot marionette that moans, groans and rolls his head until he goes up in a blaze of fireworks—dispels the hardships and trials of the past year. Zozobra, drawing a crowd of more than 30,000, is burned over the Labor Day weekend, the same time as Burning Man. Although the Fiesta dates back to 1712, Santa Fe artist Will Shuster was inspired by the Yaqui and, at the fiesta he held in his home, added the burning of the Zozobra effigy in 1924. The name "Zozobra" derives from the Spanish word for "the gloomy one" and is the epitome of anguish and anxiety. Shuster assigned all rights, title and interest in Zozobra in 1964 to the Kiwanis Club of Santa Fe, which owns the trademark and retains the exclusive copyright of the figure (see Goodwin, Lee, "Zozobra: Heritage and Change Through Community Celebrations: A Photographic Essay," *The Western Historical Quarterly* 29 (2), 1998, pp. 215–23.

8. Larry Harvey, interview with author, Black Rock City, Nevada, 31 August.

9. Bachelard, Gaston, *The Psychoanalysis of Fire*, Boston: Beacon Press, 1964, p.7.

10. Bachelard, *The Psychoanalysis of Fire*, p. 16.

11. Bachelard, *The Psychoanalysis of Fire*, p. 97.

12. Moses, Tai, "Some like it Hot," *Metro Santa Cruz*, 22–29 August, 2001, p.1.

13. Eason, Cassandra, *Fabulous Creatures, Mythical Monsters, and Animal Power Symbols: A Handbook*, London: Greenwood Press, 2008, p. 60.

14. Eric Newton, interview with author, Black Rock City, Nevada, 1 September, 2005.

15. Chris Sia, interview with author, Black Rock City, Nevada, 1 September, 2005.

16. Rich Szpigiel, interview with author, Brooklyn, New York, 4 April, 2006.

17. Dan Das Mann and Karen Cusolito have collaborated on several large-scale metal fire installations including *Crude Awakening* (2007), consisting of a "99-foot oil derrick and a group of large metal figures in worshipping poses to illustrate human beings dependency on oil" (See Figure 3) (See Burning Man Organization, http://www.burningman.com/whatisburningman/2007/07_art_funded.html#crude, accessed 5 April 2012).

18. In 2003, the group constructed *Flaming Flower Garden* where participants could wander through the installation and press buttons to shoot out flames from metal lotus flowers. In 2005, it created *Angel of the Apocalypse*, two 20-foot pyres that formed the flaming wings of a Phoenix on fire. The tremendous heat and the light reflecting off of everyone's skin forced participation on a visceral level—one example among many at Burning Man of art designed to be experienced rather than merely viewed. In 2007, the group was commissioned to create *Serpent Mother*, a larger-than-life flaming serpent; in 2008, *Mutopia*, 13 seed pods that adapted and mutated in an evolutionary series to create a giant spiraling formation; and, in 2011, *Tympani Lambada* was inspired by the bone and membrane of the ear combining fire and vibration of sound.

19. Colinne Hemrich, interview with author, Black Rock City, Nevada, 3 September, 2004.

20. Caillois, Roger, *Man, Play, and Games*, Meyer Barash trans., Glencoe, IL: Free Press, 1961, p. 17.

21. Rudnitsky, K., *Meyerhold, the Director*, Ann Arbor: Ardis, 1981, p. 296.

22. "Poi" is Maori for "ball" and, originally it was a flax bag used to carry small objects such as eggs.

The Maori also use poi as a bag to crush food in, and it was adapted as a tool for warriors—to help develop strength, flexibility and coordination. Later, it was adapted for performance. The traditional performance poi (a light ball made of raupo—a swamp plant—attached to a long or short flax rope) can be found in Maori action songs and dances, where it is swung around rhythmically to produce a percussive sound (Starzecka, D.C., *Maori Art and Culture,* London: British Museum Press, 1996, p. 46.

23. Crimson Rose, phone interview with author, 14 December 2012.

24. Crimson Rose, interview with author, Black Rock City, Nevada, 1 September, 2004.

25. Qathi Gallaher, email interview with author, 29 December, 2012.

26. Tabasco Mills, email interview with author, 18 December, 2012.

27. Qathi Gallaher, email interview with author, 29 December, 2012.

28. Qathi Gallaher, email interview with author, 29 December, 2012.

29. Qathi Gallaher, email interview with author, 29 December, 2012.

30. Tabasco Mills, Email interview with author, 18 December, 2012.

31. Qathi Gallaher, Email interview with author, 29 December, 2012.

32. Qathi Gallaher, email interview with author, 29 December, 2012.

33. Qathi Gallaher, email interview with author, 29 December, 2012.

34. Qathi Gallaher, email interview with author, 29 December, 2012.

35. Crimson Rose, phone interview with author, 14 December 2012.

36. Crimson Rose, phone interview with author, 14 December 2012.

37. Crimson Rose, phone interview with author, 14 December 2012.

38. Crimson Rose, phone interview with author, 14 December 2012.

39. Van Rhey, Darryl, "Postmodernism and the Primal World of Burning" (www.zpub.com/burn/larry4.html, 1999, p.4, accessed 15 April 2012).

40. Larry Harvey, interview with author, Burning Man Headquarters, San Francisco, 11 March 2008.

41. Yinger, Milton J., *Countercultures: The Promise and the Peril of a World Turned Upside Down,* New York/London: Free Press/Collier Macmillan, 1982, p. 9.

42. Van Rhey, "Postmodernism and the Primal World of Burning."

43. Nash, Leo, "Interview with Larry Harvey" (www.zpub.com/burn/larry3.html, 1995 p.1, accessed 13 April 2012).

44. Crimson Rose, interview with author, Burning Man Headquarters, San Francisco, 11 March, 2008.

45. Crimson Rose, interview with author, Burning Man Headquarters, San Francisco, 11 March, 2008.

46. Ohtake, Miyoko, "A fiery Q&A with the Prankster Accused of Burning the Man," *San Francisco Chronicle,* 1 September 2007.

47. Ohtake, "A fiery Q&A with the Prankster Accused of Burning the Man."

48. Ohtake, "A fiery Q&A with the Prankster Accused of Burning the Man."

49. Garofoli, Joe "Sustaining the flame/Burning Man Artists Battle Urban Constraints to Keep Spirit Alive," *San Francisco Chronicle.* 20 August 2007.

50. Crimson Rose, interview with author, Burning Man Headquarters, San Francisco, 11 March 2008.

51. Crimson Rose, interview with author, Burning Man Headquarters, San Francisco, 11 March 2008.

52. Harley Dubois, interview with author, Burning Man Headquarters, San Francisco, 10 March 2008.

53. Ohtake, "A fiery Q&A with the Prankster Accused of Burning the Man."

54. See Burning Man Organization, "07 burning man Arsonist to be Arraigned in Pershing county" (http://www.burningman.com/news/arsonist_07.html, accessed 7 January, 2014).

55. Jones, Steven T., "Paul Addis, Playwright and Burning Man Arsonist, Dies" (http://www.sfbg.com/pixel_vision/2012/10/29/paul-addis-playwright-and-burning-man-arsonist-dies, accessed 7 January 2014).

56. William Dire Wolfe, interview with author, Black Rock City, Nevada, 2 September 2005.

57. David Best, interview with author, Black Rock City, Nevada, 2 September 2005.

58. The ritual of the Lamplighters was invented and designed by Larry Harvey, once a Lamplighter himself. In 1993, Steve Mobia and Harvey placed 24 lanterns on the ground leading up to the Man, creating a ceremonial pathway of light. Several of the lanterns were stolen; so, the following year, Mobia painted them with the Burning Man logo. This time they were all stolen. As a preventive measure, and an aesthetic choice, 12-foot-tall spires were erected to put the lanterns out of reach. The lamps are controlled flames as opposed to the passionate flames of the Man: a balance of fires (Burning Man Summer Newsletter 1997, www.burning- man.com/whatisburningman/1997/97n_letter_sum_2.html, accessed 1 December, 2012). These 24 lanterns doubled every year; by 2007, over 800 illuminated the streets of Black rock City. Burning Man is the largest user of kerosene lamps in the United States, with Disneyland a distant second; both are supplied by W. T. Kirkman of Ramona, California—the largest importer and distributor of kerosene lamps in the country (Afterburn Report 2003, www.afterburn.burningman.com/ 03.html, accessed 28 April 2006). Over the course of the seven days of Burning Man, the 800 lanterns consume seven 55-gallon drums of kerosene, lighting over three miles of the city each evening. The central Lamplighter workspace, where the lanterns are prepared each evening, is known as the Chapel. Every day, 160 volunteers clean, fuel, light, carry and lift the lanterns into place. Michael Mikel recalls how Louise Jarmilowicz (aka Edwina Pythagoras), a former Suicide Club and Cacophony Society member, designed—gold lamé with red flames sewn on the bottom edge—and sewed the first lamplighter robes in 1995. (Mikel has the only one out of the first six ever made). Jarmilowicz's design was adapted and simplified so that the robes could be easily reproduced. Around 17:00 each evening, the Lamplighter Chapel is bustling with activity. A freight container is filled with the robes of the Lamplighters. All the sooty lantern globes are washed and cleaned, the lamps filled with kerosene and the lanterns are arranged, loaded onto the poles and made ready for carrying (Bowditch, Rachel, *On the Edge of Utopia: Performance and Ritual at Burning Man,* London/Calcutta: Seagull Books, 2010).

59. Crimson Rose, phone interview with author, 14 December 2012.

RACHEL BOWDITCH

After the Man Burns
Photo: "Playarazzi" Andy Pischalnikoff

TEMPLES ON FIRE:
DESERT, DUST AND DESTRUCTION
SAM BERRIN SHONKOFF

I. DESTROYING OUR TEMPLES

The Temple at Burning Man is a sacred pilgrimage site, glowing in that liminal space between the City and the vastness of the deep playa, where even dubstep bumping and flame-throwing mutant vehicles keep a deferential distance. At the Temple, burners witness weddings, sunrises, blessings and breakdowns. They meditate, remember and pray. They whisper heartfelt words and externalize their longings and secrets onto the walls with writing, photographs and personal possessions. They sob for lost loved ones, for broken relationships, for themselves, for the thickness of life. Over the course of a full week, the wood of the Temple absorbs all of this. And then, at the end, tens of thousands encircle the Temple and in surreal silence watch it burn to the ground. The huge fire illuminates every face—somber gazes, knowing smiles, poignant tears, sighs of release, uncertainty, nostalgia. The walls, pillars and beams violently implode and explode, unleash plumes of smoke into the atmosphere, and turn to dust by dawn.

From a religious studies perspective, the Temple burn is profound. A community ritually incinerates its own temple! Sure, many burners don't see the Temple as a "religious" site, per se, and its destruction even tickles an anarchic "evasion of significance" at the core of Burning Man.[1] However, while two builders of the 2011 Temple described their creation in a TEDx talk as a "secular temple," they also referred to it as "sacred" multiple times.[2] One cannot overlook the fact that the annual structure is called a "temple," and the Temple burn is undeniably a full-blown ritual.[3]

As a Jew, I contemplate how striking and strange the Temple burn is in relation to images of the ancient ḥurban (the destruction of the Temple) in Jewish consciousness. When the Babylonians destroyed the First Temple in Jerusalem in 586 BCE, and when the Romans destroyed the Second Temple in 70 CE, the dominant voices in Jewish tradition portrayed those events as catastrophes through which God punished Israel for their sins. The biblical book of Lamentations may elicit images for some readers of Sunday night at Burning Man—where God "kindled a fire in Zion which consumed its foundations" (Lam. 4:11)—but there was nothing cathartic or romantic about that ancient Temple burn. In Jewish tradition, the ḥurban is an event to be mourned. For nearly two millennia, Jews have prayed three times a day for the rebuilding of the Temple, observed the annual holiday of Tisha b'Av (the ninth day of the month of Av) as a commemoration of the ḥurban and other tragedies in Jewish history, and left synagogues architecturally incomplete in order to affirm that such buildings are only temporary substitutes for the Temple. The ḥurban was the tragedy that reduced the Holy of Holies—the innermost chamber of the Temple that contained the Ark of the Covenant with the Ten Commandments—to dust. It sent the Israelites back into the desert from whence they came, back into exile.

For my ancestors, the Temple was God's throne, designed according to God's instructions, built atop a mountain in God-given territory. This classical notion of sacred space no longer satisfies. Its underlying theology is at odds with my modern sensibilities and moral compass. I do not believe in a deity who literally dictates blueprints or declares borders. I cannot say what God is, but that unspeakable Wellspring of reality—designated in Jewish tradition by numerous names such as the Eternal, the Presence, the Name, the One, Being, Source, Infinity, Nothingness—is too vast and powerful for such simplistic concepts. As a twenty-first century seeker, convinced that

no static statement or image can capture absolute reality, the ritual of the Temple burn on the playa radiates religious meaning. Perhaps many Jews today feel spiritually and intellectually ripe to reinterpret the *ḥurban*. While a significant number of them (myself included) may yearn for a tangible Temple soaked in holiness, perhaps they are also nonetheless ready to draw meaning from destruction, to encounter themselves and God anew in the afterglow of a consuming fire.

The historical *ḥurban* should not be reduced to a spiritual metaphor. For my ancient ancestors, the destruction of the Temple was a real event that involved terror, death and displacement. However, Jewish thinkers throughout the ages have allegorized and spiritualized virtually every geographical place and narrative in the canon.[4] It is fair play for contemporary exegetes to consider spiritual significations of both the existence and the destruction of the Temple. Such reflection neither trivializes the historical *ḥurban* nor negates the importance of actual temples; it only affirms the non-radical, classical notion that religious images are complex and multidimensional. Indeed, as we shall see, to discover new meaning in material destruction can paradoxically enable us to embrace materiality in new, healthier ways.

Even if the dualistic idea that God dwells amidst particular places, practices, or communities is rejected, earthly temples are still necessary as places where people can seek and encounter that Presence. According to Jewish mysticism, the essence of God is Infinity (*Ein Sof*), which is also called Nothingness (*Ayin*)—for if the Divine is infinite, then It cannot be any particular thing, and is therefore no-thing.[5] But the mystics are also practical enough to recognize that human beings cannot bypass material reality, as it were—nor should they! Rather, the earnest seeker must primarily turn to the worldly, dualistic realm of Being (*yesh*), where rituals and relationships, scriptures and places are palpable. One needs these concrete elements to shake one out of hypnotic habitudes, to rupture routines, to produce "caesural spaces" in consciousness, through which it is possible to glimpse concealed depths of what it means to be alive.[6] Yet temples themselves are not ultimate; their walls only shelter the sprouting soul so that it can grow to grasp truths that transcend walls. While temples are entered with humility and sensitivity, they must also be spiritually "destroyed." The seeker's perennial task is to remain committed to this slippery dialectic between Being and Nothingness.[7] In my experience, this dialectic proves a fertile site for dialogue between Burning Man and Jewish tradition. It is especially rich with regard to the motifs of desert, dust and destruction—motifs that unfold on the playa of Burning Man and on the pages of Jewish tradition, and that provide wisdom about how to embrace and release one's "temples."

II. DESERT

The expanse of the Black Rock Desert where Burning Man takes place is sublime in its nothingness. The earth is flat, lifeless and monochromatic—a blank canvas colored by any subtle shift in lighting or weather. When the sun rises and sets, golden rays and purple clouds transform the landscape. When a crescent moon glides across the night sky, shadows reveal intricate mazes of cracks in the earth. When the wind blows, curtains of dust unfurl and traverse the desert floor. When 50,000 people congregate there and create Black Rock City, the wildest fantasies take shape without mufflers or filters. Every flame and face, dance move and brush stroke, gift and kiss infuses something into nothing. The desert receives and amplifies. It conducts energy and gives voice. It is empty and so it can be filled with anything.

The desert is a salient setting in Jewish consciousness, and many Jewish burners have riffed on this theme. Rabbi Menahem Cohen and Jay Michaelson founded Congregation B'nai Hamidbar ("Children of the Desert") on the playa in

2003. In a mini-documentary about Jewish life at Burning Man by a blogger called Wandering Jew (yet another desert allusion), a guy named Dreamkote remarks, "Jews are from the desert, you know? That's where our spirituality grew up."[8] The websites for the camp Sukkat Shalom ("Shelter of Peace") and the Facebook group "Jews at Burning Man" also reference the biblical significance of the desert environment.[9]

In Jewish memory, the desert is a site of wandering and the paradigmatic place of revelation. It was there that 600,000 Hebrews camped together at the foot of Mount Sinai, collectively encountered the One, and received the Torah (Ex. 19). The Talmudic sages ask why the Torah was given in the desert. After all, isn't the desert neither here nor there? Isn't it barren and vacuous and thus an inappropriate location for the grand unveiling of divine wisdom? Yet the sages indicate that this is precisely why the desert is an ideal site for revelation: it is a "free" and "open" space, so any messages that arise there are maximally accessible to all people.[10] Like "gifts" on the playa, the Torah is given gratuitously and indiscriminately. According to rabbinic interpretation, the Torah was "given in the desert—publicly and openly, in a free place, where everyone who wishes to receive can come and receive."[11]

But the desert is not only the geographical site of revelation; it is also a metaphor for the psychological conditions of revelation. Make yourself like a desert, the sages instruct.[12] "Anyone who does not throw himself open to all like a desert cannot acquire wisdom and Torah."[13] Through desert-mind—making oneself free and open—one is receptive to divine understanding. The Talmudic sage Raba comments, "If a person allows himself to be treated as a desert upon which everyone treads, the Torah will be given to him as a gift."[14] In response to this teaching, the contemporary Jewish theologian Michael Fishbane writes, "Becoming a *midbar* [desert] for the reception of Torah is an ongoing task of self-cultivation; one must carve out an inner space of empty openness, and then one may learn. Such acts of divestment are acts of spiritual poverty in the most profound sense."[15] A seeker attains desert-mind when resistance is released and the courage is found to attentively look upon all the turbulence, beauty, and subtlety of being. Such openness involves wandering into the Unknown. The prophet Jeremiah associates the desert with an *eretz ma'apelyah*, a "land of darkness" (Jer. 2:31), where one cannot see what lies ahead.[16] In relation to this image of the desert as the shadowy Unknown, it is poetic that the Hebrew word for revelation, *hitgalut*, sounds as if it could be a reflexive form of the word for exile, *galut*. Revelation involves self-exile, the destruction of one's own temples of habit and familiarity. Abraham had to "go forth" from his homeland (Gen. 12:1), Jacob had to be "left alone" across the Jabok river (Gen. 32:23-25), and Moses had to retreat to "the back of the desert" (Ex. 3:1).[17] "He who upholds the Torah makes himself like a desert and detaches himself from everything."[18]

The ultimate message of Judaism, however, is clearly not that people should retreat from material reality, social relations, and sacred physical spaces! While the Torah is replete with revelations in solitude, the divine messages embedded in those moments almost *always* pertain to the individual's duties in concrete, historical situations. Moreover, the Torah includes 613 commandments that relate to all aspects of embodied, interpersonal life—business, sexuality, eating, politics, ethics, dressing, agriculture. In fact, the Torah guides its adherents to engage with various objects and places for purposes of sanctification. There is an apparent contradiction between desert-mind and Jewish law. However, this contradiction points to that sacred dialectic between Being and Nothingness. And now a question arises: how can revelatory moments be integrated into the wholeness of life (including material life) without losing the desert-mind that makes such moments possible?

Burning Man offers illuminating responses to this question. Artists and architects devote an inordinate amount of time, energy and resources to the construction of a sacred Temple; tens of thousands of burners cherish the structure as a holy site;

everyone collectively releases it by means of fire. There is no static or direct path to that liminality between constructing temples and destroying them, between Being and Nothingness, between immanent reality and transcendent truths. The contemporary seeker must continually nourish these tensions. When the Temple of Black Rock City is wholly inhabited and then ritually burned to the ground, a fertile paradox is rekindled at the heart of spiritual life. The Temple can be mourned, but with a sober awareness that every temple is ephemeral, in a state of not-yet rubble. Just like every other religious norm, text and place, it is humanly constructed. Yet the currents of creativity that surge through the cells and souls of playa life make one wonder: How did "humanly constructed" ever receive a negative connotation? How did it come to be associated with meaninglessness?

I think that present-day Hebrews truly are *dor ha-midbar,* the "generation of the desert." Although this phrase is somewhat pejorative in rabbinic parlance, referring to those Israelites who had to wander and die off before the nation could enter the Promised Land, it may resonate in new ways for contemporary seekers. There is no permanent resting place for the soul. Homelands and temples can be blessings, but there is nonetheless great fertility in the open and empty Unknown. A "heart of fire" consumes sanctuary structures, transforming solid walls into particles of smoke that waft over boundless desert.[19]

III. DUST

You are covered in playa dust from the moment you arrive at Burning Man. It settles in your sweat, clothes, eyelashes and tents. It's beneath your feet as you walk, dance and stomp through the week. It is a dry mist that hovers in the atmosphere, mingling with laser beams, firelight and sunrays. Dust swirls past sculptures, blaring subwoofers, sex workshops and tea parties. It is fairy dust that envelops Burning Man like a dream. It cannot be ignored or conquered, so it becomes transformative. Playa dust is a reminder of how little control we have over the elements, how gracefully powerless we are in the world. And the dust sticks around well after the event—it is on everything, and is a shared code among burners. As the title of this book suggests, dust is a salient symbol of the Burning Man experience. Jewish burners have certainly refracted the spiritual significance of playa dust through the prism of Jewish tradition. The explicit mission of Sukkat Shalom is "to nourish the faith of those who sleep in the dust," a direct quote from Judaism's daily prayers.[20] Another camp offered a "Playa Dust Mikveh" in 2011, transforming the ancient purification ritual of immersing oneself in flowing water to immersing oneself in floating dust.[21]

Jewish sources suggest that dust reflects the core of a human being. According to biblical wisdom, humanity is literally created out of *afar,* "dust" (Gen. 2:7). The second-century sage Rabbi Meir teaches, "The dust of the first human was gathered from all over the world," suggesting that this *afar* was transient, wafting far and wide through open space.[22] Human beings are inherently inchoate and unsettled. The Malbim, an early nineteenth-century commentator, elaborates:

> As for the human, who was created from unsettled dust—not from a single clump—his dust gathered from numerous places and imbued him with many energies....This dust does not stay put on the earth. It floats above; it is not embedded. It reflects the way a person's spirit (*ruaḥ*), the root of his personality, is midway between above and below. [23]

The Malbim's description of *afar* is evocative of the airborne and unruly dust of the playa. He observes that human beings gradually *construct* their identities,

without any solid foundation beneath these constructions. The dusts of selfhood settle into certain shapes and forms, but the breezes of time and life inevitably re-expose the underlying formlessness. The Malbim's portrayal of our groundless "spirit" (*ruaḥ*) serves to further elucidate the image of our primordial dustiness. *Ruaḥ*, which literally means wind, is that which destabilizes and carries dust. Thus, the human being is scattered and scattering, unsettled and unsettling, disoriented and disorienting. "The foundation of a human being is dust, and his end is dust," Jews traditionally chant during the Days of Awe. "He is like… blowing wind and flying dust."[24] And if the human being created "in the image of God" (Gen. 1:27) is essentially dust, then how much more so is the Temple and every other religious structure. Indeed, the primordial state of the universe itself is *tohu ve-vohu*, "chaos and emptiness" (Gen. 1:2). Dynamic movement is the bottom-line of all Being. The anarchic ethos of Black Rock City, most vividly manifested in its various burns, is a magnificent affirmation of dusthood.

However, affirming that everything is dust should not lead to nihilism or relativism, or to detachment from structures of meaning. On the contrary, if self and world are so fluid and formless, then there is more responsibility to carefully and creatively construct reality. As the existentialist philosopher Jean-Paul Sartre reasons, if the human being is at first "indefinable" and "nothing," then only through his decisions and actions "will he be something, and he himself will have made what he will be…. Man is nothing else but what he makes of himself."[25] The Malbim reflects, "Because his soul contains within it all the energies and their opposites, he possesses the capacity for choice, to choose as he desires. Thus, two people seem like two different species. One may have compassion for a fly, while another is cruel to his own children."[26] In facing Nothingness, there is the realization that individuals can radically shape Being. Just as new revelations emerge in the emptiness of desert, new forms emerge in the shapelessness of dust. Wrestling with dusthood is a thoughtful and full-bodied immersion—a dust *mikveh*. The root of the Hebrew term for "wrestling" is *avak*, another word for dust. Wrestling is an expression of our inner nature, and it is a source of blessing and personal transformation. One who wrestles is truly *Yisrael*, "God-wrestler."[27]

The awareness that "I am but dust and ashes" (Gen. 18:27) and that "you are dust and will return to dust" (Gen. 3:19) informs a letting go, but it should not lead to disengagement. Building should continue with newfound humility. How can a Temple be constructed in light of the formless dust at the heart of everything and everyone? How can religious structures be embraced without idolatrous illusions of the ultimate or absolute? Thus, we re-approach the contradiction—between constructing and destroying temples, between desert-mind and religious normativity, between dust and solidity. When individuals and communities incinerate their temples, whether psychologically or literally, the resultant ash is a mirror that reflects inner dust. The nearly homophonous Hebrew words for ash (*efer*) and dust (*afar*) are occasionally paired together in the Torah,[28] and sometimes *afar* is even used as a term for ash.[29] Wrestling and burning kick up dust and ash, and uncover dynamic truths that flow beneath static surfaces.[30]

IV. DESTRUCTION

The Temple is not the only object that gets ritually destroyed at Burning Man—there is also the effigy. In contrast to the silent, contemplative Temple Burn, the destruction of the Man at the center of Black Rock City is an effervescent celebration, popping with fireworks and fire dancers, cheers, chants and music, and blasts of BOOM! from somewhere within the towering effigy of the Man. There is always burning at Burning Man. Frequent displays of destruction are the spirit of

Black Rock City, a world that celebrates sensory reality while uprooting materialistic possessiveness, a culture that overflows with creativity for the sake of momentary experience. The Temple burn is the last of the great fiery destructions, but it is not the last erasure. The largest destruction is the final deconstruction of Black Rock City itself. As Burning Man concludes, the city is gradually dismantled, collapsed and packed up, metamorphosing the playa back into vacuous desert. The final intention is to "leave no trace."

In Judaism the Temple is also not the only thing destroyed, and Jewish tradition offers a nuanced perspective on the meaning of destruction. Consider the moment when Moses descends after 40 days on Mount Sinai with the tablets of the Ten Commandments in his hands (Ex. 32:19-21, Deut. 9:15-21). As he approaches the bottom of the mountain, he sees the Children of Israel partying with the golden calf, an idol that his brother Aaron helped them build. Moses takes the idol, "burns it in fire," and grinds it down until it is *dak le-afar,* "fine as dust" (Deut. 9:21),[31] echoing what Aaron apparently knew all along: "There's nothing actually in it."[32] Moses reduces the idol to dust, dissolves it in water, and makes the Israelites drink it, conveying the transitoriness of material objects. However, Moses does more than merely destroy the golden calf—his lesson would be inadequate if he only destroyed the idol. He communicates to the Israelites that even "kosher" ritual objects are ultimately no more than objects. Thus, when Moses sees the golden calf, the very first thing he does is destroy the God-given tablets of the covenant. He later reminds the Israelites of his double-movement that expressed the dialectical meaning of holiness: "I *clutched* the two tablets and *cast them away* from my two hands, and broke them before your eyes" (Deut. 9:17). Although he eventually ascends the mountain again to receive a new pair of tablets, the theological lesson learned at the foot of Sinai should never be forgotten. Indeed, the shards of the first tablets are permanently preserved beside the new tablets in the Ark of the Covenant.[33] Whoever beholds the tablets must also simultaneously behold the image of their destruction. Being and Nothingness converge in a complex, multidimensional truth. According to Jewish tradition, the true prophet vividly envisions this intertwinement of construction and destruction, even with the Temple itself: "All prophets see it built, destroyed, and built."[34] As with Black Rock City's Temple, objects can be precious, but they are still only impermanent objects before the eternal Divine. As Rabbi Meir Simḥa ha-Kohen of Dvinsk (1843–1926) warned, "Do not imagine that the Temple and the Sanctuary are holy in and of themselves, God forbid!"[35]

Spiritual acts of destruction in relation to religious norms and forms can paradoxically serve to reconstruct lost layers of meaning in those very structures. In the words of the Torah itself, "There is a time when, for the sake of the Eternal, the Torah must be destroyed" (Ps. 119:126).[36] This dialectic between construction and destruction elucidates the enigmatic words of Isaiah when he encounters God within the confines of the Temple and nonetheless cries out, "Holy, holy, holy, YHWH of hosts! The whole world is filled with Its gravity!"[37] (Is. 6:3). Isaiah must stand inside the Temple to experience a heightened awareness, and yet this very experience expands his state of consciousness far beyond the walls themselves. He spiritually destroys the Temple even while he inhabits it. Millennia later, as the Black Rock City Temple burns down to the dusty ground—as flames burst forth from its structure, casting pillars of smoke into the sky and reducing towering walls to playa dust—one may sense that the Presence was in that place, and thereby sense (paradoxically) that the Presence permeates all of reality.

The Divine is one, yet human beings encounter traces of divinity in the dualistic world where life takes place. Holiness is infinite, saturating the very fabric of reality, but it is generally only perceived in particular moments of rupture, change, and uniqueness. The biblical narrative that most vividly captures this paradox is that of Elijah's theophany on Mount Sinai (I Kings 19:11-14):

And, behold, the Eternal passed by. And a great, strong wind split mountains and shattered rocks before the Eternal—but the Eternal was not in the wind. After the wind, an earthquake—but the Eternal was not in the earthquake. After the earthquake, a fire—but the Eternal was not in the fire. And after the fire—a sound of faint silence.[38] And when Elijah heard it, he wrapped his face in his robe and went out and stood at the opening of the cave. And, behold, a voice came to him saying, "What is for you here, Elijah?"

In the mind of the ancient genius who composed this text, of course, God *is* somehow in that supernatural wind, quake and fire. The narrative even alludes to the famous Sinai revelation in which God was explicitly "in the fire" (Ex. 19:18). These verses convey that while it is necessary to depend on powerful sights and experiences to unveil divine depths of being, it should not be assumed that divinity is otherwise absent in everyday reality. No! Revelation *reveals*; it does not generate stuff that was previously absent. The Eternal is most intimately within that barely perceptible, barely fathomable "sound of faint silence" that vibrates in every moment in every place. Hence the enigmatic question after Elijah's revelation: "What is for you here?" That is, why did you leave your city and community and hike all the way to this remote mountain in order to seek the Omnipresent? And yet, ironically, Elijah needed to do so in order to remember this crucial theological principle.

Extraordinary experiences like those to be had at Burning Man can awaken people from their stupors, and even after they dismantle the city they leave the playa with refreshed receptivity and rediscovered wisdom. A week of being tossed in the dust-waves there amplifies Elijah's lesson:

A great, strong wind enshrouded the world in playa dust so that even the sun was concealed—but God was not in the wind. And after the wind, the earth beneath her ecstatic body quaked with booming bass blasts from those towers of speakers—but God was not in the quake. And after the quake, Whoa look at that gigantic fucking fire over there—but God was not in the fire. And after the fire, a sound of faint silence.

To remain mindful of that hardly perceptible Presence that permeates all existence enhances one's capacity to relish faces, sights and sounds without deifying them. One can then enter a temple and simmer soulfully in its divine gravity without idolizing its structure. This is not just a matter of heady "spirituality" or theological rumination; it's about being awake and openhearted amidst all the wild and unpredictable possibilities that life unfurls in each moment. Paradigms of desert, dust and destruction from the sources of Jewish tradition and Burning Man offer profound guidance for this journey.

NOTES

1. See Erik Davis's insightful essay, "Beyond Belief: The Cults of Burning Man," Lee Gilmore and Mark Van Proyen eds., *Afterburn*, Albuquerque: University of New Mexico Press, 2005.
2. See Jai Aquarian and Erin Macri's TEDx talk, "Yes I AM," at http://tedxtalks.ted.com/video/Jai-Aquarian-Erin-Macri-Yes-I-A;search%3Ajai%20aquarian.
3. On the ritualized and religious dimensions of the Temple, see Bowditch, Rachel, "Temple of Tears: Revitalizing and Inventing Ritual in the Burning Man Community in Black Rock Desert, Nevada," *The Journal of Religion and Theater*, Vol. 6, No. 2, Fall 2007, pp. 140–154.
4. See Gershom Scholem's comment about this exegetical tendency among the eastern-European mystics known as Hasidim in Scholem, *The*

Messianic Idea in Judaism, Michael Meyer, trans., New York: Schocken Books, 1995, p. 200.
5. See Matt, Daniel, "*Ayin*: The Concept of Nothingness in Jewish Mysticism," *Essential Papers on Kabbalah*, Lawrence Fine ed., New York: New York University Press, 1995.
6. See Fishbane, Michael, *Sacred Attunement: A Jewish Theology*, Chicago: The University of Chicago Press, 2008, p. 24.
7. For readings on this dialectic between Being and Nothingness in Jewish thought, see Elior, Rachel, *The Paradoxical Ascent to God: The Kabbalistic Theosophy of Habad Hasidism*, Jeffrey M. Green, trans., New York: State University of New York Press, 1993; Elior, Rachel, *The Mystical Origins of Hasidism*, Oxford: Littman Library of

Jewish Civilization, 2006, chapter 8; Green, Arthur, "Hasidism: Discovery and Retreat," The Other Side of God: A Polarity in World Religions, Peter L. Berger, ed., Garden City: Anchor Press, 1981; Michaelson, Jay, Everything Is God: The Path of Nondual Judaism, Boston: Trumpeter Books, 2009.

8. You can find Wandering Jew's (aka Ben Harris') mini-documentary, entitled "Jewish Life at Burning Man," at: http://www. jta.org/news/article/2009/09/10/1007772/amid-hedonistic-indulgence-jews-search-for-meaning-at-burning-man. On this same webpage, see Ben Harris, "Amid Hedonistic Indulgence, Jews Search for Meaning at Burning Man," Jewish Telegraphic Agency, September 10, 2009.

9. See the "Preparation" section of the Sukkat Shalom website at http://www.sukkatshalom.net/preparation/, and see the "Jews at Burning Man" Facebook group at http://www.facebook.com/jewsatburningman.

10. Midrash Rabbah, Bamidbar (Numbers), I:7.

11. Mekhilta d'Rabbi Yishmael, Bahodesh, Section 1. Cf. Bamidbar 1:7.

12. Midrash Rabbah, Bamidbar, 1:5, 19:26. Cf. Babylonian Talmud, Eruvin 54a.

13. Midrash Rabbah, Bamidbar, 1:7. Soncino translation.

14. Babylonian Talmud, Eruvin 54a. In this statement, Raba interprets the biblical verse "And from the desert, Matanah (lit. 'gift')" (Numbers 21:18). Although this verse appears to simply recount the Israelites' journeys from the desert to a location called Matanah, Raba interprets the words hyper-literally ("From the desert, a gift") in order to comment on the relationship between revelation and the desert.

15. Fishbane, Sacred Attunement, p.148.

16. See also Midrash Rabbah, Bamidbar, 1:2.

17. These are only a few famous examples of revelatory "leave-taking" in the Bible. For an insightful reflection on taking leave as a precondition for revelation, see Lew z"l, Alan, Be Still and Get Going, New York: Little, Brown and Company, 2005, pp. 11–21.

18. Midrash Rabbah, Bamidbar, 19:26.

19. See Midrash Rabbah, Shmot (Exodus) Rabbah, 2:5, where the Rabbis draw a linguistic connection between the lavat aish ("flame of fire") of the burning bush that Moses encounters in the desert (Exodus 3) and the lev aish ("heart of fire") that is within Moses. Cf. the eleventh-century French exegete Rashi's commentary on Exodus 3:2.

20. Sukkat Shalom online homepage, http://www.sukkatshalom.net/. The phrase itself comes from the Amidah, the silent "standing" prayer, which is the climax of the morning, afternoon, and evening services.

21. See the official event listing at http://playaevents.burningman.com/2011/playa_event/5588/

22. Babylonian Talmud, Sanhedrin 38a.

23. Rabbi Meir Leibush ben Yeḥiel Mikhel (also known by the acronym, MaLBIM), Ha-Torah v'ha-Mitzvah, commentary on Gen. 2:7.

24. From the Musaf service of Rosh Hashanah and Yom Kippur.

25. Sartre, Jean-Paul, Existentialism and Human Emotions, New York: Citadel Press, 1985, p. 15.

26. Malbim, Ha-Torah ve-ha-Mitzvah, commentary on Gen. 2:7.

27. See Genesis 32, where Jacob wrestles all night with God/self/alterity and thereby receives his divine name, Yisrael.

28. For example, see Genesis 18:27, Job 30:19, and Job 42:6.

29. For example, see Deuteronomy 9:21, Numbers 19:17, II Kings 23:6, and II Kings 23:15. Avak, another term for dust, also refers to ash in Isaiah 5:24.

30. Another meaningful wordplay with afar appears in Genesis Rabbah 14:7. In this ancient midrashic commentary, Rabbi Yehudah Bar Simon interprets Gen. 2:7 ("YHWH Elohim formed the human [from] afar") to mean that the human was formed ofer olam al meli'ato, "a strong one of the world in his wholeness." Thus, Jewish tradition establishes an association between dustiness and wholeness—a connection that might seem paradoxical at first glance, but which comes to make sense in the light of our present discussion.

31. According to this passage, Moses then casts the dust into the river running down the mountain, presumably so that the Israelites at the foot of Mt Sinai would see the material from their so-called god be carried along passively in the flowing water. Cf. Exodus 32:20.

32. See Midrash Rabbah, Vayikra (Leviticus), 7:1.

33. See Babylonian Talmud, Baba Batra 14b.

34. Tanḥuma, Va-yetze, 7:9.

35. See Meir Simḥah ha-Kohen of Dvinsk, Meshekh ḥokhmah, commentary on Exodus 30:11–34:35.

36. My translation here is idiosyncratic, but this is how the Rabbis interpret the passage in Babylonian Talmud, Temurah 14b. The eighteenth-century Jewish philosopher Moses Mendelssohn also understood the passage this way. See Mendelssohn, Moses, Jerusalem: Or On Religious Power and Judaism, Allan Arkush, trans., Hanover: Brandeis University Press, 1983, p. 102.

37. Although the Hebrew word kavod is often translated as "glory," a more literal translation is "gravity," for in other contexts, kavod relates to matters of weight. For instance, the etymologically related word kaved means "heavy." Also, I translate it as "Its gravity" rather than the more traditional "His gravity" in order to convey the non-anthropomorphic, pantheistic dimension of Isaiah's theophany. In doing so, I do not violate the grammar of the Hebrew sentence whatsoever, as the masculine pronoun also serves as the neuter pronoun in Hebrew.

38. The King James Bible famously translates the phrase kol d'mamah dakah as a "still small voice," but a "sound of faint silence" is a more accurate translation. Moreover, the latter translation better captures the paradox that this text seeks to convey. For our purposes, it is also illuminating to note that the word dakah, translated here as "faint," is the same word we encountered earlier when Moses ground the golden calf down until it was dak l'afar, "fine as dust" (Deut. 9:21). There are traces of "dust" in the paradoxical "sound of faint silence" that underlies all the magnificent phenomena of worldliness. With dustiness in mind, one might alternatively translate d'mamah dakah as "fine silence."

Temple of Stars, Day, 2004
Photo: Scot Hess

TORCHING IMPERMANENCE: THE TEMPLE BURN

TED EDWARDS

PILGRIM GONE IMMORTAL

On 15 August 2000, a lovely moonlit night, 33 year-old Michael Hefflin climbed aboard his motorcycle. He'd been working with artist David Best's crew assembling an elegant structure that would become Burning Man's first official Temple. The moon blinked that night, and Michael, one of the most beloved crewmembers, propelled himself into the slipstream. On 20 August 2000, the *Marin Independent Journal* ran Michael's obituary:

> HEFFLIN, Michael L. Jr—Born 3 June1967 in Long Beach, Calif.. He was 33. In his short time on earth, he lived many lifetimes and touched many lives. He was the strongest of warriors and gentlest of gentlemen. He danced with the stars and slept with the moon. He was Michael—He was Love.

His devastating loss left Best's team struggling to continue. Their finished installation became known as the *Temple of the Mind*, and, in a gesture that characterized all of his subsequent Temples, David encouraged people to write thoughts or memories on leftover wood scraps. Five years later Katy Butler interviewed David about events following Michael's death:

> We go up to Burning Man anyway, because we had planned to, and as we build, we're thinking about Michael and doing our best.... We put a picture of him inside it. When people asked what we were doing, we said we were building a temple as a tribute to a friend of ours. Automatically people started saying, "Well, my brother was killed on a motorcycle." And from there it just snowballed.[1]

The next year, in 2001, for the first time the Temple was assigned a specific location and was scheduled to burn Sunday night. Christine "Ladybee" Kristin, Burning Man's art curator from 1999 to 2008, explained the placement of the Temple:

> Between the Keyhole and the Man is a walkway (called the 6 o'clock Promenade) lined with lampposts; in 2001, we started to place theme-related installations on either side so that participants could have an engaging walk to the Man, experiencing theme art along their way. Our Seven Ages of Man theme featured installations representing each of those ages. Birth, the initial age, was the first piece on the walkway to the Man, and Death was represented by David Best's mausoleum, the *Temple of Memory*. We placed it far beyond the Man on the same line of sight, extending the walkway all the way from the Keyhole to the Temple (and dubbed the 12 o'clock Promenade), as it remains today.[2]

Veteran Bill Codding, wearing a variety of hats over the years, has been involved in the construction of all of David Best's temples. He has dealt with logistics, communicated with the Burning Man Organization and other agencies, submitted burn plans to the BLM, Cushing County and the DMV, and managed electrical and lighting systems at the temples. He recalled, "When it appeared that the Temple burn was big, the decision was made to spread out the week's Burns. Sunday felt like the correct day for the somber tone of the Temple Burn. It sort of winds people down for their departure that night or the next day."[3]

Robert Collier chronicled David Best and Jack Haye as they assembled the 2001 *Temple of Memory*, their first official Temple. When asked about the purpose of their work, Best replied:

Put your right hand out, that's the person who committed suicide, alone and agonized. Put your left hand close to you. That's the child who died of leukemia, surrounded by love and support. Now, move the two hands together and lift them. In this way, those who died amid love will help liberate those who died in anguish. Go say goodbye to someone, forgive them or ask them to forgive you. Say whatever you have to say.[4]

The Temple has evolved into a Burning Man testimony to lives and loves lost. Michael Hefflin's untimely fate forever altered Black Rock City, transforming what was to be an art installation into a memorial and setting in motion the annual construction of a structure that has arguably become the heart and soul of the Burn week.

VIRGIN PILGRIMS

In 2008 I retired at age 62 from a lifetime of teaching and coaching, and instead of struggling with the first week of a new school year that August, I could finally attend a Burn. It was a delight to share the experience with Bob Hudson, another retired teacher with whom I'd taught for the past eight years in the Ark alternative high school in Santa Cruz, California. By great good fortune, we camped with Bob's nephew, Peter Hudson, an artist renowned at the Burn for having produced a string of magical stroboscopic zoetropes. Bob and I landed in a scene of incredible energy as Peter struggled to get *Tantalus*, based upon that year's theme The American Dream, installed and operating. We spent many hours helping Peter respond to repeated breakdowns. His kitchen shelter resembled a dusty, busy warehouse of cabling and gears. Exposure, dust and foolish Burners boarding *Tantalus'* rotating plane all wrought havoc with the thing. Throughout this week-long ordeal Peter's devoted posse stood ready to assist in any way. "Be sure," they all advised, "to check out the Temple."

We were on our way to do just that when a dust storm rolled in. For the next five hours, we hunkered down, unable to go anywhere or see anything. Our bandanas and goggles provided slender defenses against the gusting, penetrating, can't-see-beyond-ten-feet dust storm. So this was the real Burning Man. "This shit happens every day?" I wondered aloud. "Sometimes," intoned Peter.

When the storm finally cleared, Bob and I determined to have a look at this Temple, *Basura Sagrada* or "sacred trash." Constructed entirely with recycled materials, waste, all the stuff we routinely discard from our homes and lives, trash got elevated to an art form. But this "Junk" Temple, assembled by "Shrine", Tuktuk, and the Basura Sagrada Collaboratory, was seriously behind schedule. Though we could look from afar, it was Thursday before word got around that the Temple was finally open for Burners.

Eager on Thursday to finally enter the Temple, I dismounted my bike in shock. "Whoa, what's going on here?" By this point in the week, exposed to an incredible Burner community, I'd adjusted many prior paradigms, but was this not tagging? Graffiti? Sharpies in hand, folks of every demographic category were affixing their thoughts and memorabilia to any available space on the structure. Nothing I'd heard about the Temple had prepared me for this. There was no mirth, no delight evident on the faces of these folks so earnestly penning their innermost thoughts and feelings. Compelled to read our way through the Temple, one message

quickly merged into the next. Some inscriptions had less to do with love or loss, and instead addressed more philosophical content, "Trust the Universe, it has no reason to lie to you." The tough ones concerned death, divorce or suicide. Just two days later the structure was completely covered with messages, mementos, statements, hopes, dreams, Burner art of the heart.

There was no mistaking the respectful, contemplative feel of the place. While the junk chimes appeared to give voice to wandering spirits, Temple pilgrims, mourners, and witnesses gathered in the central commons or found spots off in tight corners, places providing an opportunity to plunge deep into thought or memories. Others reverently wandered the grounds, bearing witness to the welling eyes, sobs and hugs that punctuated the gathering.

Veteran Burners have come to understand that Black Rock City's Temple annually provides an asylum where one may confront the unruly dynamics of grief, those non-linear aspects of our experiential solar system. Within the Temple's embrace, haunted by repressed emotional injuries now fully exposed, composures dissemble. Clocks and calendars, rendered irrelevant as timeless emotional tides run riot, surrender their previous dominion over behavior.

Here in this site of sacred memories there is no creed, religion or god, only the intangibles of reverence, frailty and remembrance. There are no approved guidelines for mourning, no grounds for dismissal. Out of this powerful emotional tapestry, a wedding ceremony might suddenly materialize, and no one protests this unlikely superimposition of emotional states. The Temple is a physical place where the distinction between participant and observer gets blurred; here there's a synaptic bridging of elemental human energies. Invisible, insistent, painful memories furnish charged tinder, and braided emotional currents born of anger, love and grief fuel an empathic firestorm affecting everyone. Truth is, the Temple's combustion begins long before flames devour its structure.

"Wait. They're going to burn this too?"
"That's the plan."

That Sunday night in 2008, Bob and I joined a crowd vastly different from the one defining the previous night's Bacchanal Man Burn. All around us fellow Burners appeared to focus inward. At length, our attention shifted to a silent monastic torch procession approaching the Temple. Moments later small fires quietly took hold. The crowd of thousands sat speechless, awed by such an exquisite sacrifice. In its blazing demise, the resulting cauldron spawned a series of fiery tornadoes, fire devils. Spiraling, towering, firebrand sentinels forced leeward Burners into a hasty retreat. Eventually the foundation timbers toppled down and our Temple Burn was complete. Moved to the core, I realized there was way more to this Burning Man experience than simply burning the Man.

David was mindful in passing along the reins of this powerful tradition in 2005, when he collaborated with Mark Grieve and the next year, in David's absence, when Mark took on full ownership of the Temple task. Mark recalled David's mentorship:

David took notice of my work, and he invited me to work with him once a week. We'd talk and compose. He'd give me a scrap of something to work on. The Temple is sacred, beautiful. David tapped into something age-old. In 2005 and 2006 I had big shoes to fill. David knew I could build it, and I got to do David's work for two years. But I didn't want to make it look like David's work. Building a Temple is a truly unique experience, a once in a world experience.[5]

Supported by the Burner philosophy of gifting and monetary outlays restricted to ice or coffee, the Temple remains a counter-point to an unsettling rise in commercialism. During the 2011 Burn, one veteran Burner received tickets and was essentially paid to hold a camping place until mid-week, when a huge motor home on steroids rolled in and set up beside us. In 2012, one of the big sound camps paid a DJ $5,000 to spin; he was flown in and out. Also in 2012 some theme camps brought their own porta-potties that got serviced as we sat down to eat, the nasty bouquet wafting across our communal dinner table. The prevalence of motor homes and private toileting facilities liberated self-proclaimed elites from the humilities the rest of us tolerate at Burning Man—challenges that in actuality serve to knit the larger community together.

Of course this commodification compromises Burning Man values. The Temple's function and meaning cannot be contaminated by these compromises. Who among us has not confronted death and loss? Around and within the Temple there are no established brands of grief, no tithes to pay, no dispensations to be granted or sold, no luxurious ways to mourn.

A KNOWING PILGRIM

On Friday morning of the 2009 Burn I biked out to the graceful, lotus-shaped *Fire of Fires Temple*, erected by David Umlas, Marrilee Ratcliffe, and the Community Art Makers. I had a lot to commemorate that year. Since my last Burn, I'd lost my father, Ted Scantlebury, my dog Shadow, and my stepmom, Claire Fleurnoy.

In early November I had to put down Shadow, my treasured canine partner, better known to me as "Shadow-dog." Failing from advanced kidney disease, Shadow made one last visit to the veterinarian. I held him quietly in my lap, stroking his ears as he faded from us. Ahh Shadow, a mix of Cocker Spaniel and "mom got out" had privileged me with 14 companionable years trekking up mountains, hiking the hills, and dodging burly park rangers up and down Fall Creek. Shadow mastered the art of athletically retrieving tennis balls or Douglas fir cones thrown at unpredictable rebounds and could reliably sniff out the object of his search, no matter my deceptions. He gave me joy, and I hope I entertained him with my heartfelt laughter and soothed him with my honest affections.

A couple of weeks after Shadow's passing and less than two weeks before my father's passing, Claire Fleurnoy, the third of his four wives and someone whose company I deeply enjoyed, died on Thanksgiving Day. Claire was a dignified Southern Lady of grit and deep-throated laughter who served up memorable breakfasts seasoned with her raspy Southern accent.

Long before my father Ted's death, his Progressive Supranuclear Palsy (PSP) had taken him from us. The muscles that controlled his eye movement had succumbed to the palsy, and could no longer track, thus denying him the great pleasure he derived from reading books or keeping up to date with TV news. For a time books on tape kept him intellectually engaged, but his progressive loss of connectivity foretold an ugly, darkening future. Though we had no reason to believe he'd lost his any of his cognitive functioning, his muscular autonomy had departed. Eventually this silenced his once commanding voice and gusto laugh. He became a catatonic prisoner in his own skin, the same skin he nearly lost many times as a fighter pilot in the South Pacific during the Second World War and later, in the 50s, when he was flying politically sensitive flights over China.

My father was intelligent, intense and capable, and he expected others to demonstrate their capabilities and powers. While there were a lot of things we agreed on or simply appreciated as part of our genetic bond, the Vietnam War

provided years of contentious politics. Ted, as a 20-year Navy man, held that, no matter the politics, when your country called one had an obligation to serve. I viewed the Vietnam venture as an imperial war, and wanted no part of it. After being drafted into the US Army on Christmas Eve 1968, by the spring of 1969 I'd persuaded my draft board that I was indeed a Conscientious Objector. Ted later acknowledged the grave error of that war, and in the decades since, we'd become good friends and thoroughly enjoyed our shared enthusiasms.

After a year and a half of PSP-induced isolation, and hard on the heels of the deaths of my dog Shadow and my father's ex-wife Claire, Ted succumbed on 5 December. With these three deaths weighing on my psyche, I felt perplexed by my lack of tears.

I had a wealth of pent up feelings when I sought out the Temple, and I wasn't alone. Already the Temple was completely covered with a now familiar outpouring of poignant messages and philosophic meanderings. I hadn't brought photos or any sort of organized memorials so there on the spot I jotted down some of my thoughts. I wrote:

Sept. 4—Burning Man
I write to honor losses.
My father—Edwin Woodin Scantlebury —died 12/5/08, 89 years
Ted was a Commander until his diseases commanded him. He was full of life, which endeared him to all those who weren't occasionally intimidated by him. He was a complicated warrior, and a man of powerful intellect and achievement. I got to love him, and I greatly miss our good times together. Ted, I hope you are at a well-deserved peace.
I write of Shadow—a great dog that honored me with his existence for over 14 years. He knew very little about a leash, and he loved people and the great natural world. I miss his love and the way I could speak to him. He was a complete dog and he brought happiness to all that knew him.
Claire Fleurnoy—my step mom with a warm Southern heart who brought grace and humanity to my father Ted. RIP dear woman
Love, Ted

I taped my long-deferred remembrances to the structure. Tagging? Graffiti? Not so much.

Moved to the core by this memorial process, my withheld tears at last slid down my cheeks. I harbored no self-conscious desire to stop them. Rather, I felt gratified for their release.

Sunday night's Fire of Fires Temple Burn followed a long day of dust storm doubt. Would the Burn even take place in the face of zero visibility? A blinding dust storm Burn could put a lot of folks at serious risk of disorientation or elemental exposure. "The Fates have their ways," my mother liked to say; an hour prior to the scheduled Burn Ursa Major and Polaris returned to orient our night sky.

Closer to hand ghostly, white sentinel kites streamed overhead as the flames devoured our testaments to connections rendered spiritual. We watched spellbound, not in the least interested in dance. This Burn elicited the dance of immobility, the dance of reflection, moments of the dance internal. Spirits were doing the dancing, while overhead a snapping windsock bore witness to crackling reduction.

As flames reduced the Temple to no more, the resulting cauldron delivered something back to us all. As each of us bore witness to pain and grieving, the Burner collective somehow generated an emotional rejuvenation. Personally, my losses had been contextualized. Fire on Fire, that gorgeous Temple Burn, devoured those loving memories of my father, my wonder dog and a grand stepmother,

liberating finally, a sentimental river of airborne ash and ember. A spirit stream homing in on hyperspace.

A PILGRIM WOUNDED

Not to be outdone, Death guarantees the Temple's future.

For the 2011 Burn I introduced a good friend to the week-long spectacle. My buddy John retired after a remarkable 37 years as a fifth-grade teacher, enjoyed great weather, a bike-friendly playa, and the jaw-dropping pleasures and discoveries of a virgin Burner. That year's *Temple of Transition*, an inspiration manifested by Chris Hankins, Diarmaid Harkan, and the International Arts Megacrew, was said to stand taller than the Man for the first time.

John and I had both lost friends over the Burn year. John memorialized a family friend, Melissa, who slowly, agonizingly, was victimized by stomach cancer. I sent off my Dutch friend, Willem, claimed by esophageal cancer. Once engulfed, that splendid Temple generated a jaw-dropping 200-foot torch, truly a Transitional monument.

Our exit from the City of Bliss the next morning required eight hours of Burner patience to simply reach the two-lane blacktop. We made I-80 finally, and cell phones were reactivated. As John had performed yeoman's duty behind the wheel getting us off the playa, I had just taken over for our four-plus-hour drive home when my phone chimed. "Get that for me, will ya?"

John listened to my wife's message instructing him to call his wife, which he did straight away. Hell descended as he learned that just that morning his 33-year-old first-born son, Duffy, had been discovered dead in his bed. Chained to the steering wheel, I couldn't even offer a compassionate hug. My buddy was desolate, and despite my own aching need to provide some, any kind of comfort, I could only offer painful silence. Words had lost any application; twisted guts trumped.

By itself, this was insane, but following my exodus with Bob two years ago as we'd reached this same town of Sparks, I'd received phone messages to contact my wife Barb and my sister Betsy, whose husband had died that morning. Déjà vu gone rogue. An angry snarl curled my lips as our hideously tortured procession dragged into the night.

A year along, in 2012, I, aka Distrac-Ted, returned for my fifth Burn, John for his second. We both were on a Temple mission. John sought the comfort of the Temple in the wake of his son's passing. By comparison my task was simple. I hoped to figure out this chapter I was working on concerning the Temple's essential relevance and function at Burning Man.

Tuesday morning I lent a hand as John stapled his son Duffy's moving memorial onto *Juno*'s elegant north wall. This manifestation of a life too soon gone brought us both to tears; the emotionally charged moment and space overwhelmed us. As I wandered the courtyard, distracted by such emotional outpouring throughout the Temple's splendor, I was nagged by the thought that I too had someone to memorialize. That someone was Robbie Robinson, the 91-year-old Navy dive-bomber pilot turned friend, about whom I'd written my first book. I deliberately sought a surface on the Temple's Southwest side, as Robbie had experienced intense aerial combat around and on Guadalcanal in the Southwest Pacific. I took up one of the many sharpies lying around, and wrote, "Leonard 'Robbie' Robinson 7/11/20–1/2/2012. You stood your ground, flew superbly, fought many a good fight. Your bravery was an inspiration. I miss you buddy. RIP."

BEST REGARDS

Despite the power of the Temple's presence at each Burn, it is not immune to its own funding controversies and behind the scenes politics. While the 2012 Temple crew did indeed receive grant money, but that only covered a mere fraction of its costs. The remainder had to be patiently fundraised, a frustrating distraction and a drain on creative energies. When David Best committed in 2012 to building the *Temple of Juno*, his seventh Temple, he was asked if he would build all the future Temples. The Temple was not his to own, David explained, it was a structure, as were the many he had helped envision. And it was a structure made perfect by those that visited. "It's not like a private art piece, it's more of a public structure, so the public should be more responsible for it than an individual."[6]

While there have been a number of Temple architects, any serious discussion of the Temple's place in and contribution to the Burn must involve David. As I interviewed him at his Burning Man Temple Crew camp in 2012, he was gracious, straightforward, and considerate of everyone around him. It was abundantly clear he is loved and respected by a great many people. David invited me to lunch during which he made announcements and enjoyed numerous happy, hugging, goofing around reunions.

He described some of the challenges faced by the 95 hardy, dedicated, artistic souls who spent three months in extreme weather to assemble the *Temple of Juno*.

> We were prepared for winds, any weather really. We endured a lot of whiteouts. It got really hot; even the nights were hot. But there was no work scale; no one works harder than another. Our crewmembers didn't feed off others. Our goal was to keep the project equal, to focus on the project. Everyone's time and contribution was respected.[7]

Jodi Lyman has worked with David for 20 years and has been the project management coordinator. Her Herculean task has been to puzzle volunteer strengths into a coherent construction team, and oversee the team's progress. Widely understood as juggling cats. Jodi recalled their trials:

> The Temple required ten crane picks. We had winds of 50–60 mph; cranes couldn't operate under those conditions, which put us behind. One day we began at 6:30 and worked through till 05:00 the next morning. We took two hours rest, and continued through the next day. One night the crane came at 3:30. There was a payoff to all this defiance of the elements. When we finished, architects saw the Temple as an architectural and structural feat. It's such an amazing project. People are blown away when they see it. I'm blown away at the last nail driven. And I can't take credit for what that structure holds or means.[8]

Jodi shifted back in time to the incident that began it all. "Michael died not far from my home, near Cotati. It was only a couple of weeks before the Burn. He was the guy that everybody loved."[9]

David opined in 2011 that, tasked with providing someone the freedom to release personal demons, a Temple must be beautiful, "so beautiful you're about to give up the thing that's been haunting you most of your life."[10] As for the Temple's significance, he said "That is for the parents of suicides and disastrous events so they may go forward. Some things you cannot change, and what happened is not your fault." As for the value of the Burn week:

> It's about the young people. We have destroyed and polluted the earth, and food is fast becoming scarce. If we don't expose them to a Burner philosophy,

youth will be justified in turning on us. They want to save this planet, and that ethic starts with the simple concepts of MOOP, and leave no trace. So Burning Man must pay more attention to young people, not just the eco-friendly tribe.[11]

How could it be, I wondered, that the utterly exquisite *Temple of Juno* was constructed organically, without a blueprint? David explained, "I have a piece of paper, but there's no crew in charge of direction."
"Why Juno?" I asked.
"Juno was the goddess who protected women, communities and marriage. It's new to me to express my politics with the Temple, but nobody out there in the political world is protecting women. And we built this Temple under a zero tolerance policy around drugs and alcohol. This was not a party atmosphere."
Bill Codding, assisted by retired fireman Dave Bixler, choreographs the lighting of the Temple Burn. He weighed in on the question of who gets to ignite the Temple.

We want people who are smart, demonstrate strength, and have good minds about them. And David selects honorees, people who have lost sons or daughters. And there are those chosen for their long-standing contribution to Temple Burn or have somehow contributed over and above.[12]

Then he described the delicate, counter-intuitive business of setting *Juno* ablaze:

This year, for the first time, we used kerosene rather than diesel as the accelerant. There were some 14 people involved, two in silver suits, and included six firefighters dedicated to Paul, a fellow confined to a wheelchair. Of course, for any fireman, this was Satan's work; setting a building alight with people in it."[13]

As my interview window closed, and David prepared to perform a wedding ceremony, I related the story of John's unfolding horror last year. He said, "I'd like to meet him. Bring him by."
The next day John and I pedaled over to Temple camp. "We're just going to talk," David began. "Sounds good to me," I agreed. This compassionate Renaissance man and primal soul of the Temple clarified the moment, "No, just the two of us." Thus began an intimate 20-minute conversation between David and John.
John, anxious not to miss a single element of the Temple ritual, headed out on his own early on Sunday Night. He found a spot to bear witness on *Juno*'s north side where he'd situated Duffy's memorial. Several of our campmates thought to provide him company, but there was no way to locate him among the massed Burners. Afterward, chatting in our candle-lit dome, John reassured me he'd felt satisfied to secure a fiery solace by himself. Alone in this multitude, he realized that over the Burn week he'd made his way out to the Temple every day. "I thought I'd just put up our memorial and then it would burn. I guess I needed to attend to Duffy's memorial. Later, as the Temple burned, I drew a lot of empathy from the respectful crowd around me."

A PILGRIM HEALING

Fortunately, given the context of Burning Man, the Temple provides more than a safe haven for heartache. It might just set up the circumstances within which healing can begin. Back in 2009, I'd just posted my remembrances and was making my way down a ramp when I encountered a bearded fellow wearing nothing more

than a wide grin. As his image came fully into focus, I was caught up short. No. No way. Well.... Damn! Now it wasn't his nudiness that garnered my attention. This marvel of huMANity was sporting not the usual one, not two, but three identical, enviable penises. That's right, three. Nudity cubed? Nudity had just been hijacked, Expression, while not exactly standing erect, had been righteously upheld.

A furtive glance (no need to make him self-conscious) revealed two (I'm guessing here) surplus penises remarkably similar to the organic original (whichever one that was). Immediately, my imagination leapt into hyper-gear. Were all of them real? How many testicles lay concealed within this crowded pubic forest? What did his dating scene look like? Did this trio of memorable members qualify him for urologic discounts? Of course I understand that just one penis has the capability to throw things into complete disorder; I could only shudder at the disastrous potential of three dictators. For that matter, were any of them real? Was this in fact a grinning, bearded woman? In the end, none of that mattered. This absurd Tri-Fecta had shifted my emotional compass.

Layers of grief and sorrow evaporated, replaced with hearty laughter. A naked man with the three penises and the wide grin had jump-started my healing with classic Burner humor following a Temple moment of great personal depth.

Some might wonder if the Temple exists to justify the huge party that is Burning Man. No, it's much bigger than that. The Temple is humanism at its core. Each Temple's significance lies in loss and grief, both personal and communal. If the Temple serves as a memento mori for Black Rock City residents, its greater purpose lies in initiating, assisting and complimenting the healing process. There's deep comfort derived from that solemn assembly, where the Temple provides an ever-poignant oasis, a refuge that can empower each of us with its open-armed opportunity for self-forgiveness.

On the Monday following Juno's burn, John and I savored an unprecedented Exodus, vastly at odds with the previous year's eight hours spent just getting to two-lane blacktop. From our camp at quarter past 3 and Foxglove to Rt. 447 we never stopped moving. We'd experienced an easy entrance on Monday and our unexpected rolling Exodus provided a happy surprise. Our Burn had been perfect. It was time for camaraderie or a satisfied silence massaged by the sound of rolling tires. As we sprinted past Sparks with little to gain in learning of some crisis about which we could do nothing, our phones remained off.

SOURCES

http://www.pifmagazine.com/2000/09/burning-man-2000/
http://www.katybutler.com/publications/pacificsun/index_files/pacsun_sacjun.htm
http://azburners.org/files/temples.pdf
http://www.sfmoma.org/explore/multimedia/videos/462
http://jacksondeep.com/interview-david-best/
http://www.inter-disciplinary.net/ptb/mso/dd/dd5/VanMeter%20paper.pdf
http://blog.burningman.com/2010/08/metropol/placing-art-in-black-rock-city/
Kubler-Ross, Elisabeth and Kessler, David, The Five Stages of Grief.
http://www.burningman.com/installations/temple_build.html#foot1

INTERVIEWS

David Best
Jody Lyman
Bill Codding
Peter Hudson
Mark Grieve

NOTES

1. "Sacred Junk: Interview with Artist David Best," *Pacific Sun*, 5 March 2005.
2. Kristen, Christine "Ladybee", "Placing Art in Black Rock City" *The burning blog*, 5 August 2010.
3. Bill Codding, telephone interview with the author, 17 October 2012.
4. Robert Collier, *San Francisco Chronicle*, 9 September 2001.
5. Mark Grieve, interview with the author, 6 November 2012.
6. O'Shaughnessy, Jack, "Interview: David Best," *Depth Perception, Observations of the Quantum Culture: exploring evolutions in music, art, technology, science and culture in San Francisco and beyond,* 2012.
7. David Best, interview with the author, BRC, 31 August 2012.
8. Jodi Lyman, interview with the author, BRC 31 August 2012.
9. Jodi Lyman, interview with the author, BRC 31 August 2012.
10. SFMOMA video "David Best on the Impact of his Burning Man Temples," December 2011 (http://www.sfmoma.org/explore/multimedia/videos/462).
11. David Best, interview with the author, BRC, 31 August 2012.
12. Bill Codding, telephone interview with the author, 17 October 2012.
13. Bill Codding, telephone interview with the author, 17 October 2012.

THE BURNING MAN STUDIO
SAMANTHA KRUKOWSKI

Burning Man Studio on the playa, 2011

I taught the Burning Man Studio for the first time in 2010, and the second in 2011–the year Burning Man first sold out. After 2011 I couldn't guarantee that students who signed up would be able to get in the gates, so the class lasted only two years. Maybe I'll find a way to teach it again.

As far as I know, there have been only a few for-credit courses taught with Burning Man in the equation. Students have done independent projects on the playa, professors have taken groups out in an unofficial capacity, Burning Man has been the subject of courses taught from afar. But the few classes that I was able to discover that have actually engaged Burning Man as part of a curriculum were eventually taken off the books because of liability issues. I get it. When you ask university administration and legal departments to allow you to take students to an event with terms and conditions that read "I acknowledge and fully understand that as a participant, I will be engaging in activities that involve risk of serious injury, including permanent disability and death..." a resounding "no" is likely to follow.

Remarkably, the Department of Architecture and College of Design at Iowa State University supported the Burning Man Studio. There were hoops, many of them. I spent a lot of hours with the Office of Risk Management, which, I have to say, is staffed by very capable and careful, yet also curious and flexible lawyers. When I first met with them I think they anticipated that I would see them as being in my way, but I was grateful for their guidance and caution. Everyone who went was an adult, everyone read and signed the 30-plus page waiver, and, in the end there was the belief that, as T.S. Eliot wrote, "All shall be well and all manner of thing shall be well."[1]

This waiver had a number of requirements that did not align with some of the principles of Burning Man, notably that of "radical self reliance." The Office of Risk Management refused to allow the students to go to the event without support already on the ground, citing their lack of experience with survivalist camping, so

the students did not bring everything they needed to survive for a week on the playa. When the studio was approved midway into the Spring semester, I had a very short time to find a camp that would be willing to provide them with shelter, food, water and community. My husband had been part of a Burning Man camp for many years, and the camp director, Paul Mellion, took us in. What a home! A diverse, vibrant and caring group of people; gourmet food; boxes of costumes; a shower hut; misters and music in the afternoon in a huge shade structure filled with old but well-stuffed couches.

The studio was a summer class, which was good, because there is more space available then and the students needed it. We were able to work in the Armory, a cavernous hangar-like building that contains studios for Architecture, Landscape Architecture and Industrial Design and that serves as the base for ROTC at Iowa State. The Armory was a good location to spread out, produce independent and shared work, and to cement relationships that would provide much-needed support on the playa. The formal studio was scheduled for the first six weeks of the summer session, but the students were able to maintain their production space up until two weeks before classes started. With that extra time, they were able to finesse their projects, work out travel logistics, for their work and for themselves, check their packing lists and make sure they had all the equipment they needed to eventually install their work at Burning Man.

The first day the studio met, everyone introduced themselves, and both summers there were people with many different backgrounds—architecture, art, creative writing, microbiology, engineering. When asked why they were taking the class, a few students said they had no idea what Burning Man was but had seen the posters advertising the class and thought they were cool; they also needed credits towards graduation. I never anticipated that students would enroll without knowing what the subject of the studio was, and those who did were more than surprised when they learned more about it. Some dropped the studio immediately once they found out what it entailed, others dug in. A few other students were very resistant to working collaboratively; some were even socially aggressive. These students dropped too. I think they felt some unspoken pressure from the others to proceed with openness and commit or get out.

Two short projects were warm ups for the independent work they would produce for the playa. The first was a collaborative sand mandala, the second a site work. The mandala was made in the course of a very intense week. Students developed a design before transferring the image onto the floor and beginning work with the sand. There were many things to be considered—geometry, color, formal and scalar relationships, pattern, symmetry, tool making and finding, material and methods testing, technique. We talked about the Buddhist practice of making sand mandalas, their meaning as cosmograms, and how their creation and destruction relate to the idea of enlightenment. I encouraged the students to consider how what they were doing might relate to these ideas. I showed them photographs of Black Rock City, its circular form that references ideal cities and its organization as a time-piece (a means of universal measure). A mandala, too, is a circular form—an ideal form. How could they make something that reached towards an ideal? How could what they were making communicate a belief system? How could destruction also be understood as an act of creation? The mandalas that resulted were complex and detailed, evidence of an obsessive and dedicated attention. After they were complete, the students scripted, staged and performed ritual erasures, respecting historical religious practices while also preparing for the act of destroying the work they would make for Burning Man.

Next, the students chose a place in the landscape that was compelling to them in which to make an intervention. They were restricted to using the materials that

Sand mandalas, Burning Man Studio, 2010 and 2011

they found there. Land Art and Earthworks were introduced as precedents. The project encouraged students to study and experience a location, learn its material, physical and environmental conditions, and deal with unpredictable elements. Anything they made for Burning Man would have to be designed with these things in mind; they had to make work that would withstand the conditions and environment of the Black Rock Desert and Black Rock City—high winds, dust, heat, cold, packed ground, mud, light, vehicles, people. One student, Nicholas Dayton, enacted a ritual that involved road kill. He found a dead animal, then used nearby stones to create a heart around the carcass. He wrote a short narrative:

> You should know I'm terrified of cars. I'm fairly certain they want to kill me. A friend of mine died in a car accident when we were in tenth grade, and while it would be orderly and lend a certain literary logic to this whole endeavor to claim that this is the source of my paranoia, the truth is I was already seeing cars as possible harbingers of death before that.
>
> Which brings us, ineloquently, to road kill. You've got death and you've got the car, two things I'm perhaps unhealthily focused on. But you've got more than that—you've got an animal, otherwise innocent if anything can be said to be innocent, dying via accident (read: act of God) for no real reason other than that a human—due to a complex coincidence of history, technology and geography—needed (or maybe *wanted*) to get from point A to point B at the particular time that the future road kill was trying to do the *exact same thing*, albeit with different B and A points.
>
> My last girlfriend and I, she a devout if vague Christian and me a devout if vague agnostic, would have discussions about the universe in which I was unable to view it, even squinting. I mean *really trying*, like she could. That is, as a loving and benevolent place that wasn't indifferent to the living beings dwelling within it.
>
> Hence the heart. An acknowledgement or apology. I like the heart because it's a naïve, even childish, symbol of love or appreciation. It's

cutesy, but not without resonance. But my heart +++ is actually a recreation of a crude piece of graffiti on a bridge over I-80. I like it because I consider interstates an especially potent symbol of some of the grosser aspects of modernity—machinery's needs trumping humanity's in terms of aesthetics and values and all that. Plus, they're major facilitators of militarism and commerce, two things I think most human beings should at be nervous about if not outright hostile to. And the heart +++, as I see it, is a little splurt of humanity inside all of that.

After these two projects, the students turned their attention towards Burning Man. I gave them no rules or guidelines, only pointed them towards some books and films about the event. It's always difficult to face emptiness. It doesn't matter how long you have been making things—the blank page remains daunting. There was a pause in the creative energy. I made some suggestions. Make something. Anything. Do something you've never done before, learn something you've always wanted to know how to do. Choose a material you are not familiar with and explore it, manipulate it. Collect objects, without thinking about how you will use them, and when you have a pile of them find a way to create a whole from the parts. Take a way of making that is usually associated with one scale then change the scale radically. Find out what other people are doing that inspires you.

Slowly, the studios filled with sketches and models, objects and constructions. Welded trees, macramé, masks, a writing space, an apple, hammocks, tables, signs, origami, spheres—these occupied tables and floors. The more the students made, the more they found direction. They sometimes stayed up all night. Leftover sand from the mandala project was spread across the floor in one room to create a surface of play. A large painting appeared, just because. There were a lot of energies mingling: joy, excitement, anxiety, curiosity, pride, frustration, determination, laughter.

As projects began to take shape, the studios in which they were being made filled with different materials and even developed moods. There was a lengthy, obsessive, meditative exercise underway in a center space that was not officially ours—a student was weaving hemp into large organic forms and suspending them from the ceiling. After these strange tubes were transported to Burning Man, they were hung from a welded steel frame made by another student, and the finished piece was installed on the playa in an area called 'free camping' where there are no motorized vehicles. It took five people to walk it, constructed in parts for transport, out to the spot where it was reassembled.

In another studio, there were card tables, chairs, bottles, glasses, coins, wallets, glasses, books—all in the process of being painted white. The student making this work was French and he was unhappy about the lack of ritual in the eating habits of Americans, who eat while walking, talking on the phone, driving. His response was to invent a foodless restaurant that consisted of nine square tables, each accompanied by two chairs and a variety of objects. When he assembled all of the restaurant parts at Burning Man, he set the tables, glued down the settings, and added objects that hinted at prior presence. He made a dining space that required a considered menu, a planned pilgrimage, and the desire to have a meal at pause, not play. Even in whiteout conditions there were people who gathered to talk, rest and eat there.

In another adjacent studio, there were piles of computer parts, large stick figures, junk metal, old electronics, messages written on cardboard and on the walls. The student making all of these things eventually focused his energies on the writing, and began to think about making signs. We talked about disorientation in the desert, the inability to gauge distance, mirages, the lack of signposts to ease

dislocation. He ran with these ideas, and made a family of handmade signs, only to realize that they were models rather than actual signs and that they would not hold up in desert conditions. So he sent them out to be fabricated. Yet instead of making signs that were beacons of orientation and comfort, he invented obscure phrases that could only send people in myriad directions, mental or physical, further destabilizing their understanding of location in the vastness of the desert. After the signs had been up for a few days he found a Citation from the Black Rock City Department of Aesthetic Justice Art Police attached to one of them.

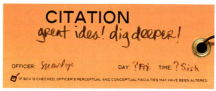

Citation given to Brandon Wloskinski for "Signs in the Desert"

There are many stories to tell about how the students and their work moved from the studio to the desert. In both 2010 and 2011, after the students vacated the Armory and stored their work, the studio officially re-started in Reno, our designated meeting point. They found their way to Reno independently. The first year some drove their cars, others flew. That year, the father of one of the students happened to also be going to Burning Man, and he pulled all of their work in his trailer out to the desert—a very lucky and cost-saving coincidence. The second year some students drove an Iowa State van and trailer, others took planes. Both years we stayed in a casino hotel that we checked out of in the early morning hours in order to avoid the long entry lines into Black Rock City. We drove in the dark—not so great for experiencing a landscape most had never seen—but we only waited about an hour to reach the greeters who lingered before the gates. They were particularly loving and gregarious the first year, and dragged us out of our vehicles for hugs. All of the students made dust angels and rang the bell—their initiation had started. Maybe it had even begun prior to arriving at Burning Man.

Those who drove the Iowa State van and trailer the second year made it to Reno in two-and-a-half days—there were enough of them to maintain reasonable shifts. They packed food, slept in the van at rest stops to save money, and maintained a bucket as a chamber pot. I later learned that this bucket was well used on the playa when they were installing their work, and that there was a nasty, smelly accident when it was unexpectedly kicked over. That was their first lesson in leave-no-trace, and in the re-telling of that adventure they were clearly very proud of the clean up job.

There were not many problems setting up the projects—both years the students worked together to get them placed and secured. There were some issues with lighting—some forgot they needed to illuminate their work at night. But they found what they needed (the playa provides) and they enjoyed checking on their work daily to see how people were responding to it and how it was holding up. They were thrilled that they were able to put their work alongside the other forms imported to the desert, knowing that it was being seen by thousands of people. Prior to Burning Man some students were aiming their work at the museum and gallery world, and after, they began to reconsider what it meant to 'exhibit' their work, and what kinds of relationships they wanted their audience to have with what they made.

The students, for the most part, acclimatised well. I was thrilled by their independence and bravery out there, by how widely they explored and the way they collaborated and looked out for each other. Yet, as their professor, I was supposed to be responsible for them. In the contract there were stipulations that the students tell me, or someone, where they were going whenever they left camp. At Burning Man?

Signs in the Desert, Brandon Wlosinski, 2011

Impossible. They couldn't predict what they would do, even if they thought they could. All their wanderings would be touched by the Burning Man distortion of place and time. They were supposed to check in at breakfast and dinner. Most came back at those times because they got hungry, but sometimes a few did not. The camp director always yelled "circle up!" before those meals—it was a time to regroup and share experiences and talk through anything troubling. It was a camp tradition and a good way to make sure everyone was ok. That was the best safety net that existed, since we couldn't follow the students and since we were surfing the whiteouts in our own ways.

SAMANTHA KRUKOWSKI

Things happened, positive and then not so much. The student I thought would handle the playa easily had a breakdown the second day. Problems in her family, with her relationship, and with her sense of self overwhelmed her, and despite the intervention of a camp psychologist we ended up taking her to a medical tent for evaluation. She was only willing to leave camp a few times during the week, though she did go out with a big group the night the Man burned. The temple burn was too much for her. Before we had left Iowa we talked about the importance of trying to resolve big personal issues before traveling to the playa because the density of experience can create an unexpected level of exposure. It was difficult for any of the students to imagine or be prepared for an environment that would strip them of their ability to maintain the envelope they carry in the default world. This student told me she never wanted to come back, but that it might be very important for her to return.

My husband and I decided to have a re-marriage ceremony with our playa friends. Standing on the Metropole, looking out at so many sunburned faces, I saw a group of animals. All of the students, wearing masks one of them had made, were out there cheering. Father Dan, in his gold short-shorts, read his speech and while he talked there were animal sounds in the background. Afterwards we were all handed drinks that tasted like rubbing alcohol and the students put a lei around our necks—a fabric scarf dotted with flowers they had made for us.

LEFT
The ceremony, with Father Dan

RIGHT
After the wedding, me and the masked students (masks by Tracy Bear)

One afternoon Burning Man Radio interviewed me and a couple of students. We were talking about how the class started and what everyone had made and then the show host said to me "Oh come on! Didn't you explain to the university that you were just bringing all of them out here to party?!" Then he turned to the students and said "Well isn't that really what you're doing? What did you think you'd be doing, anyway? Give us some dirt!" I was really hoping no one from Iowa State was listening to the radio right then. Not that it matters, since I'm writing about it here. The studio did get a lot of other press that celebrated the students' work though, both before and after we went to the playa, so the radio interview was only one voice among many.

When the week was almost over, we made plans to leave at 3:00 after the temple burned to avoid the worst of the exodus. One student did not show up. We waited. And waited. No one knew where she was. No one had seen her since that morning. She hadn't packed her stuff, her warm clothes were still in her tent, other

people had packed her things for her. But whoa! How do you even go looking for someone at Burning Man? We woke up the camp director, put signs up at Center Camp, got on bikes and went patrolling. But the problem wasn't only her absence. We had people taking planes out of Reno, catching rides in Las Vegas, trying to meet deadlines for assignments that were due because classes had already started. The contract stated that reasonable efforts would be made to find someone who was not accounted for, but that after a fair search they were responsible for themselves. We had just started to pull out when she came walking out of the receding dark in lingerie. She got in the van, did not apologize, said something vague about falling asleep on a couch with some guy she had met, and then she crashed. She might have singlehandedly killed the Burning Man Studio.

In the course of writing this, I asked a few students to send some of their own memories my way:

The first sculpture I saw was a twisting, looping roller coaster structure that (I didn't know at the time) spouted fire along its tracks at night. I had been prepared for things that were light or things that could be burned if they were large and heavy. But this thing, this was steel, permanent. I was dumbfounded. Was it a ride? Were there rides at Burning Man? How did it get there? It looked like twisted rock and roll. At that moment I realized that I couldn't have expectations at all about where I was. If this alien object had landed and taken up residence, then anything could. It was sitting there like it was supposed to be there, sleeping, still. That was the moment I abandoned what I knew.
(Brandon Wlosinski)

I was in awe when we arrived at our campsite at sunrise. The sky was pink, blue and orange—an amazing backdrop for the glowing green effigy in the distance. We first walked down at 4:30 to register our installations at the ARTery, after that, we all fell asleep. When we woke up things started getting weird. We gathered, put on glowing objects, and walked towards the man. Green lasers shot through the starry night. We saw someone skydiving, trailing flames—a human comet shooting through the sky. When we got to the open playa, the installations we had seen during the day had faded into the ghostly dust and were now on fire. There were mutant vehicles everywhere. It felt like being in a 3D LED Jackson Pollock painting. The whole thing was wondrous chaos. I only wish we could have seen the looks on our faces.
(Isaiah Sand)

After the first few hours of orientation I ran off into the wild playa yonder and found myself at the mercy of the most loving people I've ever met. I think I fell in love about five times that first night when I lost my favorite pair of earrings. The second day I worked with everyone to install their pieces and almost all of us ended up at Etienne's white café enjoying life in the blistering sun dressed for *Mad Max*.
(Kody Barton)

What bothered me most at first were the ten-thousand-dollar hippies. It was a limited judgment of my surroundings. The thinkers and inventers were there, I just hadn't seen them yet. I'd traveled a lot so there was some part of me rationalizing that this was just another place, and so I was turned off and felt like I was hearing the echo of a legend. But to say

Etienne Blanc, *Une Bouffée d'Air*, 2010

the playa is another place is to say every place on the planet has near the same gravitational constant. While I had traveled, my life up to that point was pre-conditioned stimulus. That stimulus started to change when, while walking with some others, two bicyclists crashed in front of us. Traffic was heavy and in a miscalculation the fluffy coated goggle biker riding clockwise cut off a woman heading counter clockwise with a giraffe head sculpted to her handle bars. The woman went over her handlebars and the man stopped dead weight with a solid, quick thud. I started walking forward, expecting that folks standing around would back up. But as I moved forward, others did as well, and faster than I had. That forward movement is an intrinsic part of what I was looking for at Burning Man and life in general. Get involved. Think critically. Help others at every opportunity possible. Here with the accidental crash of two bikers I started to realize I was in a different place. Before I could reach the bikers they had already been helped up, re-dusted (since you never dust off on the playa, at best you neutralize the alkaline with vinegar spray) and sent on their way. It was a new home I return to still in my brain. On the playa, I finally wasn't the best, or the brightest, or the most creative snowflake. I had the chance to melt.
(Jay Parry)

One of the most powerful experiences I had as a teacher on the playa happened as I was getting some pickles out of the cooler (pickles are somehow essential). A student approached from the other side of the van. He said he had not believed me when I told him that what he knew about creativity and human potential would be altered by what he saw at Burning Man. He had little exposure to the arts before starting his design education and had been considering leaving school because

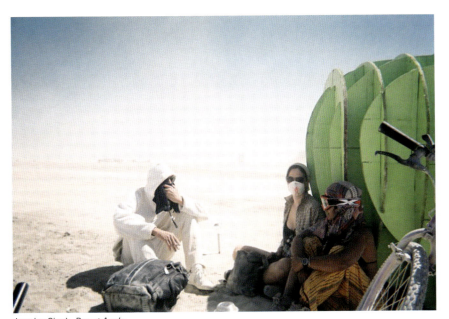

Jasmine Singh, *Desert Apple*

he wasn't sure that what he was making or thinking about mattered. He said that his imagination was on fire and that he had no idea people did the kinds of things they were doing on the playa but now understood that anything was possible. He thanked me, crying, then hugged me and told me he loved me and all the students loved each other and that they were so thankful they had found their way, through me, to Burning Man.

NOTES

1. Little Gidding, from *Four Quartets*, 1942.

SAMANTHA KRUKOWSKI

DUSTY ORDER:
LAW ENFORCEMENT AND PARTICIPANT
COOPERATION AT BURNING MAN.[1]
MANUEL GÓMEZ

Media depictions of Burning Man focus on the picturesque and eccentric appearance of the weeklong affair. The event is sometimes misportrayed as a lawless environment where participants are encouraged to engage in rowdy behavior. Most carnivalesque events offer an escape from reality and are generally thought to enable unruly conduct. Despite stereotypes, Burning Man is a different beast. Not only is the crime rate in Black Rock City lower than any other city of comparable size, but Burners show a high level of cooperative and law abiding behavior that helps maintain the social order without depending on official means of external social control. Looking at the interplay between the Black Rock Rangers, law enforcement agencies and participants themselves helps clarify how this works.

"Helping lost souls to find their way home": the Black Rock Rangers.[2]

While the name Black Rock Rangers (BRR) was inspired by image of independent actors like the Texas Rangers—not the baseball team but the law enforcement folks—their role is not only to support the police and other official agencies, but more broadly "to ensure the collective survival of the community."[3] The BRR is comprised of communicators, lawyers, educators and people from all walks of life who lend their time and expertise to help "address situations within [the Burning Man] community that would otherwise require outside intervention."[4] Rangers are participant volunteers, which heightens their legitimacy in the eyes of the Burning Man community. The Rangers were founded in 1992 when the event was little more than an anarchic campout in the middle of the vast Nevada desert. Their original purpose was to respond to the specific need of helping "locate lost participants and bring them safely back to the community encampment" (a search and rescue function).[5] Over the years, the Rangers adapted to the rapidly evolving community and reinvented themselves as safety managers, communications conduits between the Burning Man Organization and the broader burner community, and most notably as intra-community mediators.

In order to help volunteers acquire conflict resolution skills and familiarity with the distinctive challenges of working at Black Rock City, the Rangers offer training opportunities in mediation techniques year-round, all over the US, to anyone interested in being involved. In addition, some Rangers are expected to undertake special training in radio communications and emergency procedures. Undergoing basic training is mandatory for all new Rangers (Alphas), and an annual refresher course is required for the veterans. Chief among the skills offered to new and veteran Rangers is a tailor-made conflict resolution procedure fittingly designated as FLAME (Find out, Listen, Analyze, Mediate, and Explain).[6] Rangers use their orientation and training programs to instill among new volunteers a sense of community building.[7] Veterans have also constructed a hierarchical chain of command within the group and a distinctive identity that includes a uniform mode of dress in khaki colored garb that sets them apart from other Burning Man officials.

For the duration of the event, Dirt Rangers rove the playa in pairs during six-hour shifts "walking and bicycling the streets, interacting with participants, and offering creative solutions to situations they encounter."[8] The total number of Rangers varies between 400 and 500 every year, and many of them have several

years of experience volunteering at Burning Man. Aside from the Dirt Rangers (foot Rangers), daily operations involve a Shift Communications Team, an Officer of the Day, and a Ranger Operations Manager. Because Rangers are Burners they can more easily understand the social dynamics, identify the sources of tension and effectively prevent or diffuse conflicts before they escalate. They have the most direct contact with the rest of the community during the event so they are able to intervene in a vast number of situations. Black Rock Rangers do not keep statistics about how many cases they process, what outcomes, and which actors are involved—or if they do, this data is not shared with the public. The work of the Rangers in managing and diffusing conflict and helping maintain social balance is best illustrated by the following three types of situations drawn from my multiple observations of their work at the event between 2006 and 2012.

THE NOISY NEIGHBORS

Burning Man is not a quiet event and no one expects it to be. Moreover, the community views sound as a distinctive art form.[9] Sound not only emanates from the myriad open-air nightclubs, dance floors and mutant vehicles that roam the playa day and night with oversized sound systems, disc jockeys or music performers onboard. There is also the general noise of a bustling and vibrant city of people talking, singing, yelling, blowing their bicycle horns, and playing instruments at all hours. Black Rock City truly never sleeps.

In order to help balance the desire of some community members to express themselves through loud sound vis-à-vis the interests of other Burners who would prefer less noise, the organizers have come up with a four-pronged policy: 1. Large-scale sound installations shall be placed in a specific area known as the Large-Scale Sound Zone along the ends of the city; 2. Everyone should abide by a maximum level of sound amplification; 3. Neighbors are encouraged to sort out their differences directly; and 4. Black Rock Rangers are expected to intervene in case of excessive sound complaints. Even though the policy calls for the Rangers to intervene only in extreme cases, it appears that—in practice—they are involved in many others. Though not the most common, complaints about loud sounds are a recurrent issue for the Rangers who were interviewed and whose work could be observed. One veteran Ranger mentioned that he handled at least one or two loud noise complaints every other day. Other Rangers reported a similar caseload and said that almost always they were able to help the parties reach an amicable solution without requiring outside intervention from law enforcement.

A typical sound-related situation would be a disagreement between two neighbors about the noise level coming from one of their sound systems. The involvement of the Rangers could be prompted by a complaint brought by one of the parties directly to the Rangers or the Rangers could become aware of the situation through another source and decide to intervene. The Rangers would first enter, in a relaxed manner, and try to build rapport with those involved. One Ranger might take the lead while the other surveys the area and remains on standby. Cordial conversations are encouraged and empathy is exhibited to help diffuse tension between the parties. In one case, the Rangers approached the purported wrongdoer and inquired about their sound system, how it worked, and what type of music was being played with a genuine sense of curiosity. "I also like techno music," one Ranger told a Burner accused by his neighbor of exceeding the decibel limit through his camp's sound system.

An engaging and friendly exchange between that Ranger and the alleged wrongdoer followed—they discussed leading artists, bands and performers of

techno music in the US and Europe. Their shared interest paved the way for the Ranger to persuade the Burner to consider lowering the volume of his sound system and also to work out a sound schedule with his neighbor. The other Ranger had gained the complainant's empathy by asking about an art installation being built in their camp. He carefully listened to the challenges that the complainant and his campmates had faced in bringing the materials to the desert, and the contrasting conditions from those back home where "everything seemed to work fine." After a few minutes, the complainant admitted to liking the neighbor's music but said it was too loud especially in the early hours when he and his campmates "were trying to fall asleep after a hard workday and a long night out." After some back and forth, both neighbors reached a solution, and offered the Rangers drinks to celebrate. The Rangers kindly declined. No written agreement was entered, but rather a handshake and a hug, or a "hug shake" as one of them said jokingly.

The various cases I observed had different nuances. Some people were more challenging than others, especially those where the influence of drugs or alcohol were a factor. When more than two parties were involved, or a variety of issues overlapped, things got more complicated. The Rangers were, nonetheless, able to handle situations appropriately by engaging in active listening, building empathy and preserving their credibility in the eyes of the community. Sometimes, other campmates or neighbors became involved either voluntarily or upon the Rangers urging, and offered to facilitate communication as well, thus ensuring compliance beyond the Rangers' intervention. Rangers work in pairs, and this also aids ensuring their effectiveness. Pairs almost always include one veteran, so they bring familiarity with the community and its social dynamics. Because of their dual role as Burners and community mediators, people do not see Rangers as "the other," but rather as their own kin. As one Burning Man participant pointed out when I asked her views about Rangers in 2012:

> Rangers are NOT cops, or at least I don't see them that way. I see a big difference between them. Rangers are OUR people, and cops are not; Rangers just have to wear funky uniforms so we know who they are. Think of your cousin doctor wearing scrubs at the hospital, he is still your cousin, isn't he?

Those uniforms—or "costumes" as Rangers sometimes call them—are perhaps the only symbol that visibly differentiates Rangers from the rest of the community. The uniform consists of a tan-colored shirt or jacket displaying the BRR's logo on the back, a lanyard with an identification card, a wide-brim hat, and a two-way radio. Rangers who are mentors wear leopard print items, and those who work as liaisons with law enforcement (LEAL) wear zebra stripes. Rangers' costumes are often adorned with pendants, buttons, necklaces and other trinkets, and their overall appearance resembles that of any other burner with dyed hair, tattoos or colorful nail polish.

In an effort to help Rangers appear approachable and trustworthy they are expressly discouraged from wearing clothing with war motifs, camouflage items, black or dark shirts, "or other items or clothing that would make participants think 'cop' or 'military' or 'security guard'."[10] Moreover, they are also deterred from dressing or behaving "in a way that projects sexual power or other kind of power,"[11] or that "send[s] a message of hostility or aggression."[12]

"STOLEN" BICYCLES

Participant vehicular traffic is restricted only to pre-registered art cars (mutant vehicles) and vehicles for the disabled, so bicycles are the transportation of

choice at Burning Man. Although some people still prefer to walk around the city, the vast distances between camps and art installations scattered around the five square mile playa are more easily navigated with wheels. The Burning Man Organization has been increasingly encouraging the development of a bicycle culture in Black Rock City. Since at least 1997, groups of volunteers (such as the Bike Guild) organized bicycle repair points throughout the city.[13] Some offered immediate repairs while others (the Bike Gods) simply lent tools to Burners and taught them how to maintain and repair their own bikes.[14] A more recent initiative that started in 2006 is a community bicycle program called the "yellow bikes."[15] Under this program, inspired by Amsterdam's white bicycle plan (witte fietsenplan),[16] hundreds of free bicycles are made available throughout the city so people can use them then leave them for another person.

The inventory of yellow bikes (called "yellow" though they are really painted in a bright green color) is made up of hundreds of bicycles donated to the community. Members of the Black Label Bike Club of Reno have been involved in the management of this program since its inception, although more recently another team was created to help coordinate the yellow bikes, and the lost and stolen bicycles program. "Yellow bikes" is a supplementary program not intended to replace the thousands of personal bicycles brought to the playa— Burners are encouraged to bring their own. Those who fly in from far away places rent bicycles from a few dedicated outlets in Reno, or purchase new or used ones from private parties or large retailers such as Wal-Mart or Target. Burners who drive from nearby places usually haul their own bicycles from home and many have a dedicated "playa bike" especially decorated and retrofitted to withstand the harsh desert conditions and to express their unique artistic tastes.

Bicycle loss is a persistent problem at Burning Man. Since at least 2003, the organization has publicly and continuously acknowledged this issue in the annual AfterBurn reports.[17] Figure 1 shows the bicycle loss statistics (bicycles reported lost/stolen versus bicycles left post-event) since 2006.

According to this data an annual average of 238.2 bicycles have been reported lost or stolen at the Burning Man event since 2006. The average number of bicycles found in the desert post-event is 990. This latter figure includes some bicycles that were reported lost or stolen—and later abandoned, but the precise overlap is unknown. Because bicycle theft is generally an underreported crime elsewhere, it is also likely to be underreported at Burning Man. Some abandoned and unclaimed bicycles have been donated to charitable organizations and underserved populations. However, abandoned bicycles still represent a big problem. Many bicycles found post-event have parts missing or are broken beyond repair; and those that are salvageable require time, money and labor. The Burning Man Organization is forced to arrange for the transportation, inventory, and storage of hundreds of bicycles every year and to set up a reunification program. As part of its leave-no-trace commitment, Burning Man staff members are constantly making efforts to remind participants to take their bicycles home and to help prevent bicycle theft and loss.

Burners are actively encouraged to personalize their bikes to make them easily recognizable in case they are lost, stolen or misplaced. They are also encouraged to lock their bicycles when not in use—there are many bike racks placed around the city. According to the annual AfterBurn reports, virtually all bicycles reported stolen were not locked. The Black Rock Rangers have been helpful in the efforts to prevent and deal with the loss of bicycles. Some Rangers routinely remind community members about the importance of locking their bicycles to designated racks, and also make sure that they do not "flypark," or lock their bikes to large art installations, sculptures or similar structures. "It is part of an educational outreach effort to help people acquire the habit of locking their

bikes to the racks," one Ranger said. He then added: "It is not only to prevent bike theft—which does occur here, believe it or not—but also the temptation that someone might feel to 'borrow' a bicycle for a few minutes just to get to another place and then leave it there."[18]

Rangers do not have enough volunteers to scout the playa for all bicycles that are reported lost or stolen. State law enforcement officers present at the event do not take action unless they witness a bike being stolen, which is unlikely given that most bicycle thefts are stealthy and it's difficult to tell if someone owns the bike they are taking. Even when law enforcement officers are able to detain a suspect, "if the owner cannot provide proof of ownership for the retrieved cycle, then the suspect may be released without charge and may be given the stolen bike on release."[19] Nonetheless, Rangers are sometimes able to assist community members in the recovery of their bicycles, although as a rule they tend to refrain from engaging actively in such activities. Rangers have also been instrumental in keeping yellow bikes from being misappropriated, and according to official Burning Man reports, have frustrated thieves attempting to steal multiple bicycles.[20]

I witnessed one instance of Ranger mediation when a Burner tried to reclaim her bicycle that was allegedly taken by another participant. The alleged victim sought intervention from Rangers after her friend saw someone riding her lost bicycle. The victim's friend managed to stop the rider who insisted that he thought that the bicycle belonged to one of his campmates and also said that he had borrowed it two days earlier. According to the alleged victim, she had lost her bicycle two or three days earlier. One of the Rangers present at the scene asked the rider where his friend was and the location of their camp. The rider provided a playa address but said that his campmate might be out. After a few minutes, he simply offered to give the bicycle to the alleged victim "in the spirit of Burning Man." The victim was satisfied with the proposed solution ("I got my bike back, after all," she said) offered a hug to the rider and profusely thanked the Rangers. One of the Rangers asked the rider whether he knew about the yellow bikes program—he nodded. After the rider left, the Ranger said:

> He must have been just a joyrider; that is, people who 'borrow' bikes just to get to a place and then leave them there, which I suspect is what happens in most cases here in BRC. But this guy probably became attached to the bike. [...] That is clearly wrong and should not be encouraged, but we can always seize the opportunity to help educate people, so they become better citizens. [...] As for the woman, she is very lucky and I am glad that she got reunited with her ride. Most people would have to wait until next Monday to check the pile of derelict bikes left at Playa Info post-event. So this is a good day for her.

The Ranger's demeanor was always friendly and never accusatory. Even when the Ranger inquired about the campmate from whom the rider had supposedly borrowed the bike, the question was asked in a calmed and non-judgmental tone. This not only persuaded the rider to give up the bicycle, but also lessened the tension between the rider and the alleged victim who ended up grateful with no apparent grudge against the rider. In terms of the yellow bike recovery efforts, Rangers have helped locate and retrieve community bicycles that some Burners try to keep permanently. When roaming the playa, Rangers look for any suspicious behavior that would indicate intent to steal, or actual theft of, a yellow bike. Sometimes someone redecorates or personalizes a yellow bike, or keeps it parked in a secluded area to give the impression that the bicycle belongs to them. I experienced this myself in 2012 when a Ranger approached me and asked to check my bicycle, which coincidentally was bright green in color and so resembled the communal bikes.

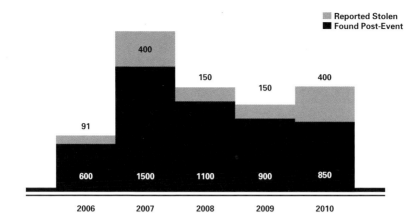

Figure 1: *Bicycle loss at Burning Man (2006-2010), AfterBurn Report 2006-2010.*

After the Ranger confirmed that mine was not a disguised yellow bike, he kindly explained that he had occasionally found redecorated community bikes that people thought they could keep and use exclusively. Some people, he said, thought that yellow bikes are mementos for them to take home. He said he often had to explain the purpose of the yellow bike program and the importance of keeping the bicycles flowing through the community. In most cases where a yellow bike was misappropriated, he said the rider would relinquish the bike and the Ranger would return it to a community rack. "It is all about encouraging people to live by the ten principles. Most people who do this sort of thing do not understand well the implications of their actions and the harm it does to the community. But when you remind them, they do."[21] When I asked if there had been situations involving bicycles that warranted law enforcement intervention, the answer was in the negative, with the exception of one instance several years ago when the Rangers sought police help in order to thwart an attempt to steal several bicycles. The Rangers resolved most other cases without any outside intervention.

PUBLIC AND PRIVATE SPACES

In Black Rock City there are certain areas occupied by villages, theme camps and "official" departments, which appear to be off limits to the general population. Most campsites lack fences, divisions, or any other type of physical barriers. Numerous camps are set up in ways that invite people to walk in and stay, and to participate in any activities taking place there. True to the no-spectator principle that guides the event, many art installations are also participatory and almost all mutant vehicles that roam the playa allow people to hop on and off as they please. All of this blurs the line between public and private space at Burning Man. The highly inclusive nature of the event, however, is does not mean that private property and privacy do not exist or are not respected at Burning Man. Participants arrive with personal possessions— whatever equipment, clothing, shelter, food and transportation they bring to support their efforts towards radical self-reliance. The clothes people wear, the shelter, tents or motor homes where they sleep, their food, are not considered communal. But because of the pervasive attitude of sharing that characterizes

Burning Man, there are situations that create a gray area regarding what is really private and what has been shared or gifted to the community.

Some of the most common problems are camp boundary disputes, the use of someone else's personal property without consent, and participants overstaying their visit at a camp. Conflicts of this kind are usually resolved internally, as most camps or villages have their own formal or informal system of private governance. There may be mediation or consensus building or even a unilateral adjudication. It is hard to know how many of these disputes there are or how many are successfully resolved before they require outside assistance, but most neighborly disputes do not require the intervention of the Rangers.

As Black Rock City has grown in size, the Burning Man Organization has adopted strategies to minimize boundary disputes. One has been to pre-arrange the placement of villages, theme camps, art installations and other structures, so the city's blueprint is in place before the event. By the time participants arrive the landscape has already been delineated with markers and survey flags by members of the Placement Team. A volunteer (placer) is assigned to help participants locate their pre-assigned spaces and sort out any issues that might arise. Any space allocation problems that occur among the first settlers tend to be minor, but as the masses begin to appear and more land is occupied disputes magnify. Boundary disputes not only occur as the city comes to life but also throughout the week. In order to maintain control and order, all villages and theme camps must have designated point persons and a group of core members who communicate with the Burning Man Organization and other villages and camps.

The Rangers intervene when squabbles among campmates or villagers get out of hand, or when "outsiders" become involved. Another layer of boundary disputes that also require the involvement of Rangers are the ones between occupants of smaller or unnamed camps, or among individual burners who pitch their tents in the walk-in camp area.

The role of the Rangers varies from mediation, community monitoring, or acting as a conduit between the Burning Man community and law enforcement officials. One dispute involved two neighboring camps whose members were arguing about whether an empty lot initially allocated to Camp A could be taken over by Camp B given that no one from Camp A was occupying the space. Because the lot looked empty, Camp B members decided to park a truck there and unload lumber and other construction materials for an art installation. Camp A complained to Camp B and stated that they had been given rights to use that lot, and that they were planning on using the land but hadn't figured out how. Camp A said that they would probably end up using the extra land to park their cars or to build an extra shelter or perhaps another place to hang out. Camp B refused to move their truck and materials, and the problems persisted for days with no solution in sight. A passing Ranger was called in by one of the parties to mediate. The Ranger engaged a conciliatory approach and was able to help the parties reach a mutually acceptable solution. Camp B would be able to continue using the empty lot to store their materials and as a workspace for their art installation for two more days. Camp A would, in turn, be allowed to park some of their cars and bikes on an unused corner of Camp B's lot. Camp B also let Camp A use their kitchen space and shaded structure to store their ice chests.

In some disputes, the Rangers act as a sounding board for a proposed solution to a boundary problem, private property abuse, or a situation involving the non-authorized use of equipment. In some cases, parties work out a solution but do not know how to implement it, and call the Rangers in to help them devise a workable plan. The Rangers sometimes act as a community watch by enforcing rules: participants cannot park their vehicles in the "streets" or other public areas, or drive through the city, or drive through private camps. And Rangers are always on the lookout for potentially hazardous structures.

There are cases when the intervention of the Rangers is only the first (or second) step in a multi-layered dispute resolution. One such case involved an allegation of trespass against a guest who overstayed his visit to a camp. The individual in question had apparently arrived two days earlier with a group of people to attend a party there. The party lasted all night and several guests—including the alleged trespasser—fell asleep on couches and hammocks scattered around the camp. The next morning, all remaining visitors left except for one. At first, the camp's members were very hospitable. After several hours, when it became apparent that he wasn't going anywhere and his presence began to make people uncomfortable, they kindly asked him to leave. He refused. A heated argument ensued and then the Rangers were called in. The alleged trespasser became hostile to the Rangers, which prompted them to involve members of the LEAL team, which "are Ranger response and Ranger backup on playa in any situation that has Law Enforcement implications."[22] At some point, law enforcement officers (LEO) arrived, presumably alerted by LEAL, and took over the situation. I last saw the alleged trespasser when LEO took him into custody, but I don't know what happened after that.

These types of cases can be successfully handled because of the successful coordination between the Black Rock Rangers, LEAL and LEO, and the collegial relationship developed among these different groups throughout the years. In order to ensure the synchronization of all activities, Rangers are part of the Playa Safety Council (PSC), which is in charge of the overall event security.[23] The PSC comprises volunteer representatives from the Rangers, the Emergency Services Department (ESD), the Department of Mutant Vehicles (DMV), Gate, Perimeter and Exodus (PG&E), and Airport Operations. During the event, PSC members meet daily to maintain the implementation of a comprehensive event-security strategy that ranges from perimeter security and ticket integrity to emergency medical services, child safety policies, vehicle safety, and a contingency plan.[24] The scope of activities and obligations of each entity are generally outlined in the event's Operating Plan (OP). The Burning Man Organization submits the OP annually to the Bureau of Land Management (BLM) as it is one of the required documents to obtain the Special Recreation Permit needed to use the public land where Burning Man is held.

BIG BROTHER IS (ALWAYS) WATCHING YOU: OFFICIAL LAW ENFORCEMENT AT BURNING MAN.[25]

The fact that Burning Man takes place on public land justifies the involvement and physical presence of several federal and state agencies. These are: The Federal Bureau of Land Management (BLM); the Federal Aviation Administration (FAA); the Federal Communication Commission (FCC); Nevada Department of Transportation (NDOT); Nevada Highway Patrol (NHP); Nevada State Health Department (NSHD); Pershing County Sheriff's Office (PCSO); Washoe County Sheriff's Office (WCSO); and the Pyramid Lake Paiute Tribe (PLPT). Although all of these agencies play a role at the event, only the BLM, PCSO and NSHD deploy personnel at the playa during the week of the event, and at least the former two are referred to as LEO (Law Enforcement Officers). The other agencies including the Nevada Highway Patrol, the Pyramid Lake Paiute Tribal Police, and the Washoe County Sheriff's Office, are responsible for enforcing state, tribal, and county (mainly traffic) laws in the surrounding areas before, during and after the event.

In general, the relationship between law enforcement agencies and the Burning Man Organization appears to be cordial and productive. On more than

one occasion, the organization has praised the role of the BLM and other law enforcement agencies in helping to facilitate the event. Likewise, law enforcement agency representatives have been positive about the Burning Man Organization. Nonetheless, there are disagreements and sour points on both sides. Perhaps the most salient one is the ongoing dispute between Burning Man and Pershing County over the fees collected by the county to offset costs incurred by municipal authorities in connection with the event. The dispute began in 2004 when Pershing County's tried to apply a local Festival Ordinance to Black Rock City, LLC. The LLC argued the ordinance should not apply because it was preempted by federal law and because doing so would mean that the County was in violation of a longstanding agreement between BRC and the County.

In 2005, the Burning Man Organization and Pershing County officials reached an agreement to establish a compensation scheme, but in 2012 there was an impasse and Black Rock City, LLC brought a federal lawsuit against the members of Pershing County's Board of Commissioners.[26] The complaint sought to enjoin the co-defendants from collecting any fees established by State or County festival laws and ordinances, in addition "from those specifically set forth in the BLM (federal) permit."[27] Although this litigation has caused tension between the Burning Man Organization and Pershing County officials, the organization has continued to make important efforts to preserve their positive relationship with the Sheriff's Office, and has urged the community to do the same.[28] In the fall of 2013 the parties reached a new Settlement Agreement.[29] A federal judge, however, denied the parties' request to approve the agreement, in January of 2014.[30] Black Rock City, LLC filed an appeal against the judge's order, which is still pending as of the time of publication.[31]

Community members do feel concern about the presence and conduct of law enforcement officers at Burning Man. Several individual attorneys[32] and citizen advocacy groups such as Lawyers for Burners (LFB),[33] and the American Civil Liberties Union (ACLU) have become advisors at the event and offer legal information and advice about issues that might potentially affect participants. In the last few years the ACLU has held "office hours" at the event. ACLU representatives have also led an outreach effort through the distribution of pocket-sized cards ("know your rights cards") that contain basic information about how to speak to law enforcement, and clarifying when police officers have a legal basis to stop and search citizens.

The ACLU also collects data about encounters between Burners and law enforcement officials at the event, but does not share it with the public. A similar data collection effort is led by the Burning Man Organization, which encourages participants to share their experience about incidents involving law enforcement officials during the event.

LFB, on the other hand, is a "grassroots project formed to help Burning Man participants with Bureau of Land Management (BLM) citations they received during the event."[34] LFB is staffed by volunteer lawyers who take cases directly, or who connect community members and counsel willing to assist Burners who are challenging arrests or citations issued at the event. According to their annual reports, LFB lawyers have assumed the defense in most of these cases. The majority of them involve drug offenses allegedly committed by participants and unlawful searches, seizures and other abuses supposedly committed by BLM and Pershing County Sheriff officers. The overall perception of LFB among Burners tends to be very positive. The group has been credited for repeated court victories, and for negotiating a tentative fine and plea schedule for drug-related offenses with the US attorney's office, back in 2010. Qualifying defendants are offered the opportunity to plead guilty to a non-drug related offense, such as "littering," and ordered to simply pay a fine.

Number of participants	25659	28979	30586	35664	35567	38989	47097
Number of BLM citations	100	135	177	218	218	155	331
Number of arrests	5	0	10	1	6	1	1

Number of participants	49599	51454	53963	53963	56149	38989	47097
Number of BLM citations	129	287	293	42	230	155	331
Number of arrests	6	9	8	3	22	1	1

Figure 2: BLM citations and arrests made at Burning Man between 2001 and 2014

The use and possession of drugs and drug paraphernalia is one of the most polemic issues involving law enforcement at Burning Man. The Burning Man Organization has repeatedly stated that is "does not promote or condone the use of illegal drugs,"[35] and also has an explicit controlled substance and alcohol abuse policy,[36] which warns participants that "the use and possession of illegal drugs at (or near) Burning Man are violations of Federal, State and County law."[37] The Burning Man Survival Guide, given to all participants every year, has a thorough description of this policy as well as an explanation of the possible legal and health consequences.[38] The guide includes a set of recommendations about how to interact with law enforcement officials. Nonetheless, the media sometimes tries to depict Burning Man as a drug-fueled desert party, and law enforcement agencies devote a significant amount of time prosecuting drug crimes—more than that spent on all other offenses. Undercover officers have been deployed—they are sometimes in costume[39]—and the use of drug sniffing dogs, and night vision goggles to detect drug trafficking and consumption, have become routine in recent years.[40] LFB has reported the use of sting operations against alleged drug traffickers and the severe and sometimes abusive treatment of suspects by BLM officers. Only a few arrests involving Burning Man participants have reached the local news,[41] while most are buried in police files and court dockets. One reason for the scant media coverage of Burning Man-related offenses might be that there are very few of them. As Figure 2 shows, the average number of arrests made at Burning Man since 2001 is six, and the average number of citations is about 175. With the exception of 2012 when a record number of 22 arrests were made, arrest statistics have barely reached ten cases per year.[42]

The total number of arrests (72) made at Burning Man during the last twelve years has been significantly lower than the arrests made in one year at other comparable large-scale events such as the Coachella Valley Music and Arts Festival (235 arrests in 2012), and the Stagecoach Country Music Festival (174 arrests in 2012). Burning Man also requires much less local police presence than any of these other events. In 2011, for example, the Pershing County Sheriff's Office only deployed 22 deputy sheriffs at the event. In the Sheriff's opinion "there were sufficient personnel most of the time to handle the incidents as they occurred."[43] BLM, however, provides many more officers, which has been a point of contention between BLM and BRC during some years of negotiations.

In stark contrast with the portrayal of Burning Man as an anarchic and chaotic gathering, the existing data demonstrates that Burning Man is a remarkably low-crime event as the Burning Man community is quite well behaved. Although the presence of law enforcement officials certainly contributes to the low crime statistics, volunteer groups such as the Black Rock Rangers play a key role in further galvanizing cooperative and norm-abiding behavior. But Rangers are no more

than slightly trained event participants. The social equilibrium attained at Burning Man does not exist only because of the presence of a handful of law enforcement officials or the few hundred Rangers deployed at the event; most importantly it exists because of the collective consciousness and communal efforts of those who attend Burning Man.

NOTES

1. This chapter is based on a previous article titled "Order in the Desert: Law Abiding Behavior at Burning Man," 2013 J. Disp. Resol. 349 (2013).
2. "Over time, the camp became a city and a community became many communities. The role of the Rangers has changed and grown at the same time, but the original purpose still holds true; Helping lost souls to find their way home." (http://www.rangers.org/rangers.v5/Origins.html)
3. http://www.burningman.com/on_the_playa/infrastructure/brc_rangers.html
4. http://www.burningman.com/on_the_playa/infrastructure/brc_rangers.html
5. http://www.rangers.org/rangers.v5/Origins.html
6. "Black Rock City Rangers Manual," 2012, p. 9
7. Chen, Katherine, "Laboring for the Man: Augmenting Authority in a Voluntary Association," *Rethinking Power in Organizations, Institutions, and Markets* (*Research in the Sociology of Organizations*, Volume 34), David Courpasson, Damon Golsorkhi, Jeffrey J. Sallaz, eds., Emerald Group Publishing Limited, p. 145.
8. *Rethinking Power in Organizations, Institutions, and Markets*, p. 17.
9. http://www.burningman.com/themecamps/resource_guide.html#sound
10. http://www.burningman.com/themecamps/resource_guide.html#sound
11. http://www.burningman.com/themecamps/resource_guide.html#sound
12. http://www.burningman.com/themecamps/resource_guide.html#sound
13. See "AfterBurn Report," 2006, available at: http://afterburn.burningman.com/06/community/bikes.html (hereinafter, "AfterBurn Report" 2006).
14. "AfterBurn Report," 2004, available at: http://afterburn.burningman.com/04/community/bikes.html
15. "AfterBurn Report," 2006.
16. PROVO, "White Bicycle Plan Manifesto," http://www.gramschap.nl/provo/chrono/prpk5.jpg
17. "AfterBurn Report," 2003–2011, available at http://afterburn.burningman.com/
18. Interview with Ranger #10 at Black Rock City, 26 August 2008. (On file with author).
19. Johnson, Shane D. et al., Community Oriented Policing Services, U.S. Department of Justice, "Problem Oriented Guiders for Police, Problem-Specific Guide Series No. 52— Bicycle Theft," June 2008, p. 5, available at: http://www.cops.usdoj.gov/Publications/e060810143.pdf (hereafter Johnson, Bicycle Theft Report).
20. "AfterBurn Report," 2004, http://afterburn.burningman.com/04/community/bikes.html
21. Interview #20 with Ranger at Black Rock City, 28 August 2012.
22. "Black Rock City Rangers Manual," p. 31.
23. Bureau of Land Management, Environmental Assessment DOI-BLM-NV-W030-2012-0007-EA, Burning Man 2012–2016 Special Recreation Permit NVW03500-12-01, pp. 12, 9, available at: http://www.blm.gov/nv/st/en/fo/wfo/blm_information/nepa0/recreation/burning_man.print.html
24. See for example, "Burning Man 2011 Operating Plan," p. 50, available at: http://www.blm.gov/nv/st/en/fo/wfo/blm_information/nepa0/recreation/burning_man.html
25. Orwell, George, *1984*, New York: Plume,1983.
26. Black Rock City v. Pershing County Board of Commissioners, et al. The U.S. District Court for the District of Nevada, Complaint filed on 16 August 2012. For more information about this litigation, visit: http://brcvpc.com/

27. Complaint, p. 29.
28. http://blog.burningman.com/2012/08/news/taking-the-high-road-with-pershing-county/
29. http://blog.burningman.com/2013/11/news/burning-man-settles-lawsuit-with-pershing-county-nev/
30. Black Rock City LLC v. Pershing County Board of Commissioners, et. al., No. 3:12-cv-00435-RCJ-VPC (U.S.D.Nev. 6 January 2014), p. 29.
31. Notice of Appeal, p.2, Black Rock City LLC v. Pershing County Board of Commissioners, et. al., No. 3:12-cv-00435-RCJ-VPC (U.S.D.Nev. 4 February 2014)
32. http://www.nvcounsel.com/lawyers-for-burners
33. http://lawyersforburners.com. This group was established in 2007 by Palo Alto lawyer David Levin (aka Burning Man Barrister) "to aid festival revelers in their brushes with the law." (http://www.abajournal.com/news/article/burning_man_barrister_offers_free_legal_advice_to_festival_revelers/)
34. http://www.lawyersforburners.com/
35. Black Rock City, LLC, "Burning Man Survival Guide," 2012.
36. Black Rock City, LLC, "Controlled Substance and Alcohol Use Policy, 2012," available at: http://www.burningman.com/media/doc/pdf/blm_stipulations/2012_drugalcoholpolicy.pdf
37. Black Rock City, LLC, "Controlled Substance and Alcohol Use Policy, 2012."
38. "Burning Man Survival Guide," available at: http://www.burningman.com/preparation/event_survival/#.UUfJ1lvF3-E
39. http://www.lawyersforburners.com/2008
40. Doherty, Brian, *This Is Burning Man: The Rise of a New American Underground*, Dallas, Texas: BenBella Books, 2004.
41. The most recent example was the arrest of Robert Louis Ruenzel II and Lindsey Ann Neverinsky, a couple charged for the possession of narcotics while on their way to Burning Man. Although their case was widely covered by the local media for a while, they ended up pleading guilty to a misdemeanor charge of simple possession of a controlled substance, and were also barred from returning to the festival. See KYVU.COM, "Strange court case for Burning Man drug suspects," Monday 3 September 2012. Another newsworthy arrest, this time for arson, took place in 2007 when participant Paul David Addis was taken into police custody for setting ablaze the effigy of "the Man" five days before the scheduled burn. Addis was later charged and convicted of felony charges of arson and destruction of property and served two years in a Nevada prison. See, http://www.sfgate.com/news/article/Burning-Man-is-burned-too-soon-arson-arrest-2524487.php
42. Complaint, p. 34, Black Rock City, LLC v. Pershing County Board of Commissioners, et al., No. 3:12-cv-00435-RCJ-VPC (U.S.D.Nev. Aug. 16, 2012).
43. Complaint, p. 35, Black Rock City, LLC v. Pershing County Board of Commissioners, et al., No. 3:12-cv-00435-RCJ-VPC (U.S.D.Nev. Aug. 16, 2012).

FOOTPRINT
DOUGLAS GILLIES

INTRODUCTION

The playa is nestled in the Black Rock Desert High Rock Canyon Emigrant Trails National Conservation Area, 800,000 acres of public land managed by the Bureau of Land Management (BLM).[1] This is where ThrustSSC made history as the first car to break the sound barrier with a sonic boom at 763 mph on 13 October 1997.[2] But the playa is better known for a civilization that rises on the dusty alkaline desert floor for one week every year, and then vanishes.

The circular footprint of Black Rock City (BRC) is a three-mile wide hieroglyph where tens of thousands of inhabitants explore the ragged edges of human potential.

They travel from six continents to participate in a celebration monitored by Black Rock Rangers, who act as a resolute thin khaki line, riding the edge of chaos.[3] Regional contacts have signed up from every continent but Antarctica. Burners travel from every part of the world, including Russia, Austria, Israel, Africa, the Yucatan, Columbia, Brazil, Chile, South Korea, Malaysia, Vietnam, and many more.[4] BRC is an indication that a primal force in human nature includes the desire to celebrate, share resources, inspire wonder and joy in one another, and take responsibility for our own survival. This is how the world might look in 50 years after corporations lose their grip on perception, oil companies abandon the race to extinction, and banks stop reigning in people with "interest" based on 1s and 0s precipitated out of thin air.

> You load 16 tons, what do you get?
> Another day older and deeper in debt.
> Saint Peter don't you call me 'cause I can't go
> I owe my soul to the company store.
> <div align="right">Tennessee Ernie Ford (1956)[5]</div>

Technically astute, environmentally sensitive, and precariously popular, Burning Man was limited to 68,000 participants by BLM in 2013. One of the ten principles of Burning Man is Communal Effort. "Our community values creative cooperation and collaboration. We strive to produce, promote and protect social networks, public spaces, works of art, and methods of communication that support such interaction."[6] Almost a thousand theme camps were approved for pre-placement in 2012 and 360 art projects were registered. In 1999, the population of BRC was 25,000. The official count in 2012 was 56,149 celebrants, plus crew, rangers, police, truck drivers, and the department of public works. The population rose another twenty per cent in 2013. When it reached the limit of 68,000 on Friday morning, arrivals were delayed at the gate and let in on a one-in-one-out basis.

LEAVE NO TRACE

The BLM permit states, "All recreation permittees will be required to adhere to Tread Lightly!® and Leave-No-Trace® principles."[7] Tread Lightly and Leave No Trace are registered trademarks of the US Department of Agriculture. Leave-No-Trace is also registered to a Missouri company that sells firearm attachments—catchers for expended bullets.[8] In the early 1990s, gunslingers crossed the playa to shoot stuffed animals at the Drive-by Shooting Range by Frog Hot Spring.[9] "Building absurdly

TOP
Black Rock City from above
Photo: AJPN Anthony Peterson

BOTTOM
Black Rock City seen from Old Razorback Mountain
Photo: Peretz Partensky (CC)

destructive machinery and destroying things became a characteristic part of Burning in the mid- to late 1990s," wrote Brian Doherty in *This is Burning Man*.[10] Burning Man originally borrowed the term from LeaveNoTrace.org.[11]

Conditions changed after Thrust's sonic boom shattered the silence. BLM started issuing permits and local sheriffs cruised the playa. You won't find expended bullets in Black Rock City any more. The Wild West phase of Burning Man faded with the dawn of the twenty-first century. Items not allowed through the gate include explosives, aerial flares, rockets, fireworks, and firearms of any kind, including BB guns, air rifles and paint ball guns.[12]

DOUGLAS GILLIES

Burning Man founder Larry Harvey was interviewed by BBC radio in 2003:

This is a city not only where you can't buy or sell anything, it's a city without trashcans. We tell people that they must take everything away that they have brought to the desert, leaving no trace, in what is almost a metaphysical sense. Every sequin, every grain of sawdust. There is nothing there when we come, and there is nothing there when we leave.

Littering is taboo in BRC, but there is always MOOP (Matter Out Of Place) remaining in the dust—nails, rebar, pistachio shells, cigarette butts, feathers and other jetsam. Black Rock City is recognized by the Bureau of Land Management for setting high standards by which other recreation events are measured. A Playa Restoration crew combs the playa for weeks to collect the last remnants of a 200-hour celebration. Then BLM inspects and BRC passes inspection for another year.[13]

When Burners head for home on Labor Day, exploded trash bags, discarded furniture and disintegrating mattresses are found along the road.[14] Nevada Department of Transportation (NDOT) crews removed nine truckloads of trash and two abandoned vehicles along the highway after the 2011 event. Garbage bags were found in dumpsters from Gerlach to Fresno and Salt Lake City, despite warnings, suggestions, instructions and tips on BurningMan.com. Trash bins are now removed from nearby rest stops on Labor Day weekend and BRC provides at least two roadside crews to clean up litter and debris along the roads and highways after the event.[15]

BurningMan.com advises that "Everyone who attends Burning Man should be aware of the uniqueness of the environment we have chosen to build our city. We ask that each person contribute two or more hours of time on the day of departure to 'detail' your camp and boundaries."[16]

In 2012, over 100 people scoured the playa for MOOP in all its forms after Labor Day.[17] Restoration crewmembers spent two-and-a-half weeks walking most of the 3,347-acre site picking up any remaining trash, and once again, Black Rock City passed the BLM site inspection.[18] Footprints remained in the desert floor, but trash was nowhere in sight.

Despite the transgressions of a few participants, Burning Man does an exceptional job of managing MOOP, and instills a sense of shared responsibility in the community.

Leave No Trace is a cultural priority of organizers and participants, including recycling, composting and reducing waste. According to BLM Environmental Assessment for Burning Man 2012–2016:

The applicant has cooperated successfully during previous events with both NDOT and the Pyramid Lake Paiute Tribe to reduce impacts to nearby communities by removing off-site trash and by supporting and promoting tribal enterprises that are set up to collect participant trash and recycling for a fee.[19]

BLM sets a high standard for leaving no trace. Residue debris must not exceed 1.0 square feet per acre. The debris area increased more than 50 per cent from 0.5 square feet in 2010 to 0.763 in 2011. The stated goal for 2012 was a reduction back to 0.5 square feet, but results from 2012 and 2013 had not been posted on BurningMan.com as of 30 April 2014.[20]

Larry Harvey wrote the "Ten Principles of Burning Man" in 2004. They were crafted not as a dictate how people should be and act, but as a reflection of the community's ethos and culture. The eighth principle of Burning Man is Leaving No Trace:

Our community respects the environment. We are committed to leaving no physical trace of our activities wherever we gather. We clean up after ourselves and endeavor, whenever possible, to leave places in a better state than we found them."[21]

Despite extraordinary efforts to Leave No Trace, impressions remain after BRC vanishes from the desert floor. Footprints linger in the dust left by desert boots, bicycles, art cars, buses, RVs, forklifts, tractor-trailers, and several dozen airplanes. They vanish when the lake returns with the winter rains, leaving a faint mark the following year. The city site is rotated between three locations to allow each site to "heal."

This is the bright side of the equation, footprints that can be seen and touched and erased with reasonable effort. However, a place is a region, some indefinite or particular piece of the complex, interconnected environmental puzzle we call planet Earth. Burning Man is a place in Nevada, but it has links to every region of the world.

OIL DRIPS

The Burning Man website includes a BLM Oil Drip Survey that studied oil leaks during the 2002 event, when the number of participants was 30,000. The number of vehicles was estimated to be 7,500 based on the assumption of four occupants per vehicle. However, this would only be possible if every car pulled a trailer loaded with costumes, food, water, camping gear, stoves, tarps, tables, wood, sound equipment, rugs, solar arrays, and everything that turns the playa into a whimsical city. Inspection of a sample of 102 vehicles in 2012 revealed a total of 19 oil spots associated with 16 vehicles. The study concluded that 14.5 gallons of oil had dripped onto the playa. [22]

The BLM 2012 Environmental Assessment of Burning Man continued to rely on the sample from the 2002 study, but reduced the visitors-per-vehicle assumption from 4 to 1.6. Based on the premise that one in six vehicles drip oil, BLM concluded that vehicles deposited 72.5 gallons of vehicle-related hydrocarbons on the playa in 2012 and 85 gallons in 2013, when the population reached 68,000.

Population	# Vehicles	# Dripping Vehicles	Oz. per day	Total Oz.	Total Gallons
58,000	37,120	6,187	1,856	9,280	72.5
62,000	39,680	6,613	1,984	9,920	77.5
66,000	42,240	7,040	2,112	10,560	82.5
70,000	44,800	7,467	2,240	11,200	87.5

BLM Oil Drip Projections for 58,000 to 70,000 persons[23]

The BLM 2012 Environmental Assessment states that Black Rock City LLC will train greeters to identify vehicles likely to have an increased risk of oil or fluid drips, inspect suspect vehicles and provide leaking vehicles with cardboard, hazmat pads, or drip pans to minimize impacts. BLM also recommended that BRC conduct an oil drip survey in 2012, to include a scientifically valid methodology for sampling collection with verifiable results.[24]

The BLM worked with the Earth Guardians and about 20 Black Rock City participants who volunteered to look for and test oil drip diameters under cars. The good news is that less than four per cent of the cars checked were leaking. The bad news is that the older the vehicle, the more likely it was to leak. Although not such a big surprise, RVs were way more likely to leak than smaller vehicles, and their

leaks were not just from the engine: RVs were sometimes found to be leaking grey or black water from the holding tanks. We will use this information to create more educational messaging to Black Rock citizens.[25]

The beater that drips oil at Burning Man will drip oil when it gets back home. Runoff in the city flows into the ocean where it can harm sea life and damage reefs. Water in the playa evaporates in the hot air or settles into alkaline dust where its residue will be absorbed in the top layer of sediment of the playa and then volatilized, dispersed as a film in the intermittent lake surface or photo-degraded over time by sunlight.[26] Oil drips are a fact of modern life, but if the default world is slipping into an environmental abyss, Burning Man might have to set a higher standard to remain sustainable in a rapidly changing world.

CARBON FOOTPRINT

As with many footprints, there is an elusive shadow to Burning Man, footprints that cannot be seen or touched as the community heads back to a world where footprints on a grander scale portend an incomprehensible future.

It is not simple to measure the environmental footprint of human activity. What is the carbon footprint of driving a few miles to the market to pick up a pint of ice cream or a six-pack? Ten miles might burn a gallon of gas, with starting and stopping, driving in traffic, waiting for the light—but who's counting? Carbon emissions are invisible as they rise into the atmosphere, where carbon stores heat from the sun. More than 95 per cent of participants ride a motor vehicle to the playa, whether it's a car, a truck, or an RV.[27]

To conserve energy, BurningMan.com lists over 350 locations in the Reno, Carson City, and Fernley area to buy water, gas, biofuel, costumes, camping gear, food and other supplies, as well as locations in every direction to deposit trash and recyclable materials on the way home. It posts a Google Map pinpointing locations of 'hot spots' to reduce driving time while stocking up. Einstein Brothers Bagels recharges electric vehicles for free during business hours.

If it seems like too much trouble to measure every little carbon footprint we leave on Earth, we can always take the high road and point the finger at BP-Chevron-ExxonMobil-Shell. The value of their stock is based on the book value of their oil reserves. The amount of carbon stored in proven coal and oil and gas reserves on the books of the oil companies is 2,795 gigatons. That is the quantity of fossil fuel they anticipate their customers will burn. It is five times more oil, coal and natural gas than climate scientists think will be safe to burn. If we listen to the scientists and leave 80 per cent of oil company reserves in the ground, the oil companies will write off $20 trillion in assets as they watch their bonuses evaporate.[28] Burn all that carbon and investors can laugh all the way to the bank, but the planet will be a lonely place to spend the money.

Burning Man encourages solutions that reduce the impact on the environment. One example is the Gray-B-Gone (GBG) wind-powered evapotron, a device that uses wind for its power source to evaporate wastewater rather than gas-powered generators. Workshops in San Francisco teach people how to build them from parts. Starting in 2010, evapotrons based on the GBG design were used in dozens of camps, evaporating about 800 gallons of wastewater per day. The GBG website provides a construction guide to build a GBG evapotron.[29]

Even as carbon footprints on the playa are reduced, CO_2 is released as participants make the round trip to BRC. The carbon footprint of driving 42,500 cars roundtrip from San Francisco for a total of 29 million miles at an average of 22.5 mpg would be 13,466 tons of carbon, according to the NativeEnergy carbon

calculator,[30] and more people are arriving each year by plane. One round-trip flight from New York to San Francisco creates a warming effect equivalent to two to three tons of carbon dioxide for each passenger, whereas the average American generates about 19 tons of carbon dioxide a year.[31]

Burning Man started providing the Burner Express bus service to Black Rock City in 2013, with pickups in San Francisco and the Reno airport. Almost 2,500 riders rode the Burner Express the first year. Capacity will double to 5,000 in 2014. The carbon footprint of transportation can be reduced by mass transit, but there is no way to transport everyone to BRC on carbon-free conveyances without recalibrating Douglas Adams' Infinite Improbability Drive.[32]

It takes energy to light the playa, make ice, serve cappuccinos, blend margaritas, amplify sound, project images on screens, charge batteries, cool RVs, and power all the lights worn by participants to avoid collisions as thousands of bicycles crisscross the open desert at night.

Generators burning fuel can be annoying and harmful to the environment. BurningMan.com posts these recommendations:

> While the drone of raves in the night is something we can all adapt to, the relentless brrrraaaaaaaaappp of a noisy generator is quite another. Just as bad, the exhaust can be like sleeping inside a garage with a car running. You should consider environmentally friendly energy solutions but if you do choose to bring and share a generator, bring the quietest generator you can afford, and the smallest that will meet your actual needs. Large generators are more difficult to transport, use more fuel and cause more pollution.[33]
>
> A tarp or metal pan under your generator will keep oil and gasoline spills off the playa. Use kitty litter or sawdust or playa dust on top of the tarp, not directly on the playa, to facilitate cleaning up any spills.[34]

Green Energy is advocated on the Burning Man website:

> Greening your energy comes down to reducing the pollution that your solution generates. The pollution from a battery comes from the fact that it is made of toxic materials, which can wreck an ecosystem if not properly dealt with (like if you toss it in your landfill trash). Rechargeables get some credit since they can go through a lot of cycles before being dumped. A generator is an engine, so its pollution comes from what it's burning—regular gas, or diesel, or biodiesel. Pollution from a solar panel also comes at the end of its life, since it includes highly processed parts and possibly toxic chemicals. If you're worried about how to power your personal blinky lights, go with rechargeable batteries, and consider a solar-powered recharger. Combine batteries with your solar panel for a green solution! More small-scale solar solutions are hitting the market pre-packaged with batteries, inverters, power strips, radios and air compressors. The Alternative Energy Zone website has documentation and pointers if you're interested in building your own wind turbine.[35]

Carbon is the backbone of life; oxygen is the fuel. Humans are standing on a precipice. We must strike a new balance with nature if we are to continue our odyssey.

CARBON OFFSETS

BurningMan.com refers participants to the CoolingMan project to purchase carbon-offsets.[36] CoolingMan was a small non-profit started by Jeff Cole and David

Exodus Traffic
Photo: Victor Grigas (CC)

Shearer in 2005.[37] It encouraged burners to purchase carbon offsets to cancel out their contributions to playa-related greenhouse gas emissions. SFGate.com reported in 2006, "'We think CoolingMan is pretty cool,' said Marian Goodell, Burning Man's director of communications and business." [38] CoolingMan estimated that Burning Man generated 27,000 tons of carbon dioxide in 2006, including 87 per cent from transportation to and from the location.[39] "That number was really just a guess, with an error factor that may be pretty high," said David Shearer. BLM estimated a population of 39,100 in 2006.[40] Burning Man's footprint in 2013 would be 47,000 tons of CO_2 according to CoolingMan's estimate, but nobody has run all the numbers. Environmental science is evolving. Many websites now offer carbon emission calculators, including NativeEnergy.com, the Nature Conservancy, the Guardian, British Petroleum, and the EPA.[41]

NativeEnergy.com encourages visitors to purchase carbon credits to offset their carbon footprints.[42] Carbon calculators are based on emerging models. Native Energy offers three input options—small, medium or large—but a Prius (51/48 mpg) is not the same as a Honda Pilot (18/25 mpg) and a Nissan Pathfinder Hybrid (26 mpg) is not the same as a 450-hp Winnebago Tour® (8 mpg). Speed counts— driving 55 mph instead of 70 mph reduces gas consumption by one third.

CoolingMan.org provides a comprehensive list of steps participants can take at home to become carbon neutral, or better yet, carbon negative, and asks participants to report any reductions to help CoolingMan track the total climate benefits achieved by participants.[43] However, CoolingMan.org has not been revised since 2007 and its fill-in forms to calculate carbon footprint no longer take input.[44] Yet CoolingMan.org presents a bold challenge on every page: "If 70 per cent of burners reduced or offset one ton, Black Rock City could be the first carbon negative city in the world."[45] That is a goal with a plausible future.

Burning Man may have the resources to enable participants to compute their Burning Man carbon footprints door-to-door, and then register carbon credits in a database such as the one proposed on CoolingMan.org as they aspire to reduce a ton of carbon emissions in the default world, encourage others to take positive steps, and participate in activities that point their communities in the direction of a sustainable planet.

SOLAR POWER

CoolingMan evolved into Black Rock Solar, a non-profit founded by Tom Price,[46] David Shearer, Matt Cheney, and Marian Goodell in 2007 to power the Man and its surrounding exhibits with solar energy. In 2007, the Green Man was chosen as an environmental theme for Burning Man. Volunteers and employees installed a 30-kilowatt photovoltaic array on the desert floor to power the lights illuminating the Man and several adjoining environmental booths. After the event, the array was donated to Gerlach High School and installed by a volunteer crew.[47]

Black Rock Solar hosts a Solar Summit each year at Burning Man and conducts tours of solar installations on the playa. It collaborated with the Temple of Whollyness, the Ichthyosaur Puppet Project, and Solar Sunflosers in 2013 to provide clean, renewable energy for their night lighting.[48] Tax breaks in Nevada make it possible for Black Rock Solar to install photovoltaic arrays at low or no cost for nonprofits, schools, communities and Native American tribes, many of which could not otherwise invest in renewable energy. Black Rock Solar promotes the principles of Leave No Trace and Radical Self Reliance by helping local communities lower their utility bills and become less reliant on conventional energy sources.

Nixon, Nevada, seat of the Pyramid Lake Paiute Tribe, has more distributed solar energy per capita than any other town in the United States, thanks to Black Rock Solar—including an arrowhead-shaped array powering the Pyramid Lake Paiute Tribal Museum. In 2010, Nevada Governor Jim Gibbons named the 75-mile length of Highway 447—"America's Solar Highway."[49]

When not installing photovoltaic arrays, Black Rock Solar focuses on education and art. It helped found GREENevada, a coalition for providing environmental education to K-12 students. GREENevada's annual Student Sustainability Summit draws youths from across the state to see the benefits of solar energy and compete for tens of thousands of dollars earmarked to help them "green" their campuses. Black Rock Solar also offers job training and internships to tribal members and college students, and provides grants to artists working with renewable energy.[50]

As of June 2013, Black Rock Solar had installed 15,000 solar panels in 60 installations, including schools, hospitals, tribal buildings, community centers, and nonprofit organizations in Nevada with a total capacity of three million watts of solar power. Later in 2013, Black Rock Solar installed 150 kilowatts for the Pyramid Lake Paiute Tribe's Sutcliffe Fish Hatchery, 100 kW for the Walker River Paiute to help power their water treatment plant, and 200 kilowatts for the water system in the small town of Lovelock.[51] By the spring of 2014, Black Rock Solar had installed over four megawatts of solar power for tribes, nonprofits & schools.[52]

Black Rock Solar reports:

> Over 500 people camp together with not a single generator at the Alternative Energy Zone (AEZ). AEZ is one of the pioneering, radically self-sufficient, fossil fuel minimizing groups on the playa. They've been around since 2001.... Each set of campers at AEZ provides their own energy solution, whether it's solar, wind, or surviving without electricity altogether.[53]

Nectar Village is another camp with over 300 people and two solar arrays. The largest solar installation on the playa, it produces 31 kW, enough electricity to power all of the village's operations. Power is distributed via circuits and cables to tents, trailers, and common areas.[54] Sun-powered villages could be the advent of a sustainable future.

Solar powered vehicle
Photo: Scott Hess

WATER

Each year the production of water bottles in the United States takes enough oil and energy to fuel a million cars, and then 80 per cent of the bottles end up in landfills.[55] The carbon dioxide released into the atmosphere by participants transporting their personal water to Burning Man in plastic containers, combined with the carbon needed to produce the bottles, increases the carbon footprint of the event. The playa is a semi-arid desert with annual precipitation of 6.75 inches. An average of 0.25 inches falls in August and September, and the average daily high temperature in August is 91°F, although temperatures can rise to 120°F.[56] The alkaline soil is corrosive. Dehydration and heatstroke can happen quickly.

Alternative Energy Zone recommends that participants bring two gallons of water a day per person for drinking, cooking, cleaning and misting, plus one-to-two gallons for each shower.[57] If 68,000 people consumed three one-gallon jugs of water a day for a week, a total of 1,428,000 plastic containers would be used. If they were, for example, Crystal Geyser one-gallon jugs with the plastic handles on top, and they were lined up single file along the highway, they would extend from Burning Man all the way to Reno. Filled with water, those hypothetical 1.428 million bottles would weigh 6,000 tons, which is equal to the weight of three space shuttles. If each burner carried those 21 gallons of water 340 miles from San Francisco to BRC, the community would haul the equivalent of one space shuttle over a thousand miles, i.e., from LAX to Denver. There was a big fuss when the space shuttle Endeavour was towed ten miles from LAX to Exhibition Park in 2012. Imagine the reactions if NASA had towed Endeavour to Denver.

After the Burn, empty plastic water jugs are carried away by participants to be recycled, reused, or buried in landfills. The use of recycled water bottles is discouraged on BurningMan.com: "It is highly recommended that if you do bring water in used containers that you use that as utility water for cleaning and bathing, running mister systems, and such, and keep your drinking (and cooking) water only in new containers."[58]

Most plastics do not biodegrade. The low cost of plastic encourages ever-increasing use in single-use packaging, while it discourages recycling.[59] BurningMan.com suggests that stainless steel drums are the best alternative.[60] Burning Man Earth Guardians offers 20 tips on how to reduce plastic at Burning Man as part of the Plastic Footprint Project. For example, bring water in stainless steel containers and skip the disposable plastic glow sticks.[61] Earth Guardians works with school and community groups in Lake Tahoe

to raise awareness about ways to reduce use of plastic products at Burning Man and at home.

Not all water used at Burning Man arrives in plastic containers. BLM estimates that the total non-potable water use is 6,018,600 gallons, or 18.5 acre-feet. Potable water, which is suitable for drinking and cooking, makes up only one-fifth of the total water consumed on the playa.

Non-Potable Water Use	Gallons
Dust Abatement	6,000,000
Fire Suppression	12,000
Art Installations	6,600
Total	6,018,600

Burning Man Non-Potable Water Requirements 2012[62]

Water is trucked to BRC for fire suppression and dust abatement from the Fly Ranch on the edge of the Hualapai Valley, eight miles northwest of BRC on the northwest corner of the Black Rock Desert. The water from Fly Ranch is not suitable for drinking or cooking: it contains salt, coliform, E. Coli, and fluoride concentrations that exceed maximum contaminant levels for drinking water. Anyone who is tempted to chase the dust abatement trucks for a quick shower might think twice. The playa surface is composed of salts to such a degree that Fly Ranch water is not considered likely to have a detectable impact after the constituents break down.[63]

Burning Man contracts with potable water vendors to service staff RVs and travel trailers, large-scale theme camps, and interdepartmental needs. The carbon footprint of Burning Man would be reduced if all water for personal use was transported to the playa in trucks, stored in water tanks on public plazas, and made available to participants to carry to their camps on bicycles, rather than transporting it hundreds of miles in 42,500 vehicles. BurningMan.com recommends that large camps network and rent large potable water trucks to transport water to the playa.[64] This strategy could be expanded to serve the needs of all participants. No midsize city requires that its residents travel hundreds of miles to collect household water. Although "Burning Man encourages the individual to discover, exercise and rely on his or her inner resources,"[65] it may be reaching a point where Radical Self-Reliance must align with Communal Effort to Leave No Trace.

Indeed, BurningMan.com states:

We have committed ourselves to spreading the Leave No Trace ethos beyond the boundaries of the trash fence. By embracing alternative energy and earth-friendly technologies, we will create a Black Rock City that leaves less of an impact on its environment—while also taking these principles out of the desert and back with us to our local communities.[66]

For every action taken or resource consumed at Burning Man, there is a corresponding action that would be taken by an individual if he or she stayed home. The average use of water by a participant on the playa is three gallons per day. The average indoor water use per person per day in California is 70 gallons, which includes 14 gallons for toilet and seven gallons for showers.[67]

If Burning Man is an apple, where an individual consumes three gallons of water per day, and the default world is an orange where the same individual consumes 70 gallons per day, Burning Man is ahead of society by a big bushel of fruit in the conservation of water, a scarce resource in California and Nevada. However, burning

gas to make bottles out of oil, filling them with water and transporting them to market, then hauling the water across the desert in plastic jugs tips the basket on the carbon footprint scale. If participants could ride bicycles to water stations on the playa to fill reusable stainless steel jugs, the carbon footprint of Burning Man would be reduced, and most vehicles would have room for an extra passenger.

ECOLOGICAL FOOTPRINT

In his 2013 State of the Union address, President Obama said, "The 12 hottest years on record have all come in the last 15."[68] Thomas Tidwell, chief of the United States Forest Service, told the Senate committee on energy and natural resources on 4 June 2013, that 1,452 counties in the US were declared disaster areas in 2012 due to drought. America's wildfire season lasts two months longer than it did 40 years ago and burns twice as much land because of hotter, drier conditions produced by climate change.[69] California in 2014 is experiencing its worst dry spell on record, according to the National Oceanic and Atmospheric Administration. Facing what is "perhaps the worst drought that California has ever seen," Gov. Jerry Brown declared a drought emergency for the state on 17 January.[70]

The Ecological Footprint tracks human demands on the biosphere by comparing humanity's consumption against the Earth's regenerative capacity, or biocapacity. It does this by calculating the area required to produce the resources people consume, the area occupied by infrastructure, and the area of forest needed to sequester CO_2 not absorbed by the ocean.[71] The size of a person's Ecological Footprint depends mostly on what they eat, what products they consume, and how they travel.[72] Humanity's annual demand on the natural world has exceeded what the Earth can renew every year since the first Earth Day in 1971. This "ecological overshoot" has continued to grow over the years, reaching a 50 per cent deficit in 2008. It takes 18 months for the Earth to absorb the CO_2 people release into the atmosphere every year.

Since 1870, global sea level has risen about eight inches as a result of increased CO_2 in the atmosphere. Sea level is expected to rise at a greater rate during the next century. Oceans become more acidic as CO_2 emissions in the atmosphere dissolve in the ocean. Acidification adversely affects many marine species, including plankton, mollusks, shellfish and corals. If CO_2 concentrations continue to rise at their current rate, corals could become rare on tropical and subtropical reefs by 2050.[73]

The growing biocapacity deficit—when a population uses more biocapacity than the Earth can regenerate in a year—is driven by the combination of consumption rates, that are increasing more rapidly than improvements in efficiency, and populations growing faster than the biosphere's capacity to keep up.

If the Ecological Footprint of participants on the playa is significantly lower than their footprint in the default world, this helps to offset Burning Man's biocapacity deficit. If the Ecological Footprint of Burning Man participants in the default world could be reduced to anything less than two thirds of the resources consumed by the general population, this premium would further offset Burning Man's biocapacity deficit. Reduction in consumption of fuel, electricity, water and other resources could be measured and reported in a database such as the one envisioned on CoolingMan.org.[74]

A whole lot of carbon is released when you throw an annual party in the Black Rock Desert and 70,000 people show up from all over the world. Compartmentalized thinking got us into this predicament. Letting the carbon elephant out of the closet does not necessarily mean that Burning Man is not sustainable. A solution may already be on the books, and it started with Hurricane Katrina.

PARTICIPATION

Burning Man 2005 was in full swing when Hurricane Katrina hit New Orleans and scores of Burners headed to Mississippi. Some of them brought heavy equipment. Calling themselves Burners Without Borders (BWB), they provided one million dollars' worth of disaster relief to a community that was under the radar of major relief organizations.

In 2007, when Pisco, Peru was devastated by an 8.0 magnitude earthquake, BWB headed south. The goal was to stay for five years and help the town recover and move forward. Five years later, Pisco Sin Fronteras had become a thriving, Peruvian-run organization that had hosted hundreds of volunteers to help with rebuilding.[75]

After Hurricane Sandy struck the East Coast, the Mayor of Union Beach, NJ asked BWB for help. Hundreds of damaged homes needed to be removed, but doing so would bankrupt the town. Homeowners could not access federal emergency funds until their damaged homes were cleared. Uncle Sam had dropped the ball. The BWB Sandy Relief Crew demolished 200 houses and cleared debris from 80 sites, providing three million dollars in services for Union Beach residents while helping residents get back on their feet.[76]

Greening the Beige, an eco-minded BWB arts collective in Beijing, works with several organizations and projects in China to nurture awareness of environmental issues and promote earth friendly artists and organizations in Beijing. They focus on creating a more sustainable planet while raising funds for Roots & Shoots and the China Mangrove Action Project.[77]

These projects demonstrate that Burning Man culture reaches well beyond the playa as the principle of participation in society is propagated throughout the world. New emission reduction projects could lower Burning Man's carbon footprint. Participation may be the key to a carbon neutral future for Burning Man.

Following Leave No Trace, the ninth principle of Burning Man is Participation, formerly known as No Spectators:

> Our community is committed to a radically participatory ethic. We believe that transformative change, whether in the individual or in society, can occur only through the medium of deeply personal participation. We achieve being through doing. Everyone is invited to work. Everyone is invited to play. We make the world real through actions that open the heart.[78]

The tenth and final principle is Immediacy:

> Immediate experience is, in many ways, the most important touchstone of value in our culture. We seek to overcome barriers that stand between us and a recognition of our inner selves, the reality of those around us, participation in society, and contact with a natural world exceeding human powers. No idea can substitute for this experience.[79]

As an example of participation in society, the goal of revitalize—a "Leave No Trace" art and education program—is to bring the collective consciousness of Burning Man to the outside world through a recycling program that engages children across the country. In 2013, students collected thousands of toothbrushes as they raised awareness about the consumption of plastic material in the world. The toothbrush is a symbol of plastic that children can identify with. ReVITALize made a giant disco ball out of the toothbrushes and suspended it 100 feet in the air to light up the desert. Its recycling partner, TerraCycle, pays participating schools two cents for every piece of plastic they collect and recycle.

GIFTING

The culture and the consciousness of Burning Man have evolved over the past 25 years and additional steps are being taken to meet environmental challenges. Tom Van Sant, founder of the GeoSphere Project,[80] posed a question one generation ago in 1994: "How can we speed up the shift to holistic thinking from linear, reductionist, compartmentalized thinking? In other words, how can we see the big picture?"[81] Burning Man's picture is composed of 70,000 people hauling things to the Black Rock Desert from every continent on Earth, burning stuff, celebrating for one unforgettable week, and then disposing of a mountain of plastic and trash on Labor Day when everyone heads home. Yet a bigger picture is emerging.

The second principle of Burning Man is Gifting:

> Burning Man is devoted to acts of gift giving. The value of a gift is unconditional. Gifting does not contemplate a return or an exchange for something of equal value.[82]

If the average Burner spent $1,500 dollars to go to Burning Man—including admission ($380), travel ($190 from SF on the Burner Express), housing, water, food, bicycles, costumes, gifts, tequila, art cars, Viking ships, Thunderdomes—that would add up to a budget of $100,000,000 for Black Rock City—per week! Plastic toothbrushes reflect the growing commitment to meet the challenges of wasted resources and climate change. Burning Man is a large city with a significant economy and a vast network of affiliations.[83]

For all the carbon extracted from the Earth and released into the atmosphere for Burning Man, there arises a responsibility to future generations. The next steps are to collect the data, be increasingly carbon conscious, and participate fully on a global level in the gifting economy.

NOTES

1. http://www.blm.gov/nv/st/en/fo/wfo/blm_programs/planning/Black_Rock_Desert-High_Rock_Canyon_Emigrant_Trails_National_Conservation_Area/black_rock_desert-high.html
2. www.cnn.com/TECH/9710/13/land.speed.record/ (on the 21st birthday of my son, Nathaniel Gillies).
3. http://rangers.burningman.com/regional-ranger-organizations/11-points-of-rangering/
4. http://afterburn.burningman.com/12/history.html
5. http://www.youtube.com/watch?v=Joo90ZWrUkU
6. http://www.burningman.com/whatisburningman/about_burningman/principles.html
7. BLM Environmental Assessment Burning Man 2012–2016, pp. 1–2, REC-21; https://www.blm.gov/epl-front-office/projects/nepa/28954/37412/39212/Burning_Man_DOI-BLM-NV-W030-2012-0007-Final_EA.pdf
8. http://tess2.uspto.gov/
9. http://www.burningman.com/whatisburningman/people/senior_alumni.html (bio. of Joseph F. Fenton)
10. Doherty, Brian, This is Burning Man, Little, Brown & Co. 2004, pp. 63–65.
11. https://lnt.org/ (Source: Megan Miller)

12. http://survival.burningman.com/transportation-traffic/items-not-allowed-through-gate/
13. http://www.burningman.com/environment/playa_restoration/
14. http://afterburn.burningman.com/12/dpw/setup_cleanup.html
15. BLM Environmental Assessment Burning Man 2012–2016, supra, pp. 4–20.
16. www.burningman.com/on_the_playa/environment_concerns/index.html
17. http://blog.burningman.com/2012/09/environment/moop-map-live-2012-and-theyre-off/
18. http://blog.burningman.com/2012/10/news/blm-site-inspection-passed/
19. BLM Environmental Assessment Burning Man 2012–2016, supra, pp. 4–20.
20. http://afterburn.burningman.com/12/dpw/setup_cleanup.html
21. www.burningman.com/whatisburningman/about_burningman/principles.html
22. www.burningman.com/preparation/event_survival/oildrips.html
23. BLM Environmental Assessment Burning Man 2012–2016, supra, Table 4.11–2, pp. 4–26.
24. BLM Environmental Assessment Burning Man 2012–2016, supra, pp. 4–19, 6–1.

25. http://afterburn.burningman.com/12/environment.html
26. BLM Environmental Assessment Burning Man 2012-2016, *supra*, pp. 4–19, 4–27.
27. http://www.burningman.com/environment/resources/transportation.html
28. McKibben, Bill, "Global Warming's Terrible New Math," (www.rollingstone.com/politics/news/global-warmings-terrifying-new-math-20120719)
29. https://sites.google.com/site/evapotrons/home
30. http://www.nativeenergy.com/travel.html
31. http://www.nytimes.com/2013/01/27/sunday-review/the-biggest-carbon-sin-air-travel.html
32. Adams, Douglas, *The Hitchiker's Guide to the Galaxy*, 1979.
33. www.burningman.com/preparation/event_survival/generators.html
34. http://www.burningman.com/environment/resources/energy.html
35. http://www.burningman.com/environment/resources/energy.html
36. http://www.burningman.com/environment/resources/energy.html
37. David Shearer holds a doctorate in Environmental Epidemiology from UC Irvine, a Master's Degree in environmental microbiology from UC Irvine, and a bachelor's degree in biology from the University of Oregon.
38. http://www.sfgate.com/green/article/Burning-Man-Goes-Green-2513430.php August 26, 2006
39. Burning Man 2006 generated an estimated 27,000 tons of greenhouse gas (GHG) emissions. This figure includes emissions from participant and staff travel to and from Black Rock City, as well as on-playa power generation, art cars, fire art, and burning the man. Dividing 27,000 tons by 40,000 people yields an estimated 0.7 tons per Burning Man participant. www.coolingman.org/learn_more/burning_man_estimated_climate_impact.html
40. http://www.blm.gov/nv/st/en/fo/wfo/blm_information/newsroom/2006/10/burning_man_2006_reaches.html
41. http://www.bp.com/en/global/corporate/sustainability/bp-energy-lab/calculator.html; http://www.theguardian.com/environment/interactive/2010/apr/21/national-carbon-calculator www.nature.org/greenliving/carboncalculator; http://www.epa.gov/climatechange/ghgemissions/ind-calculator.html
42. http://www.nativeenergy.com/household-carbon-calculator.html
43. http://www.coolingman.org/lets_do_it/reduce_your_emissions.html
44. http://www.coolingman.org/learn_more/calculator.cfm; burningman.com/environment/resources/energy.html
45. http://www.coolingman.org
46. Managing Director of Green Man, Burning Man theme in 2007.
47. http://www.blackrocksolar.org/about/who-we-are/
48. http://www.blackrocksolar.org/burning-man/
49. http://www.blackrocksolar.org/news/2010/447solarhighway/
50. http://www.shareable.net/blog/5-burning-man-projects-changing-the-real-world
51. http://www.blackrocksolar.org/news/2013/3-megawatts; http://www.blackrocksolar.org/news/2013/thanks-for-your-support-in-2013
52. http://www.blackrocksolar.org
53. http://www.blackrocksolar.org/news/2011/black-rock-solar-at-burning-man-2011

54. http://www.blackrocksolar.org/news/2011/black-rock-solar-at-burning-man-2011/
55. "The Story of Stuff" (http://www.storyofstuff.org/story-of-bottled-water/story-of-bottled-water-faqs/)
56. BLM Environmental Assessment Burning Man 2012-2016, *supra*, p. 3–6.
57. http://ae-zone.org/category/bm-camping-tips/cooling-methods
58. http://www.burningman.com/preparation/event_survival/water.html
59. http://www.plasticdisclosure.org/about/why-pdp.html
60. http://www.burningman.com/environment/resources/potable_water.html
61. http://www.earthguardians.net/green_burners_plastic.htm
62. BLM Environmental Assessment, Burning Man 2012–2016, *supra*, p. 4-24, Table 4.11-1.
63. BLM Environmental Assessment, Burning Man 2012–2016, *supra*, pp. 4-24, 4-26.
64. http://www.burningman.com/environment/resources/potable_water.html
65. http://www.burningman.com/whatisburningman/about_burningman/principles.html#.Uyca_q1dXlY
66. http://www.burningman.com/environment/statement.html
67. California Single-Family Water Use Efficiency Study (20 July 2011), Aquacraft Water Engineering and Management, William DeOreo, Principal Investigator.
68. http://www.whitehouse.gov/state-of-the-union-2013
69. http://www.guardian.co.uk/world/2013/jun/04/climate-change-america-wildfire-season
70. http://www.nbclosangeles.com/news/local/Drought-California-Drought-Weather-Water-Conservation-250398291.html
71. See Galli et al., 2007; Kitzes et al., 2009 and Wackernagel et al., 2002, p. 36.
72. Living Planet Report 2012, World Wildlife Fund, pp. 36–43, http://awsassets.panda.org/downloads/1_lpr_2012_online_full_size_single_pages_final_120516.pdf
73. http://www.epa.gov/climatechange/science/future.html
74. http://www.coolingman.org/lets_do_it/report_ghg_offsets.cfm
75. http://www.shareable.net/blog/5-burning-man-projects-changing-the-real-world
76. http://www.burnerswithoutborders.org/projects/bwb-sandy-relief
77. http://www.burnerswithoutborders.org/projects/greening-the-beige; http://www.greeningthebeige.org/
78. http://www.burningman.com/whatisburningman/about_burningman/principles.html
79. http://www.burningman.com/whatisburningman/about_burningman/principles.html
80. http://www.geosphere.com/home.htm
81. http://www.eastbeach.org/la_casa.cfm
82. http://www.burningman.com/whatisburningman/about_burningman/principles.html
83. An accurate survey has not been released describing Burning Man's daily population, participants' average expenditures, distances traveled, water consumed, or commodities recycled and/or deposited in landfills.

OCCUPY BLACK ROCK!
THE METAPOLITICS OF BURNING MAN
MARK VAN PROYEN

Common sense, which is the sense of the in-common, is the norm to the
extent that it distributes the critical plurality of opinions in accordance with
the discernment of good and evil. This discernment is the very ground of the
in-common, and is the ultimate condition for thought: the power of thought is
bound to the capacity to distinguish good from evil.... Ultimately, the norm that
regulates the debating of opinions is the transcendental evidence of the good/
evil distinction with respect to the in-common.

Alain Badiou, *Metapolitics* (1998)[1]

Everything moves continuously. Immobility does not exist. Don't be subject
to the influence of out-of-date concepts. Forget hours, seconds and minutes.
Accept instability. Live in time. Be static—with movement!.... Resist the anxious
wish to fix the instantaneous, to kill that which is living.... Stop insisting on
"values" which cannot but break down. Be free. Live. Stop painting time. Stop
evoking movement and gesture. You are movement and gesture. Stop building
cathedrals and pyramids, which are doomed to fall into ruin. Live in the present:
Live once more in Time and by Time—for a wonderful and absolute reality.

Jean Tingley, *For Statics* (1959)[2]

I

As annual journalistic rituals go, the annual *Time Magazine* "Person of the Year" has
been the most enduring barometer of the spirit of the moment of its announcement.
For close to a century, the banner was "Man of the Year," but after Corazon Aquino
and Queen Elizabeth smiled at the world from the front cover of that influential
publication, gender neutrality became the preferred modality. In 1982 "the computer"
received the coveted award, so gender went out the window altogether. But the 2011
award was given to "the protestor," and the representative image was a masked
face of an angry-eyed anonymous person. This image followed a long year of public
demonstrations that started at Cairo's Tafir Square in late January 2011, spread to the
shores of Tripoli and then moved on to Damascus. In September 2011, it arrived in
New York's Zucotti Park, a tiny sliver of public space surrounded on all sides by the
world's most prominent financial institutions. According to the surging multitudes
that participated in what would come to be known as Occupy Wall Street, those
institutions were evil, and needed to be called into account.

It took the major media a full ten days to report the story of the occupation of
that little park, although the story had already been thoroughly distributed via social
media networks. The movement's rhetoric was ingeniously crafted for those modes
of distribution, and usually took the form of declarative slogans. These proclaimed
that the protestors represented the 99 per cent of the American population that
would no longer stand for being fleeced by irresponsible government tax policies,
a lack of regulation of the financial markets and a vast system of political bribes
routinely called "campaign contributions." Conservative commentators squealed
"Class War!" in comic disregard of an OWS placard reminding its readers "they
call it class war when we fight back!" From the OWS point of view, that war had
been ongoing since Ronald Reagan's first term in office. When the major media
did get around to picking up the story, "What do they want?" or "What are their
demands?" were published everywhere, as if the protestors were unintelligible
in their calls for economic justice and political fair play. OWS did not give in to the

"demand for demands" and this is crucially important, because their movement never was, nor is now a conventional exercise in political advocacy. It is much better to describe it as a case of spontaneous socio-cultural upheaval intended to reshape contemporary political priorities into a more ethical form.

In an America where an *uber*-wealthy minority has garnered a proportionally larger piece of the economic pie for decades, one might have anticipated that the protesters would have adopted a more conventional form of utopian rhetoric. But theirs was decidedly pragmatist. They pointed at real problems that could and should be solved in a political practice governed by simple sanity. One sign read, "I don't mind you being rich. I mind you buying my government out from under me." The sign referred to the draconian political atmosphere created when the Supreme Court voted five to four to overturn the McCain/Feingold Campaign Reform Act in the now infamous Citizens United vs Federal Election Commission decision of 2010.[3] The real issue at stake in the Occupy Movement's actions is the control that money exerts over the political process. The movement reveals the plutocratic Achilles heel of neoliberal corporatism's claim that it is more democratic than its chief rivals in model government. I call these rivals "state capitalism" and "theocratic tribalism," and intend them to be non-euphemistic names for what are conventionally called socialism and religion-based social organization.

Because of its distinctly modern emphasis on upholding the prerogatives of individual political actors, neoliberal corporatism is easy to sell as the ideology of choice for free thinkers. But, as history shows, free thinking never stays free for long, because it too has to live in a marketplace of encouragements and discouragements governed by instrumental rationales that are epiphenomenal to the formation and protection of wealth. In other words, those who have the gold set the standards, regardless of any vision of or obligation to social fair play. This insures that instrumental reason will always protect itself from any utopian vision so that in the realms of conventional discourse, we are always given an "intelligentsia" that functions as the public face of bureaucracy and policy. However "oppositional" its posture of hidden loyalty might be, it will nonetheless always end up fleeing from the Socratic mandate that philosophical thinking helps its aspirants to actually live better. From the point of view of the Occupy movement, that mandate desperately needs to be returned to the core of any thinking that seeks to establish anything resembling a political priority.

When I refer to model forms of governmentality, I am not pointing to any operational political entity, any and all of which are circumstantial admixtures of the three models of neo-liberalism, state capitalism and tribal theocracy all achieving legibility much in the same way that tertiary colors do through the mixture of the primary hues of red, yellow and blue. For example, social democracy is really a blend of neo-liberal corporatism and state capitalism. Another example reminds us that there will always be a black market of goods and subversive ideology working in the shadows of any state capitalist system, or for that matter, within any theocratic tribe. Any system configured around any of these three model forms will also contain latent aspects of one or both of the others, arranged into dominant and subordinate formations. These are always in a perpetual state of change and reconsolidation.

They are also always in a state of subtle redefinition, and the factors that shape these redefinitions can sometimes come from surprising vectors. The Occupy Wall Street movement is one such example, surprising in that it refuses to operate according to the rules of normative political advocacy. Whereas the extremely conservative Tea Party rallies held during the previous year were examples of a durable tradition of anti-government American populism, the OWS movement is representative of an equally durable anti-bank populism that has a long-standing place in American history reaching back to early colonial laws against debtors'

prisons. Even though the two groups blamed different entities for the economic misery that swept the land after the 2008 financial crisis, there is an important difference: in an act of support for the second amendment, Tea Party activists often brought guns to their rallies. The only firearms seen at Occupy Wall Street (and its more contentious sister event, Occupy Oakland) were in the hands of over-zealous law enforcement officers.

Occupy Wall Street events are significantly more complicated animals than their Tea Party predecessors. The movement has gone far out of its way not to be co-opted by the mass media or any collection of candidates for public office. Conversely, the Tea Party groups were all too happy to be ventriloquized by Rupert Murdoch's Fox News affiliates. OWS had a justifiable concern that any such affiliation would inevitably lead to the seven stages of political futility: cooptation, division, dilution, pacification, neutralization, disappointment and betrayal. Because of these concerns, what one sees coming out of the Occupy movement is not an exercise of politics defined by the normal terms and conditions of any conventional political science. Rather, it operates as an example of what Alain Badiou has called a Metapolitics, that is, a strategic restaging of the ethical grounds by which political matters are imagined, understood, debated and acted upon. According to Badiou, Metapolitics is a form of "Resistance by Logic." [4]

No group, no class, no social configuration or mental objective was behind the Resistance... there was nothing in the course of this sequence which could have been described in terms of objective groups, be they 'workers' or 'philosophers'.... Let us say that this resistance, proceeding by logic, is not an opinion. Rather, it is a logical rupture with dominant and circulating opinions.... For the contemporary philosophical situation is one where, on the ruins on the doctrine of classes and class consciousness, attempts are made on all sides to restore the primacy of morality.[5]

It is particularly interesting to look at Badiou's metapolitical thesis in light of his larger project to transform the most basic grounds of philosophical inquiry so as to place greater emphasis on ethics. He is well known for proposing a change in the basic categories of philosophy (metaphysics, ethics, logic and epistemology), seeking to restage them as the interdependent "truth procedures" of "art, love, politics and science."[6] His metapolitical restaging of the truth procedure of political science can be understood to be of a piece with his postulation of an ethical "inaesthetics." This seeks to deny the meditative subject/object relationship of contemplation with something suffused with "immanence and singularity," leading to a "transfiguration of the given." The Occupy Wall Street movement has followed suit on this score, fashioning itself as an immanent and singular metapolitical gesture that has embraced a unique resistance by logic that was and still is a vigorous disruption of logic. It has accomplished this by staging a theatrical moment that calls attention to the withering state of the commons, that being the place of democratic co-existence and rational debate where all citizens can freely enter and exist regardless of their inability to rent media time.

And let there be no mistake: in the second decade of the twenty-first century, social media has become the new commons, needing only a shared event to galvanize its attention to the point of putting a wide-ranging discourse about political priorities into play on a vast and unregulated scale. Occupy Wall Street is one such event, one whose time has clearly come. But the model for this kind of actual/virtual exercise in reformulating a common space into a rhetorical congregation had been established two decades earlier in a very different public location that also galvanized a vast virtual community. It too was a brilliantly conceived exercise in a metapolitical "resistance by logic." That space was and still is the vast Black Rock Desert, a dry lakebed in northwestern Nevada that is administered by the Federal Bureau of Land Management. The event was and still is Burning Man.

Since the early beginnings of the Internet, many observers have postulated that there was revolutionary potential in its ability to widely and instantaneously distribute unmediated information. Some have proclaimed it to be the new commons, this in recognition of how the forces of neoliberal corporatism have turned the old commons into shopping malls of various kinds, those being places where the subtle doctrine of "pay to play" began to slowly displace all other opportunities for political participation. Burning Man was the first major instance of an organized recognition of this new communal possibility of the digital revolution, and the first to act upon it at any meaningful scale. It did so by "occupying" a piece of public land in a wilderness area, and then configuring itself as a kind of free city where monetary exchange and corporate advertising would not be allowed. Participation, collaboration and self-reliance were upheld as paramount civic virtues, and art was defined and welcomed as the product of any "radical free expression" that any person could devise, regardless of any lack of previous experience or education.

When web-browsing software first became available in 1994, Burning Man was already nine years old, and had already been using email networks and virtual bulletin boards to distribute its messages to a growing audience. The emergence of such communications technologies were a natural fit for the event, and even to this day, it has never paid for any advertising beyond the printing and mailing of its own promotional materials. That was the same year that the mass media initially came out to report on the event. The following year, the population doubled, making it clear that a tax on participants was needed to cover necessary costs for staging the event on a much larger sale. Admission tickets were sold, and federal rules were re-written so that the federal Bureau of Land Management could charge the organizers of Burning Man a hefty fee to use the space. Soon after that, much more money was spent in legal fees to support litigation that should have never have come to any court's attention, if constitutional guarantees of rights to free assembly and self-expression were deemed worthy of any respect. But they weren't, because it was difficult to convince certain political operators that the self-expressive thing that had engendered Burning Man's free assembly of pilgrims had anything to do with art. From their point of view, what was happening at an increasingly large scale every year in the Black Rock Desert on Labor Day weekend was much more frightening, in that its almost complete lack of artistic supervision portended something akin to a mass participation Satanic ritual.[7] It also threatened to unmask the lie that art had become.

II

From the perspective of an art world populated by museum curators, globe trotting art collectors and the toney gallerists working the crowds at international art fairs, Burning Man represents a kind of Special Olympics for Art. To give credence to this view, all any nay-sayer would have to do is attend the event and take in its many starry-eyed unicorns and countless geodesic domes built in service to obscure comic-book deities fashioned from disfigured mannequins. If our nay-sayer were guided by courage and in search of additional evidence to support her initial observation, the next logical destination would be the large indoor exhibition space called the Café, which is usually decorated by the work of a great many amateur photographers and collage artists working on heavy doses of misinformed spiritual pretense and undeserved self-esteem. And yet, as revealing as the Café environment might be, it still pales in comparison to the best place to witness Burning Man's culture of unfettered creativity, that being the array of unmapped theme camps located away from the Esplanade that separates the event's semi-circular camping area from the mile-wide no-camping zone at its core. Here, one is liable to find a vast assortment of incomprehensible do-it-yourself efforts at representational makeshiftery, often times manifested in things that

look more like distorted family entertainments than the objects of any conventional art history. Looking like the mutant offspring of a theme park and a slum conceived in the prop closet of George and Mike Kuchar's Studio 8 Production Company,[8] these provisional amalgamations of such materials such as fluorescent fabric and solar powered lava lamps oftentimes seem to allegoricize the traumas and contradictions of a consumer culture blindly addicted to the debt-driven circulation of pseudo-goods and non-services; all saying something troublingly oblique about an America that is amusing itself to death in the age of Walmart. The real value of Burning Man lies in how it reverses this model. It does so by simply allowing its participants to amuse themselves back to life through their participation in a week of collective catharsis.

Fortunately for our dyspeptic pilgrim, the artistic offerings of Burning Man get bathed in a seemingly endless sea of electro-luminescent blinky lights when nightfall arrives, and her attention will then most likely be diverted by an omnipresent soundscape of pulsating techno music punctuated by the explosive flashings of propane fireballs surging into the sky. To this, add the lumbering peregrinations of large, slow moving vehicles that appear as grotesque carnival rides taken from a Dada-themed amusement park, and the picture of a vastly absurd semiotic entity comes close to completion, a relational esthetics *gesamtkunskwerk*[9] that is metaphorically and geographically located at the exact half-way point between San Francisco's Mission District and Robert Smithson's Spiral Jetty protruding from the north shore of the Great Salt Lake. It is equal parts game space and refugee camp, and as such, it presents itself as a gargantuan omni-participatory rejoinder to the regulation of subjectivity embedded in the cognitive illusions bred by normative market-defined existence. And for this reason, the ensemble experience of participating in Burning Man provides a much-needed transfiguration of everyday assumptions about what passes for cultural nourishment. Its chief lesson lies in the way that it demonstrates how well a do-it-yourself social economy can work if and when it reframes itself in the terms of a do-it-with-others ethos, and this represents a profound political revelation as well as its chief metapolitical legacy to be later taken up by the Occupy Wall Street movement.

Rather than calling this vast entity by its proper name of Black Rock City, lets give it a more descriptive moniker: the living model of an alternative version of contemporary culture based on advancing an ethical glocalism as the highest of priorities. And then let us note that, in theatrically performing itself as such a model, it also forms itself into a fun house mirror reflection of the absurdities of twenty-first century existence, all-the-while organizing itself as a temporary corrective for many of that century's social and political shortcomings, especially those pointed toward systematically excluding people from social participation for no good reason. At Burning Man, the stranger is always welcome, and there are always opportunities for any given participant to do things that she never imagined herself to be doing. And in so doing, she oftentimes learns a great deal about the roles that she plays in her everyday life, in turn allowing her to imagine and act upon other roles that might lead her to a better world, at least for herself and maybe for others.

Yes, Burning Man does feature a great deal of so-called "New Age" art made by people who might best be called hippies, and yes, almost all of that art is at best a guileless exercise in naïve cluelessness that is scripted not so much by any "radical free expression" as it is by the simplistic recirculation of pop cultural cliché. At worst, it is something on a par with toenail fungus, but even that can be strangely entertaining when contrasted with the vastness of the desert. Indeed, accounting for maybe two- or three-dozen notable exceptions during the past decade, we would have to concede that almost all of the art at Burning Man is as bad as its detractors say that it is. But in admitting this fact, another obvious question comes to the fore: in the great scheme of things, how important is it whether any of it is bad or good?

And following from this, another obvious set of questions: who or what are the entities that are empowered to decide on any such differentiation? What values do they represent? What is masked by the authoritative proclamation of said values? And again: why does any of it matter?

Turnabout being fair play, it now becomes obligatory to imagine what an everyburner might make of the current world of contemporary art, resplendent as it is when ensconced within opulent museum architecture and festooned with price tags that are the monetary equivalent of real estate when it is not. It is undeniable that those environments are the sites of a kind of authoritative coldness designed to intimidate the viewer into a kind of passive submission to the historical authority of those things that are beheld within them. It is also undeniable that the large majority of those snobjects contain very little that conveys the kind of truthful generosity that might reward the attention of the serious viewer who is not party to the vested interests that have been influence-peddled into the visible existence of their environment's adoration. And so, our everyburner would no doubt ask: given the sorry state of the world, why all the fuss?

Presumably, money is part of the equation, although it is difficult for the uninitiated to see exactly how it plays out through the elaborate web of private, corporate and public support that buoy any given museum's orchestration of the importance effect. As Paul Werner succinctly put it in 2005: "The illusion that art museums could be run for profit like everything else was derived from the notion museums themselves had worked so hard to foster: that art and capital were all one and circulated in the same manner."[10] Werner goes on to quote former Metropolitan Museum director Phillipe de Montebello's statement that "It is the judicious exercise of the museum's authority that makes possible the state of pure reverie that an unencumbered esthetic experience can inspire,"[11] and then goes on to state that "by the same logic, the absence of 'a state of reverie' interferes with 'the judicious exercise of authority.'" Werner drives this point home when he writes "What Brecht wrote of the Nazis then now applies to cultural apparatus of the twenty-first century: they want to turn the People into an audience. Same policy, different means."[12] Once again, we are reminded of the truism stating that propaganda works best when those who are being manipulated believe that they are acting on their own free will.

How you might ask, and the answer is obvious: in the way of the translation of a certain class of objects—let's call them symbolic commodities—into a certain class of equities. It is easy to suppose that said equity is simply gained from the fortuitous position that any given investor might take amid the normal value/worth fluctuation of the commodity in question. But works of art are not commodities in same way as are barrels of crude oil or tons of copper, nor is it a form of reserve currency as are ounces of gold or silver. The commodity value of a given work of art is instead a function of its status as a reliquary representation of its own myth status, and that is something that continues to be manufactured long after said work of art leaves the studio of the artist who created it. Ultimately, it is the museum that confirms the mythic status of the objects that it chooses to display and collect, creating a fortuitous feedback loop that points to how the world of contemporary art has been transformed into a rather perverse epiphenomena of the financial services industry.

Here is how the normative art economy actually works. Artist *a* makes a work of art *b* and shows it at the gallery of dealer *c,* who gets it written about by critic *d* and then sells it to collector *e* for *f* amount of money. Collector *e* hangs on to artwork while the reputation of artist *a* rises by way others repeating the same machinations described in the aforementioned equation, and then, at a fortuitous moment, she either sells said artwork for profit *f+x,* or more normally donates said artwork to museum *g,* for which she receives donor recognition *h,* which represents the fair

market value that museum g places on artwork b. Because the work has been accepted into museum g's collection, its fair market value automatically rises, so that donor recognition h is actually worth much more that the original purchase price f of work of art b. And it is donor recognition h that collector e sends to the tax collector as a claim for a tax deductable charitable contribution that reduces collector e's overall tax burden by a significant sum of money (yes, the federal government does support the arts!). The value added portion of this equation lies in how much greater a sum of money donor recognition h represents in relation to original cost of artwork b, and in many cases that sum is ten or 20 or 100 times the original investment. Thus the economy of art is laid bare, and it can rightfully be called a speculative marketplace in objects that might represent a significantly enhanced tax-deductability that can be exercised at some future juncture, all assuming that museum g is interested in acquiring work of art b at any point in time. This means that work of art b has to fit in with what museum g considers to be a worthwhile esthetic experience, based in part on its own vested interest in perpetuating its ability to exercise such consideration. Werner gets that particular point right when he states that "if the Guggenheim, or any other museum, had actually covered its expenses through admissions, that would have harmed its true function: The manufacture of exclusiveness."[13]

But, even though money is a major part of the equation, it by no means is all of it. It is worth noting that Werner's remarks about the museum world point to a specific historical moment, and that moment was defined by the aftermath of the politically motivated reformulation of the National Endowment for the Arts that took place between 1989 and 1994. After that reformulation (which effectively ended government support for the arts in the United States), both the world of the museum and the larger world of contemporary art were momentarily recast as perverse sub-functions of the entertainment industry, with a reigning style called "Pop Surrealism"[14] coming to the fore as the stylistic marker for the art of that brief and bygone moment, and indeed, a perfectly useful and legitimate term that could accurately describe much of the art that one might find at any given iteration of Burning Man. In fact, it is a far more accurate term than the more common ascription pointing to it as new form of "outsider art." This is so because at that particular moment, there was a major lack of clarity about what was inside or outside of anything other than what financially motivated turnstiles might keep in a state of separation, and in the wake of the cessation of government funding, an increase in audience size became an necessary institutional mandate. Thus, we had an art style that "took its inspiration from popular culture," meaning that it was trying and failing to be popular culture, rather than the kind of critical comment on it that we saw with 1960s Pop Art.

Part-and-parcel with the 1990s embrace of Pop Surrealism as an audience development strategy was another related trend called Postart spectacle, which transformed whole museums into elaborately staged pseudo-operas of the type made famous by Matthew Barney, Paul McCarthy and Martin Kippenberger—artists who all infused Pop Surrealist esthetics with the theme park ambience of an arena rock concert. Finally, it is worth noting that the rhetorical pendent that was hung around the neck of this esthetic shift toward popular entertainment was something called "art writing." It did not come from the traditional world of art historically trained art critics, but instead issued from a new hybrid discourse that proclaimed itself to be something called "visual studies," which in many cases was little more than culturally sensitive entertainment reporting—"celebrity porn journalism" to use a deservedly uncharitable term. Its most characteristic feature was a shameless willingness to be used as a tool for institutional audience development.

Nonetheless, in the art world, all of this was brief and transitional, because the focus would again shift in dramatic form after the 9/11 terrorist attacks, making Pop Surrealism suddenly look very anachronistic. Very soon thereafter, Globalism

became the new buzzword for a suddenly robust emphasis on a transnational art hailing from under-recognized parts of the world. Presumably, Globalism represented an impetus toward encouraging the embrace of art as an instrument of national liberation, or failing that particular pretense, as a focal point for the kind of cultural lubrication that might politically facilitate desirable access to the labor, natural resources and markets of the developing economies so dearly prized by neoliberal corporatism. It might also represent a politically motivated usage of art as an instrument of pacification, that is, as an administrative technology for deflecting the potential for actual conflict into the containable realm of symbolic conflict.

The visible shape that this newly globalized art took on was not manifested in any particular form of artistic cultural production, but instead, was revealed as a relatively new form of cultural presentation called the Mega-Exhibition. These were exemplified by such time-honored extravaganzi as Documenta and the Venice Biennial, but also by a metastasizing host of newer entries into the global mega-exhibition fray, held in such cities as Istanbul and Taipei. These are giant affairs that operate under the guidance of an elite class of internationally renowned curatorial directors, and in addition to operating as certification mechanisms for the investability of the art contained by them, they also function as major engines of cultural tourism and transnational ideological propaganda that have been used to enrich the coffers of their host cities. It is also worth thinking about how other imperatives might be in play. As Okwui Enwezor has written, globalism embodies a new vision of global totality and a concept of modernity that dissolves the old paradigm of the nation-state and the ideology of the 'center,' each giving way to a dispersed regime of rules based on networks, circuits, flows, interconnection. Those rhizomatic movements are said to operate on the logic of horizontality, whose disciplinary, spatial, and temporal orders enable the mobility of knowledge, information, culture, capital, and exchange, and are no longer based on domination and control.... Globalism was part of the maturation of a certain kind of liberal ideal, which in its combination of democratic regimes of governance and free market capitalism was prematurely announced as the end of history.[15]

These attributes are all pointed at the imagination of "a truly unified world system whereby all systems of modern rationalism would finally be properly fused."[16] Of course, the inquiring mind will ask, to what end? And more importantly, to whose end? Of course, answers to these questions are never made clear, perhaps because they cannot be made clear. But it is worth pointing out that the impetus toward the aforementioned fusion is a very different thing than the impetus toward cultural diversity, and it is also interesting to note that among the many topics of cultural identity that have surfaced during the heyday of the global mega-exhibition, the debt obligations of post-colonial nation states is one that almost never comes up. That is because the thing instigating and benefiting from the aforementioned fusion is a global, trans-national banking system that has learned how to use both art and nation states as tools for its own purposes. That much said, we can go on to productively note Burning Man is also a mega-exhibition, but in many ways it is also an anti-mega-exhibition, especially in the ways that it prefigured, mirrored and satirized the "the rhizomatic logics of horizontality, interconnection and dispersal" that have become de rigueur themes in twenty-first century art.

III

For all of Burning Man's claims of being a place apart from the default world that it pretends to leave behind, it nonetheless does seem that the event sustains an oblique relationship to that world. During the technologically addled 1990s, Burning

Man seemed to be prophetically far ahead of the cultural environment surrounding it. The chief reason for this was its far-reaching imagination of the ways that new technology could recast how social relations might be reconfigured in critical relation to what Naomi Klein would later call "Disaster Capitalism."[17] In those days, the presiding spirit of Burning Man was not any getting back to the mythical garden that so captured the imagination of the Woodstock generation so much as it was a celebration of various kinds of real and imagined love taking place amongst the post-apocalyptic ruins of rampant military adventurism and financial and ecological unsustainability. But in 2001, the specter of real apocalypse became traumatically evident when the 9/11 terrorist attacks ushered in an unfunded war wedded to the draconian trappings of the National Security State. Suddenly, the world caught up with Burning Man's parsing of the utopian and dystopian themes of technologically-assisted social capitalism, making them seem redundantly similar to the mass media narratives about a brave new cyber-economy as well as the emergence of other forms of Postart spectacle that had come into prominence in the art world.

The fact that Burning Man had become the putative darling of a kind of trivializing mass-media condescension did not help, and over time the event become more-and-more indistinguishable from the "wild and crazy" caricatures that were heaped upon it. By 2007, the event had clearly become a victim of its own clichés of flagrant silliness, mired in a repetitive cycle of nostalgia for the exuberant 1990s. Soon after that, the world would pass it by, because in 2008, the story would take another turn, a downturn to be exact. The financial crisis that exploded in October of that year once again recalibrated the larger terrain of cultural understanding, and the urgency of that moment began to make Burning Man look every bit as indulgent and frivolous as it did the institutional art world. Soon thereafter, a new concern for the politics of social justice had come into the foreground, eclipsing the themes of alternative identity and self-sustaining community-of-desire that were such prominent features of the event during its 1990s heyday. It was time to pass the metapolitical torch of the do-it-with-others ethos so that a very different fire might be lit with the aid of a few well-placed Falstaffian pitchforks.

Returning to Badiou, we read that the ethical understanding of justice is something quite specific. It is based on the following injunction: "to examine political statements and their proscriptions, and draw from them their egalitarian kernel of universal signification."[18] If Burning Man has done nothing else, it has certainly created an Archimedean ground from which such an examination might proceed, much more successfully than anything that happened in the institutional art world during the same time period. Following from this recognition, we might then ask how the metapolitical kernel of Burning Man was passed to Zucotti Park, as if, in an age of social media, the assertion and exertion of any influence on anything can somehow be supposed to not be operable until proven otherwise. We know that one of the key instigators of the OWS movement was Micah White, the Berkeley-based co-editor of the Vancouver-based journal *Adbusters*, therefore a Bay Area connection is easily made, although it is not clear if White was in any way influenced by Burning Man. Because there is a very large contingent of Burning Man participants that hail from New York City, one could easily suppose that their experience of the event might have had something to do with the encampment at Zucotti, especially since Occupy Wall Street initially took place just ten days after the conclusion of the 2011 Burning Man event.

But there is one important kernel of indisputable influence that clearly stands out, and that is Bill Talen, who is better known in his performance guise of Reverend Billy of the Church of Stop Shopping, a New York-based performance group that has extensively toured the United States and is the subject of two widely circulated documentary films. What makes Talen's performances so timely for this discussion is his evocation of the tropes of a theocratic tribalism that are severed from the

politics of hate and fear, all enacted in service to the kind of communitarianism and pleas for justice that earmarked the earliest Christian communities of the second century. Obviously, those same values are in short supply among so-called evangelical churches populated by legions of CINOs (Christians-in-Name-Only), reminding us of how deeply perverted the gospel message has become in twenty-first century America. The fact that the more organized churches proclaiming allegiance to the gospels have been outdone on this score by a performance artist should be cause for concern, outrage and cruel mockery.

Starting in 2002, the 30-member band and gospel choir of the Church of Stop Shopping has regularly performed at Burning Man, putting on a rousing revival show that is a stunningly convincing mimic of similar services consecrated to "the old time religion" *a la* Elmer Gantry, only at Burning Man, it was comically staged under the shadow of an 40-foot-tall effigy that echos the real old old old time religion of Neolithic cult worship. At the forefront of the Church's performance is Talen's character named Reverend Billy, who preaches in passionate, Elvis Presley-inflected voice about the evils of consumerism and the tragic human cost of debt-driven consumption, backed up by a gospel chorus and small orchestra featuring a church organ. The chorus sings songs about the virtues of an economic democracy that is described as a promised land, and the mood is always persuasively festive, even joyous.

Talen's passionate and eloquent sermons come across like rhapsodic poems made from the many fragments of Occupy Wall Street signage, and in fact, Talen did perform (*sans* choir) at the 17 September 2011 beginning of OWS, just a few days after returning to New York from Burning Man. Subsequently, he performed with the choir at Zucotti Park on several other days, to audiences that grew ever larger during the month of October. These were rousing and inspirational shows that galvanized the attention of ever-growing crowds in a way that gave them a coherent group identity, meaning that, for a few brief moments, the Occupy protesters found themselves attending a church of their own politically inclusive revelation, which allowed them to see themselves as being a part of something much larger than themselves. As always, Talen's performances were a brilliant obversion of the pernicious role that religion has come to play in American politics, where so-called "values" candidates have been using church affiliation for decades as the preferred excuse for supporting candidates and policies that embody the hateful opposite of Christian morality. Such ethically duplicitous rhetoric also has a metapolitical name, and that name is Neoconservatism when practiced by Americans who identify with Judeo-Christian tradition, and fundamentalism when practiced by others. Either way, the word "fundamental" applies in all of its many nuances, especially the one that highlights its definitional opposition to enlightened sophistication. Essentially, Neoconservatism is a subtle theologicization of the neoliberal doctrine that defines the subject along the secular lines of economic self-interest, but it deviates from that doctrine in that it assumes that self-serving moral edicts are required when the economic interests of cultural Others begins to gain too quickly in relation to the economic self-interest of the culturally entitled.

Talen's Reverend Billy performances are so entertaining and well executed that it is easy to miss the seriousness of the metapolitical critique embodied in them. Certainly, they provide a thoughtful and dramatic critique of the empathy deficit disorder that is bred by neoliberal corporatism, and they command and entice their audiences to insist on ethical correctives. As for the relation of his work to his experience of Burning Man, Talen himself has a clear vision of the similarity between Burning Man and the OWS movement. He writes:

Burning Man and Occupy Wall Street share this: we discovered that living together is a performance with long-range power. How we live—people

watch and learn. Then they live back at us and we change too. We experience the decisions of how to live as drama, and (we found out) as protest—more than traditional theater which rarely has electrical charge these days. For years we were the butt of journalist jokes, calling us refried 60s protesters— angry people carrying signs and chanting. All that was wiped away by the glorious arrival of Occupy, which was the simple notion of living together in public, in a park under the scrapers of Wall. Sharing food, stories, making media, figuring out laws, discussing health, feeding each other—LIVING TOGETHER is the devastating protest form of our day. Burning Man's fascination—you see it around the world—flows from living together under arid desert conditions for a week. BM also chucks the conventional stage and finds a new charged theater in sashaying in outrageous costumes and nakedness in front of 50,000 people who are doing the same thing back at you. Burning Man is great theater—leaves Broadway in its playa dust. And Wall Street guys are there too—wearing fluorescent underwear while they check out a 100-foot-long chandelier. How change comes to the world from these two forms of theatrical living— stay tuned! It has begun.[19]

To this, I can only say Amen.

NOTES

1. Badiou, Alain, *Metapolitics,* Jason Barker trans., London: Verso Books, 2005, p. 19.
2. Tingley, Jean, "On Statics," (text from a leaflet dropped near Dusseldorf in 1959. Recorded in *The Diary of Anaïs Nin,* Volume VI, edited by Gunther Stuhlman, New York: Harcourt, Brace and Jovanovich, 1966, p. 284.)
3. See Adam Schiff, "The Supreme Court Still Thinks That Coroporations Are People," (July 18, 2012) *The Atlantic Monthly*; http://www.theatlantic.com/politics/archive/2012/07/the-supreme-court-still-thinks-corporations-are-people/259995/court-still-thinks-corporations-are-people/259995/
4. Badiou, *Metapolitics,* p. 5.
5. Badiou, *Metapolitics,* pp. 5–6.
6. For a synopsis of Badiou's key claims, see his "Manifesto for Philosophy," translated by Norman Maderaz, State University of New York Press, 1999. Further references to Baudiou's ideas are extracted from this source, unless otherwise cited.
7. Claims of Burning Man being a socially dangerous satanic ritual were made on the 18 May 1998 broadcast of Pat Robertson's *700 Club* program on the Christian Broadcast Network.
8. George Kuchar (1942–2011) and Mike Kuchar (b.1942) were San Francisco-based underground filmmakers whose low budget works used and misused exaggerated gender clichés to satirize the most preposterous aspects of conventional "sinematic" exposition. George Kuchar's most well known film was titled *Hold Me While I'm Naked,* 1966, while Mike Kuchar is best known for his 1966 film titled *Sins of the Fleshapoids.* In 1997, they collaborated on a book of comic reminiscences titled *Reflections from a Cinematic Cesspool* (San Francisco: Zanja Press). Here we might note a persistent albeit unconfirmed rumor that San Francisco's long-running stage play titled *Beach Blanket Babylon* was originally indebted in some way to the George Kuchar aesthetic. In Jennifer Kroot's 2009 documentary film titled *It Came From Kuchar,* it was revealed that Bill Griffith's comic character named Zippy the Pinhead was modeled on George Kuchar.
9. *Gesamtkunskwerk* literally means "total work of art." It was coined by Richard Wagner to describe his view opera production as a synthesis of all of the arts. See his *The Artwork of the Future* (1849, translated by William Ashton Ellis) at: http://users.belgacom.net/wagnerlibrary/prose/wagartfut.htm. "Relational Aesthetics" was a term originally coined by Nicholas Bourriard in 1986 as a way of calling attention to certain artistic practices that were/are less concerned about the creation of a final product than they are about the social processes of inclusion and participation leading up to it. Bourriaud defined the approach simply as "a set of artistic practices which take as their theoretical and practical point of departure the whole of human relations and their social context, rather than an independent and private space." (p. 113). See Bourriard, Nicholas. *Relational Esthetics,* Dijon, France: Les Presses du Reel, 2002. For a critique of Bourriard's thesis, see Bishop, Claire, "Antagonism and Relational Aesthetics," *October* 110, Fall 2004. Bishop points out that "The curators promoting this 'laboratory' paradigm—including Maria Lind, Hans Ulrich Obrist, Barbara van der Linden, Hou Hanru, and Nicolas Bourriaud—have to a large extent been encouraged to adopt this curatorial modus operandi as a direct reaction to the type of art produced in the 1990s: work that is open-ended, interactive, and resistant to closure, often appearing to be 'work-in-progress' rather than a completed object. Such work seems to derive from a creative misreading of poststructuralist theory: rather than the interpretations of a work of art being open to continual reassessment, the work of art itself is argued to be in perpetual flux. There are many problems with this idea, not least of which is the difficulty of discerning a work whose identity is willfully unstable. Another problem is the ease with which the 'laboratory' becomes marketable as a space of leisure and entertainment. Venues such as the Baltic in Gateshead, the Kunstverein Munich, and the Palais de Tokyo (in Paris) have used metaphors like 'laboratory,' 'construction site,' and 'art factory' to differentiate themselves from bureaucracy-encumbered collection-based museums; their dedicated project spaces create a buzz of creativity and the aura of being at the vanguard of contemporary production. One could argue that in this context, project-based

works-in-progress and artists-in-residence begin to dovetail with an 'experience economy,' the marketing strategy that seeks to replace goods and services with scripted and staged personal experiences. Yet, what the viewer is supposed to garner from such an 'experience' of creativity, which is essentially institutionalized studio activity, is often unclear." (p. 52) Bishop goes on to quote Bourriard: "It seems more pressing to invent possible relations with our neighbors in the present than to bet on happier tomorrows" (p. 54; *Relational Esthetics*, p. 45), Then she adds "This DIY, microtopian ethos is what Bourriaud perceives to be the core political significance of relational aesthetics." (p. 54). It is worth noting that there has never been much difference between Bourriard's assertion of "Relational Aesthetics" art practices and Allan Kaprow's much older advocacy of Happenings, the first principle of which being "the line between the Happenings and daily life should be kept as fluid as possible," so that "the reciprocation between the handmade and the ready-made will be at its maximum power." (Allan Kaprow, "The Happenings are Dead: Long Live the Happenings!," *The Blurring of Art and Life: The Collected Writings of Allan Kaprow*, Jeff Kelly ed., Berkeley: University of California Press, 1996, p. 62). The key point lies in how both Relational Esthetics and the earlier Happenings resurrect the tenants of Lukasian social realism by substituting real-time face-to-face encounters for the older tropes of representing and/or narrating ideas of "class consciousness." More recently, similar activities have again rebranded themselves as "Social Practice Art," as a way of emphasizing more specific political ambitions. See Thompson, Nato, *Living as Form: Socially Engaged Art from 1991 to 2011*, Cambridge, MA: MIT Press, 2012. But even here, the obvious equation of institutionally supported "social practice art" with inefficacious postures of mild political concern (scented with the bad faith of loyal opposition) are never directly addressed. An important early instance of a Relational Aesthetics artwork was San Francisco-based artist Tom Marioni's *Drinking Beer with Friends is the Highest Form of Art*, a weekly relational aesthetics performance that has been ongoing since the mid-1970s. Clearly, San Francisco-based Burning Man is far and away the largest and most complex example. Neither was mentioned in Bourriard's famous book.
10. Werner, Paul, *Museums, Inc.*, Chicago: Prickly Paradigm Press, 2005, p. 9.
11. Werner, *Museums, Inc.*, p. 15.
12. Werner, *Museums, Inc.*, p. 58.
13. Werner, *Museums, Inc.*, p. 41.
14. Pop Surrealism was the name of a 1998 exhibition organized by Richard Klein, Ingrid Schaffner and Dominique Nahas held at the Aldrich Museum in Ridgefield Connecticut. It contained the work of artists such as Peter Saul, Mike Kelly, Paul McCarthy, Lisa Yuskavage, Ed "Big Daddy" Roth, John Currin and Robt. Williams, and could be said to have reprised and expanded upon an earlier exhibition titled Helter Skelter that was organized in 1992 by Paul Schimmel at the Museum of Contemporary Art in Los Angeles. The monthly publication *Juxtapose* (founded by Williams in 1994) has done much to promote many of the artists associated with the Pop Surrealism movement, but the publication's claim that the movement originated in southern California is erroneous. The real historical sources of the Pop Surrealism movement is found in the earlier work of Bay Area-based artists such as Peter Saul and George Kuchar, as well as the underground comics movement that was based in the same area during the middle

1960s. Chicago artists of the early 1970s such as Jim Nutt, Gladys Nielson and Karl Wirsum were also important early influences. The most important aspect of the Pop Surrealism movement lied in its embrace of a populist turn in art that was responsive to circumstances related to the political controversies surrounding government funding for the arts. In 1998, the National Endowment for the Arts published the findings of a multi-year research project that concluded that the arts were widely perceived to be irrelevant and elitist. The project was called American Canvas. See Larson, Gary O., *American Canvas: An Arts Legacy for Our Communities*, Washing ton D.C.: US Government Printing Office, 1998.
15. Enwezor, Okwui, "Mega-Exhibitions and the Antinomies of a Transnational Global Form," *Other Cities, Other Worlds: Urban Imaginaries in Globalizing Art*, Andreas Huyssen ed., Duke University Press, 2008, pp. 148–149.
16. Okwui, "Mega-Exhibitions and the Antinomies of a Transnational Global Form," p. 149. In an anonymous introductory remark made in the online journal Italian Greyhound, we read that "Enwezor uses as an illustration of the serious and thoughtfully considered nature of righteous internationalists in fomenting new representations in academic programs and curated collections by pointing to a think tank he participated in 1997 in Italy whose members came from Brazil, Turkey, Cuba, Australia, South Africa, and Thailand, amid other countries. These panelists endeavored to recode the complex dialectics between globalization and the long process of modernization towards market basked-economies on the course of which much of the developing world was set since the early days of decolonization. Enwezor reports that this group drew and reached no conclusions other than to continue meeting at subsequent retreats and biennale exhibitions." The same anonymous interlocutor also summarizes a response formulated by art critic George Baker to Enwezor's essay that takes exception to its optimistic assessment of the equalizing nature of enormous international art fairs, arguing that "the only valid definition of globalization is one that must include an acknowledgement of the invasiveness of multinational corporations." Baker defiantly asks "who and where is the audience for mega-exhibitions?" echoing Enwezor's use of the words "spectatorship" and "spectacle." The roving biennale, Baker says, "creates a traveling fair for global elites, excluding both artists and the local populations where such exhibits take place." Baker dismisses Enwezor's Trauma and Nation model concepts, claiming instead that "shows such as Documenta existed for years merely as a forum for exported American art and views of art." Baker further argues "mega-exhibits are in fact created, like the Olympics, with the intent of defining, promulgating, and delineating American culture." Baker asks "why it is that biennials," (which are, he says, "essentially the same showcasing of many of the same works repeated in different time zones") "are the new model for counter-hegemonic spectatorship?" (See the summary provided at: athttp://italiangreyhounds.org/errata/2007/06/13/"mega-exhibitions-and-the-antimonies-of-a-transnational-global-form"-by-okwui-enwezor-vs-"the-globalization-of-the-false-a-response-to-okwui-enwezor"-by-george-baker/)
17. See Klein, Naomi, *The Shock Doctrine: The Rise of Disaster Capitalism*, New York: Henry Holt &Co., 2007.
18. Badiou, *Metapolitics*, p. 17.
19. Bill Talen, email correspondence with the author, 7 April 2012.

MARK VAN PROYEN

SLOW BURN
BARBARA TRAUB

Monolith, 2012

BARBARA TRAUB

Playa Play, 2000

Greeter Station, 1997

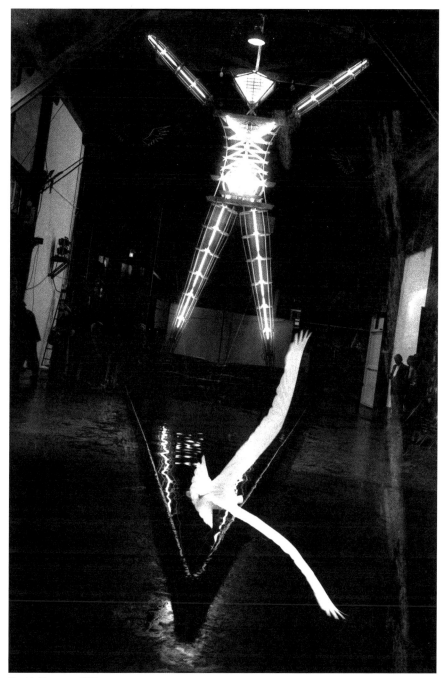

Double Expusure, 1995

BARBARA TRAUB

Guiding Light, 1999

BARBARA TRAUB

Ravishing Raven, 2000

Desert Rat, 1997

BARBARA TRAUB

Dust Cloud, 1996

Tableau Vivant, 1994

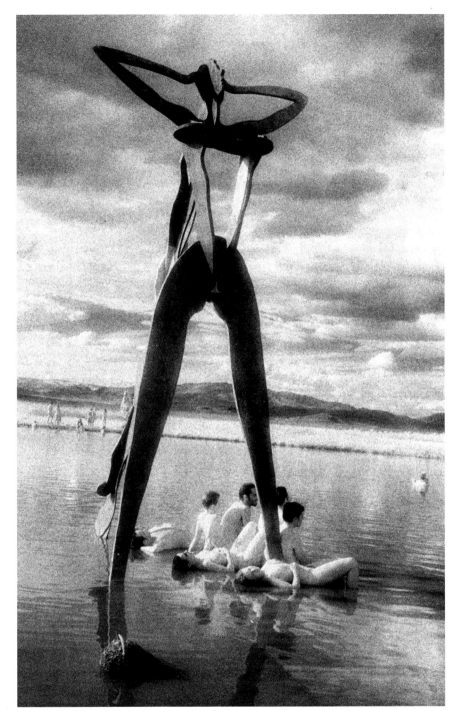

Water Woman, 1997

BARBARA TRAUB

LIST OF CONTRIBUTORS

Rachel Bowditch MA/PhD, is a theatre director, performance studies scholar, and an associate professor in the School of Film, Dance, and Theater at Arizona State University. She has been attending and studying the phenomenon of Burning Man since 2001. She wrote *On the Edge of Utopia: Performance and Ritual at Burning Man* (Seagull Books/ University of Chicago Press, 2010) and her second book *Festive Performance: Staging Community and Utopia in the Americas* is forthcoming in 2015. Her articles on Burning Man have appeared in the *Journal of Religion and Theatre, Puppetry International, Street Notes, Performance Research* and *Festive Devils of the Americas* anthology.

Jessica Bruder is the author of *Burning Book: A Visual History of Burning Man* and a frequent contributor to *The New York Times*. She teaches narrative writing and reporting on subcultures at the Columbia School of Journalism.

Michael Christian has been building sculpture in the San Francisco Bay Area since 1995. Born and raised in Texas, he earned a BFA in sculpture from the University of Texas in Austin and apprenticed with sculptor Luis Jimenez. Michael has completed 17 commissions for the Burning Man project. He has built and exhibited works for 100 events and festivals in the US and abroad. His sculptures are included in collections and museums throughout the country and have been displayed in cities across North America and Europe. Michael's current studio, Xian Productions in Berkeley, is a mainstay of the Bay Area arts community. Xian Productions continues to be home to a variety of artists of all disciplines, as it has been for the past 12 years.

Karen Cusolito studied at Rhode Island School of Design and Massachusetts College of Art. She worked on several public art installations in and around the Boston area before moving to San Francisco in 1996. Her art has taken many forms, from painting and mixed media to large-scale steel sculptures, many of which have appeared at Burning Man. Much of her work focuses on humanity and the environment, and the delicate balance between the two. Since 2009, she has been running American Steel Studios in Oakland, CA, which provides studio and gallery space to over 100 artists and small businesses.

Ted Edwards is a public historian whose career path might best be termed as "adventuresome." With graduate degrees in counseling and history, for some four decades he taught in the public schools in the US and Caribbean (elementary through university levels), while also competing in, coaching and judging gymnastics on the national and international stage. His passion for mountains has taken him to peaks in North America, Europe and Asia, and his experiences and insights are chronicled in an earlier publication on

the commodification of mountaineering. These days his time is largely focused on oral history; specifically he works with Second World War veterans to document their memories, and, through broader interviews and archival work, substantiates their experiences in ways that correct the historical record. It is the adventurer in Edwards that brought him to Burning Man, and his interviews and journals guide his understanding of that compelling counter-cultural event.

William Fox is a writer whose work is a sustained inquiry into how human cognition transforms land into landscape. His numerous nonfiction books, which include *Playa Works* (University of Nevada Press, 2002) and *The Black Rock Desert* (University of Arizona Press, 2002) rely upon fieldwork with artists and scientists in extreme environments to provide the narratives through which he conducts his investigations. He serves as the Director of the Center for Art + Environment at the Nevada Museum of Art in Reno. Fox was born in San Diego and attended Claremont McKenna College. He has edited several literary magazines and presses, worked as a consulting editor for university publishers, and formerly directed the poetry program at the Squaw Valley Community of Writers. Fox has exhibited text works in more than two-dozen group and solo exhibitions in seven countries. He has published poems, articles, reviews, and essays in more than 70 magazines, has had 15 collections of poetry published in three countries, and has written 11 nonfiction books about the relationships among art, cognition, and landscape. In 2001–2002 he spent a number of months in the Antarctic with the National Science Foundation in the Antarctic Visiting Artists and Writers Program. He has also worked as a team member of the NASA Haughton-Mars Project, which tests methods of exploring Mars on Devon Island in the Canadian High Arctic. He was a visiting scholar at the Getty Research Institute, the Clark Institute, the Australian National University and the National Museum of Australia. He has also twice been a Lannan Foundation writer-in-residence. Fox has been awarded fellowships from the Guggenheim Foundation and the National Endowment for the Humanities.

Douglas Gillies writer and filmmaker, is the author of *101 Cool Ways to Die* and *Prophet—The Hatmaker's Son*, a biography of Robert Muller, Assistant Secretary-General of the United Nations. Gillies produced the documentary *Fall of Man* about Burning Man 1999, which toured the country as a part of Larry Harvey's lecture, "The Bohemian Life." He has produced six documentaries. *On the Edge* features Mikhail Gorbachev, Jane Goodall, Ted Turner, Oren Lyons, Huston Smith and Carl Sagan addressing the state of the world. *The Big Picture* asks the question, "How can we speed up the shift to holistic thinking from linear, reductionist, compartmentalized thinking?"

Manuel Gómez is a law professor at Florida International University College of Law. His research interests include formal and informal dispute resolution mechanisms, social norms, legal cultures, and the influence of social networks on dispute resolution and governance. His most recent publications include *Law in Many Societies: A Reader* (Stanford University Press). Manuel's research has earned prestigious awards, such as the Law and Society Association's Dissertation Prize, the Richard S. Goldsmith Award in Dispute Resolution at Stanford University, and the annual of the Venezuelan Studies Section of the Latin American Studies Association (LASA).

Stewart Harvey has taken photographs of Portland, New Orleans and Burning Man that have been shown in dozens of solo and group exhibitions and are in numerous public and private collections including: The Portland Art Museum; The Visual Chronicle of Portland; The Universities of Oregon and Colorado; The New Orleans Museum of Art; The Portland and Tacoma Biennial Exhibits; and the State Museum of Louisiana. A veteran Burning Man photographer, Stewart's work has appeared in international publications including: *Wired*; *LIFE*; *Northwest* (cover); *LensWork*; *Saturday Night Magazine* (Canada); *Valakuva* (Finland); *OM* (Russia); and *PM* (Germany). Book photographs include: *The Burning Man Book*; *Katrina Exposed*; *On the Edge of Utopia*; and *Burning Book*; as well as image covers for *The Road to Zena* and *Yoga for People Who Can't be Bothered to Do IT*. In 2011, The University of Washington Library purchased his hand-bound artist book, *I Am What I Need To Be*. He was recently included in the book *100 Artists of the Northwest*. Stewart resides in Portland, Oregon with his wife, Lynda and dog, Brianna.

Jerry James was born in 1954 at Wheelus Air Force base in Tripoli, Libya. The eldest of two sons, his family lived in Japan and various US locations until his father retired from the Air Force in 1968 and his family moved to Boise, Idaho. After a couple of years at Boise State University, Jerry began his career as a builder in 1975. He moved to San Francisco in 1980 and, in 1986, built what would come to be known as (the first) Burning Man with Larry Harvey, to mark that year's summer solstice. The following year they repeated this event, enlarging the effigy. By 1988 the sculpture was approximately 30 feet tall; Jerry was the primary builder, though both he and Larry collaborated on the design. Jerry and Larry had a falling out after the 1989 burn, after which Jerry began to withdraw from his role in the event. He continued to participate in Burning Man in other ways until 27 August 2007—Jerry's birthday, and the night that Paul Addis burned the effigy in an act of defiance. Jerry lives in Mill Valley, California and works as a general contractor. His company, FR James Construction, is named for his father.

Andrea Lundquist joined The Space Cowboys during her first burn in 2002. It was one of the first established theme camps that carried over its party and work ethics from Burning Man to San Francisco. She quickly became immersed in the friends, music and business of running a camp, establishing a profitable partnership, and producing large-scale events in the Bay Area. On the playa the Cowboys are best known for the Unimog—a Cold War-era military truck converted into a mobile DJ booth. In San Francisco they are best known for their annual Halloween and New Years Day events with their DJs, friends and fans. Andrea is the Event Manager at The Crucible, an industrial arts school for youth and adults. She may not have plans to return to Burning Man, but it finds her every day on the job and in the streets of San Francisco.

L. Gabrielle Penabaz is an interdisciplinary artist living in New York City. Writer, performer, filmmaker, subversive, Miss Penabaz's critically acclaimed theatre show, *Sex Crimes Cabaret*, questions sex laws and how people react to them. Her one-on-one live-art piece *'Til Death Do You Part.*
MARRY YOURSELF!, features a non-denominational chapel complete with rings, costumes, vows and refreshing mini-exorcisms. Her character in this piece, The Encouraging Priestess, marries participants to themselves in the US (Prospect One Biennial, Figment Festival, Burning Man), overseas in art festivals (Visions of Excess/SPILL UK) and in private gatherings. She is sought after as a video editor and voiceover talent when she isn't making absinthe.

Tony Perez was raised the youngest child of four sisters and a brother in a suburb of Detroit by his single mother and later schooled in the northern Michigan town of Traverse City. Coming of age in 1979, he followed his music dreams to San Francisco. He found work as a musician and traveled on the road playing saxophone and singing for almost 20 years. Sensing a plateau in his life, he followed a friend's lead to the Black Rock Desert in 1996 to find the new creative community of Burning Man forming. There, he quickly took to the event and its surrounding desert and joined the staff—he was made Site Foreman in his second year, and City Superintendent of the Department of Public Works in the years to follow. 2014 will be his nineteenth season supervising the building and striking of Black Rock City. He has since fashioned the reputation of "bard of the desert" with his gift of telling stories.

Zoe Platek has attended Burning Man every year since 1998. She is the Queen Pee of Pee Funnel Camp, a marketing, branding and advertising professional in the default world, and a full-time traveler. She is fascinated by almost anything about cultural anthropology and the techniques of persuasion.

Dr. Austin Richards aka Dr. Megavolt is a physicist, multi-media artist, author

and teacher based in Santa Barbara, California. He has been making Tesla coils since 1981, and is the creator of Dr. Megavolt, the character that has been performing in a metal suit with Tesla coils since 1997. In 1998, at the urging of a friend, he took Dr. MegaVolt to Burning Man, and has performed there nine different years. Since those beginnings, Dr. MegaVolt has performed internationally and has been featured in TV and film. Austin is the author of *Alien Vision: Exploring the Electromagnetic Spectrum with Imaging Technology* (SPIE Press, 2011) and works as a senior research scientist at FLIR, specializing in thermal infrared imaging systems. See www.austinrichards.com

Adrian Roberts is a 20-year-plus veteran Burner and the editor and publisher of the *BRC Weekly*, Black Rock City's independent newspaper. From 1995–2007, he was the editor and publisher of Burning Man's alternative newspaper, *Piss Clear*, which was anthologized into the book, *Burning Man Live: 13 Years of Piss Clear, Black Rock City's Alternative Newspaper* (RE/Search Publications, 2009). He's also the co-creator of Bootie Mashup, where he DJs and produces mashup-themed Bootie parties around the world.

Anna Romanovska has worked as a costume designer for dance, film and theater with a variety of companies in Latvia and Canada. Currently she is a PhD student in Adult Education and Community Development at OISE, University of Toronto. She is a part-time faculty member at the School of Fashion, Ryerson University, Toronto where she teaches design fundamentals, color theory, fashion illustration, and digital textile design. Her research interests include the role of costumes and fashion in visual communication and identity development, and the role of adult education in sustainability and arts-informed research methodologies.

Sam Berrin Shonkoff is a PhD student in History of Judaism at the University of Chicago Divinity School. His current research focuses on embodied theology in modern Jewish thought. He holds an MA in Religion and Jewish Studies from the University of Toronto and a BA in Religious Studies from Brown University. His recent publications include "Bodily Immediacy and the Body Politic in Buber's Social Thought" in *Theocracy and Nation in Jewish Thought: Past and Present* (Doshisha University, 2014), and "The Two Tablets: On Dissolving Ethical-Theological Dualism in Sacred Attunement" in *The Journal of Religion* (University of Chicago, 2013). He's been a burner since 2009.

Graham St. John is a cultural anthropologist (i.e. vibeologist) currently researching the Burner-diaspora in Europe as a Postdoctoral Research Fellow for the project *Burning Progeny: The European Efflorescence of Burning Man* supported by the Swiss

National Science Foundation and the University of Fribourg. He is the author of several books including *Global Tribe: Technology, Spirituality and Psytrance* (Equinox, 2012), *Technomad: Global Raving Countercultures* (Equinox, 2009), and the edited collections *Victor Turner and Contemporary Cultural Performance* (Berghahn 2008) and *FreeNRG: Notes From the Edge of the Dance Floor* (Commonground: 2001). He has held postdoctoral fellowships in Australia, United States, Canada and Switzerland and is Executive Editor of *Dancecult: Journal of Electronic Dance Music Culture.*

Bryan Tedrick is a San Francisco Bay native raised in Point Richmond along the shores of the Bay. After completing public school he worked in the local shipyard for a couple of years, saved his money and bought unimproved acreage on the Gualala River in rural Sonoma County. Building a cabin, traveling to India, and attending the San Francisco Art Institute followed. He graduated with a BA in Sculpture, married Terry Roberts and bought a home in Glen Ellen to raise their two children, Nathalie and Jakob. Coupling his wood and metal working skills, he started a small business making custom gates while Terry worked as an English teacher at public schools. He received his first public art commission in 1995 to make the Sacramento Convention Center gates. Several other public art commissions followed over the next ten years and gate-making became secondary to sculpture. Bryan discovered Burning Man in 2005 and has brought sculpture to the event every year since, receiving multiple honorarium grants.

Barbara Traub is a photographer whose work combines surreal elements and decisive moments with a dramatic sense of style in a way that suggests the poetry of vision. In 1987 she launched her career with a solo show at the Hubble Space Telescope Science Institute and won first place in the *Baltimore Sun Magazine* annual photo contest. Since then her work has appeared in exhibitions and publications worldwide. She was chief photographer for *Burning Man* (Hardwired, 1997), curator of the Art of Burning Man exhibit at Photo SF 2004, and author of *Desert to Dream: A Dozen Years of Burning Man Photography* (Immedium, 2011).

Mark Van Proyen is an artist and art critic based in the San Francisco Bay Area. He is associate professor in the Painting and Art History Departments at the San Francisco Art Institute, and is a corresponding editor for *Art in America*. His most recent writing includes *Administrativism and its Discontents* (SUNY Stony Brook, 2006) and "Facing Innocence: the Art of Gottfried Helnwein" in Diana Daniels (ed.), *Gottfried Helnwein: Inferno of the Innocents* (Sacramento, Crocker Art Museum, 2011).

LIST OF CONTRIBUTORS

ABOUT THE EDITOR

Samantha Krukowski is an author, artist and educator. She is curious about how images, objects, people and places function in the context of a society where information is aggressive, multilocated, fluid and slippery. She has written about the problems of historicizing time-based artworks; presence and absence in the pictorial field; the nature of creativity and the identity of the artist. Her studio work often involves examining bits of the world at micro and macro scales in order to discover shared pattern languages; her videos, paintings and drawings have been exhibited nationally and internationally. Originally from New York and St. Louis, she currently lives in Iowa where she teaches architecture at Iowa State University. She created the Burning Man Studio, a course in which students design and build works for Burning Man. Dr. Krukowski holds a PhD and MArch from the University of Texas at Austin, an MA from Washington University in St. Louis, and a BA from Barnard College.

COLOPHON

© 2014 Black Dog Publishing Limited, the artists and authors.
All rights reserved.

Black Dog Publishing Limited
10A Acton Street
London
WC1X 9NG

t. +44 (0)207 713 5097
f. +44 (0)207 713 8682
e. info@blackdogonline.com

All opinions expressed within this publication are those of the author and not necessarily of the publisher.

Designed by João Mota at Black Dog Publishing.

British Library Cataloguing-in-Publication Data.
A CIP record for this book is available from the British Library.

ISBN 978 1 908966 64 3

All rights reserved. No part of this publication may be reproduced, stored in a retrieval system, or transmitted, in any form or by any means, electronic, mechanical, photocopying, recording, or otherwise, without prior permission of the publisher.

Every effort has been made to trace the copyright holders, but if any have been inadvertently overlooked the necessary arrangements will be made at the first opportunity.

Black Dog Publishing is an environmentally responsible company.

Playa Dust is printed on sustainably sourced paper.

art design fashion
history photography
theory and things

black dog publishing

www.blackdogonline.com **london uk**